Drawing
Masterclass

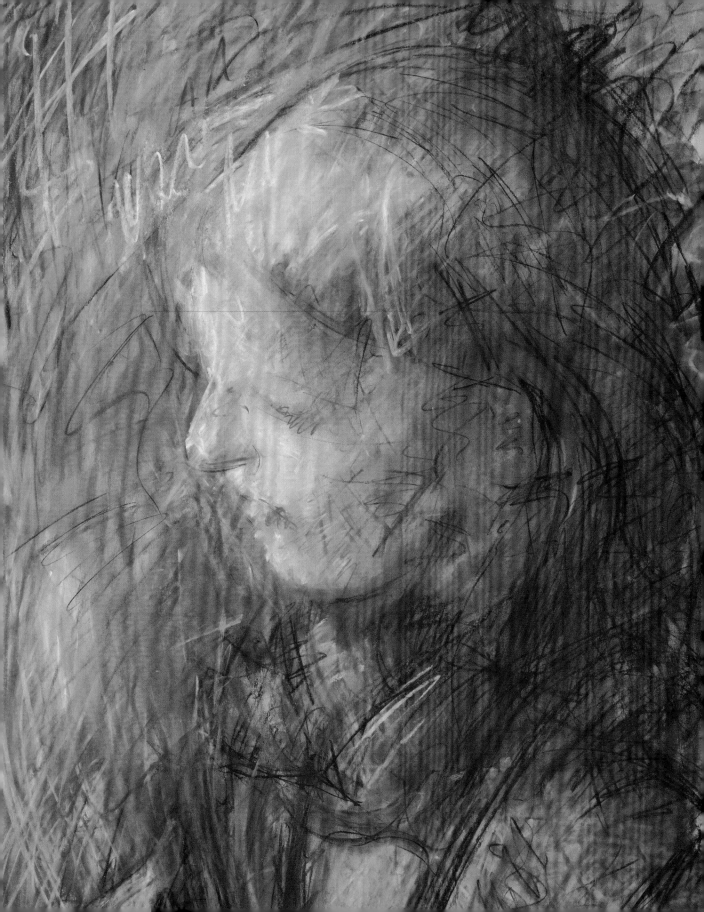

Drawing Masterclass

100 CREATIVE TECHNIQUES OF GREAT ARTISTS

Guy Noble

Thames & Hudson

Previous page
Head No 6 (Detail) 2015
© Guy Noble

Following page
Yellow Girl No.2 (Detail) 2003
© Guy Noble

On the cover
Front
Head of a Man, Seen from Behind 1583–90
Federico Barocci, Nationalmuseum, Sweden

Back, Above
Tahitian Faces (Frontal View and Profiles) *c.*1899
Paul Gauguin, Metropolitan Museum of Art, New York, USA

Centre
The Fire at San Marcuola *c.*1789
Francesco Guardi, Metropolitan Museum of Art, New York, USA

Below
Digger in a Potato Field: February 1885
Vincent van Gogh, Van Gogh Museum, Amsterdam, Netherlands

First published in the United Kingdom in 2017 by
Thames & Hudson Ltd, 181A High Holborn,
London WC1V 7QX

Copyright © 2017 Quintessence Editions Ltd.

This book was produced by
Quintessence Editions Ltd.
The Old Brewery
6 Blundell Street
London N7 9BH

Project Editor	Hannah Phillips
Editor	Fiona Plowman
Designer	Josse Pickard
Picture Researcher	Giulia Hetherington
Proofreader	Sarah Hoggett
Indexer	Ruth Ellis
Production Manager	Anna Pauletti
Editorial Director	Ruth Patrick
Publisher	Philip Cooper

British Library Cataloguing-in-Publication Data
A catalogue record for this book is available from the British Library

ISBN: 978-0-500-29339-3

Printed in China

To find out about all our publications, please visit **www.thamesandhudson.com**.
There you can subscribe to our e-newsletter, browse or download our current
catalogue, and buy any titles that are in print.

Contents

Introduction 8

Creative tips and techniques 28

Basic drawing techniques 40

Basic materials 46

Still Life 52

Heads 68

Landscape 108

Figures 136

Abstraction 184

Nudes 210

Fantasy 252

Glossary 280

Index 283

Picture credits 288

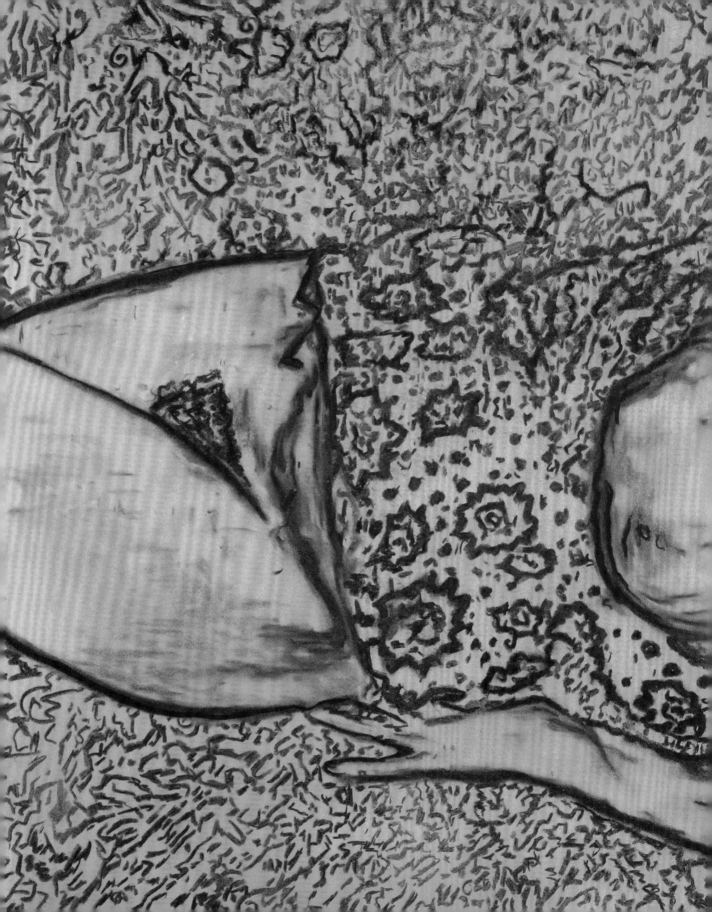

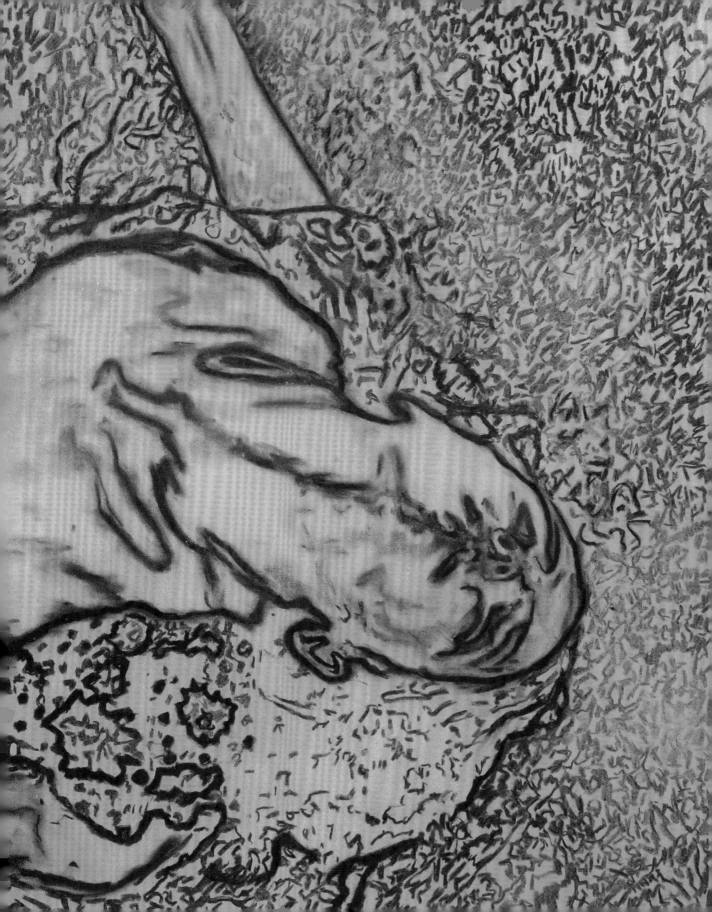

Introduction

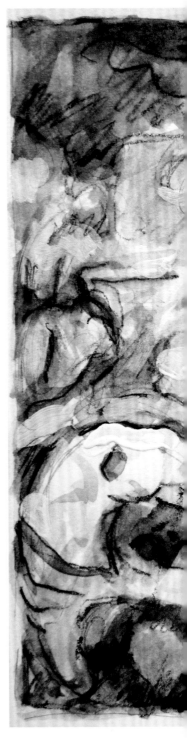

All works in the introduction are by the author, Guy Noble.

The act of drawing is an intimate one and some artists find showing their drawings to be deeply revealing. Often sketchy in style and at times bordering on the diagrammatic, drawing is a discipline that plots points, explores perspective and establishes relationships with space and dimensions. The act of drawing can be like charting a course towards a greater work; artists place value on their drawings, but often see them as studies waiting to be fully realized – stepping stones towards a more developed and finessed painting. For this reason, it can be argued that each artist's personal history is exposed more directly in their drawings than in any other aspect of their work. By studying the pared-down product of the simple act of putting pen or pencil to paper, audiences can draw closer to great artists, who often seem so distant when their work is framed and hung in galleries.

That terrible question: what is drawing?

A few years ago, I was invited to a seminar at the British Museum on this subject, and almost all day was spent attempting to define the word 'drawing'. Several weeks prior to this, in 2014, Alison Carlier won the prestigious Jerwood Prize with her sound installation *Adjectives, lines and marks*, which she described as 'an open-ended audio drawing'. This was the first time an artwork made up primarily of sound had won the top prize in its twenty-year history and it prompted debate and discussion around the question. Today drawing seems far more multifaceted and transgressive than when Paul Klee famously defined it as 'taking a line for a walk'. It is strange that in art we find it hard to accept what other disciplines have little issue with, however, it could be argued that this is due to the challenges posed by the classification of such a fluid form of expression.

The drawn image is the earliest known means of recording ideas and communicating with others. Regardless of recent technological phenomena such as Snapchat and the selfie, and the invention of new artistic methods, drawing holds a special place in the halls of human creativity as a form of self-expression.

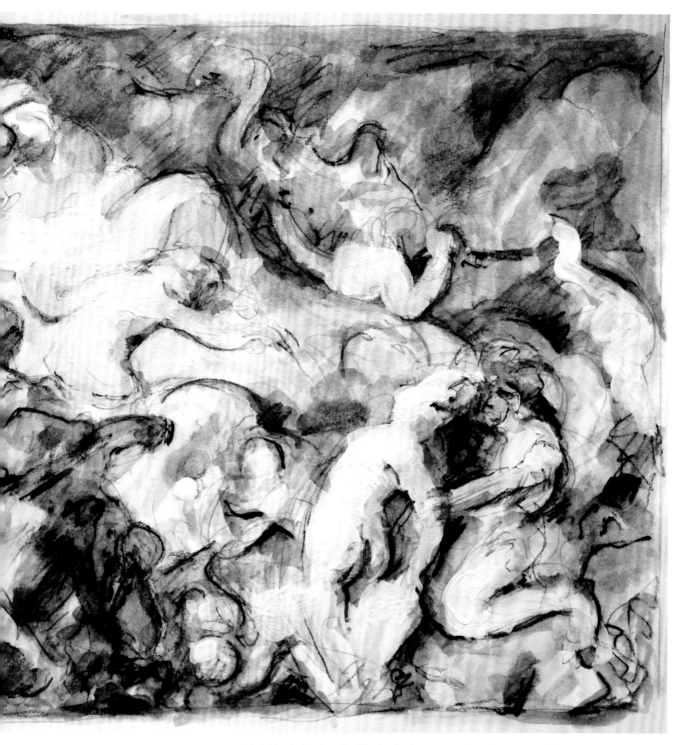

Sketchbook drawing after *The Death of Sardanapalus* (1827) by Eugène Delacroix 2015
Pencil, ink wash, soluble graphite pencil and white acrylic on paper
18 × 23 cm (7⅛ × 9 in.)

Here, the artist paid close attention to the swirling rhythms underpinning the sketch rather than addressing details. Using a Japanese brush pen and pencil, he preserved the rhythms but controlled the gradation of tones. As some lighter areas became too dark, he introduced white acrylic.

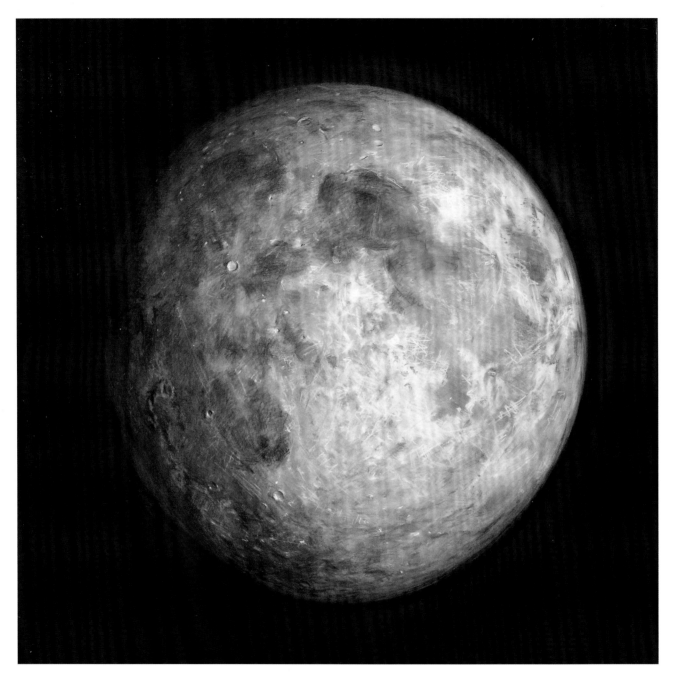

Spooky Moon 2014
Mixed media on paper
122 × 122 cm (48 × 48 in.)
Collection of Mary and Philip Hay-Jahans

The moon is not a subject that immediately comes to mind when drawing and it obviously requires using photographs. However, it has a deep and symbolic connection to our lives. The artist chose this subject in response to a tragic event in his life; he wanted a subject that was universal but also deeply personal.

The Undertaker 2012
Monoprint, charcoal and black watercolour on paper
59 × 42 cm (23 ¼ × 16 ½ in.)

This image was inspired by a visit to an unusual museum underneath the office of a funeral directors in Barcelona. The museum showed a collection of hearses and coffins dating back several hundred years. Each exhibit was decorated with mannequins dressed in funeral apparel. Everything was lit in a rather dull, flat neon light. The image was not developed into a series, but it still creates a haunting, powerful atmosphere.

Universal, humble and versatile, the art form is also highly practical. It transcends geographical boundaries and crosses class divisions: in every culture there is some form of graphic work, whether it be decorative, instructive or expressive. Most people are fortunate enough to have access to tools that will enable them to draw, be it a pencil and paper, a surface and stone, or a stick in the sand. You can achieve reasonable results with a small amount of effort, and elaborate materials are not necessary to produce startlingly sophisticated effects.

History

Most books on drawing begin by explaining how human beings have exercised the desire to make their mark, illustrate their history and make sense of the world around them for thousands of years. The first examples of cave painting are believed to have been made approximately 35,000 years ago but their function is disputed: they may have been decorative, communicative or for religious and ceremonial purposes. Drawing is therefore a deeply primal and instinctive medium, and illustrations can have multiple motivations and purposes behind them. Perhaps the most evident is the desire to capture and share a feeling or idea. From these early cave paintings through to the development of symbols with agreed and shared meanings, there evolved a highly sophisticated means of communication.

The invention of paper completely revolutionized the way these symbols could be used. The earliest known archaeological fragments of what we consider to be the precursor to modern paper date from around the 2nd century BC in China, but it was not until the 13th century that European artists began to use paper for drawing. However, it was a luxury; expensive and difficult to manufacture, it was not readily available as it is today.

The oldest drawing in this book is Leonardo da Vinci's *Study for the Head of a Girl*, created in 1483 (see p.72). Leonardo used the then-popular technique of silverpoint on specially coated paper. His beautifully rendered, precise drawing was similar to that of

many Northern European artists of the previous century – artists such as Robert Campin, Jan van Eyck and Rogier van der Weyden.

Until the beginning of the 20th century each generation of artists not only built on established traditions and skills but also brought their own unique vision to their work. From the early 15th century, there began an extraordinary unfolding of artistic invention in Western Europe – the Renaissance. Looking back over the last 500 years, people have their favourite artists, but there are not many who, in spite of personal preferences, are true giants. Michelangelo, Leonardo, Raphael and Titian were undeniably giants, although each had an individual style. Even at that time it was understood that these artists excelled in different areas; for example, Michelangelo's monumental forms were distinct from Titian's extraordinary, fluid late work. The High Renaissance was an exceptionally rich period for great Italian artists, but it is worth noting that in northern Europe an almost exact contemporary of Leonardo's was a very different visionary: Hieronymous Bosch. It is a mistake when art historians and commentators interpret art history as a linear progression, moving relentlessly towards abstraction. Nothing could be further from the truth. Bosch's world has more in common with that of René Magritte than it does with Leonardo's.

With all these great artists, the role of drawing was absolutely central. They not only experimented with planning out their more elaborate and developed paintings, but also used drawing as a means of expression independent of other art forms. Rubens would use his drawings to work out complex compositions, whereas Rembrandt explored biblical stories that seemed to him to express something profoundly human (and in turn, his responses to his subject utterly convince viewers of his humanity). By contrast, Claude Lorrain created volumes of drawings that simply recorded a visual catalogue of his painted compositions.

The Rococo period may seem at a first glance frivolous and even perhaps deserving of the sticky end the French Revolution brought to such a decadent age. On closer examination there

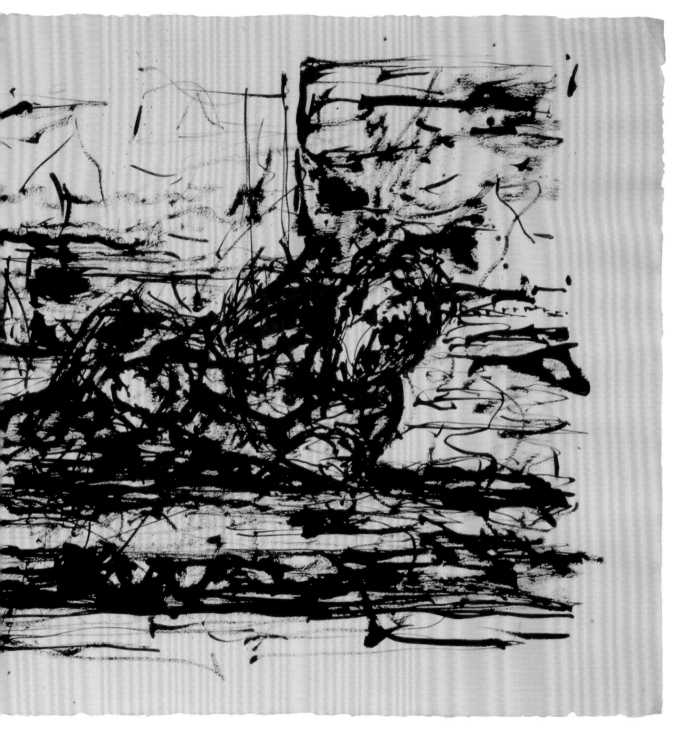

Man Lying in the Street 1995
Indian ink on cream wove paper
78 × 86 cm (30 ¾ × 33 ⅞ in.)

This drawing was made directly from an extremely poor photograph taken at night. The artist has broken up the form with slightly chaotic and animated brushstrokes. The brush used was a long-haired thin brush called a 'rigger', which is used in sign writing.

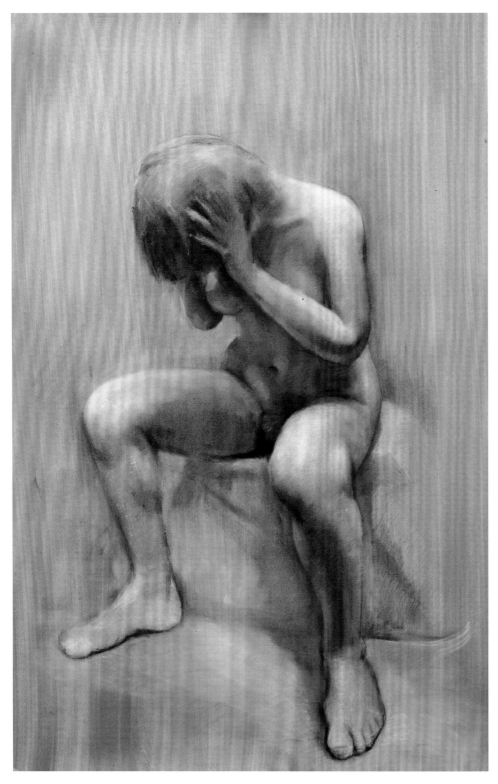

(Left) **Girl with Head in Hands** 2015
Charcoal on hand-toned grey paper
86 × 63 cm (33 ⅞ × 24 ¾ in.)

In this drawing, the artist toned the paper a mid-tone grey that has slight variations. The texture of the paper is slightly grainy, although not highly textured. The dry surface provided an excellent surface for the charcoal to grip on to.

(Right) **Woman Looking Back** 2010
Coloured chalks on paper
63 × 36 cm (24 ¾ × 14 ⅛ in.)

Here, the background area has been deliberately kept clear of any detail or tone in order to focus the viewer's gaze directly on the figure, particularly the head.

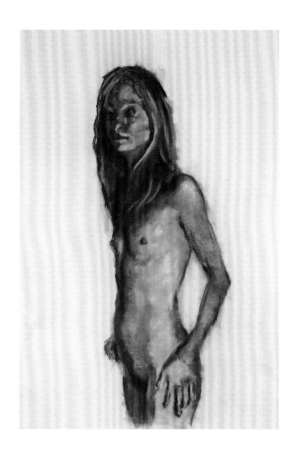

were many great artists working at that time. Jean-Baptiste-Siméon Chardin, François Boucher, Francesco Guardi, Thomas Gainsborough, Jean-Honoré Fragonard and later Francisco Goya all employed the medium of drawing as an integral part of their creative output, each developing it to suit their specific needs and individual styles.

The art of the 19th century is probably best known to most people. The important role museums and collectors played in preserving the art created during this period – together with the industrialization of the means by which artists could produce their work cheaply – made the 19th century enormously significant. Edgar Degas, Paul Cézanne and Vincent van Gogh best exemplify the way the century unfolded. Degas wanted to be a classical painter of large history paintings that could compete with the artists he admired, whereas Young Turks such as Cézanne wanted to go in a different direction, and endeavoured to make a more radical break with the past.

Without doubt one of the most moving characters in art history was Vincent van Gogh. His story has been made into films, books and plays, but it is his drawing and painting that continually enthral an enthusiastic public. With most of the artists featured in this book, the technical expertise they undoubtedly possess is always at the service of a bigger purpose. Van Gogh's reed pen drawings are completely original and unlike anything done before. He provides yet another example of an artist adapting drawing to fit their needs.

The 20th century exploded into life with that huge character Pablo Picasso. His dominance of the 20th century is hard to overstate. His insatiable appetite for experimentation led him to explore so many different creative possibilities that numerous artists later in the century found themselves treading in his footsteps, in spite of the most strenuous effort not to. Slightly older than Picasso, Henri Matisse – whom Picasso considered his only serious rival – was the other monumental artist of the 20th century. Today, more than sixty years since Matisse's death,

we can see that Picasso was right. Between them they produced thousands of drawings – not all of them are great, but the best are as good as anything done in any period.

Finally we come to the late 20th and early 21st centuries. It is impossible to judge more recent periods objectively and it is right to be highly sceptical of judgments that are so easily made. However, it is also necessary to respond to the spirit of our age and engage with contemporary debates. From Leonardo to Peter Doig, drawing has played a pivotal role in shaping the way artists think and produce work. Through closely studying the way that individual artists in history have used drawing, we can improve and refine an understanding not only of their drawings, but also our own.

Conventions and schematic drawing

The most useful of all conventions and systems of representation is perspective. The first known written description of perspective was by Leon Battista Alberti in his treatise *Della Pittura* (1435). Perspective has proved to be one of the most effective ways of representing three dimensions on a two-dimensional surface ever invented, and it is used by almost all creative individuals. Like all systems, however, it has its limitations and the 20th century, especially after the invention of Cubism, raised some serious questions over exactly how useful perspective can be across many areas of fine art. Nonetheless, anyone who is interested in learning how to draw should have a basic understanding of how perspective and all other systems work.

When most children learn to draw, they quite understandably make an oval to represent a head. Of course, the head is nothing like an oval – but of all simple geometric shapes, it is most like an oval. Building a figure from a series of geometric solids is a remarkably good way of creating a convincing figure, although this kind of construction has more to do with what you know than with what a figure actually looks like. When an artist tries to paint what they see using conventional schematic language, they are hopelessly undermined. This is one of the most fundamental

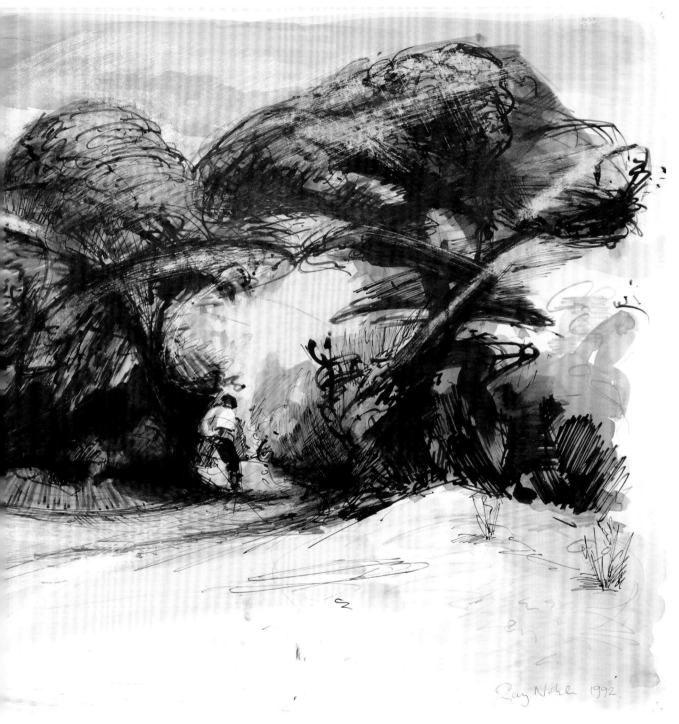

Two Men at a Forest Crossroads 1989
Charcoal, ink, pencil and white chalk
56 × 87 cm (22 × 34 ¼ in.)

This drawing is from a series exploring how figures become focal points and catalysts to activate the whole image in a dynamic and rhythmic way. The artist built two life-sized mannequins and posed them in a landscape. The movement created by the figures is echoed in the rest of the image.

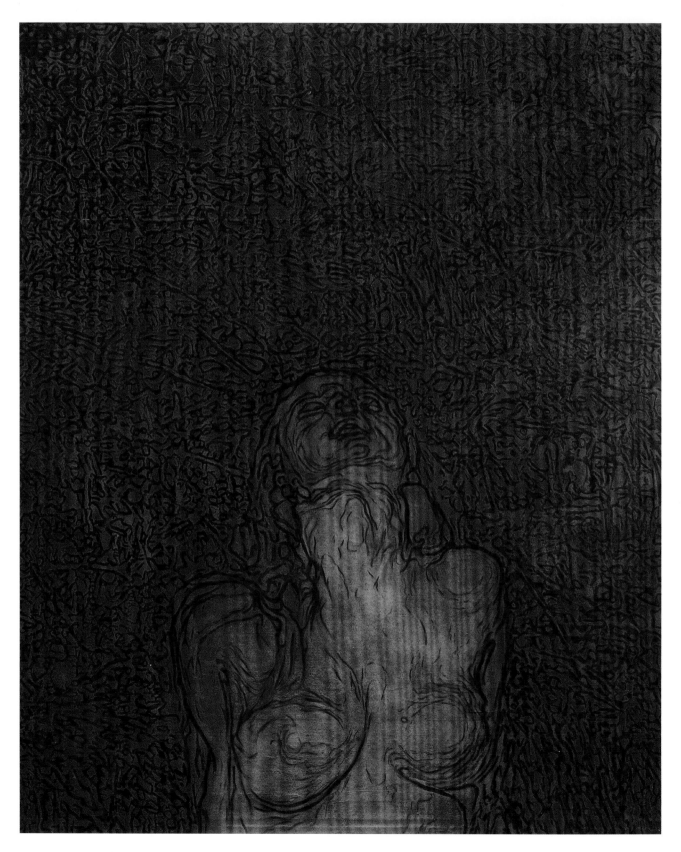

(Above) **Self-portrait in Profile** 1985
Pencil on paper
45 × 31 cm (17 ¾ × 12 ¼ in.)

A profile self-portrait is very difficult to do and
requires the use of mirrors. It is very important to
ensure that the light is intense enough to carry
through the two mirrors and show the form of
the head in the way you wish. Here the artist
has tried to articulate each plane clearly, but
not schematically. Rather than separate each
individual plane as a clearly defined shape, he has
chosen to reduce the tonal separations. There are
problems when working in this way; for example,
it is easy to see the planes on the flesh but as you
move into a more ambiguous surface, such as the
hair, it becomes too artificial to be convincing.

(Left) **Burning Up No.1** 2005
Charcoal and spray paint on paper
213 × 183 cm (83 ⅞ × 72 in.)

This drawing was inspired by the simple
sensations of feeling the sun's heat on one's skin
and at the same time looking into the blue sky.
Blue sky is a strange phenomenon in nature: it is
a strong colour with no surface and after a few
moments staring intensely at it, the sky seems
to vibrate. This drawing attempts to represent
these sensations.

divisions between illustration and art; and again there is a
problem of definition. Illustration tends to tell viewers what
they already know, possibly with a rather entertaining twist, but
essentially it is about getting the facts across clearly. However,
fine art, particularly drawing, concerns itself with appearance – it
is about telling viewers something they do not know or making a
transformation that is surprising. This distinction is key, because
so much art education is based around the idea that illustration
and fine art are essentially the same. A sound installation can be
great, an illustration can be great and a piece of fine art can also
be great – but they are not the same.

Finding your own vision

Anyone who has ever tried to draw or teach drawing will know
that the way one learns is hugely influenced by the type of
personality one has. Those who are sympathetic to the primal
and instinctive roots of drawing may be faced with a continual
struggle to control and harness these forces. They may find it
very difficult to develop their drawing. However, others who
are more methodical and organized may find it hard to trust
their intuitive responses, and their work will continue to look
restricted and prescriptive.

We live in an age when every artist has to develop his or her
own visual language – there is no established tradition to draw
on or act against – but not every visual language is of equal
merit. In deciding which ones are most interesting, people have
to exercise judgment – yet this causes many people great anxiety
and seems to run contrary to ideas of creative freedom. Although
it is an attractive idea to work in splendid isolation – not looking
at any other art keeps one's vision pure and totally individual – it
has not proved a very successful strategy. By contrast, artists who
have carefully studied masters of the past seem to have benefited
beyond measure. A word of warning, however: slavishly copying
the work of great artists will never produce anything other than a
slightly more skilful version of yourself.

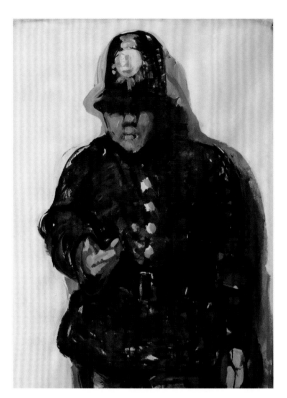

Looking back 200 years, it appears that practising art was much easier. Established traditions could either be embraced and developed or rebelled against. Now, every artist can do what he or she wants. Yet one only has to read the journals and diaries of many artists and writers of that period to realize that they also had their anxieties. In our age, as in many but not all periods in history, the fashions of the day exert disproportionate influence over the work. It is very easy to regard the Old Masters as separate and disconnected from today's cultural and fashionable considerations, not to mention the fact that they seem more able to achieve technical dexterity. If we look at the work of Leonardo da Vinci or Pierre-Paul Prud'hon, for example, we see skill that seems almost impossible to emulate.

Weighing up the different influences and dynamics that contribute to the responses of an artist is a tricky business. To some extent, it is like being a ship battered by the waves. First there are personal tastes, desires and ambitions to deal with; then the good opinion of friends and people you respect; then perhaps the necessity to make money and so work; then the demands of galleries and collectors; then the fashions of the moment and what is in or out. The list goes on and it is easy to lose sight of simple, fundamental ideas about the art we love so much.

Following the masters

Some artists seem able to concentrate entirely on a singular vision and ignore all the background noise that can be so distracting and destructive for others. Looking at the work of an artist such as Lucian Freud, it is hard to imagine how Abstract Expressionism could have in any way influenced his vision, yet his contribution to late 20th-century painting cannot be denied. Take a step back and it is possible to see that the world of painting and drawing is big enough to encompass both the Abstract Expressionists and Freud, just as it was big enough to embrace both Raphael and Titian.

There are artists who have managed to do one thing brilliantly; Giorgio Morandi is a good example. Although he flirted with

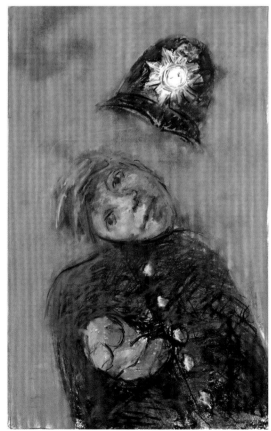

(Left) **The Third Policeman No. 4** 2015
Chalk, charcoal, Indian ink and acrylic on paper
150 × 120 cm (59 × 47 ¼ in.)

This trio of images was inspired by Flann O'Brien's novel, *The Third Policeman* (1967). The artist listened to an audio reading of the book while he worked on the drawings. The images produced quickly moved away from any kind of illustration of the book. In these large drawings, the medium became a significant element; it pushed the images in a specific direction, making the forms more massive and concrete than the artist had originally planned.

(Bottom Left) **Discombobulated Policeman No. 6** 2016
Pastel, charcoal, ink and pencil on paper
167 × 110 cm (65 ¾ × 43 ¼ in.)

Here, the artist started to disconnect parts of the image in order to disrupt the viewer's expectations. The result is an intriguing mixture of realism and fantasy. The image explores the way these sensations connect with our experiences.

(Right) **The Third Policeman** 2015
Pastel, chalk and charcoal on paper
160 × 120 cm (63 × 47 ¼ in.)

In this drawing, the artist has kept the pastel colours fairly separate. This reveals the individual gestures and preserves the distinct colours.

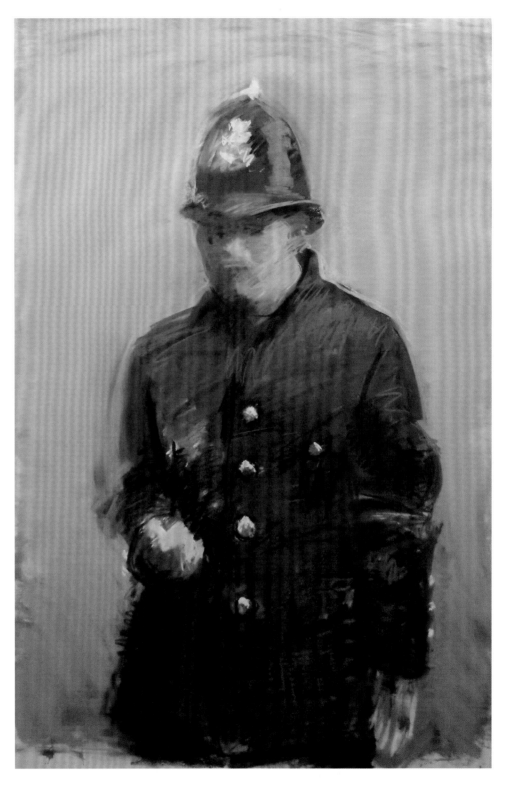

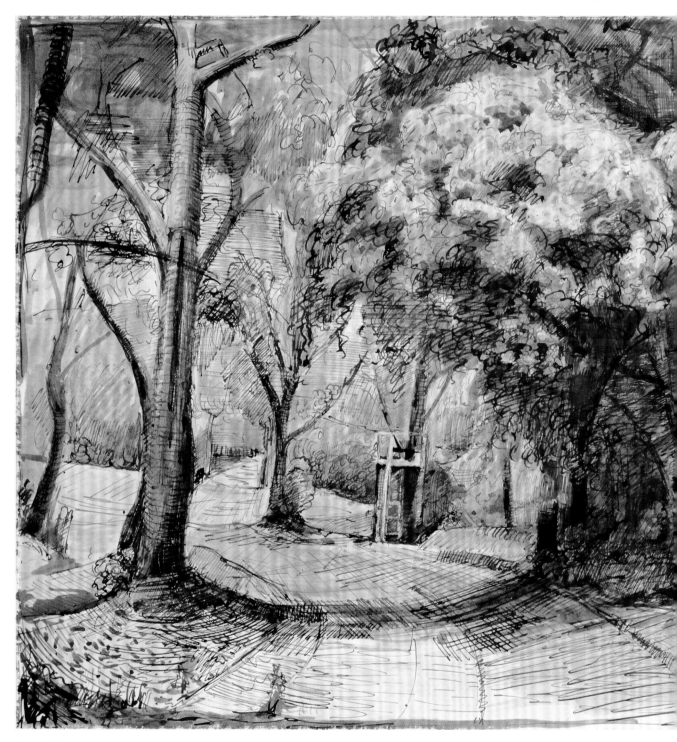

Forest 1989
Pencil, sepia ink and white chalk on paper
38 × 55 cm (15 × 21⅝ in.)

This drawing was built up in a series of layers
while maintaining the basic composition. The
artist was primarily interested in the extraordinary
tree (centre right); this form was seen in conjunction
with the concave shape underneath (the centre
being the little construction in the distance).

Surrealism early on, he spent most of his time working on simple still lifes, only a few pots and vases in an even grey pearly light. These drawings, together with his paintings, say nothing directly of the period he lived in and make no psychological statement about his relationships. They are cool, optical contemplations of simple objects in a controlled environment. There are other artists who move so easily between different styles and media that it is difficult to identify a common theme. Here, Picasso comes to mind. When Picasso was beginning to formulate the ideas that eventually led to Cubism, he locked himself away in his ramshackle studio with a model and produced hundreds of drawings; some took only a few seconds whereas others were more elaborate. It was through this process that Picasso almost single-handedly revolutionized painting with the extraordinary work, *Les Demoiselles d'Avignon* (1907).

From this we should learn how important it is to be true to oneself and to follow one's interests and instincts without worrying about what other people think. However, this also needs to be squared with a desire to be more insightful, more skilful and more profound. While this is not about compromise, it is about balance. Understanding how to develop one's own visual language is helped tremendously by looking at how other artists have developed theirs. Yet, again, this can be taken too far; copying or aping the superficial style of another artist is going to end up as a destructive force rather than a liberating one.

We live in a period that values the individual vision of the artist extremely highly, but it is also a time in which art is treated as a product, since there are considerable commercial forces at play in today's art world. Reading the output of many commentators, critics and writers, one would think we are living in an age of great artists. The work of contemporary artists sells for millions of pounds and dollars, whereas that of some significant Old Masters sells for considerably smaller figures. Thankfully, the more discerning among us understand that the marketplace is rarely a reflection of quality.

It could be argued that every period has its great artists, so copying the greats of one's contemporary period will, at the very least, secure a place in history. But is this true? As we have seen, there are too many unreliable influences that are brought to bear on judgment of one's own period. History has shown that around 1700 there was only one artist that had a marked influence on subsequent generations – Jean-Antoine Watteau. It could easily turn out that this period is looked back on as one being bereft of great artists – a perhaps shocking thought to some. While playing that particular game may be entertaining and not without interest, it is ultimately futile.

About this book

This book focuses on the individual artist and their relationship to the medium of drawing. It looks at what a drawing actually does and how it does it. It examines 100 drawings and uses each one to explore an aspect of the medium from a particular point of view. For example, Edgar Degas's *A Man Carrying an Urn* (see p.160) demonstrates how he cleverly expresses the sensation of the weight of an urn without actually drawing it. If it were described in drawing terms, we would use our knowledge to project into the drawing some expectation of what that weight would feel like. What Degas achieved is quite extraordinary, as it is the one object in the drawing that he has not actually portrayed. By emphasizing certain elements, he creates a drawing from which you could tell almost exactly how much the urn weighs. Of course, this is not the point of the drawing – but to see the actual lines that illustrate the effect of weight is highly educational.

Through analysis of each drawing, the reader will develop a more constructive understanding and appreciation that might change the direction of his or her work. Creative tips panels, carefully informed by the drawing on each page, are also included to provide illustrative examples, practical advice and simple exercises to hone skills and inspire your work. The artists featured in this selection cover a broad range of approaches but all exist

Sketchbook drawing after *Minerva Protects Pax from Mars ('Peace and War')* by Peter Paul Rubens (1629–30) 2015
Pencil, ink wash and soluble graphite pencil on paper
58 × 80 cm (22 ⅞ × 31 ½ in.)

This sketch was completed in the National Gallery in London, where the painting by Rubens is located. When drawing from paintings, it is almost always better to be in the gallery rather than to use photographs (although it can be rewarding to work from photographs). It may feel uncomfortable at times with people peering over your shoulder, but you will get used to it and they will get bored and move on.

(Left) **Ghosts No. 5** 2016
Pastel, ink and charcoal on paper
80 × 58 cm (31½ × 22⅞ in.)

(Right) **Ghosts No. 7** 2016
Pastel, ink and charcoal on paper
80 × 58 cm (31½ × 22⅞ in.)

These are from a series of fourteen drawings, each done on consecutive days. The subtle gradations of colour generate a mysterious atmosphere. Although the drawings were spontaneous, the composition was worked out using sketches and the model was carefully posed so that verticals and the angles of the arms create a still, yet fluid, composition.

(Bottom Right) **Red Hoodie** 2012
Mixed media on paper
60 × 42 cm (23⅝ × 16½ in.)

In this experimental image, the artist used blotting paper to run through a thermal inkjet printer. He then drew in the detail in watercolour and ink. Controlling the various stains and runs became an integral part of the image's development. For example, the black stain on the inside of the hood is entirely accidental.

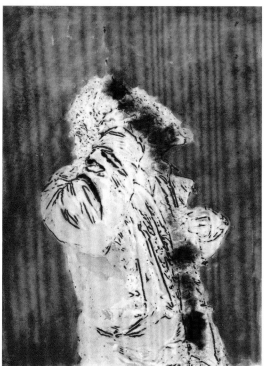

within the canon of fine-art drawing. Degas's intensely observed drawing represents one specific approach, whereas Ken Kiff's approach is more to do with creating an imaginary world. The broader historical context of these works varies massively – from periods of huge social unrest, cataclysmic epidemics and wars to periods of utter frivolity and silliness. Politics, philosophy and social conventions also play a role in shaping the context in which artists have found themselves throughout the history of art. Finally, of course, there is the individual artist and their personality, which also significantly shapes the marks they make on the paper.

A unified whole

A theme that consistently runs throughout this book is the importance of creating a unified whole. The more one reads about the opinions and ideas of great artists, the more one becomes aware that artists prize the unity of their images above almost any other quality. But what do we mean by unity? Simply put, it means that every part contributes to the whole effect without breaking up the image. Highly unified images seem to give viewers an enormous sense of satisfaction, even though the image may depict a disturbing subject. Conversely, images of relatively benign subjects can be of no interest because they appear like a shopping list of various parts.

From the diverse selection of drawings themselves and the careful analyses of each work to the creative tips panels that offer instructive and practical advice, the holistic approach of this book should serve to inspire and inform both the beginner and the more experienced artist. The attention, discipline and care required by the medium of drawing can prove therapeutic, and examining the work of great artists should be aspirational for the budding artist. I recently had the good fortune to meet the wonderful artist Paula Rego who is also featured in these pages. When I explained that I was writing this book she asked me why, and I replied, 'Because I love drawing and I want other people to love it as much as me.'

Creative tips and techniques

Each entry in this book is accompanied by a series of technical and creative tips that relate to specific techniques utilized by each featured artist and exemplified in each drawing. Although all artists employ different methods to achieve their desired effects, it is possible to identify some recurrent themes and examine several basic elements that artists use most of the time when drawing. Understanding what these techniques are and how they work with each other is one of the first steps any aspiring artist should take when learning to draw. Under this heading several themes are covered, including tone, space, form, shape, line and colour.

Tone

Tone, light and shade, chiaroscuro – all these terms have a similar meaning and describe the gradations between white and black. With most drawing, a pencil or other implement is used to make a darker mark on a white or light surface. Simple tonal drawing is about taking away the light of the paper by the addition of dark marks with whatever instrument is used. The transitions between the tones are what are known as half-tones, quartertones or simply transition tones – any tone that is between white and black.

This system of dividing tones has been in use for hundreds of years and it continues to be the most effective way to represent light and shade. However, it is easy to assume that the Old Masters employed a different system to contemporary drawing. Many of the conventions they used are no longer valid, but nevertheless this system remains remarkably consistent. It is true that differences in tone can be used to simply distinguish one mark from another rather than representing light and shade (see Line, p.33).

The most important thing to bear in mind when working with tone directly from reality or observation is that the eye has a remarkable ability to look into shadows and exaggerate differences in order to be able to make sense of the information contained within the shadow. When an artist is faced with a subject that contains shaded areas, the temptation is always to exaggerate the differences in tonal values within the shaded area. This applies to the very light areas as well, but is most noticeable in the shadows. In order to combat this trap, an artist must always make comparative assessments by switching attention from the large areas to the small, localized shadows.

When working directly from life, it is important to look at the subject in the same way that you look at your drawing. Pay particular attention to the way reality presents the tonal relationships, then quickly move to your drawing and notice how the parallel relationships you have created connect with what you have just looked at.

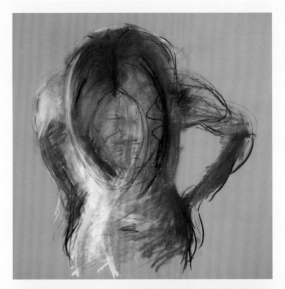

(Top Left) **Woman
Looking Down** 2016
Charcoal and white chalk
on blue paper
76 × 78 cm (29 ⅞ × 30 ¾ in.)

Here, the artist has used mid-toned
paper worked up to the highlights
and into the shadows with either
white chalk or black charcoal.

(Bottom Left) **Model
Looking Down** 2006
Pencil, charcoal and pastel
on cream wove paper.
76 × 78 cm (29 ⅞ × 30 ¾ in.)

This drawing was done from a very
precise photograph. However, the
artist has concentrated on creating
different kinds of textures within the
image. Although the colour range is
narrow – reds, golds and yellows –
the tones have been kept relatively
separate and lines of different tones
overlap, creating a transparent
effect. This effect has varying
degrees of density, from solid to
smoky to transparent.

(Right) **Nude Seen
from Behind** 2016
Charcoal and white chalk on
grey sugar paper
80 × 53 cm (31 ½ × 20 ⅞ in.)

This powerful life drawing has a
simple structure that has been
maintained even as the drawing
developed. The movement in from
the base of the foot, up the leg
to the bottom and through to the
shoulders and head never becomes
illusionistic, but still suggests depth.
Light and shade and contours
weave in and out, creating a series
of dramatic forms. The drawing was
completed in about sixty minutes.

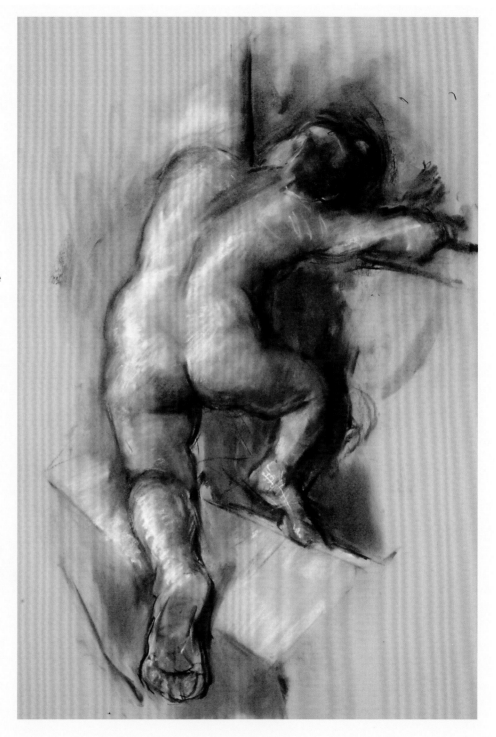

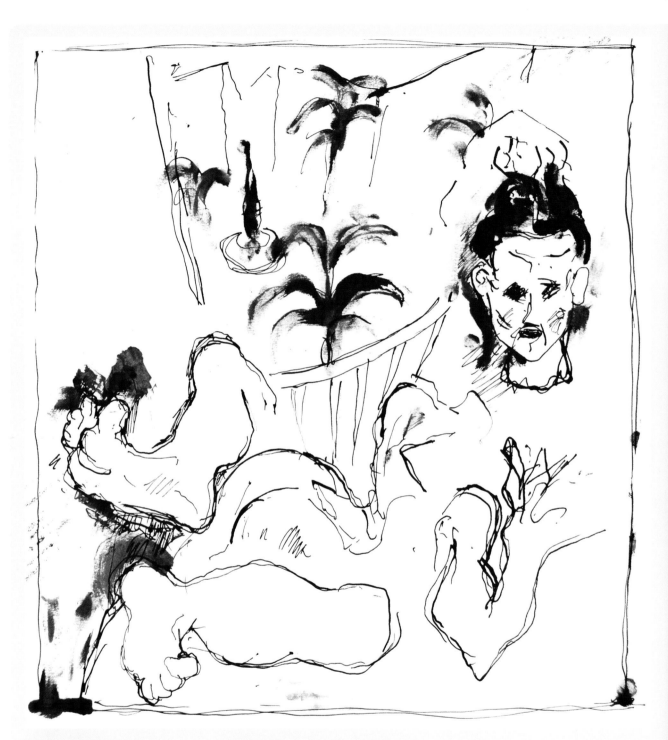

Barcelona Drawing No.12 1992
Pen and ink on paper
58 × 58 cm (22 ⅞ × 22 ⅞ in.)

Here the artist has created an imaginary space.
Each area seems to float, creating a strange,
disconnected type of reality. The artist took
logically constructed drawings and cut them up,
rearranging the pieces on a clean sheet of paper.
He then made drawings of these arrangements.

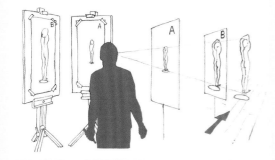

The picture plane
This is an imaginary plane between you and the subject – it represents the surface of your drawing. If the artist stands still and the object is at a set distance away, as the picture plane is moved closer to the object the bigger it will appear in the window of the picture plane.

Space

In drawing, there are three types of space. First, there is real space; this is the space that we see all around us and respond to in drawing that deals with reality. Second is the two-dimensional space of the drawing. Finally, there is an imaginary space that is created inside your head and that you might want to recreate in a drawing.

Before we examine space more closely, it is important to establish an understanding of a term that is often used in painting and drawing – the picture plane (see explanatory diagram to the left). This is an imaginary, flat plane between the artist and the subject they are depicting. It represents a transparent version of the surface of the paper. Standing still and looking at the subject, if the picture plane is close to you then the subject will look very small in relation to the picture plane. If the picture plane is then moved closer to the subject, the subject will look larger.

The conventional wisdom is that most artists up until the mid-19th century thought of a picture as being a window on to reality (or a parallel reality). Occasionally, artists played with this idea, as in the extraordinary effects of *trompe l'oeil* painting. It is certainly true that many paintings and drawings looked at creating a deep space that gives a very convincing illusion. Looking at many of the drawings of these great masters, however, we can recognize a different appreciation of the artificial nature of a drawing or painting. Artists seem to understand that a painting is at once both deep and flat. This extraordinary duality is at the very centre of what makes a painting or drawing so effective and moving.

It is certainly true that the mid-19th century brought about a shift in emphasis. The development of the medium of photography played an enormous part in removing the necessity for a painting or drawing to be descriptive. Today, however, nearly 200 years since the invention of photography, artists are still fascinated by the interaction between flatness and depth and continue to want to represent reality.

Shape

Of all the terms in the visual language of art, this is probably the easiest to understand because it equates most directly to the two-dimensional surface of paper. Although we can understand shape as simply the silhouette of whatever forms we are looking at, it also relates to the shapes that surround the objects in a composition. These shapes are often referred to (rather confusingly) as negative space. We live in a world in which language, both written and verbal, is very good at categorizing individual objects; however, this is not particularly helpful to the artist. The artist is looking to create a unified image and concentrating on one part – the object – will create a feeling of separation.

(Left) **Standing Figure** 2015
Pastel on grey paper
45 × 25 cm (17 ¾ × 9 ⅞ in.)

Here the artist has reduced the forms down to geometric shapes. These shapes are connected to the contours.

(Right) **Sketchbook drawing after *Minerva Protects Pax from Mars ('Peace and War')* by Peter Paul Rubens (1629–30)** 2014
Pencil, ink wash and acrylic white on paper
21 × 30 cm (8 ¼ × 11 ¾ in.)

The works of Rubens are extremely useful to draw from, as he was a master of clear compositional structure. This structure allows Rubens to load the painting with opulent detail that never undermines the simple structure.

Form

'Form' is one of those words that artists tend to make mean whatever they want, but in this book it means three-dimensional form or volume. This three-dimensional volume can obviously have different qualities. It can be anything from transparent – for example, a bubble – to completely opaque like a lump of concrete. It can be broken and fragmented or whole and contained.

Form is very connected to shape. For example, the more clearly defined the shape is, the more likely the form is to look flat and two-dimensional. In *Standing Figure* (see opposite) you can see that the exaggerated contours (overlapping lines that indicate three-dimensional form) create a stronger sense of three-dimensional form than a continuous silhouetted outline. Closely connected to form is contour. This is dealt with in more detail in the Line section, but it refers to the way forms and contours generate rhythm and which can make a drawing feel very animated (see Tintoretto, p.260).

Line

A line can be anything from a dot to a long and continuous mark. It can represent the edge of an object or the contour of an object. A continuous line will make the area look flat whereas a contour line (a line or series of lines that overlap) looks three-dimensional.

Line can be made to do many different things. As referenced earlier in this introduction, the artist Paul Klee famously said that drawing was like taking a line for a walk. Apart from its use as an outline describing the silhouette, it can also be used as a contour, as will be seen throughout this book. However, the quality of the line has another role in the way the image presents itself. The line can be indicative of the gesture the artist makes. That gesture need not be connected in any way to the representation of an object in reality. It can simply be an expression of the movement of the artist and that movement can contain enormous power, making it an expressive element in the drawing (see Frank Auerbach, p.202).

Structure

The structure of a drawing refers to a more specific skeletal architecture that connects certain passages or areas to the whole image and leads the viewer's eye around the composition. No matter how complex the content of any drawing or painting, the underlying structure should be simple and well conceived. For example, in Rubens's great painting *Minerva Protects Pax from Mars* ('*Peace and War*'), the overall movement created by all the figures is one of a tilted elliptical structure. The elliptical shape does not necessarily correspond to any specific element in the composition, but is the result of the forms working together.

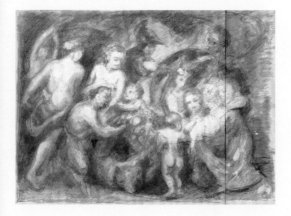

Composition

Composition is simply the way you organize the visual elements into a coherent whole. It is made up of the big simple geometric shapes that connect the principal parts of a drawing to the overall shape of the paper. These are not necessarily explicit, but they underpin the distribution of the parts. For example, the Renaissance madonna drawing (see illustration, right) is organized around simple geometric shapes that correspond to certain parts of the drawing.

There are many so-called 'rules' of composition that can help an artist make strong, interesting images, but do not forget that rules are meant to be broken. Always remember first what it is you are trying to express with an image, then think of how to express it using the formal techniques available to get across the content of the picture.

There are three principal rules about dividing any rectangle: the rule of thirds, the Fibonacci sequence and the golden section (which is related to the Fibonacci sequence). Depending on the temperament of the artist and the period in which they are living, these mathematical and geometric principles are more or less attractive to the artist. Research into perceptual psychology continues to throw light on the way humans respond to images and it seems clear that, while there is some truth that we find these divisions particularly appealing, artists continually present new possibilities that defy the rules. Of course, it could be that we do not understand the rules well enough. As with much of this creative advice, the artist has to always ask themselves, is it useful? If you find that going into specific detail about these mathematical rules results in images that are compelling and interesting, then that justifies having an interest in them.

Sources
Drawing from photographs

Most artists will try to use photographic material at some point in their work. It is important to remember that the type of photograph used will make a big difference to what is actually achieved in the drawing. For example, if you have a photograph where there are very strong contrasts and you are trying to use the photograph to gain specific information about details, you are obviously going to be frustrated. Here basic rules apply: there is little point in making a facsimile copy of a photograph. Photorealism is an impressive skill, but it is only that. Using photographs as specific detailed information demands that the image itself has a good range of detail in both the highlights and in the shadows, even if this means that the overall image looks rather flat. Using photographs as a provocation for an overall sense of mood can be particularly useful but needs to be treated with great care, as it is easy to get sucked into making a replica. In this instance it is better to use this as an

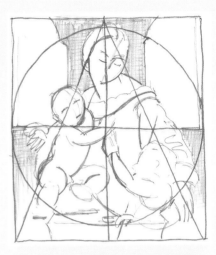

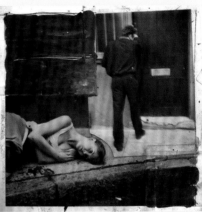

(Top) **Compositional Madonna sketch** 1993

Here, basic composition conforms with simple geometric shapes. A strong triangular shape is formed from the bottom of the drawing up to the top middle, which serves to give the image symmetrical stability.

(Above) **Two Figures in the Street** 1993
Polaroid photograph and paint
16 × 16 cm (6 ¼ × 6 ¼ in.)

The poor quality of this Polaroid creates an odd space – the figure at the door seems like a figment of the girl's imagination. If it were more realistic, the mood would not have been so well expressed.

(Right) **Girl in the Street** 1995
Chinese ink on cream wove paper
85 × 83 cm (33 ½ × 32 ⅝ in.)

This drawing takes inspiration from the Polaroid above. It concentrates on recreating the strange mood generated by the subject and the location through interconnected gestural brush marks.

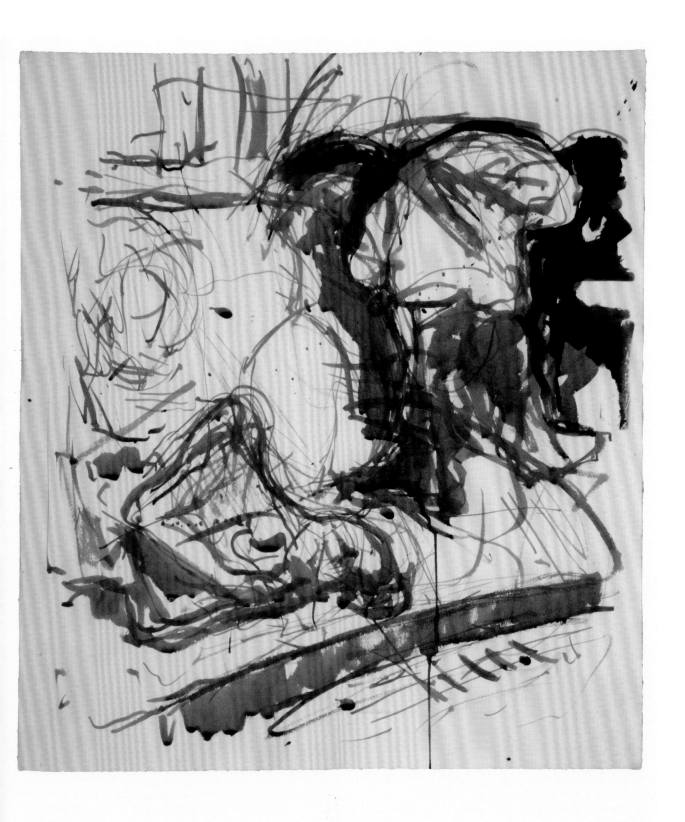

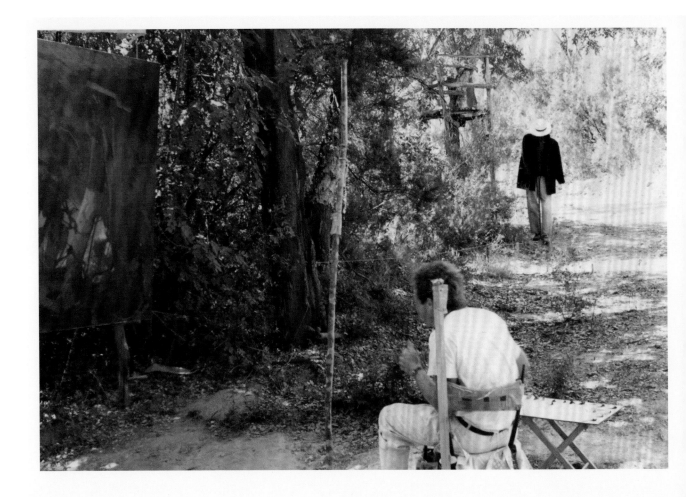

aid to your memory. As a general principle, it is best to make the photograph a distant relation to the drawing.

Often very bad photographs – overexposed or underexposed and slightly blurred – can be more useful. Try to use a medium that makes copying the photograph extremely difficult. Basing a drawing or watercolour on a small, crisp photo and using large brushes can produce quite magical results and even change the way you see the photograph.

Drawing outside

Public, cold and generally uncomfortable – so why should we draw outside? The answer is because it presents the world in the most alive and direct form. Our responses are unmediated and our sensations are as full and broad as possible. What is therefore needed is an approach that enables us to capture something of the living quality of what is in front of us. It is relatively easy

to focus on static buildings, but people are as important. They animate a scene, give buildings a sense of scale and can bring the viewer into the drawing. If you are working on an overall view of a landscape or cityscape, try to work all over the whole drawing simultaneously. If you are using sponges or large brush washes, these abstract marks should bring the whole paper into the drawing. These kinds of loose marks will create rhythmic energy across the surface that you should be able to develop as the drawing progresses.

Abstraction to figuration

It is a good idea to work from the abstract to the figurative or vice versa. Even if you have a narrative objective and want to tell a story, the images still have to work as a unified whole and one of the best ways to make this happen is to concentrate on abstract qualities. Exploring the spaces and shapes between

(Right) **Six small sketches for street figures** 1994–96
Pencil, ink, watercolour, Conté crayon on paper
c. 25 × 25 cm (c. 9 ⅞ × 9 ⅞ in.)

Working on a series of small drawings quickly and moving rapidly from one sketch to the next will generate images that, at the time, you may not consider particularly interesting. Always keep these sketches, because in the future you may find something in them that you can go on to develop further.

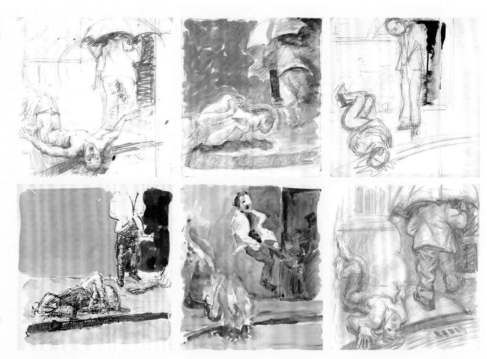

objects can change the way you see them. This can be an almost revelatory process, because it is as if you had never seen the object before. Starting with abstractions – as Leonardo da Vinci did when he made drawings of rock formations – and finding ideas for compositions of figures is also an extremely useful and productive exercise.

Drawing from drawings

Working from drawings that you have done previously can be extremely rewarding, especially when you switch to a different medium. Small sketches can be enlarged to enormous effect. One often sees Old Master drawings that have a square, gridlike drawing over the top. You can make an enlargement of that earlier work by drawing the same number of squares on a large sheet of paper or canvas and then copying each square to make an enlargement.

Copying other artists' work

Many years ago, young artists made a reasonable living by copying famous paintings. This was a tradition carried on for many years particularly in 19th-century France. The copies were then purchased by the state and sent to provincial art galleries. Matisse did many such copies, but failed to get them bought by the state. He always maintained that he learned an enormous amount by working in this way. When copying a drawing, make sure that you try to understand what the artist was doing rather than simply concentrating on making a facsimile replica. After you have made a copy, it is a good idea to do another drawing from life (see Annibale Carracci, p.84).

Keeping a sketchbook

For anyone interested in drawing, keeping a sketchbook is absolutely crucial. Eugène Delacroix maintained that a good

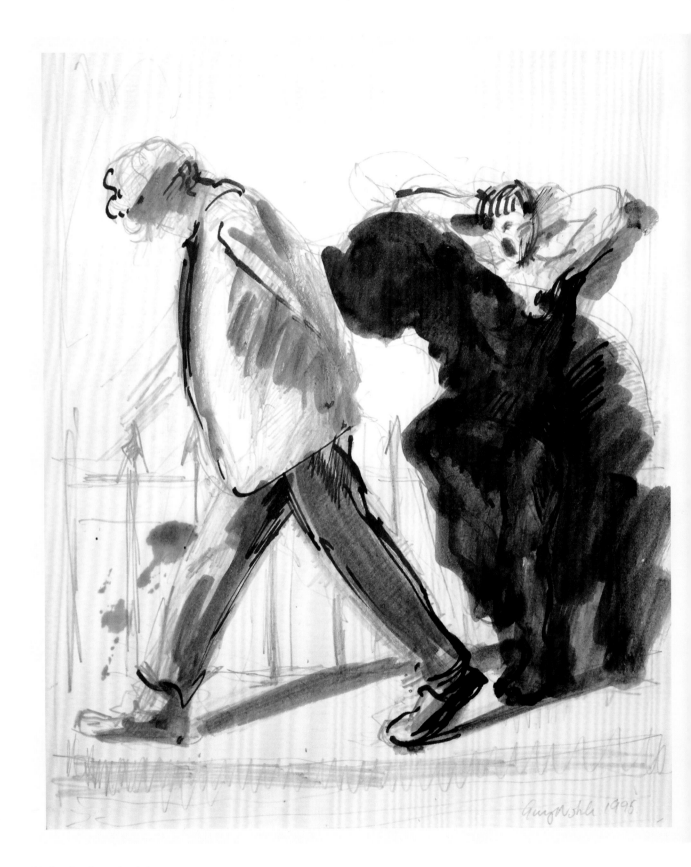

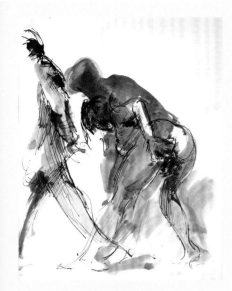

(Above) **Woman in the Shadow No. 3** 1995
Pencil, pen and ink, and ink wash with
scraping on paper
28 × 23 cm (11 × 9 in.)

In this drawing the shadow works effectively
with the naked woman, resulting in a unified
image. It shows that you can make a convincing
drawing no matter how problematic the subject
matter. The movement created from the hand of
the nude figure, down the arm, across the chest
through her other arm and into the shoulders
and head of the man works particularly well.

(Left) **Man Walking with Woman
in Shadow** 1995
Ink, pencil and charcoal on paper
32 × 28 cm (12 ⅝ × 11 in.)

This is one of a series of small sketches based on
the subject of the street. The dominant feature
is shadow – the artist explores the different
possibilities around this concept The viewer
might ask whether the woman in the shadow
is a product of the man's imagination.

draughtsman should be able to make a reasonable drawing
of a man falling from the fifth-floor window by the time he hits
the ground.

Working in series

Many artists work in series. Although it can sometimes take an
enormous amount of effort and energy to complete a series,
it can also liberate the artist from being over precious about
one specific image. Different alternatives can be explored
simultaneously. Of course, one of the dangers is that you risk
losing contact with your initial subject.

Subject matter

The objects or the scene you choose to draw is probably the
single most important decision that is made at the beginning
of a drawing. Or so it would seem. Although it is extremely
important that your subject engages you or holds some specific
meaning, once you start drawing it is extraordinary how you
gradually forget what it is that you are actually drawing. It
might sound a bit of a cliché, but people often ask, 'how can
you draw a beautiful naked woman – isn't it distracting?' Any
artist will tell you that you soon become more preoccupied with
the actual process of drawing.

Acceptable and unacceptable subjects

This is an area that everyone seems to have an opinion about,
but it is also one that is highly susceptible to what society
considers acceptable. For example, a Christian fundamentalist
is going to have a very different attitude to nudity than an
urban liberal, and if the society is predominantly Christian
fundamentalist the artist is going to be at odds with the
authorities. This is a situation that has no obvious remedy and
the artist is faced with a simple choice – to fight for what they
believe in or go along with what everybody else does.

Working directly from life

In almost every period throughout the history of art, artists
have learned by drawing directly from life and in many
instances they have continued working in this way. Developing
the skills to transcribe the three-dimensional world into
the two-dimensional reality of paper equips the artist in
numerous ways. However, two of the late 20th century's
finest artists – Francis Bacon and Lucian Freud – had very
different approaches to this way of working. Bacon found it
too distracting and awkward to paint directly from life: he
found that he needed what he was looking at either to be in
direct contact with his imagination or to use the provocation
of photographs. By contrast, Lucian Freud found working from
his imagination or photographs problematic and required direct
visual contact with his subject.

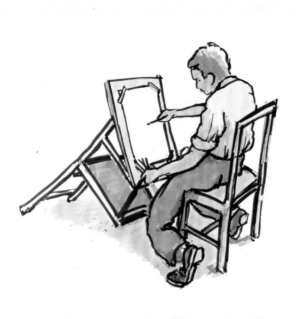

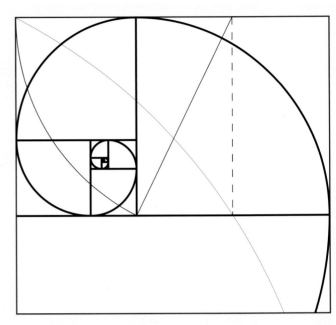

Basic drawing techniques

Many basic techniques are included in the creative tips section for each artist. The following pages give a brief outline of some of the techniques covered. Every artist will eventually develop his or her own technique through trial and error, but it is a good idea to learn how to handle materials before you experiment.

Practical set-up

In a studio, it is possible to control almost everything so that you are comfortable and can see what you are drawing. It is most important to make sure that if you are right-handed your left shoulder is towards what you are drawing. Try to position yourself so that most of the time you are looking at your subject not your drawing. If you do not have an easel use an upside-down chair to rest your drawing board on.

If you are outside drawing the landscape, the most important thing is that you are warm. This may sound strange, but sitting still even in quite warm climates you can still get cold quickly. A small sketching stool is always a useful thing to have and will allow you to position yourself in the best place.

Selecting your composition

There are three elements key to a sense of composition: instinct, awareness of other artists' compositions and understanding the theory of composition. Most of the time we use our own instinct and find it difficult to articulate why something looks better a few centimetres to the left or right. This is a useful way to decide on your composition, but it is also easy to get wrong and often feels arbitrary. Looking at other artists' work and studying the way they have composed their drawings is probably the most useful method and the one whereby you are going to improve the quickest.

The theory of composition – the Fibonacci sequence, the golden section and the rule of thirds together with many other different theories – can prove helpful to certain individuals, but it can be a major distraction to others. If you are spending the majority of your time working out a certain mathematical formula you may not be focusing on other practical aspects that are more important. As with the majority of advice about technique and methods, it is important to use only what will help you achieve your goal.

(Far Left) Practical set-up
Use an upside-down chair to rest your drawing
board on if you do not have access to an easel.
You can also use the chair the right way up by
placing your drawing board on the seat and
resting it against the back. If it slides off then stop
the bottom of your drawing board from moving
using Blu-Tack.

(Left) Compositional theory
The Fibonacci sequence is a series of numbers
where a number is found by adding up the two
numbers before it (1, 1, 2, 3, 5, 8, 13, 21, 34 and
so on). There is a strong connection between
this sequence and the composition of art. By
visualizing each number as a square (increasing
in size like the number sequence) and connecting
the opposite corners of each square, you can
create the Fibonacci spiral (see left), which can
be used to create aesthetically pleasing images
(see Glossary).

(Right) Framing your composition
Two pieces of L-shaped cardboard held together
as shown provide a very good way of framing a
scene that you wish to draw.

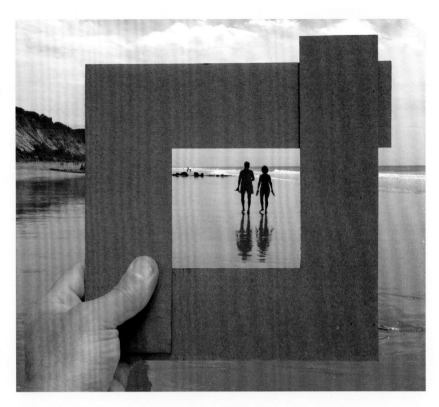

With modern technology it can be very useful to take
photographs, crop them in different ways and then look at
the results from the point of view of each of the three points
outlined above. First, judge them all on instinct; second, ask
yourself if they conform to paintings and drawings you are
familiar with; finally, look at them from the mathematical,
theoretical point of view.

Using two L-shaped pieces of cardboard can help you make
a quick decision as to where you want the principal forms of
the composition to appear within the overall shape of an image.
It is often an advantage to make your drawing smaller than
the overall shape of the paper – this way you can extend the
drawing in any direction as required.

Working from photographs
All kinds of photographs can be useful in your working process.
As a general rule, a photograph should contain more information
than you need to complete your drawing. It is better that the
photograph has plenty of detail in the shadows and in the
highlights, and is not under- or overexposed. This can make the

image look quite flat, but it does provide lots of information that
you can use. Wherever possible, try to use as big a photograph
as you can. Try using a computer and printer to print out two
sheets of A4 paper, then join them together to make a large
A3 photograph.

Photographs as an aide-memoire
It might be that you need small pieces of information that you
can introduce into a larger work. In this instance, collecting a
range of photographic-based information can be very helpful.
However, it is important to remember that you are not trying
to imitate the photograph when you come to transfer the small
details into a larger work (unless that is your objective).

Photographs as a provocation
It can be highly productive to use poor-quality photographs
that might remind you of some particular quality, mood or
atmosphere that has little to do with the actual objects in the
photograph. This can be a very effective way to use photography
in drawing.

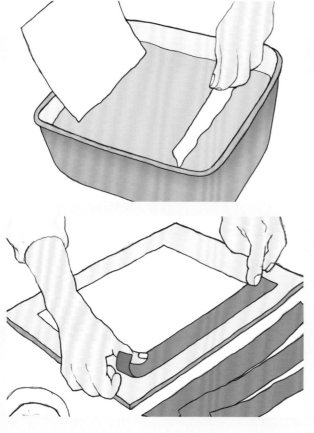

(Left) **Stretching paper**
First cut the paper to size, then cut strips of gummed tape. Drag the paper through a shallow bowl of water, or dampen with a sponge until wet through. Lay the wet paper flat on the drawing board and secure edges with strips of tape, made wet in the same way. The tape will hold the paper in place and stretch it as it dries.

(Right) **Pencil drawing**
Here the forms have been developed as the highlights are enhanced and the darks are strengthened through shading. If you look closely, you can see the different pencils that have been used, with the softness of the shadow and hardness of the forms.

(Far Right) **Charcoal background**
Toning paper with charcoal is an excellent way to start a drawing that focuses on light and shade. As you develop the drawing put in the dark areas and take out some of the lighter areas with a putty rubber. Remember you have to really push the charcoal into the surface. You can use soft tissue paper to rub some of the loose charcoal shading into the surface of the paper.

Exploring form

Before you start drawing, it is beneficial to draw some simple geometric shapes in controlled light. This will give you practice in shading and positioning objects on the paper. When choosing objects make sure that they are not heavily patterned, as this will disguise any three-dimensional form and distract you into trying to draw the pattern rather than the overall form.

Stretching paper

When working in a wet medium, the paper will buckle. This can look unattractive and cause serious technical problems. To avoid it, especially with very wet watercolour work, it is best to stretch the paper on the board before you start (see above). This is not complicated; although there may be a small amount of buckling as you work, the paper will soon dry flat. When you have finished the drawing, simply remove it from the drawing board.

Working with pencil

Pencil drawing has many advantages and the technique employed can vary massively. Small sketchbook drawings can be done in a matter of seconds, whereas large intricate drawings can be worked on over a long period of time. The main attribute of pencil is that it is precise, so if you are interested in doing a big dynamic drawing you would not choose pencil on an A4 sheet of paper. The best way to sharpen a pencil is with a knife, but as it takes time to acquire the skill to sharpen accurately, an ordinary pencil sharpener is as suitable.

The kinds of marks you can make with pencil vary in many ways – the pressure of the mark, the speed with which you draw, the bluntness or sharpness of the pencil and the grade of the pencil itself. There are twenty different grades of pencil, ranging from a very soft 9B to a very hard 9H. A 9B pencil will make a very dark, inky black line, but it will become blunt very quickly. A 9H pencil is extremely hard and is almost impossible to make black – it comes out light grey.

Working with charcoal

Just as pencil is very precise charcoal tends to be the opposite; Georgia O'Keeffe, however, proves the exception (see p.100). It is possible to make huge drawings using charcoal very effectively

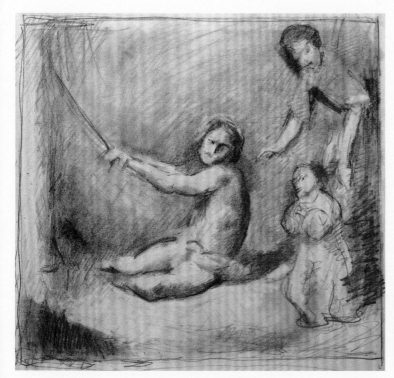

and even quite small drawings can be done rapidly with charcoal, but as soon as you start trying to be more precise and intricate charcoal becomes a problematic medium. This can be mitigated to a degree by using compressed charcoal, which is more like pencil, or Conté crayon.

Charcoal lends itself to drawing light and shade and strong energetic lines (see Lee Krasner, p.190, and Hans Hofmann, p.194). Using charcoal to tone the whole sheet of paper can be a very effective way of making a more modelled three-dimensional form (see Henri Matisse, p.234). If the charcoal falls off very easily then you will need to rub it into the surface with some soft tissue paper. If it is pushed too hard into the surface, you will find it difficult to remove the charcoal to make the light areas, so some degree of practice is necessary. Your drawing will be quite patchy to start with (an effect compounded by natural oils from your hands, so avoid touching the paper where possible), but avoid using lines to balance these areas with each other and keep your attention on the overall image not individual parts. When you need a mark to be dark, push hard into the surface of the paper and then rub your finger over the

top, taking care not to touch much of the surrounding paper. Once you have put charcoal on paper you will find it difficult to rub out completely. The best surface to work on with charcoal is a relatively smooth, thick cartridge paper. The beauty of charcoal is that it is a medium that can be robustly used. If you don't like getting dirty using charcoal, you can minimize this by wrapping silver foil around the end of the charcoal you hold on to. A very useful tip when working with charcoal is to use a piece of masking tape to remove chalk, charcoal or crayon from your drawing. This will avoid the smearing that can happen when you use a rubber.

Working with chalk or Conté crayon

The technique of drawing with Conté crayon is more precise than using charcoal, but it has similar characteristics. A significant difference is that Conté crayon is a pigment mixed with wax. When it is pushed into the surface of the paper, it is extremely difficult to rub it out. Because it is denser, however, it is possible to sharpen it to a point, therefore making it possible to draw clear lines and details. An interesting technique with Conté

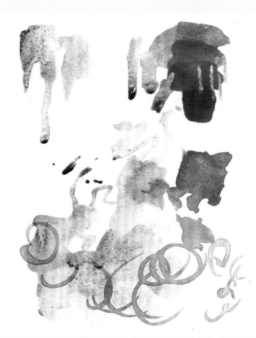

crayon is to use a chamois leather in the early stages – very soft gradations of tone can be achieved rapidly and on a reasonably large scale.

Working with pastels

If you are working on a coloured drawing requiring different shades of pastel, remember that it can be difficult to mix primary colours to make subtle shades in this medium. In this instance, allow your colours to be more broken and intersperse them with other colours – preserving the marks can create a far more interesting effect. Many artists blend their colours seamlessly together; although this looks very impressive, it can also appear rather saccharine and overly slick. Edgar Degas was a master at using pastels. Although he did occasionally blend his colours in his work, generally each colour sat next to another colour, remaining unblended.

Working with inks

The main advantage of using inks is that they are almost all transparent but saturated with pigment. This means that the white of the paper can give colours a more luminous and intense appearance. Obviously this does not apply to black ink, which depends on its opacity to create its visual power. When black is applied more thinly, it creates a very beautiful range of greys and as you can see from the illustration above, different kinds of ink produce different coloured greys.

The way colours and inks bleed into one another or how they leave a crisp edge as they dry can give a drawing considerable charm and appeal. Painting inks on to dry paper is very different to painting the ink for colour on to wet. Of course, both these processes need to be experimented with so that you can learn to control them.

Using a pen

The biggest problem encountered when using a pen is when it becomes overfilled; as soon as it touches the paper, a large blot goes straight from the pen onto the paper. This is usually because the reservoir – a small triangle of either metal or folded plastic that sits on the underside of the nib – is not correctly positioned. Although this is difficult to get right, and some

(Far Left) **Conté crayon**
Soft, generalized gradations of tone can be made easily using a chamois leather on the crayon.

(Left) **Working with wet media**
A large variety of marks can be made with wet media and manipulated as the drawing develops. Here Chinese ink (top left), Indian ink (bottom) and ivory black watercolour (top right) are illustrated, showing different variations of black.

(Right) **Dogs Fighting** 1990
Pastels on grey sugar paper
30 × 30 cm (11¾ × 11¾ in.)

As preparation for this drawing, the artist kept a recording device by his bed and when he woke up from a dream in the night he recorded as much detail as he could remember. The next day, he spent the first hour drawing a version of the recorded dream. Here, the chaotic marks of the landscape become part of the violent confrontation between two dogs and a hunter.

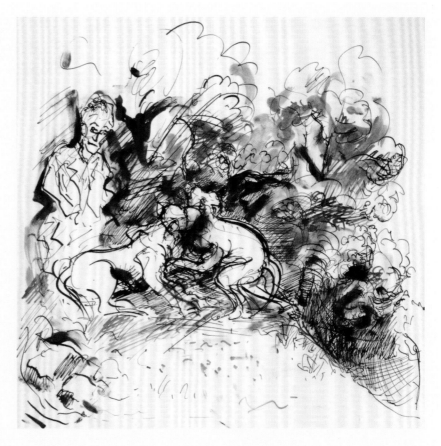

degree of experimentation is necessary, once achieved it will prolong the length of line you are able to make before having to re-dip the nib in the ink.

Using a pen of this type demands a certain degree of skill and the best way to achieve that skill is to practise. However, it is now possible to buy pens that are made of nylon, which are extremely good. The problem is that the ink that is used in many of these pens will not last and it will almost certainly change colour over time.

Working with mixed media

Most contemporary drawings will be described as mixed media because modern artists tend to combine various mediums to achieve their goals. Mixed media can mean any combination of more than one medium and can be as simple as a combination of charcoal and chalk, or as complicated as pencil, acrylic white, ink wash and sand. As a general rule it is better to keep your medium as simple as possible and use material that is stable and will not degrade over a short period of time. The restoration department at London's Tate Modern has a far more problematic

time trying to restore relatively recent works of art compared to that of the National Gallery, which deals with the work of Old Masters. This is because the experimental nature of art over the last 100 years has involved all kinds of wild and crazy materials. In recent years acrylic media and paints have become much more sophisticated and can be combined in drawings on paper. Collaging pieces of photographs into paintings can be highly effective but, as most of us have seen, inkjet-printed photographs have a relatively short life.

Cleaning your brushes

It is important to clean your brushes after you have used them to avoid ink or paint working its way up into the base of the bristles. Gradually, as the paint accumulates it will push the bristles outwards, making a fan-shaped brush. The best way to clean brushes is under slightly warm water with a bar of soap. Hold the soap in one hand and gently rotate the brush over the surface of the soap. Periodically, squeeze out the soap and rinse. This will remove any paint that has worked its way up the bristles.

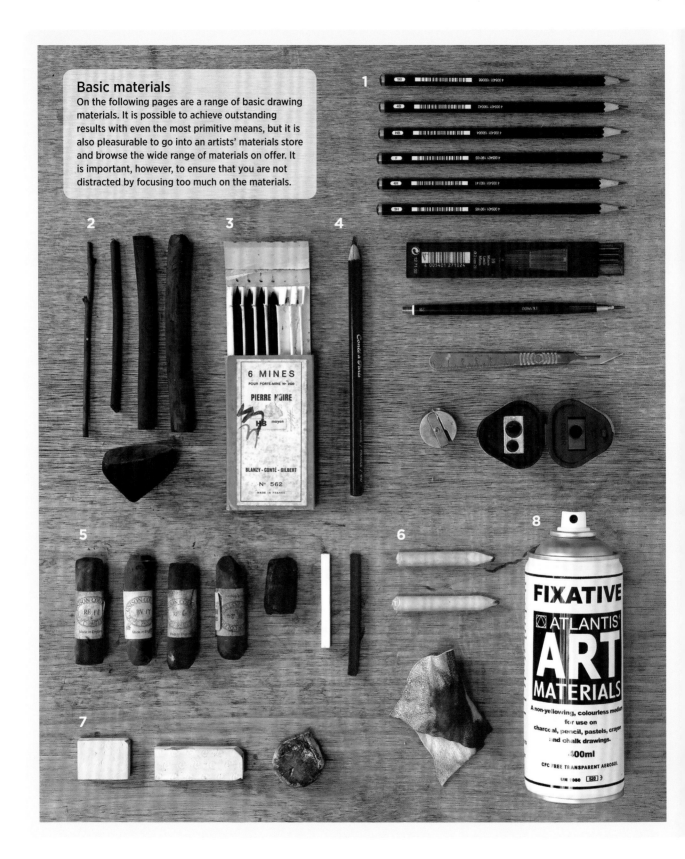

Basic materials

On the following pages are a range of basic drawing materials. It is possible to achieve outstanding results with even the most primitive means, but it is also pleasurable to go into an artists' materials store and browse the wide range of materials on offer. It is important, however, to ensure that you are not distracted by focusing too much on the materials.

1 Pencil

For a long time, the only source of solid graphite was in Cumbria. It was not until England put a ban on exporting graphite to France in the late 18th century that Napoleon started the process of sourcing a different option. He commissioned Nicolas-Jacques Conté to find an alternative. He devised a way of compressing graphite powder into a wooden casing, thus inventing the pencil. Modern pencils are available in many different gradations, ranging from very hard (9H) to extremely soft and black (9B). Cheap pencils are not always accurately graded, so be careful. The best way to sharpen a pencil is with a knife or scalpel, but it can take time and precision to perfect this skill.

2 Charcoal

The best and most useful charcoal is made from willow or vine, and the medium can vary slightly depending on the manufacturer. Charcoal is fragile and breaks very easily, but it can be bought in different sized sticks and even larger, more robust chunks. When working with charcoal, it is generally easier to work on a large scale (using paper bigger than A3 size) and it is particularly difficult to work any smaller. Charcoal is a useful material, because it can be manipulated easily.

3 Compressed charcoal

Compressed charcoal is simply charcoal dust mixed with a small quantity of gum arabic or wax and compressed into pencil-sized sticks. These can be sharpened to a fine point and are very much like black Conté crayon. Because wax is used as a binding agent, compressed charcoal is much more difficult to remove from the surface of the paper, but you are able to make more precise marks. Compressed charcoal usually comes in cylindrical sticks, which can be used with a clutch holder.

4 Conté crayon or chalk

This comes in short, square-shaped pieces about 8 cm (3 in.) long. Like compressed charcoal, Conté crayon is black pigment mixed with a small amount of gum arabic or wax. Several different companies now make this type of crayon, but the original Conté is the best and the company has started to produce many different colours. If you are primarily interested in using it for red chalk drawing, the best colour to use is sanguine 2450. Conté pencils (pictured) tend to be hard and scratchy, but they offer a reasonable alternative.

5 Coloured chalks, pastels and white chalk

The most expensive component part of coloured chalks is the pigment, so when you buy very cheap chalk it probably has very little pigment content. This is particularly noticeable with white chalk. When it comes to chalks and pastels it is particularly difficult to mix primary colours in order to achive subtle shades, so try to think about the tones and shades you might want to include in your work before you buy. It is best to spend a little extra to get a good quality pastel. If you find soft pastels too imprecise, then use a good-quality 2B white Conté crayon.

6 Blending tools: stump, rags and Chamois leather

Stump is compressed rolled paper. This can be sharpened to a small point and is useful for blurring pencil, chalk lines or shaded areas. You can also use tissue or a rag for blurring, both of which are better than using your fingers. Chamois leather can be cut into small pieces about 10 cm (4 in.) square and is an excellent blending tool. It is particularly useful with a red chalk drawing, as it will allow you to make very subtle sweeping marks that can, to some extent, be removed by an ordinary eraser.

7 Erasers and putty rubbers

In the past, materials like stone and wax were used to erase marks on paper. Around 1770 it was found that natural rubber from plants could work, but erasers were not very effective until 1839, when Charles Goodyear invented vulcanization for curing rubber. Rubber erasers are good for pencil, but are less so for charcoal; instead use a putty rubber, which slowly changes colour as it absorbs the charcoal. Avoid soft kneaded rubbers – they can become too soft and warm when held in the hand while working, losing their shape and effectiveness. The best type is a hard white putty rubber.

8 Fixative and hairspray

If you are using dry media for drawing, eventually you will have to use fixative to make them more robust. The big drawback of charcoal is that it is difficult to achieve strong, dense blacks without using fixative. Smudging and erasing marks are also problems posed by using charcoal, which the use of fixative can help to avoid.

There are now many brands of aerosol fixative spray. It is possible to buy liquid fixative and apply it using a small spray diffuser. However, no matter what brand you use it is important not to saturate the surface of the paper with the fixative. It is better to have thinner layers. Nonetheless, many students tend to spray their work from too far away, rendering the process useless. Carefully follow the instructions on the product you have bought. With some drawings, you will need to fix the drawing as you are working. This will allow you to build up the darks, making them much blacker than one layer would usually allow.

Cheap hairspray can also be used as a fixative but this is only a last resort and is generally not advisable.

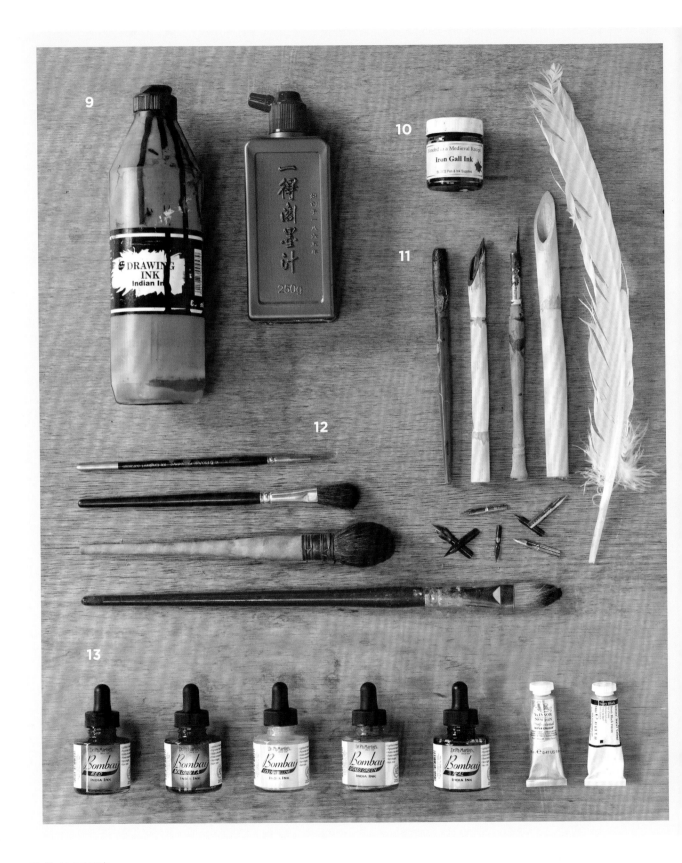

9 Chinese ink and Indian ink

Chinese ink is simply black pigment. It can be bought either as a solid stick (to grind and add water) or ready diluted. The quality of this ink varies massively, but a tell-tale sign is that if it smells slightly of pine nuts and peat it is very good; however, if it smells highly toxic it is probably made from some petrochemical by-product. The beauty of Chinese ink is that it is not permanent so you can wet the paper and remove most of it. It varies a little in colour but tends to be slightly colder and lighter than Indian ink.

There is some confusion between the terms 'Chinese ink' and 'Indian ink', arising from the fact that their origins seem similar. What matters for the 21st-century artist is that generally Chinese ink can be remoistened and removed once dried, whereas Indian ink cannot. Indian ink is pigment mixed with a binding medium, usually shellac. Shellac is soluble in alcohol. In the illustration on p.44, Chinese and Indian ink are compared to ivory black watercolour. The Indian ink at the bottom has a slight yellow tinge.

10 Ox gall ink and iron gall ink

Iron gall ink was the standard writing and drawing ink used across Europe from around the 5th to the 19th century. The use of both these inks (made from iron salts, tannic acids and vegetable sources) has largely died out since the 19th century with the invention of more permanent and stable products, such as waterproof formulae better suited to writing on paper. However, it is worth noting that many of the Old Masters used ox gall ink in their drawings. Rembrandt's work on p.146 is a good example of how the drawing's colour has changed. When first completed the ink would have been a blue-black colour, but gradually over the course of time it became browner.

11 Pens, brush pens, reed pens (bamboo) and quills

Pens are a slightly more specialist material. Old-fashioned steel or brass nibs are still available in some art materials shops. With practice these can be used very effectively and they provide a wide range of marks that can add life to your drawing.

Like Vincent van Gogh, it is also possible to make your own pens from reeds or bamboo. However, unless you live near a place where these reeds grow, you will have to buy them from a specialist calligraphy shop. Quills are easier to cut and will stay sharper for longer. With all these traditional-style pens, it is important to remember that you will need to practise using them to master their creative potential.

Modern products are much easier to use, but the inks are often non-permanent and will fade very quickly (within three to four years if hung on a wall facing a window).

12 Brushes

Brushes have long handles for several reasons, the main one being that when working on large oil paintings the artist needs to work at a distance from the surface of the canvas in order to be able to see the marks they make in context. If you are working on a smaller scale, then short-handled brushes will obviously be easier to use. Brushes can also be made from unusual materials, such as polystyrene, pieces of twig or leaves and other such items.

13 Gouache, watercolour and coloured inks

It is not necessary here to go into the details of using colours in drawing, as it is a very big subject that is covered in many excellent books. It is important that with wet media drawing you always keep the colours relatively simple and don't overpower the drawing itself.

Lithography, etching and printmaking (Not shown)

Printmaking and drawing are very closely related, which is why this book touches on aspects of the printed image. The most direct and similar printmaking process to drawing is lithography. Here the artist draws directly on to a prepared stone or plate with a lithographic pencil (see Edvard Munch, p.230). Etching is a slightly more complicated process involving several stages. The quality of the line and tones created by etching can be almost indistinguishable from certain types of dry drawing, but the process is fairly complicated and needs more technical explanation. Processes such as screenprinting begin to move into a different realm and are not relevant here.

Mould-made

Handmade and textured

Handmade and textured

Coloured machine-made

Handmade and textured

Handmade and textured

Coloured machine-made

Coloured machine-made sugar or construction paper

Handmade paper

Up until the mid-19th century, most artists' paper was made from rags by hand and was therefore not only expensive but also quite small. However, this meant that the materials used to make the paper could be carefully controlled and were often very good quality. Good handmade papers have now become available to a wider market and, although they are expensive, they provide excellent surfaces for the artist to work on.

Machine-made paper

With the introduction of wood pulp in the 1840s, paper manufacturing became much cheaper and paper was therefore more widely available. Industrialization also meant that large sheets of paper could be produced easily and cheaply. As is often the case in art, scientific inventions and discoveries often lead to a change in the practices of artists.

Textured: smooth and rough

Much of the early paper used by artists was heavily textured due to the materials used. Hemp, linen and cotton rags were made into pulp and laid in flat, shallow moulds. Across these moulds, thin wires held the pulp in place but left slight ridges on the finished paper. Handmade paper is easy to colour and often has a charm that is lacking in machine-made paper.

Smooth, shiny paper is slightly cold to the touch; it probably has either a coating or glue size mixed in with the pulp, whereas thicker paper can feel almost warm to the touch. Choosing the right paper for the kind of drawing you wish to do is crucial. For example, working with charcoal on smooth, shiny paper is extremely difficult, as the charcoal just sits on the surface – a thicker, more robust paper is required for the best effects. However, if you want to make a very precise pencil drawing, a smoother paper would be the correct

option. As with all of these materials, it is important to experiment and keep an open mind to the possibilities that they offer.

Coloured paper

Machine-manufactured, coloured paper is generally poor quality; the colours are often far too even and usually too intense. Some handmade papers offer good alternatives, but they can be very expensive. Grey sugar paper is an excellent option, but bear in mind the fact that the dye used in this very cheap paper will fade over time, especially if framed and hung near a window. The only solution is to stain your paper with watercolour or ink, although if you use an eraser you will lose some of the surface colour.

Mould-made paper

Mould-made paper combines the consistent quality of machine-made papers, but preserves the individual character of handmade papers. Papers of this kind are particularly useful and interesting to artists due to their unique, beautiful texture and superior surface ability – meaning the paper is sufficiently robust and will not deteriorate when the drawing is repeatedly erased or heavily worked. Mould-made papers are acid and cotton free and are available in a selection of three surfaces: HP, NOT and Rough. The paper is surface sized with gelatine.

Sugar paper (sometimes known as construction paper)

Sugar paper is used to create bags that carry sugar, hence the name. It is manufactured using wood pulp combined with recycled old papers, which creates the rich, blended texture. It is usually tough, coarse and coloured; the texture is rough as the surface is unfinished, making it useful for projects or crafts, and meaning it works especially well with charcoal and chalk.

Collage (Not shown)

There are many useful books on collage that you can consult if this is an area you want to explore further. The main technical consideration when working with collage is the kind of glue that you use to stick anything to the surface of a drawing. The best glues to use are anything that is pH neutral or archival quality – a good art materials shop should be able to offer specific advice.

Piet Mondrian 56

Juan Gris 58

ife

Somewhat confusingly named, still life includes subjects that are, broadly speaking, inanimate or dead. In the hierarchy of genres, the powerful 17th-century French Academy placed still life at the bottom, with history painting at the top and genre (almost as confusingly, referring to depictions of everyday life), portraiture and landscape in between.

Georges Braque said if you can't reach out and touch it, then it is not a still life. That is a good definition; however, the implication is larger than simply what is within hand's reach. It is that the space we can reach into easily in the rooms in which we live has a particular kind of relationship to our bodies. A small world, perhaps – but within that same small world there are enormous possibilities. When artists sit down to paint or draw the objects in front of them, there is an intimacy that is unlike anything else.

Removing ourselves from other human presence while we are working frees us from the psychological demands of interaction. Still life and its environment can become an extension of our internal world: for a moment we reach outside ourselves and time seems to stand still.

This is apparent in a beautifully resonant drawing by Giorgio Morandi (see p.64) that suggests the artist's trancelike state, whereas Piet Mondrian's almost forensic treatment of the patterns in a flower's petals takes a hypnotic hold on the viewer (see p.56). Although the genre has been discredited at times, in many works an element of still life remains as the depiction of objects epitomizes a domestic, middle-class world. Although the way these objects are treated has varied in terms of style and technique, there has been little change in the objects themselves.

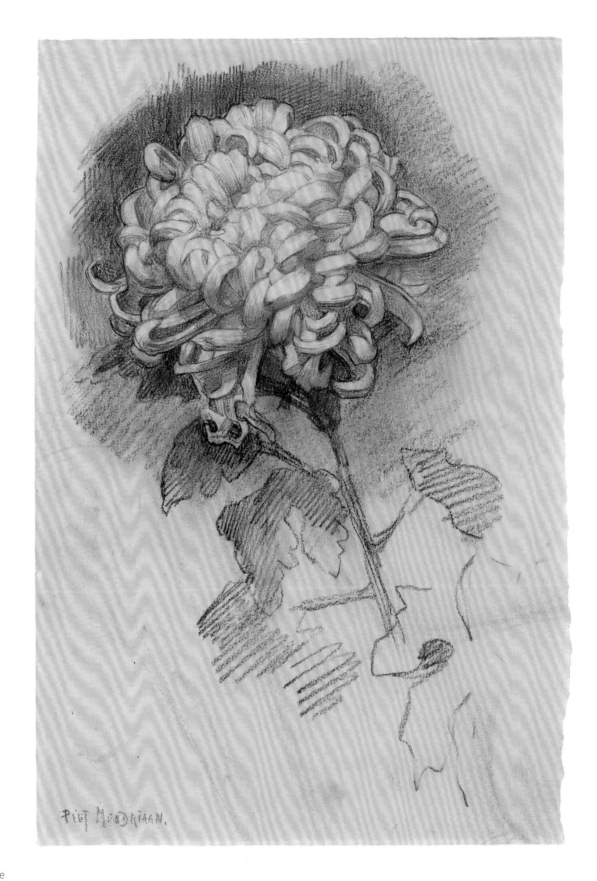

Piet Mondrian

Chrysanthemum 1906

Charcoal on paper
36.2 × 24.5 cm (14 ¼ × 9 ⅝ in.)
Museum of Modern Art, New York, USA

After leaving art school in 1897, Piet Mondrian experimented with many styles of representation. Over the next twenty-five years he returned frequently to floral motifs, completing over a hundred works depicting various flowers. Later in life he reflected on his attraction to the subject: 'I enjoyed painting flowers, not bouquets, but a single flower at a time, in order that I might better express its plastic structure.' It was this interest in what he calls the 'plastic structure' that led to the spare gridlike configurations that we are familiar with in his later work. In 1909 Mondrian became interested in theosophy, a philosophical mysticism that seeks to disclose the concealed essence of reality. A few years later he wrote: 'I too find flowers beautiful in their exterior beauty, yet there is hidden within a deeper beauty.' The nature of this universal harmony beneath the visible world was what captivated him.

This drawing is less rigid and symmetrical than most of Mondrian's flower drawings, yet it still illustrates his search for rhythmic patterns that hold the form together. Here, he is not interested in the way the form of the flower relates to the overall shape of the paper, but only in the isolated form and how the individual petals interweave. His treatment of the flower is almost like that of a scientist or botanist rather than an artist. Sensing an underlying pattern, the intensity of the focus on the white petals creates an almost hypnotic hold on the viewer's attention.

See also
Leonardo da Vinci (p.72), **Georgia O'Keeffe** (p.100), **Eva Hesse** (p.200)

Piet Mondrian (Dutch, 1872–1944) was born Pieter Cornelis Mondriaan, changing his name in 1906. He was taught to paint by his uncle, the artist Frits Mondriaan (1853–1932). Mondrian studied at the Royal Academy of Fine Arts in Amsterdam, initially painting landscapes in a naturalistic style. In 1911, he moved to Paris but returned to the Netherlands in World War I, co-founding the De Stijl (The Style) group in 1917. On his return to Paris in 1919, he developed Neo-Plasticism, whereby he restricted his painting to straight horizontal and vertical lines using primary colours with white, black and grey. He moved to New York in 1940 to escape World War II.

Subject Matter
Mondrian's drawing was not done in a sketchbook but it represents a good example of how to explore the visual world. Looking for patterns in the world around you helps you to understand the range of expressive possibilities when using only a pencil and paper. For example, this illustration of a standing water scene (see left) shows a pattern of horizontal divisions and the slight variations within those horizontal divisions.

Structure
Mondrian was primarily interested in the intricate structure created by the petals of the flower. Although he draws each petal in great detail, they are always placed in the context of the overall group. Don't worry about composing the whole image, or fixate on the edges of the paper: concentrate on the internal connections – as shown, for example, in the illustration of geometric building shapes (see left).

Forms
If you discover a rhythmic pattern as you work, concentrate solely on that and see how it repeats itself and reverberates through the rest of your subject matter. For example, in the illustration of a more figurative subject (see left) triangular shapes and angular spaces (as in the angle of the arm, leg and exercise equipment) echo with each other across the surface of the paper, eventually forming a whole.

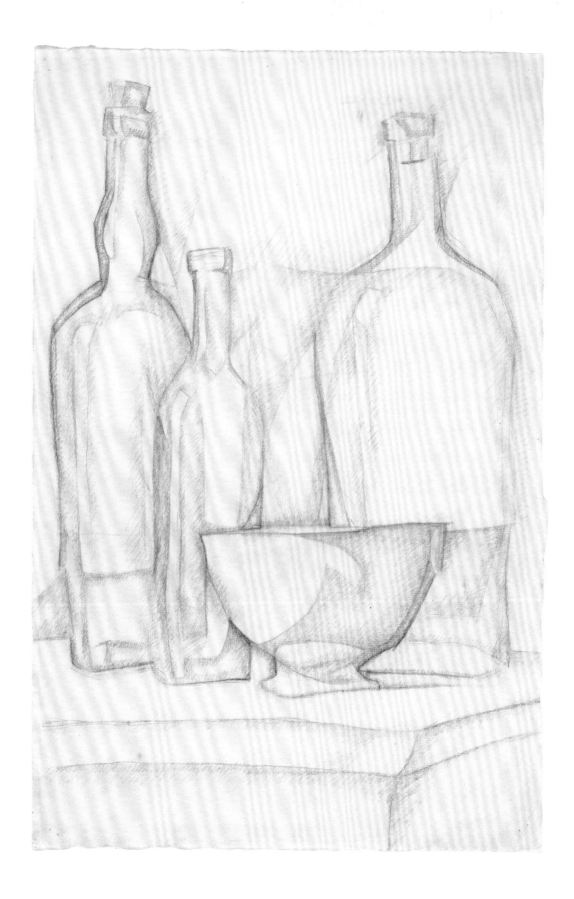

Bottle and Bowl 1911
Graphite on laid paper
48 × 31.7 cm (18 ⅞ × 12 ½ in.)
National Gallery of Art, Washington DC, USA

Juan Gris died young, at the age of forty. He had a year's art training in Spain but it was not until the year before this drawing was completed that he took up painting in a serious way. When he moved to Paris in 1906 he stayed at Le Bateau-Lavoir, the now famous ramshackle set of studios in Montmartre, Paris, where Pablo Picasso lived and which Georges Braque frequently visited. Although he was not one of its originators, Gris arrived at the birth of Cubism and was closely involved in the new movement. Cubism strived to develop a visual vocabulary that could express a more complete visual understanding of the world. Ultimately, the experiment was flawed, as colour had to be sacrificed to develop form in this way.

In this drawing, we can see the artist's first step towards a Cubist interpretation of reality. The divisions of tone and colour, outline and contour, are accentuated. Gris is beginning to sacrifice convincing naturalistic three-dimensional form, in the process reinventing not only the forms but also the space that contains those forms. Note the gap between the two taller bottles: there is a line that goes vertically through the side up into the background. Another curved line, moving from left to right, joins the round edge of the bottle on the far right. For Gris these divisions are tentative – they do not yet fracture the actual forms. However, soon after he made this drawing his work begins to exemplify his wholehearted embrace of Cubism.

See also
Pierre Bonnard (p.60), **Giorgio Morandi** (p.64),
Nicholas Volley (p.66)

Juan Gris (Spanish, 1887–1927) was born José Victoriano González-Pérez in Madrid and studied engineering at the city's School of Arts and Sciences. From 1904 to 1905, he studied painting with the academic artist José Moreno Carbonero (1860–1942), and adopted the name 'Juan Gris'. He moved to Paris in 1906, and began to frequent the same circles as Pablo Picasso (1881–1973) and Georges Braque (1882–1963). He began to explore the principles of Cubism, subverting the traditional genres of portraiture and still lifes, working first in the Analytical Cubist style and then, after 1913, in the Synthetic Cubist style while incorporating collage into his work.

Space
Still life is a good genre to begin with as you practise this style of experimental drawing. Although we are now familiar with the visual conventions of Cubism, exploring these ideas in your own work can prove challenging. Don't include a lot of blank space around the objects you have chosen to draw. You should be aiming to create an integrated surface: if there are big areas of blank paper it will be more difficult (see left).

Structure
The space around the group of objects in the Gris image is minimal, creating naturally small areas. Try to treat the areas of paper around the objects in the same way as you treat the objects themselves, as they are equally important. Establish a simple overall structure to your drawing from the very beginning. As you work, gradually break this structure down into smaller and smaller component parts (see left).

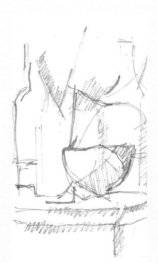

Form
Try especially hard to concentrate on the edges of each part of your drawing, paying equal attention across the surface of the paper. Remember that you are not trying to reproduce the look of a Cubist drawing. You need to understand what happens when you try to construct a drawing in this way. For example, the illustration (left) shows more evenly broken-up shaded forms, each distinctly outlined within the whole.

Preparatory Sketch for *Coffee* 1915

Graphite on paper
9.6 × 13.7 cm (3 ¾ × 5 ⅜ in.)
Tate, London, UK

Since his death in 1947, Pierre Bonnard's work has for some periods been seen as unfashionable. However, any artist who finds themselves interested in the relationship between painting that tries to capture sensations gained from observation and the structure of an image will inevitably find his art fascinating.

Bonnard did not paint from life: he drew his subjects, sometimes photographing them, then painted his canvases in the studio. This small sketchbook drawing depicts a modest domestic scene, with half the paper taken up by the tablecloth. The simple composition has a geometric structure that allows the smaller objects to almost hover, as if weightless, within the grid. On the left-hand side, the relatively blank area pushes against the table and the area above it. The table in turn pushes up, thereby compressing the figure and the dog from both below and from the left. These large compositional elements generate an internal tension that presents a familiar scene in an unfamiliar way. In part, this clever balance contributes to creating a mood of quiet stillness.

In the painting *Coffee* (1915), Bonnard made much more of the tablecloth and less of the area to the left. The drawn composition changed with the introduction of colour. The intense colour relationships and dissolving quality of light are woven into the compositional architecture or structure – it feels as if the structure will hold, no matter how tenuous and transitory the light and colour become. In his preparatory drawing, Bonnard makes a perfect graphic equivalent to his painting.

Subject Matter

Look for subjects that are right in front of you throughout the course of an ordinary day. For example, when you are taking a bath, what can you see? Make a quick two-minute drawing of the scene in front of you, as in this sketch of a bathroom (far left). At the end of the day, review your series of drawings and ask yourself how you have translated the scenes in front of you. The next day repeat the process,

Pierre Bonnard (French, 1867–1947) was a painter and a printmaker. Initially he bowed to family pressure and studied law, but he was determined to become an artist and concurrently took classes at the École des Beaux-Arts and the Académie Julian, first exhibiting his work at the Société des Artistes Indépendants in 1891. He went on to have a successful career and cofounded the Les Nabis group of avant-garde painters. He is famed for his depictions of domestic scenes, often featuring his wife Marthe as a model, which exude a sense of intimacy and well-being. He is also known for his posters, book illustrations, prints and theatre set designs.

See also

Georges Braque (p.62)

John Constable (p.122)

John Singer Sargent (p.162)

this time trying to move away from description towards understanding how the same scene is made up of shapes, tones and lines (left). Your drawings should demonstrate a progression from being more descriptive to concentrating more on actual shapes. Here objects such as the sink, mirror and bottle have become more precise, recognizable and established forms.

Sources

Looking at the world pictorially is a habit that brings great rewards. You start to see differently and become more optically aware. Carry a sketchbook and draw what you see while waiting at the platform for your train (left). The roles played by shape, space, colour and light become apparent. Being responsive to the sense impressions of these abstract qualities allows an imaginative space to open up.

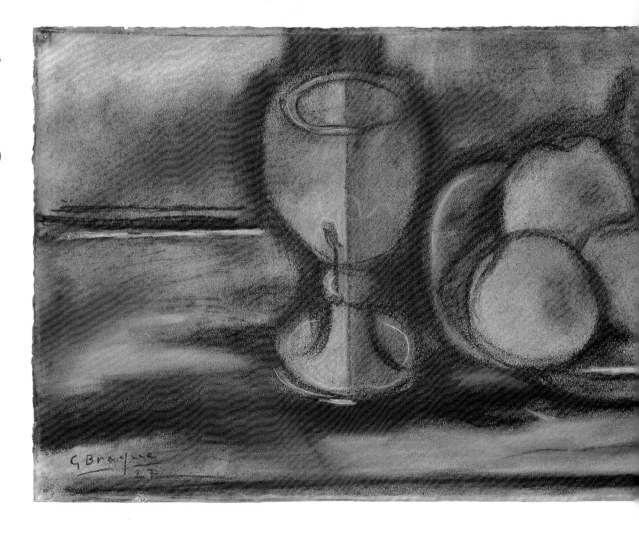

Still Life with Glass, Fruit Dish and Knife 1927
Pastel, with touches of charcoal, white chalk and traces
of red Conté crayon on cream wove paper
26.2 × 65.4 cm (10 ⅜ × 25 ¾ in.)
Art Institute of Chicago, Illinois, USA

Along with Pablo Picasso, Georges Braque is renowned for
his central role in the development of the most revolutionary
art movement of the 20th century – Cubism. However, he
is less well known for the extraordinary work he achieved
subsequently. His life's work focused on still lifes and on
ways of viewing objects from different perspectives. In this
large, horizontal-format drawing, the viewer is presented
with what initially appears to be a rather clumsy and
scruffy rendering of a classic still-life subject. Braque's
subject in this instance has been chosen for purely formal
reasons – the repeated curves of both the fruit and the
wine glass pull the viewer's eye across the surface of the
paper. The fact that they are apples or some other fruit is

completely irrelevant – there is no sense of the lushness
or scent of ripe fruit in the depiction.

These drawn forms appear as if they have been
steamrollered onto the surface of the paper: the mass of
the form has been concentrated and squeezed. The same
treatment has been given to the gaps and spaces surrounding
the objects – they, too, have become concentrated versions
of themselves. Consequently, everything sits on or is
embedded in the paper's surface. This results in the space
being recreated as a tactile entity, which is quite different
from visual or illusionistic space – there is no air between
the objects. It is as if Braque has made space into an object.
He described this approach to art historian John Richardson
in 1958: 'Tactile space separates us from objects, as opposed
to visual space, which separates objects from one another.
I have spent my life trying to paint the former kind.' Braque
also remarked that if a subject was out of reach it was not
still life. Such thinking could not have happened without the
development of Cubism.

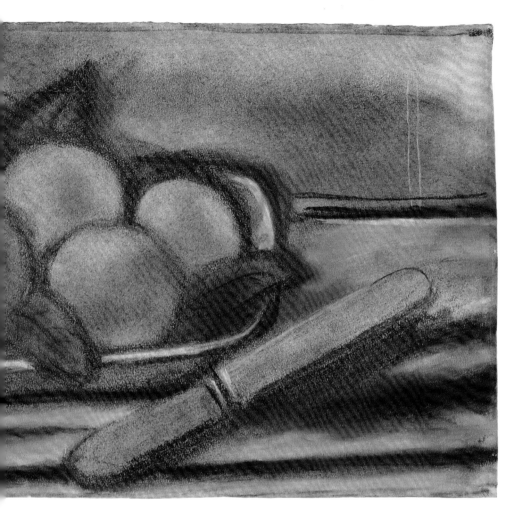

Georges Braque (French, 1882–1963) was born in Argenteuil-sur-Seine in northern France but grew up in Le Havre. He trained as a painter and decorator, while studying fine art in the evenings. His early influences were Impressionism, Fauvism and the work of Paul Cézanne (1839–1906). In 1907, he met Spanish artist Pablo Picasso (1881–1973) in Paris and together they forged the tenets of Cubism. In 1914, Braque enlisted in the French army and fought in World War I until he was wounded in 1917. He moved to Normandy where, working alone, his style remained Cubist but with a meditative character.

See also
Nicholas Volley (p.66)
Michelangelo (p.140)
Alberto Giacometti (p.242)

Tone

Although there is a variation of tone in Braque's drawing, this only approximately relates to light and shade. For example, the wine glass is surrounded by a halo of shading that bears no relation to the angle of light or background. When working from life it is easy to copy tonal values. In this sketch (left), tone has been used to make each area (not each object) possess a character on the paper. These areas will sometimes conform to a specific object but not always.

Space

How is it possible to see space as if it were an object? More crucially, how is it possible to draw it? Imagine the space between the legs of a chair, the floor and the seat, as illustrated (left). Think of that gap being filled by a perfectly square or rectangular-shaped balloon. Imagine that balloon being pumped up so that it fills the entire gap. It now becomes easier to see and you are no longer drawing a gap – you are drawing a gap-shaped balloon instead.

Giorgio Morandi

See also
Georges Braque (p.62)
Nicholas Volley (p.66)
Alberto Giacometti (p.242)

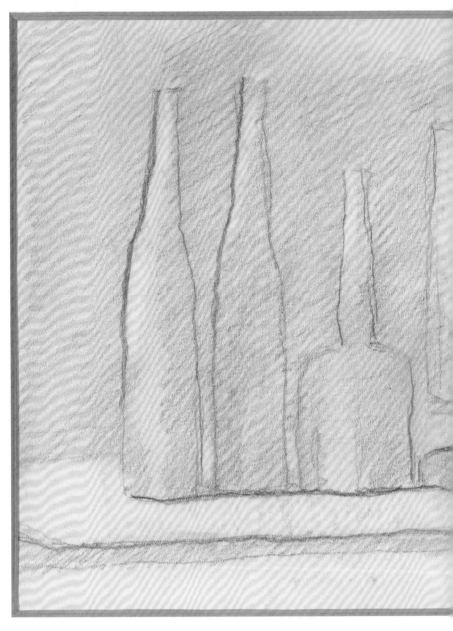

Giorgio Morandi (Italian, 1890–1964) was born in Bologna, where he lived his whole life, producing subtle still-life paintings of bottles, jugs, kitchen utensils and bowls in a small atelier. He studied at the local Academy of Fine Arts and then taught drawing at schools and later etching at the Academy. Initially he was associated with the Italian metaphysical painting movement, but towards the end of the 1920s his tenuous allegiances to the movement dissolved. From then on, he pursued his enquiry into the nature of painting free from making any concessions to stylistic advances. He was awarded first prize for painting at the Venice Biennale in 1948.

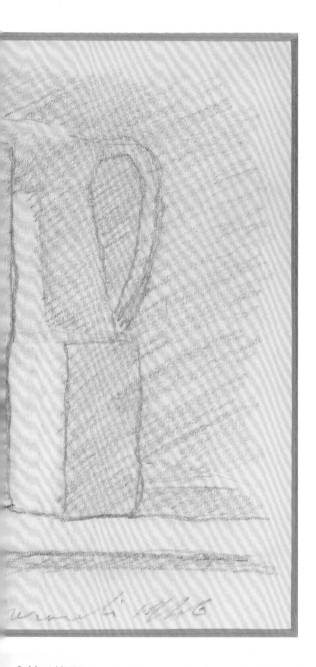

Still Life 1946
Graphite on paper
17.8 × 25.4 cm (7 × 10 in.)
Metropolitan Museum of Art, New York, USA

For most of Giorgio Morandi's life Italy's art world reverberated with the noise of various groups declaring their latest manifestos, yet he never entered into this world in any meaningful way. With the exception of no more than half a dozen trips outside Italy, Morandi spent his life in Bologna. In 1910 he visited Florence, where he saw the work of Giotto, Masaccio, Piero della Francesca and Paolo Uccello – paintings that made a profound impression on him. For Morandi, modern painting was a question of concentrating on the formal grammar of the image. He slowly distilled his perceptions into single images that are solid and monumental, but which also gently shimmer like mirages.

A photograph is a moment of time to be contemplated at leisure, but Morandi manages to compress what feels like the whole of time into one image. In this drawing the dusty pots, jugs and vases are lined up like slightly tremulous figures in a queue waiting for a bus. The shapes between the objects generate their own unique forms and, if you look at the base of the objects, the group as a whole is on the brink of coagulating into a single form. We know from first-hand reports that Morandi spent hours arranging objects into these highly organized groups. Even when he had started his paintings or drawings, he would still change the set up to suit his pictorial needs. Morandi shows us how powerful and resonant painting from life can be.

Subject Matter

With still life, having a subject that you can control is very helpful when drawing. However, one of the issues you will face is that the objects you arrange can often have patterns or surfaces that seem to contradict their three-dimensional nature. For example, the decorative pattern on a vase can easily disguise its three-dimensional form. The strong contrasts of either colour or tone will be more noticeable than their overall form. We can see from the many photographs of Morandi's studio that the objects he used in his still lifes had little or no pattern. A good exercise is to take some objects and paint them with a light colour of matt emulsion paint (far left). Lighting is also very important: try to have light not shining straight onto the objects, but slightly angled (left).

Materials

Most of Morandi's drawings were done in simple HB or 2B pencil on a pale brown or cream wove paper. The pencil is ideally suited to this faint line and the uniform, angular strokes of shading add to the sense of vibration across the surface of the paper. As a general rule it isn't a good idea to make an ostentatious show of your signature, as here, as it will detract from the drawing.

Nicholas Volley

Basket and Candlestick 1997

Charcoal on paper

109.2 × 112 cm (43 × 44 in.)

Private collection

Looking back on the last fifty years, it is clear that artists working directly from life are not as rare as many critics and art historians suggest. Some of the most interesting artists have worked in this way – Lucian Freud, Frank Auerbach, Alberto Giacometti, among others. Although Nicholas Volley tried to paint from imagination and memory, he was never comfortable with that approach. It was that direct encounter with a person, object or landscape in space or in a specific light that Volley found so compelling.

This drawing depicts a timeless subject that could have been captured yesterday or 300 years ago. The simple objects shown could be found on a table in a garden shed or, equally plausibly, in a trendy New York loft. Although it was important for Volley to draw the objects he loved to look at, this drawing is more about space and form. Areas of the paper (rather than individual details) move in and out of space and interact with other areas as forms and as active spatial components. Look at the knife penetrating the space: the back of the table seems in its rightful position, behind, but as the eye moves across the tabletop it starts to come up on to the surface of the paper. There is a recurrent visual pushing and pulling – pushing into depth and then pulling back up onto the surface. This is not arbitrary: it is a series of perceived sensations that have been reorganized within the drawing's structure. The collective effect of the parts and the way these have been reorganized form the structure of the whole image – it becomes monumental, greater than the sum of its parts.

Nicholas Volley (British, 1950–2006) is more known as a painterly painter than for his drawings, yet he was a skilled draughtsman. He was born into a working-class family in Grimsby, Lincolnshire, and studied at the local art school from 1967 to 1970. He then spent five years at the Slade School of Fine Art (now University College London), where he was taught by Euan Uglow (1932–2000), Patrick George (1923–2016) and William Coldstream (1908–87). Influenced by the work of Rubens, Manet, van Gogh and Cézanne, his own portraits and still lifes had a traditional style featuring familiar objects, family and friends. His work is in many private collections and was recently acquired by Abbot Hall.

See also

Georges Braque (p.62)

Giorgio Morandi (p.64)

Alberto Giacometti (p.242)

Space and Form

For Volley the areas are active parts of the composition rather than details like the spoon. An unsuccessful drawing would take attention from an area to a detail, thereby breaking the unity (left). Each area locks into another in a deep space that is active. These proactive areas are never compromised by gestures. Lines always serve a purpose and shading is kept to a minimum. Volley's highly optical drawing is about the process of seeing and organizing on paper.

A still life is one of the most practical subjects you can choose, but it's also easy to get the set-up wrong. Most people make the mistake of arranging some objects in a few minutes and then start drawing. All the great still-life painters – Chardin, Matisse, Cézanne and Morandi – spent a long time getting their subject matter right. During the course of drawing, don't be afraid to change things around; if an object doesn't work in one position, try it in another.

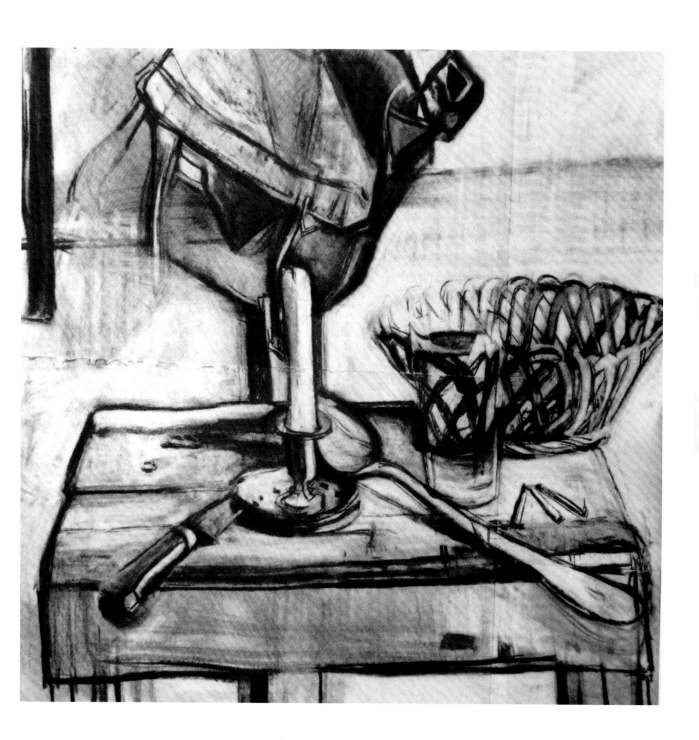

Leonardo da Vinci 72

Raphael 74

Pontormo 76

Polidoro da Caravaggio 78

Hans Holbein the Younger 80

Federico Barocci 82

Annibale Carracci 84

Jean-Antoine Watteau 86

Adélaïde Labille-Guiard 88

Carl Philipp Fohr 90

Gustave Courbet 92

Paul Gauguin 94

Henry Tonks 96

Francis Picabia 98

Georgia O'Keeffe 100

Pablo Picasso 102

Antonin Artaud 104

Lucian Freud 106

The human head brings emotional, psychological and formal considerations neatly into one subject in art. The way viewers interpret and connect complicated visual and psychological experiences around images of the human head is one that continues to fascinate both artists and public alike. Each generation brings new sensibilities, but fundamentally humanity does not change. This, therefore, makes the head almost unbeatable as a subject.

It is important to think about the 'head' as opposed to a 'portrait', because the relationship between the face and the whole of the head is more important than you might imagine. Great artists from Leonardo da Vinci (see p.72) and Rembrandt to van Gogh and Picasso (see p.102) have made drawings and paintings of heads that are referred to as portraits, although these works are more

far-reaching than the simple concept of facial likeness. It is as if the head suggests everything that is profoundly human, whereas the face – the exterior facade – suggests only the personality. But we must not lose sight of the fact that, above anything else, these heads – while highly connected to their respective subjects – are reinventions. As viewers with sophisticated expectations, we place huge demands on the skills artists can use to achieve what is almost impossible. There is a paradox here: the more information the artist adds to an image, the higher the expectations of the viewer – whereas the less detail or information there is, the more willing the viewer is to believe the lie. Artists can take advantage of this paradox to imbue their work with an almost mystical quality, as witnessed by Rembrandt's mysterious and haunting self-portraits.

Study for the Head of a Girl *c.* 1483

Silverpoint on paper
18.1 × 15.9 cm (7 ⅛ × 6 ¼ in.)
Biblioteca Reale, Turin, Italy

Born in 1452, Leonardo da Vinci was about thirty years older than his contemporary Raphael, who made a similar study to this one in 1503, *A Young Woman, Half-Length, Seated* (see p.74). Raphael's work was in black chalk, whereas Leonardo used silverpoint – a technique in which a thin metal wire is dragged across a prepared surface to make a fine line. Although very beautiful, the line was almost impossible to rub out and it was laborious to tone large areas. By the end of the 15th century, silverpoint was in decline. Artists wanted greater versatility and newly discovered graphite deposits in Cumbria, England, offered a more appropriate medium.

What is striking here is the perfect control Leonardo has over the shifting tonal gradations. Each area is built up with a series of lines of varying density. We can see this work in progress in the lower half of the drawing. First, some simple, loose contours are positioned, then more specific tonal shading; this is then developed in detail. It is worth noting a change to the contour running down the side of the face. Even though we can, when using pencil, rub 'mistakes' out, they do the image no harm. It is the peculiar nature of its incompleteness that contributes to the drawing's mystery. Looking from the eye on the right up into the forehead, the eye seems to pop out. As you look up, the curve and volume of the top of the head become substantial and push the eye back in place. This is odd and if Leonardo were to continue the drawing, he would likely work on that area more. However, as it stands, it remains extraordinary.

Leonardo da Vinci (Italian, 1452–1519) was born in Tuscany as Leonardo di ser Piero da Vinci. He was apprenticed to sculptor Andrea del Verrocchio (*c.* 1435–88) and by the late 1470s was working as an artist in Florence. In 1482, he went to Milan and worked at Duke Ludovico Sforza's court, producing *The Last Supper* (1495–98). In the early 1500s, Leonardo was based in Florence once more and began the Mona Lisa (*c.* 1502). In 1508, he returned to Milan to act as architectural and engineering consultant to King Louis XII. He left for France in 1516 to become King Francis I's chief artist and engineer.

See also

Piet Mondrian (p.56)
Raphael (p.74)
Pierre-Paul Prud'hon (p.218)

Materials
Every medium has limitations: with silverpoint, it is almost impossible to get the rich blacks that are are achievable with Conté crayon. Instead, darks are slowly built up with linear shading (see details, left and right). This gradual building of the image gives a different kind of control compared to the gestural immediacy of charcoal. Changing medium opens up new possibilities, but don't lose focus on making an image work – the technical is always a means to an end.

Silverpoint has largely died out in art, but it is good to experiment with different media. Silverpoint works on the principle that when you drag soft metal over a slightly abrasive surface it will leave a mark. Paper is coated with either a ready-made compound or a home-made option (zinc white gouache mixed with extra gum Arabic is adequate). When applying the coating, always use thick paper – this will prevent buckling – or stretch the paper first.

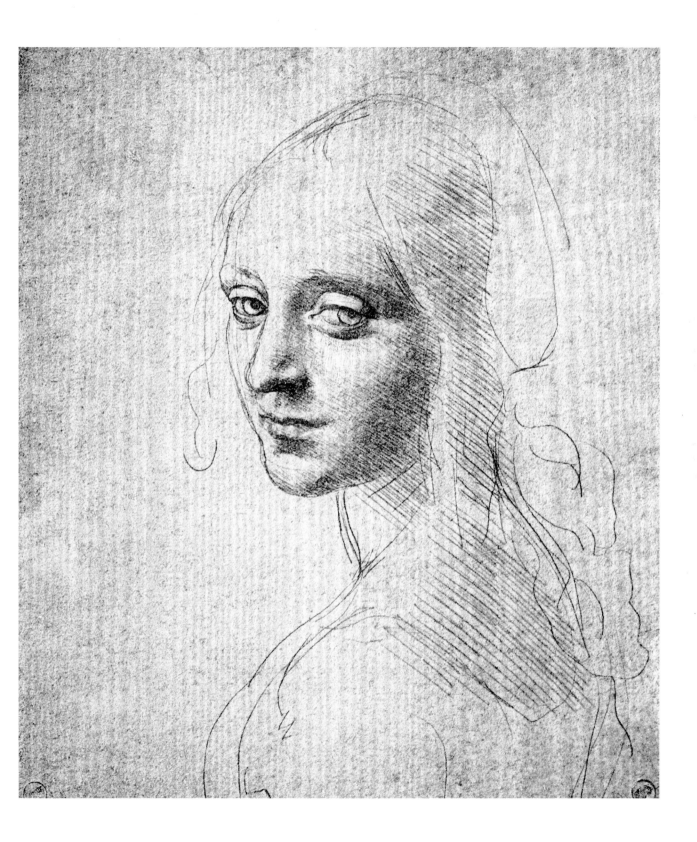

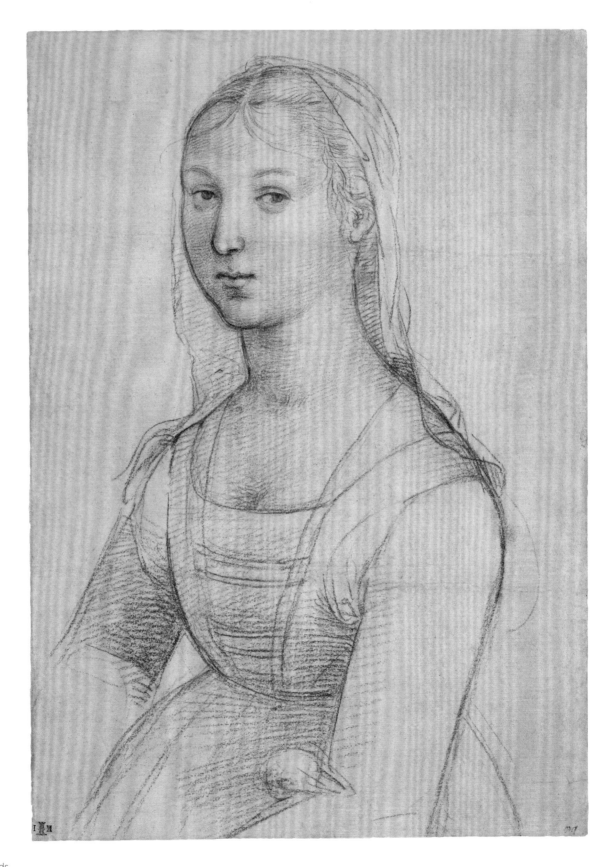

A Young Woman, Half-Length, Seated 1503
Black chalk
25.7 × 18.2 cm (10 ⅛ × 7 ⅛ in.)
British Museum, London, UK

Raphael was about twenty years old when he made this drawing and yet it shows an almost miraculous technical ability. The drawing is smaller than an A4 sheet of paper; this is important because when using a thin instrument such as sharpened chalk or pencil, making the drawing too big can create problems that are difficult to deal with. Presented with a reproduction, we often have little idea of the scale of the drawing. The placement of the figure within the paper seems pinned down and critical – it is almost as if she is concentrating on sitting absolutely still. The pose seems unnatural, but it does feel tense and convincing. The way the features are placed within the head again seems to underline this idea of exact placement – a tiny shift left-to-right would be wrong. If you move your eye down from the hairline straight to the girl's eye on the right, it is as if the eye floats for one second and then is part of the form of the head the next.

Raphael's ability to integrate contours into the whole drawing, yet maintain their independence and separateness, is uncanny. As you move from the girl's dress and lower half – up into the shoulders, neck and head – the contours become firmer, creating a relationship with the tonal gradations. The lower half does not have this quality as it is yet to be worked up. Of course, this is an unfinished drawing with much that is unresolved, but to the modern eye this adds to its charm. It is probably because the image is incomplete that we feel we can get closer to the artist's intentions and possibly better understand Raphael himself.

Raphael (Italian, 1483–1520) was born in Umbria as Raffaello Sanzio da Urbino. He was the son of Giovanni Santi (c. 1435–94), who was a court painter to Federico da Montefeltro, Duke of Urbino. Raphael was a child prodigy and after his father's death, he entered the workshop of Pietro Perugino (c. 1446–1523). By the age of twenty-one he was working in Florence and regarded as the equal of older artists Leonardo (1452–1519) and Michelangelo (1475–1564). In 1508, Raphael moved to Rome, where he lived for the rest of his life and famously decorated the Raphael Rooms of the Vatican Palace.

See also
Leonardo da Vinci (p.72)
Jean-Auguste-Dominique Ingres (p.152)

Tone
Raphael was particularly interested in preserving a more linear-shaped base composition. By contrast, Leonardo da Vinci, for example, was concerned with tone. He was interested in the way forms move in and out of light so that the edges dissolve, leading to a deeper, more modelled effect. A good exercise is to take a linear-based drawing and make a tonal version of the same subject (left). Then go back and start again, using a more linear style.

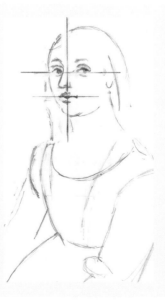

Composition
Raphael creates such poise and stillness partly by the orientation and position of the head. Verticals and horizontals give the impression of stability and calmness. The central axis of the head is vertical and the features are at 90°, as shown (left). The tension between this and the way that shapes around the head seem to lock it all together is masterful. Look at the neck, body and skirt – these elements are simple, curved shapes that again lock together.

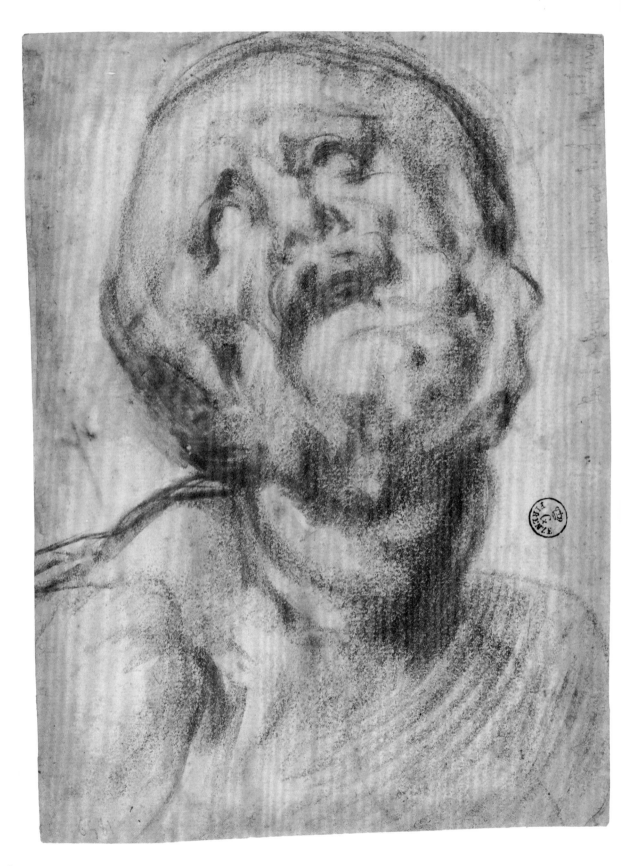

Head of a Bearded Man (Study for Pala Pucci) 1517

Red chalk on paper
17.5 × 12.7 cm (6 ⅞ × 5 in.)
Uffizi Gallery, Florence, Italy

With some rare exceptions, artists up to the mid-19th century built on the achievement of previous generations, making modifications to the traditional language of art. Pontormo was no exception and the formal elements that make up his drawing vocabulary were common to all artists of his period.

In this preparatory drawing for the painting *The Madonna with Child and Saints* (1518, also known as *Pala Pucci*) light, shade and transition tones are clearly stated. Line is used in a limited way to define contours or to give internal planes direction. There are some indications of facial expression, but the power of the drawing comes from the spontaneous quality of the contours and the broad internal marks, which generate a rhythmic sense of movement. It is worth considering the size of the drawing, which is smaller than A5. Paper was expensive until machine production provided cheap, mass-produced paper in the early 19th century, and drawing on a small scale was therefore a matter of economy. This has several consequences. First, the whole drawing can be seen in one glance, so the impact of the whole composition is constantly taken into account as the artist works. As a result, internal rhythms and connections are more easily achieved. Second, the artist is less likely to fill in areas and is able to treat shadows as active parts of the drawing. Finally, the speed at which the eye moves around the drawing appears to be connected to the speed at which the artist was moving around the subject.

Pontormo (Italian, 1494–*c.* 1556) was born Jacopo Carucci but he is called after his birthplace, a village in Tuscany. The son of a painter, the young Jacopo, grew up surrounded by the best of the High Renaissance as he was apprenticed to various artists in Florence, including Leonardo da Vinci (1452–1519). However, unlike his contemporaries in the city, he also studied Northern European artists, particularly Albrecht Dürer (1471–1528). Influenced by his friend Michelangelo (1475–1564), Pontormo developed his own style, producing religious paintings with sculptural figures, and he became one of the leaders of the Mannerist movement.

See also

Hans Holbein the Younger (p.80)
Federico Barocci (p.82)
Annibale Carracci (p.84)

Form

The relationship between the face and the whole head is crucial. Try to consider the whole head from the start. Look at the subject (left, top) and switch your attention rapidly from area to area, becoming aware of a particular quality you wish to place in your drawing. Now move quickly to your drawing and glance again from area to area, placing the marks. In this drawing (left, bottom), the marks contain a high degree of gestural autonomy but still describe individual features. This balance is hard to get right and demands practice.

Line

It is important that you are able to make different kinds of marks. You can either blend the chalk or use lines to create shaded areas. Using the chalk broken or on its side, as shown (left), will enable you to create interesting variations. Taken to extremes, this can be visually confusing (if there are too many changes in one image) or stylistically monotonous (if too uniform). As you push the sides of the chalk into the paper, gradually press one end as this helps create a graduated tonal range.

The Head of St Thomas *c.*1527

Red chalk
20.9 × 26.8 cm (8 ¼ × 10 ½ in.)
Royal Collection Trust, London, UK

At first glance, this is an utterly compelling red-chalk life study by Polidoro da Caravaggio. Although the expression on the man's face is brilliantly drawn, the power of the work comes from the composition as well as something more mysterious.

First consider the scale – the size of the head in relation to the size of the paper. The head takes up half the surface area of the paper. This creates a strong feeling of closeness and claustrophobia – it is as if the viewer is right there, sitting next to him. The ear is phenomenally well drawn; however, it is not the brilliance of any one detail that impresses – it is how that detail looks in the context of the rest of the head. The ear looks strangely separate from the hair; either side of the ear the hair seems believable, but moving up the head the hair becomes flatter and rather odd. Another peculiarity is the nose; the nostril seems to bend towards the viewer, yet we are looking down on the nose and it should conform to that perspective.

The question is, did the artist deliberately intend to create these proportional effects – and, if so, why? We will never know for sure, but Caravaggio appears to have been drawing a man who is looking intently, perhaps apprehensively, at something that is happening to the right of the viewer. The title suggests that it might be St Thomas at the moment when Christ showed the incredulous disciple his wound after the Resurrection. The drawing is not simply an illustration of a man in profile – it is a record of how the appearance of the man is changed by the feeling of apprehension that is being expressed.

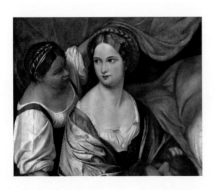

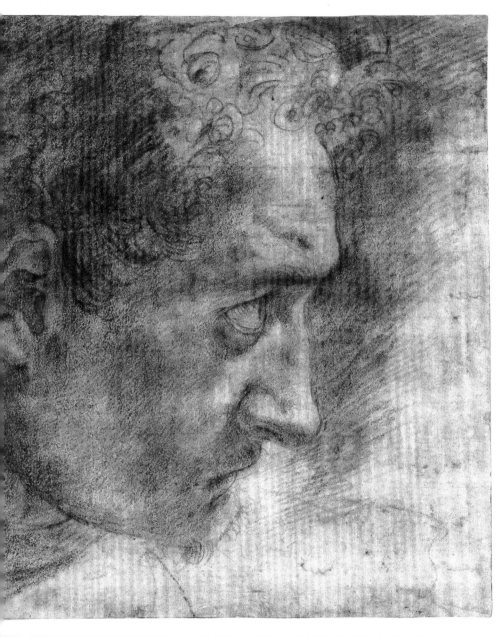

Polidoro da Caravaggio (Italian, c. 1499–c. 1543) was named after his birthplace of Caravaggio, Lombardy. At a young age he moved to Rome, where he assisted Raphael (1483–1520) in decorating the Vatican Loggia. He and another of Raphael's assistants, Maturino da Firenze (1490–1528), set up as painters of palace facades until the Sack of Rome in 1527. Caravaggio fled the city, first to Naples and then to Messina. After completing various projects in the Sicilian city, Caravaggio intended to return to Rome and withdrew his savings from the bank for the trip. Sadly he never made it, as one of his assistants murdered him for the money.

See also
Francisco Goya (p.150)
Pierre-Paul Prud'hon (p.218)

Subject Matter

Choosing which angle to draw from can make a big difference to the way you unlock the interesting aspect of a subject; drawing from the wrong angle can ruin a piece of work. It is a good exercise to choose a famous work to copy from (far left); first, draw straight from the work itself (middle left) and then make a drawing from a different point of view entirely (left). This will make you think about why the artist chose a particular viewpoint.

When artists draw a head in profile they invariably spend too much time on the eyes, nose and lips. To make a convincing three-dimensional head it is better to think that you are drawing a temple and ear, because that area is in the centre of the head. Keep coming back to the centre of the head as it appears to you and draw the external contours that simply express the features.

Sir Thomas Lestrange (*c.* 1490–1545) *c.*1536

Chalks, pen and ink and metalpoint, on pink prepared paper
24.3 × 21 cm (9 ½ × 8 ¼ in.)
Royal Collection Trust, London, UK

In 1526, Hans Holbein the Younger moved from Germany to England with a letter of introduction from Erasmus to the court of King Henry VIII. Europe was in a period of enormous religious and political unrest. Titian and Michelangelo were then at the peak of their powers, but Rome was sacked in 1527 and many cite this date as marking the end of the High Renaissance. By the beginning of the 16th century, a realistic and precise style had been developed by Northern European artists. Holbein was not the highest paid court artist but his work was considered important and widely collected, although some of it has been lost. He was admired for his ability to achieve an extremely good likeness, however, it was only in the 19th century that he was recognized as being among the great portrait masters.

We know that Holbein's drawings were done in sittings that lasted for about three hours. The simple and direct technique makes this drawing – of the prominent courtier Sir Thomas Lestrange – look highly contemporary. It is incredibly nuanced, with the sitter's face only very lightly shaded; the slightly emphasized lines in the eyes, nose, lips and collar are just sufficient to support the subtle shading. The lips work particularly well. After a drawing was finished, Holbein would transfer it onto a wooden panel using a mechanical device. He made many portrait drawings of the leading figures in Henry VIII's court and they provide extraordinary visual documents of real-life characters.

Hans Holbein the Younger
(German, *c.* 1497–1543) trained in his father's painting workshop in the cosmopolitan Renaissance city of Augsburg. In 1515, he found work in Basel, Switzerland, which was a centre of humanist thought. There Holbein painted the Dutch humanist scholar Erasmus. In 1526, Holbein went to London with a letter of recommendation from Erasmus to paint the family of Sir Thomas More. He also provided designs for jewellery and silverware, work that made good use of his draughtsmanship. During his second stay in London, from 1532, Holbein developed his distinctive formula for portraits. By 1535, he had achieved his ambition to become court painter to King Henry VIII.

See also

Jean-Antoine Watteau (p.86)
Antonin Artaud (p.104)
Edgar Degas (p.160)

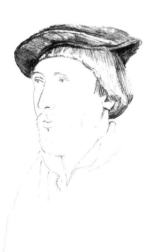

Line

The temptation with a head portrait is to treat each area as a separate field of colour. Try to find similarities rather than differences. For example, the hat and hair in the Holbein are close in colour and tone, as shown here (left), so only slight changes in texture create difference. The understated colour is enough to differentiate forms without breaking up the unity. It is important to work with a light touch, bringing the whole portrait together.

Sources

Likeness is a major issue for artists when they start to work on drawing heads. This is understandable but a mistake. As soon as you focus on likeness, you can easily stop thinking about making a good drawing. A likeness is achieved by getting the shape of the face area right and then the position of the features, as shown (left). The more you look at the whole, flicking your gaze back to the details, the quicker these positions will be established.

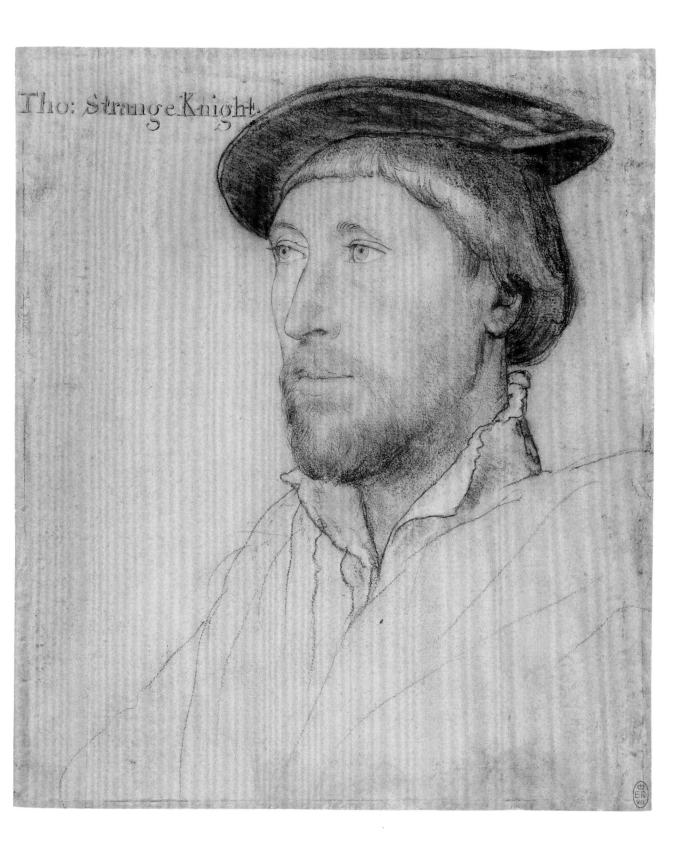

Tho: Strange Knight.

Baroche

Federico Barocci

Head of a Man, Seen from Behind 1583–90
Black and red chalk on blue-grey paper
36.7 × 25.3 cm (14 ½ in. × 10 in.)
Nationalmuseum, Stockholm, Sweden

Students are often faced with unfeasibly difficult angles when working from life and this often applies to drawing the model's head. Not everyone can be in the best position and there will always be some students that have this kind of view to deal with. Here Federico Barocci makes a virtue out of a relatively featureless head. He concentrates on the difference between the neck and the side of the face and the contrast with the hair. The contours have a fluid character and the ear appears to float on the side of the head. Compared to a more modern artist such as Pierre Bonnard, Barocci's head looks contained and solid. However, the more you look at this drawing the more the sense of movement becomes apparent.

We know that Barocci spent considerable time drawing ordinary people in the street, which suggests that he was interested in different types of physical appearances. Furthermore, he would have understood that drawing directly from life gives an artist's work a particular quality that is difficult to achieve when working from studies or memory. This immediacy and Barocci's unmediated responses to his subjects resulted in many compelling images. He also made clay and wax maquettes that he would dress and then draw. Although not one of the high-profile, late Renaissance artists he was contemporary with, Barocci nevertheless displays enormous graphic dexterity in his drawings.

Federico Barocci (Italian, c. 1535–1612) was born in Urbino, where he remained for most of his life apart from two trips to Rome. On the second of these, he is said to have abandoned frescoes he was painting for the Pope because he thought he had been poisoned. He suffered from stomach pain for the rest of his life. Most of his output was religious paintings, and he was the leading painter of altarpieces in the second half of the 16th century. He was a prolific draughtsman – more than 2,000 of his drawings have survive – and he was also one of the first artists to use pastels extensively.

See also

Annibale Carracci (p.84)
Jean-Antoine Watteau (p.86)
François Boucher (p.216)

Materials
Barocci used pastels with very limited colours. He cleverly used the blue-grey paper to create cool colours in contrast to warm flesh tones. In this illustration (left), the brownish shadow on the left moves into the centre white highlight; very little pastel has been used in the transitions, as the grey of the paper shows through. We can learn from the great masters how to use a limited colour range – blues were expensive so they used blacks to make greys to provide a cool colour range.

Tone and Line
Strong contrasts tend to advance towards the eye and often up to the surface of the paper, whereas smaller divisions and fainter contrasts tend to recede away from the eye into the space, creating the illusion of depth (left). Consider reducing the tonal contrasts around contours. When you draw multiple contours, you create a strong contrast between the background tone and the darkness of the contour lines. Shading the background reduces this contrast.

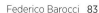

Annibale Carracci

Male Portrait (The Lute Player Mascheroni) *c.*1593–94
Red chalk, heightened with white, on reddish-brown paper
41.1 × 28.4 cm (16 ⅛ × 11 ⅛ in.)
Albertina, Vienna, Austria

This is a drawing of great refinement and elegance. It is one of several done by Annibale Carracci in preparation for a portrait of the lutenist Giulio Mascheroni. Some of these drawings are small, quick sketches; others, like this one, are highly finished. It is known that Carracci thought drawing directly from life central to his practice, so it is likely that this portrait was created, certainly in part, in this way. The drawing is larger than many of the period, about A3 paper size, and the head is just over life size. At this time, paper was hand made and therefore very expensive; this is one of the reasons most Old Master drawings have sketches on the back. The orangey-red chalk and reddish-brown paper is an appealing combination, and with the addition of a few well-placed white highlights the form of the head has been brilliantly realized.

As the eye moves across the surface the transitions between tones are not so refined as to be invisible, but they are in step with one another. The shading in the cheek beautifully transforms into the texture of the hair. Parts of the composition have been less worked; the shoulders and coat have simple shading that could be developed more. Yet if you look at the buttons and cross-hatching and then move your eye up to the head, there is a surprise in the way the form of the head comes across. The insubstantial nature of the shoulders makes the head seem even more emphatic. Note the revised contours on the left-hand shoulder – Carracci made no attempt to erase the first two attempts. Again, this echoing of contour seems to make the side of the cheek more certain, even though it is incredibly sensitively drawn.

See also

Pontormo (p.76), **Polidoro da Caravaggio** (p.78), **Antonin Artaud** (p.104),

Annibale Carracci (Italian, 1560–1609) was the most inventive and talented of a family of artists known as 'the Carracci'; the family worked initially in Bologna in the late 16th century. Annibale trained from a young age in the studio of his cousin Ludovico (1555–1619), along with his brother Agostino (1557–1602). Annibale left for Rome in 1595 to study the work of Raphael (1483–1520) and Michelangelo (1475–1564), as well as antique sources. He was commissioned to decorate the ceilings of the Palazzo Farnese, working on them for about ten years, and his monumental classical nudes became the touchstone for artists painting in the Grand Manner.

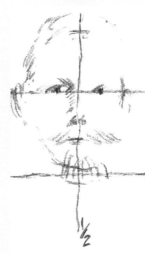

Materials
Compressed red Conté chalk is ideal for this kind of drawing. It is more solid than charcoal, so you can sharpen it to a very fine point. This enables you to shade by means of lines – for example, hatching and cross-hatching. Conté crayon comes in short sticks about 5–6 centimetres (2–2⅓ in.) long. If you find this uncomfortable to hold, you can buy clutch holders (as shown, left) from good artist material shops or art suppliers online.

Form
When making a copy, first consider the placement of the head within the paper (the eyes are a third of the way down in the centre and the head is left of the centre). The oval-shaped line for the head is useful, but it is better to mark the extremities of each form (left). Build the form from the centre out to create volume. The middle of the cheek (the highlight) is a good place to start; as you draw, go back into space towards the contour.

Composition
It is important to work on the whole of the drawing simultaneously. Don't fixate on one area. Although the shoulders and chest areas are relatively undeveloped in this illustration (left), the effect enhances the substantial feeling of the head; looking from the head to the shoulders, the head seems to increase in power and intensity. Carracci was willing to sacrifice some details in order to achieve the finish he desired.

Jean-Antoine Watteau

Head of a Man *c.*1718
White, red and black chalk on cream paper
14.9 × 13.1 cm (5 ⅞ × 5 ⅛ in.)
Metropolitan Museum of Art, New York, USA

The transition between the 17th and 18th centuries was an interesting stage in art history – between the Baroque and Rococo periods, which produced many great artists. Yet, Antoine Watteau was the only one working at his peak during this transition period who is remembered as significant. During his lifetime he was not well known outside a small circle of admirers. His paintings sold to the bourgeoisie and to wealthy bankers, but not to influential, aristocratic patrons. However, his drawings were widely collected.

Watteau perfected a technique known as three-colour chalk drawing or *trois crayons*. This involved using black, white and red chalk in one drawing, often on cream-coloured paper. It was not until the mid-19th century that cheap blue pigments were available; until that time, artists had to either use very expensive lapis lazuli or black mixed with white to make grey. The grey, if placed next to a warm colour, could appear very blue and cool. It is this coolness that creates an added dimension – the red-brown then creates luminous warm shadows or a hint of local colour. The cream paper and the white chalk provide the high tones. In this drawing – a preparatory study for a man's head in Watteau's painting *Mezzetin* (*c.* 1718–20) – the position and overall shape of the head have been drawn first in light red chalk. Watteau then used white and black chalk, switching back and forth from colour to colour.

Jean-Antoine **Watteau** (French, 1684–1721) was born in the French border town of Valenciennes and moved to Paris in 1702. He received his artistic education from 1705 to 1708 in the workshop of Claude Gillot (1673–1722), a painter of theatre scenes. Gillot took his pupil to see the theatrical antics of the *commedia dell'arte*, which was an inspiration for Watteau's most important creation – the *fête galante*, or courtship party. This was a picture of an outdoor idyll in which elegant figures whiled away the hours flirting with each other. The French Academy invented the term when it had to categorize Watteau's work after granting him membership in 1717.

See also

**Hans Holbein
the Younger** (p.80)
Adélaïde Labille-Guiard (p.88)
François Boucher (p.216)

Materials and Line
With the three-colour chalk technique, consider three factors: first, warm and cool – reds and blacks; second, light and shade – lightest (white) to darkest (black); third, contrasts – strong and soft (far left). When using black and white, assess what are the lightest and darkest areas. Blacks can be mixed with white to make greys – these can look cool, like blues. Reds can be mixed with white to make pinks. Strong contrasts tend to come forward and soft, complex ones recede.

Remember, you are making an equivalent set of relationships, not an identical set. Finally, a toned paper gives the white a stronger effect when creating these colours and tones. Decide what aspect of your subject is most important. If you want to create a strong, three-dimensional form, then reduce the contrasts around the edge (left). A strong contrast on the edge brings the form forwards and contradicts the idea of it moving away (as on the far side of Watteau's head).

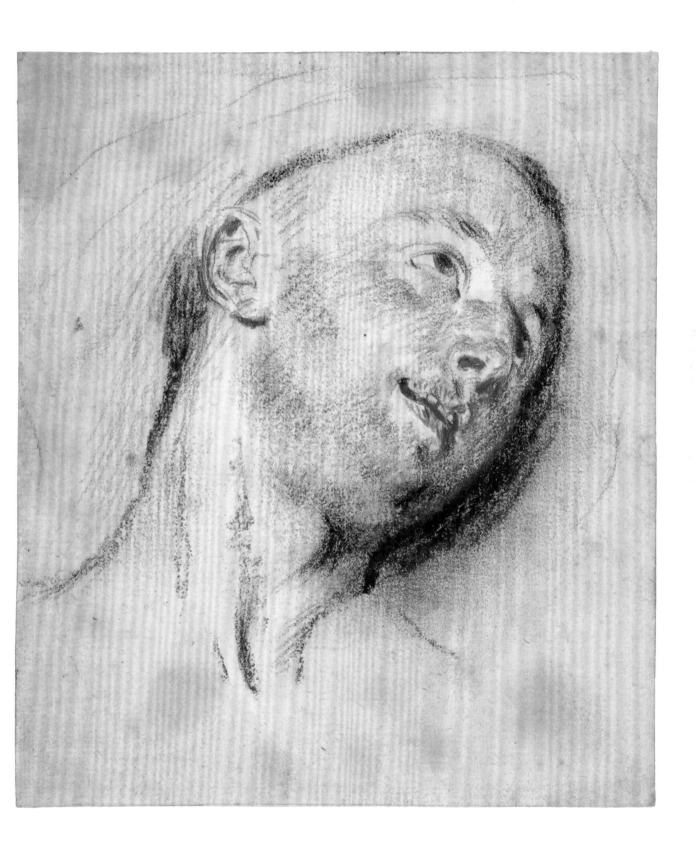

Study of a Seated Woman Seen from Behind (Marie-Gabrielle Capet) 1789

Red, black and white chalk on toned laid paper
52 × 48 cm (20 ½ × 18 ⅞ in.)
Metropolitan Museum of Art, New York, USA

Adélaïde Labille-Guiard was twelve years older than her devoted pupil Marie-Gabrielle Capet – the subject of this drawing. They became close friends and Capet eventually moved into the artist's apartments at the Louvre in Paris. Little is known about Labille-Guiard's training, although her family connections suggest that she would have been aware of many well-known artists of the period. Labille-Guiard and the Neoclassical French painter Jacques-Louis David were almost exact contemporaries; by comparison her work appears less significant, but next to most contemporary work of the period it is extraordinarily accomplished. By the end of the 18th century the Rococo style was dying out, soon to be replaced by Neoclassicism as exemplified by David.

Rococo portraits can appear superficial and frivolous, but Labille-Guiard's work is of another calibre. It brilliantly captures a connection between the artist and sitter. As the eye moves from the chair back up into the hair around the face, the viewer becomes aware of the sensuous, three-dimensional quality of the shoulder. Yet when you register the expression on the sitter's face, you interpret the fleshy quality of the shoulder in a slightly different way. This comes from the most important attribute any artist must have – empathy with the subject.

Adélaïde Labille-Guiard (French, 1749–1803) was born in Paris. She took private lessons in art as an adolescent, learning how to make miniature portraits. She apprenticed with the pastel master Maurice Quentin de La Tour (1704–88) from 1769 to 1774. After the apprenticeship, she exhibited one of her pastels of a magistrate at the Académie de Saint-Luc and she continued displaying her works there until it closed in 1776. She separated from her first husband a year later and made her living teaching art. In 1783, she won admission to the Académie Royale de Peinture et de Sculpture and was awarded the title Peintre des Mesdames (Painter to the King's aunts). She supported the French Revolution and also created portraits of deputies of the National Assembly.

See also

Jean-Antoine Watteau (p.86)
François Boucher (p.216)

Materials

This is a drawing of quite large proportions, made in three coloured chalks: black, red and white. The toned brown paper highlights the white and is one of the drawing's most striking attributes. When working on a large scale, try not to compartmentalize the process: individual areas should not be developed too quickly and out of step with others. Bring the whole work on together – this allows you to adjust the composition before you develop the forms.

Sources

Drawings will always be more powerful and effective if you avoid clichés. Certain subjects present the artist with a dilemma; on the one hand if you try to be original it can often look ridiculous, and yet if you don't, it can easily become clichéd. Producing an image that successfully suggests sexual allure or sensuality is particularly difficult to master.

There are many different approaches to this problem. Some artists create images that are deeply ironic, whereas others are shockingly direct.

Generally, it is important not to be too obvious – in fact, try to be as subtle as you can. In this drawing, Labille-Guiard focuses on the beautiful quality of the sitter's shoulder and arm. She doesn't attempt to replicate their smoothness; instead, she translates a whole set of relationships – she captures the subtle connections between the compressed flesh under the sitter's arm and breast and its similarity to the folds in her white top.

Technical expertise does not make a great artist – if that were true, the world would be full of masterpieces. Yet there has been a gradual de-skilling in drawing generally. We cannot rely on achieving a certain look when we want to because we simply do not have the technical skill necessary. By studying art closely, however, we can learn a great deal, and as your drawing develops so your technical skill will increase. But always remember that technique is the servant of your intentions.

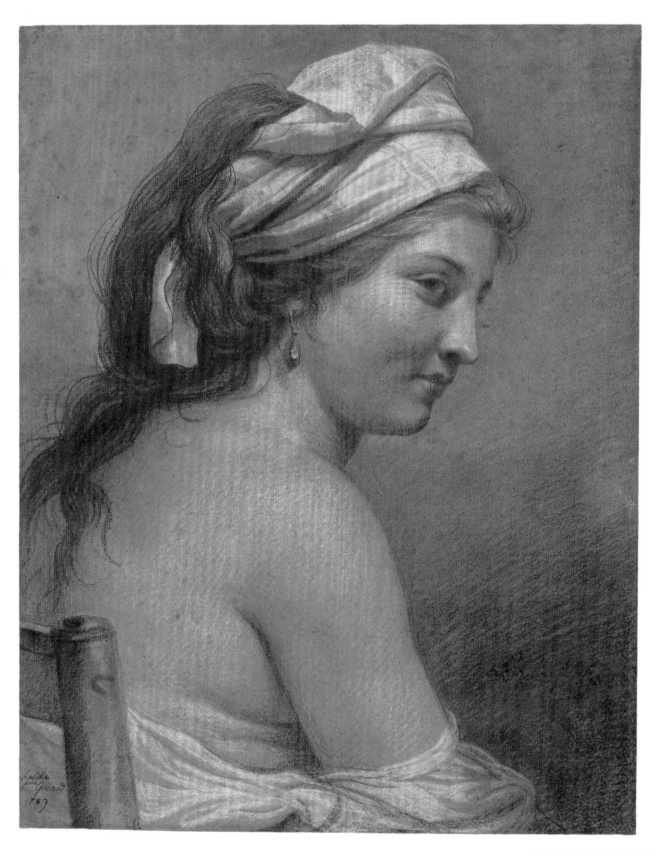

Adélaïde Labille-Guiard 89

Self-portrait 1816
Pen, Indian ink and wash on yellowish paper
23.5 × 18.5 cm (9 ¼ × 7 ¼ in.)
Kurpfälzisches Museum, Heidelberg, Germany

It is hardly surprising that Carl Philipp Fohr is so little known. He lived for only twenty-three short years, with contemporaries that included some of the giants of 19th-century art such as Jean-Auguste-Dominique Ingres and Honoré Daumier. Fohr was working at a time when there was a resurgence of interest in the work of Albrecht Dürer and he was also influenced by the Romantic painter Caspar David Friedrich. We can see from his work that he was an incredibly skilful artist and his approach and way of working fits within the German tradition. He was largely self taught and followed his instincts. This led him to Rome, where he spent time working on landscape painting with the Austrian artist Joseph Anton Koch.

What is striking about this drawing is how modern it looks. When viewed in conjunction with Lucian Freud's self-portrait (see p.106), it is as if both works could have been done by the same artist. There are other parallels looking back to Holbein. Here, there is a cool precision and economic use of the language of drawing in which every part is distilled down into its most essential qualities. The viewer's attention therefore focuses on these minimal details. In a busy, energetic drawing you get a sense of the artist's personality and inner feelings, but it can feel frustrating if things are not concrete and factual. Here the reverse is true. Large areas are beautifully controlled and the precise, minute details pull the viewer into the drawing, creating a sense of intimacy. Yet paradoxically, we feel the artist is hiding his feelings.

Carl Philipp Fohr (German, 1795–1818) was born in Heidelberg. He studied in Munich, but then headed to Rome in 1816, where he became part of the Nazarene circle. The Nazarenes were a group of German Romantic artists who endeavoured to create art that embodied spiritual values. Fohr soon became a popular figure among the German colony of artists who gathered to meet at the Café Greco. He specialized in landscapes, producing views of his birthplace and Tivoli, but his career never had the chance to flourish as he met an early death by drowning while bathing in the River Tiber.

See also

Hans Holbein the Younger (p.80)

Lucian Freud (p.106)

Jean-Auguste-Dominique Ingres (p.152)

Line and Form
What is so impressive about Fohr's drawing is how economic and simple the overall effect is. The temptation is to remove – or not even try to include – all the internal shading or lines, and to concentrate on the outline, going over and over it (far left). This will flatten the image, so you need to be careful not to lose the character of the contour.

If you are careful, it is possible to generate full forms with little internal articulation and definition.

Remember that while you work to simplify, what remains has to be precise.

Work very lightly to start with, possibly using a slightly harder pencil but gently stroking the paper (left). The difficulty is getting sucked into drawing more and more detail. Fohr has been selective in the details he emphasized and the way that he abbreviated them. Concentrate on deciding which details you want, how you will simplify them and where they are positioned.

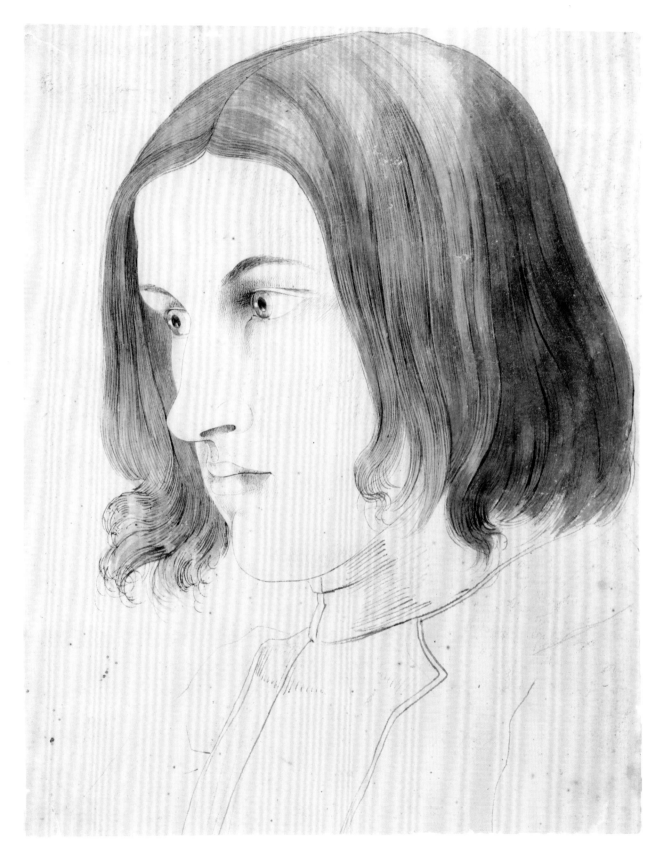

Self-portrait *c.* 1849

Black chalk on paper
29.2 × 22.2 cm (11 ½ × 8 ¾ in.)
Wadsworth Atheneum Museum of Art, Hartford, Connecticut, USA

This surprisingly small drawing has a unity and completeness that makes it seem more like a finished painting. The paper's rough texture makes precise details difficult to achieve and almost every square centimetre is covered in Conté chalk. Yet, the textured paper also helps to keep light in the shadows: the little pits are kept free of black chalk. The way specific edges are drawn in focus, with other areas much less defined, is reminiscent of the work of Jean-Siméon Chardin, an artist Courbet greatly admired. As a young man Courbet was a larger-than-life, politically active character who went to prison for his part in an attack on the Bastille in 1871. Although a pioneer of Realism, much of his work seems dark and sombre and not particularly realistic. He produced several huge paintings (more than 6 metres long) that now hang in the Louvre.

Henri Matisse once described Courbet's inability to create atmosphere in his figure paintings: 'his nudes in a landscape look as if they were stuck onto the background. . .On the other hand, solidity and richness, that's in Courbet.' Matisse was, of course, right about the paintings, but this drawing looks totally convincing and creates a strong sense of atmosphere and complete integration of form. Courbet focuses entirely on the gradations of light and shade and how these reveal or disguise the forms. The lips, nose, hat and collar emerge out of a more ambiguous shadowed area. In his paintings he seems to sacrifice this unity of light and shade so that he can accentuate the plasticity and monumentality of the form, but here no such sacrifice has been made.

Gustave Courbet (French, 1819–77) was born in Ornans in the Jura region of eastern France. He spent most of his life in Paris, but was always drawn to the countryside. He was a leading proponent of Realism that depicted rural life in a naturalistic fashion. He shocked critics at the Salon of 1850, with his paintings portraying the everyday life of peasants and farm labourers in a monumental style that was traditionally the preserve of grand history paintings. After the fall of the Second Empire, Courbet was elected President of the Federation of Artists, which was dedicated to expanding art and freedom from censorship, and he was active in the Paris Commune of 1871.

See also

Antonin Artaud (p.104)
Paul Cézanne (p.224)
Georges Seurat (p.228)

Subject Matter

With its long and honourable tradition in both drawing and painting, the self-portrait is an excellent subject for the artist. Look to use props to add interest. Items such as hats are useful as they can change the light on the face, as illustrated here (left). When working on a self-portrait, looking at yourself in a mirror while drawing can be disconcerting. But concentrating on the likely effects that a hat provides will help keep you focused on the drawing itself.

Tone

Lighting your face from the right angle for a self-portrait is crucial. Don't begin until you are sure it is right. When focusing on light and shade, you must take the whole scene into account. Distracting contrast in the background behind your head will confuse the image, as illustrated here (left). The background should be dark (not black). Try to arrange it so that the lightest areas are on your face. Avoid profiles and square-on, full-face views where possible.

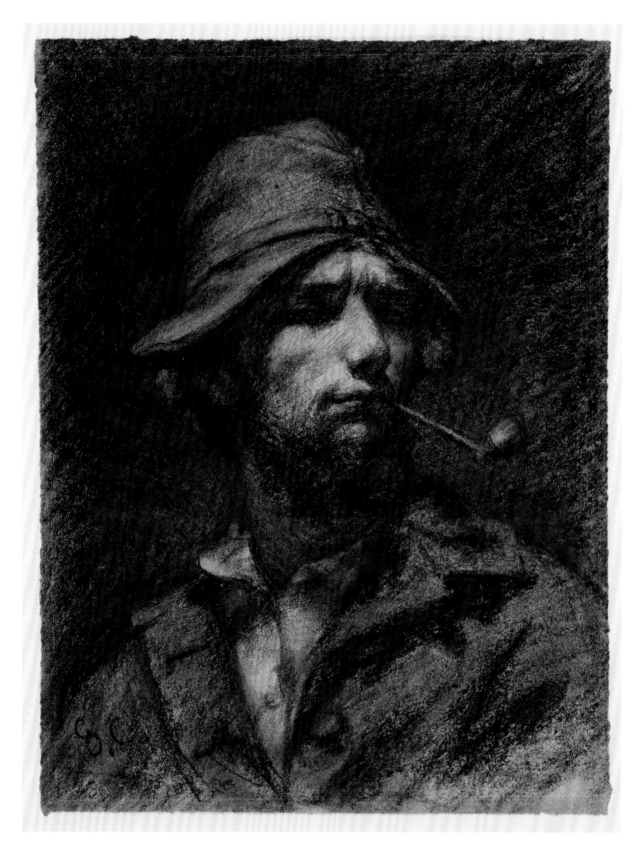

Paul Gauguin

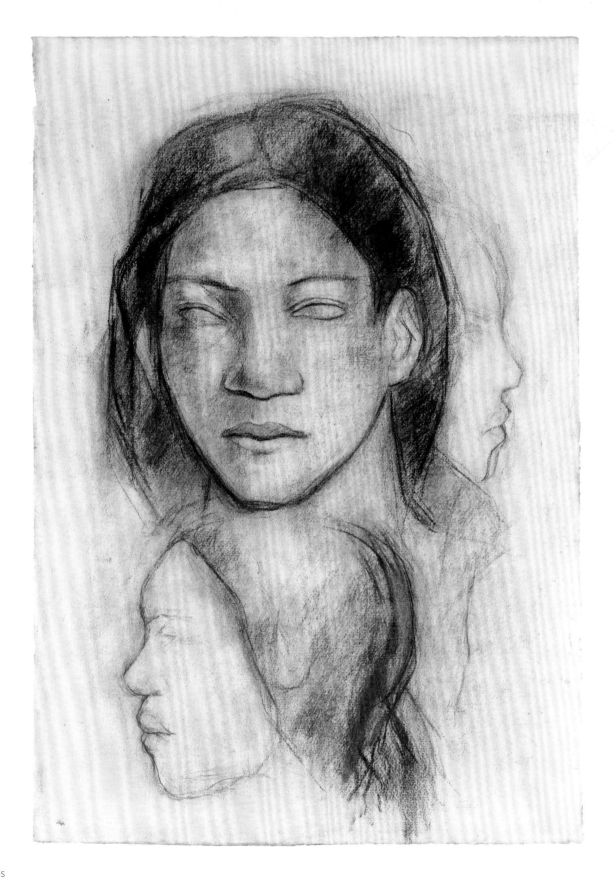

Tahitian Faces (Frontal View and Profiles) *c.*1899
Charcoal on laid paper
41 × 31.1 cm (16 ⅛ × 12 ¼ in.)
Metropolitan Museum of Art, New York, USA

In this study by Paul Gauguin we see three Tahitian faces – two in profile together with a full frontal view. The neck of the main head seems twisted, as if viewed from the side. This gives the drawing a primitive feel, but also suggests a more complex preoccupation. Gauguin was highly secretive about his drawings – likening them to private letters rather than finished presentation drawings – and he rarely showed them. Many of them were of individual objects, figures or heads and were studies for larger paintings. If we consider his paintings, it is clear that Gauguin was concerned with orchestrating large coloured shapes within the rectangle of the painting. These shapes then went on to have subdivisions that were complex or simple, depending on what was needed.

When we study the drawings, however, it is as if Gauguin found it difficult to translate the orchestrating of shapes into a black-and-white graphic language. When he starts to introduce colour, shapes take on greater meaning and move outside the individual figures or objects. To best appreciate the black-and-white studies, one has to think of internal relationships – the shape of the hair against the shape of the face or against the shape of the neck and, in turn, the shape of the eye compared to the shape of the lips. Look closer and you see that the contour has been reworked many times, as if he was pushing the forms into the surface of the paper. In fact, the features of the main face seem embedded in the shieldlike flatness of the head. The result of this focusing on shapes that interlock gives the drawing great immediacy.

Paul Gauguin (French, 1848–1903) is best known for his bold-coloured paintings set in a tropical environment. By 1872, he was a successful stockbroker in Paris and a year later he married. He went on to have five children but then abandoned his family to pursue his artistic goals. By 1885, Gauguin had become a painter and a dominant figure in Parisian artistic circles. He then moved to rural Brittany for a more carefree life and by 1888 he had adopted a more expressive, less Impressionist style. In 1895, he travelled to Tahiti and Oceania in search of indigenous inspiration, where he died in poverty.

See also

Georges Braque (p.62)
Robert Pugh (p.182)
Suzanne Valadon (p.238)

Subject Matter
Gauguin's study was probably drawn from life, but it has the air of a remembered head. Before you start drawing a head from memory, practise the process. Try closing your eyes and making an image in your imagination. Then go to your paper and quickly sketch the image you have in your head. Avoid anything too obscure – keep it very simple at the beginning, as in this example (far left). A few simple lines will give you enough information.

The temptation when drawing from memory is to make a schematic representation. What tends to happen is that you will remember fragments – keep adding these fragments into your drawing, not worrying about making a logical whole. As you become confident, the image you create in your mind will become more complete (left). When you feel that the drawing has enough information, you can erase anything unnecessary. Now try this with a head.

Portrait of a Serviceman 1916–18
Pastels on paper
26.6 × 20.6 cm (10 ½ × 8 ⅛ in.)
Hunterian Museum, London, UK

Henry Tonks was a British surgeon who became one of the most influential art teachers in England during the first half of the 20th century. Although he was one of the first British artists to be influenced by the Impressionists, he was sceptical of modernism. Tonks resumed his medical career during World War I when he worked for Harold Gillies producing pastel drawings recording facial injury cases at the Cambridge military hospital in Aldershot and the Queen's Hospital, Sidcup, and he became an official war artist in 1918. Tonks was less impressive when it came to reading the history of art and it is arguable that he was one of a generation of British artists who looked back rather than looking towards opening up new possibilities.

However, the drawings he made of wounded soldiers during World War I are some of the most startling and extraordinary images to come from that period. To a modern audience these works have a directness and authority that is truly shocking. What is alarming about them is not necessarily the terrible deformity caused by the weapons of war but the beauty with which these forms have been drawn. Tonks treats the deformities with remarkable candour – anyone who has ever had a serious medical problem will appreciate this honesty and frankness – but also manages to imbue them with a kind of shocking beauty.

Henry Tonks (British, 1862–1937) trained in medicine and became a house surgeon at the London Hospital in 1886. He taught anatomy at the London Hospital medical school from 1892. From 1888, he took evening classes at Westminster School of Art and first exhibited his paintings in 1891 with the New English Art Club. From 1892, he started to teach at the Slade School of Fine Art. In World War I, he served as a medical orderly and then produced pastel drawings recording facial injury cases before becoming an official war artist in 1918. He was Slade Professor of Fine Art from 1918 to 1930.

See also

Antonin Artaud (p.104)
George Grosz (p.168)
Georg Baselitz (p.176)

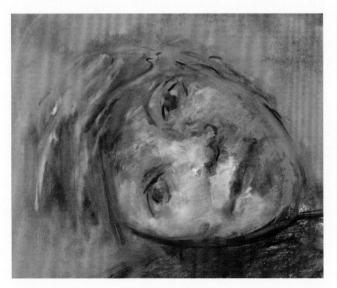

Materials

Tonks uses pastels brilliantly. The soft consistency of pastel makes blending colours particularly easy, but Tonks manages to preserve the rough look of the pastel in the right places. Think about the differences in texture between fabric, hair and skin and try to capture these in your strokes. In this illustration (left), you can see that the artist has blended some colours together but has also used charcoal. Mixing media can be a highly effective technique.

Sources

Many would feel that Tonks's subject matter is so emotive and distressing that to talk about the practical side of making such images is inappropriate, but this is the gift of war artists – they capture the horror and in some small way try to prevent future conflicts. Tonks here is a master of his medium. He observed the delicate transitions between light, shade and colour across the surface of the face, and in doing so made the grotesque beautiful.

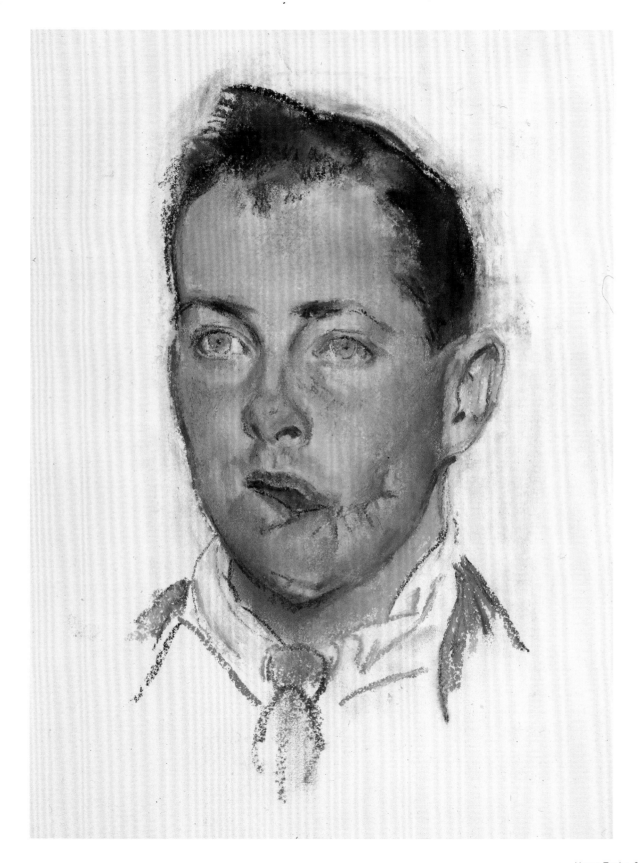

The Bitch of the Baskervilles *c.*1932–33
Brush and Indian ink and charcoal on paper
64.1 × 49.2 cm (25 ¼ × 19 ⅜ in.)
Private collection

Francis Picabia is a darling of the art world. Dealers and galleries adore him because he was prolific; serious artists admire him because he was inventive and eclectic; students love him because he was irreverent and witty. And the public like him because he poked fun at the establishment. Between 1928 and the mid 1930s, Picabia produced a major body of work based around an idea he described as spaces where he might express 'the resemblance of my interior desires. . .[in paintings]. . .where all my instincts may have a free course'. For this work he referenced imagery ranging from ancient Rome to the Renaissance, often juxtaposing incongruous objects. Picabia's ideas were influenced by his experiences and interest in photography and film. Here, the term 'transparency' has a particular significance to photography.

In this drawing, it is as if the artist is looking at one object while thinking about another. The viewer can almost see his mind wandering. This work, like others Picabia produced during this period, is totally original but he had to make sacrifices. For example, the very fact that layers of the image are transparent means that he could not develop the form. He seems to compensate for the lack of three-dimensional form in the headless body by emphasizing the black contour line, whereas the shaded head, which has more three-dimensional form, is far lighter in touch. Having your attention pulled back and forth between the different layers of the image causes an odd and disturbing sensation.

Francis Picabia (French, 1879–1953) grew up in Paris and studied at the École des Beaux-Arts and the École des Arts Décoratifs. He and Marcel Duchamp formed the Section d'Or Cubists in 1912. A year later, Picabia exhibited at the Armory Show in the United States. He followed up this success with a visit to New York in 1914 when he, Duchamp and Man Ray helped form the New York society of Dadaists. By 1917, Picabia had published his first mechanical drawings to critical acclaim. In 1921, he dissociated himself from Dadaism. He started to construct collages and work with transparent overlaid images, looking for ways to depict three-dimensional space without using traditional perspective.

See also

Joan Miró (p.204)
René Magritte (p.266)
Paul Klee (p.268)

Subject Matter
Using a basic visual language – form, tone, line and colour – need not be confined to a realistic rendering of your subject. Picabia cleverly combined the linear with the tonal. Play with different subjects; remember that interesting images are more likely to happen if you're looking for ways of connecting things that don't appear to be related. For example, hair blowing in the wind might look like the waves in the sea, as shown here (left).

Materials
Combining different media can be powerful, but it can also be difficult to manage successfully. Be decisive: work until you have what you want, then look at the drawing and ask yourself if it's any good. Make the medium the servant of your intentions. If the drawing won't go in the direction you want, then let the drawing direct you. Judging how and when to push the medium takes time – some will work, many will not. Gradually you'll get a feel for what works and what doesn't.

Francis Picabia

Georgia O'Keeffe

Dorothy Schubart 1936
Charcoal on paper
60.3 × 45.3 cm (23 ¾ × 17 ⅞ in.)
Georgia O'Keeffe Museum, Santa Fe, New Mexico, USA

Georgia O'Keeffe was born in the 1880s – a golden decade in which many great artists of the 20th century were born. It is probably because of her longevity (she died aged ninety-eight) that we regard her more as a mid to late 20th-century artist. She is best known for her paintings of enlarged flowers, which have a highly suggestive, sexualized appearance – and discovering her more figurative work can be surprising. Like her American contemporary Edward Hopper, another 1880s artist, she had worked as a commercial illustrator and was highly skilled.

O'Keeffe only made a few portraits and the studies she made in charcoal are likely to have been done from life. This one was completed when O'Keeffe was in the middle of her productive years. It has a meticulous feel, and at first glance it is difficult to tell that it has been done in charcoal. There are no preliminary sketch outlines or rough shading that needs finishing, nor is there evidence of revisions or changes. Everything has been carefully rendered with precision, and there is no smudging or blurring, as can be the case with charcoal drawings. O'Keeffe is primarily interested in shape and surface. The space the sitter's head occupies seems inconsequential, as if it has been folded up neatly and stored away. The three-dimensional plastic quality of the head is somehow reduced; even though it is without doubt a three-dimensional form, it does not have a position in space to relate its volume to. The overall effect is one of density of line, offset by the lightness and transparency of the surrounding empty space.

Georgia O'Keeffe (American, 1887–1986) studied at the School of the Art Institute of Chicago for a year, but left when she fell ill with typhoid fever. In 1907, she took classes at the Art Students League in New York and then worked as a commercial illustrator. In 1915, she sent some abstract charcoal drawings to a friend, who showed them to photographer and gallerist Alfred Stieglitz (1864–1946), who exhibited her drawings in his 291 Gallery in New York. She and Stieglitz became a couple and married in 1924, the year she first painted flowers at close range. From 1929, she spent part of the year in New Mexico, where the landscape inspired her subsequent work.

See also

**Hans Holbein
the Younger** (p.80)
Antonin Artaud (p.104)

Materials
Although this drawing uses only simple charcoal, we can appreciate O'Keeffe's absolute mastery of the medium. She controls it to such an extent that you have no idea that it is a charcoal drawing. Using charcoal in this way means a very gradual build-up of layers, probably using fixative on each one. Close attention to the surface of the face means that the artist transcribes a journey across the face as if an ant were crawling across it.

In this illustration (left), the artist has made a crude version of his subject. Each plane is defined – as the drawing progressed, he has made the transitions from plane to plane more subtle. When drawing in this way, it is still important to have some idea of the positioning of the head within the paper. As you can see in this illustration, the artist has lightly sketched out the position of the parts that are yet to be defined to give an idea of where they will go – guidelines will help inform your work.

Space
O'Keeffe precisely describes the surfaces of the face and hair, yet it isn't a photorealist work. It's more idealized, as if the head has been made in wood and its edges sanded down into a perfect form. She expresses the intricate changes in tone from one surface to the next. Rough shading or abstract lines would disrupt this surface unity. Don't worry about trying to express deep space. Any spatial relationships achieved are to do with changes in scale or tone.

Pablo Picasso

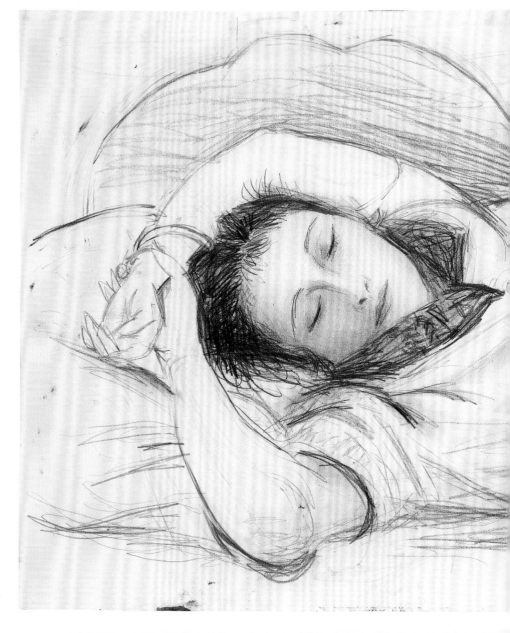

Pablo Picasso (Spanish, 1881–1973) dominated 20th-century art. Shifting from one style to another and between media, his output was prolific, always original and often provocative. He studied at La Coruña Arts School when he was eleven years old and enrolled at the Real Academia de Bellas Artes de San Fernando in Madrid at the age of twenty. In 1904, he settled in Paris. His Primitive Period was inspired by pre-Roman Iberian sculpture, and his groundbreaking work *Les Demoiselles d'Avignon* (1907) shows the influence of African art and a shift towards Cubism. During the Spanish Civil War his work became anti-Fascist, as seen in his monumental painting, *Guernica* (1937).

Sources

It is the range of marks Picasso produces that allow textures to be so clearly expressed in his drawing. When you draw in this way, think about characteristic shapes and lines within certain areas. The way these shapes and lines echo each other generates a kind of interdependency that unifies the whole drawing. For example, in this illustration (left) the circular shapes on the sheet of the bed echo similar shapes that appear in the background. The human brain likes these connections, as the eye moves around an image. Remember that you can vary the scale as well. For example, a small curved mark might echo a large curved mark, as the curve of the arm and cleft in the hand echo the curve of the buttocks in this illustration. Creating a unified whole while also making it interesting to look at is the objective.

Portrait of Dora Maar, Sleeping 1937
Pencil on paper
37.6 × 50.8 cm (14 ¾ × 20 in.)
Private collection

Pablo Picasso was a much-written-about celebrity of the art world during his lifetime. In 1937 he produced one of the most extraordinary paintings of the 20th century – *Guernica* – a political and shocking revolutionary work. This drawing – made in the same year – could not be more different. In 1936 Picasso met Dora Maar, a talented photographer with whom he went on to conduct a nine-year affair. Maar was poles apart from Marie-Thérèse Walter, his model and mistress until 1935, who was a compliant and sensual character. By contrast Dora was highly strung, challenging and clever. This drawing, however, shows another side to both Picasso and Dora.

Drawings in pencil made on this large scale are rarely successful. The composition and placement are perfect, but without the arch of the pillow the unity of the figure would be lost and the image would not be as successful. As in many other drawings presented elsewhere in this book, scant regard has been paid to anatomically correct proportions – note how small the hands are. What makes the drawing so sensitive is the beautiful luminosity of the skin of the face. Picasso has contrasted textures with one another throughout. The rough textures suggested in the hair and scarf create the impression of softness in the face that makes you want to reach out and touch her. What is extraordinary about the scratchy, scribbled pencil marks in the rest of the drawing is that – although not as worked up – they still seem absolutely right as part of the composition. This is because Picasso draws the forms together not as separate parts – they relate to each other.

See also

Philip Guston (p.196), **Anselm Kiefer** (p.272)

Materials

Picasso was always willing to experiment with everything from simple children's crayons to elaborate techniques. When you draw, make sure that the visual idea is always the primary driving force for any technical experimentation. In Picasso's drawing, the materials used could not be more simple – pencil, stump and paper. Experiment with basic materials (left).

Self-portait 1946

Graphite on paper
59.6 × 45.3 cm (23 ½ × 17 ⅞ in.)
Private collection

Antonin Artaud was an avant-garde theatre actor and director who wrote poetry and drew, often using storyboards in his work. Artists as diverse as Henri Matisse and Francis Bacon were influenced by the three giants of late 19th- and early 20th-century thinking – Nietzsche, Freud and Marx – and Artaud was no exception. He strived to get theatre audiences to react instinctively, and believed that the way to do this was by tapping into the unconscious. These ideas were key to Surrealism, with which he was closely linked. He described his form of theatre as 'The Theatre of Cruelty' and wrote that it was created 'to restore to the theatre a passionate and convulsive conception of life, and it is in this sense of violent rigour and extreme condensation of scenic elements that the cruelty on which it is based must be understood'.

If we look at Artaud's drawing expecting a realistic self-portrait, then it appears amateurish – not in an outrageous or violent way like artists closer to our time (Jean-Michel Basquiat or Jean Dubuffet, for example), and not as skilful as more refined artists. There has been no attempt to prettify or describe the form of the head literally; the surfaces are scratchy, crude and direct. The placement of the head is significant, as it underlines the unconventional interpretation. The result feels crazed and disturbing – the head appears almost decapitated. There are more extreme drawings by Surrealists and Dadaists, but Artaud's self-portrait is so unaffected that it demands our attention.

Antonin Artaud (French, 1896–1948) was a hugely influential playwright, essayist and actor. A theoretician of the Surrealist movement, he proposed the concept of the Theatre of Cruelty, which had a major impact on avant-garde theatre in the 20th century. He was born in Marseille to Levantine-Greek parents and contracted meningitis as an infant; ill health and a subsequent addiction to opiates, including heroin, dogged him for much of his life. By the 1940s, Artaud's schizophrenia was diagnosed and he spent nine years in mental asylums where he underwent art therapy treatment, and began drawing and writing in notebooks as a way of coping with his delusions.

See also

Georg Baselitz (p.176)
William Turnbull (p.198)
Edvard Munch (p.230)

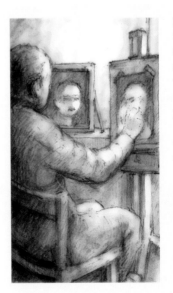

Form

With a self-portrait, work from a mirror rather than a photograph, which is too flat. Ensure that the mirror is big enough for you to see your head in context within it (left). Check that you are close enough to the mirror or the drawing's subject will become the figure, not the head. It is important that you are most comfortable looking in the mirror rather than actually drawing. You will need to spend more time looking at your head than looking at your drawing.

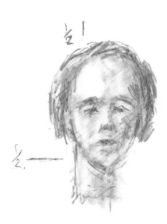

Line and Shape

In Artaud's work each detail is emphatically stated with direct, certain marks. The mass of the head seems well formed, giving it physical presence. Note the head's placement here (left); if it was dead centre, it would be static. The scale of the head compared to the overall shape of the paper suggests a more distant view. If much bigger, it would create a more intense intimacy. The way the neck is drawn makes the head appear as if it has been ripped off the body, which jolts the viewer.

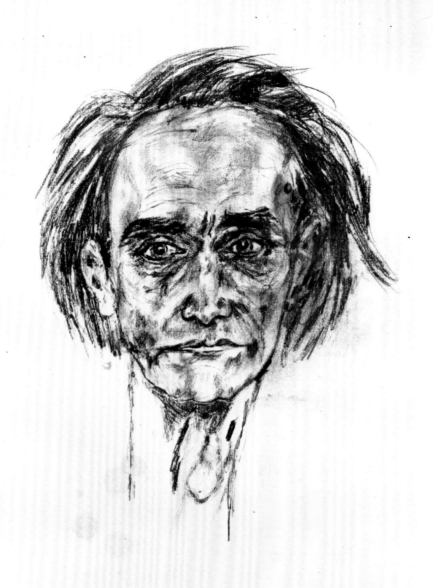

antonin Artaud
1er décembre 1946

Lucian Freud

Man at Night (Self-portrait) 1947–48
Pen and ink on paper
51.5 × 42.5 cm (20 ¼ × 16 ¾ in.)
Private collection

Lucian Freud is one of the foremost figurative painters of the 20th century. Loosely grouped with the School of London, which embraced such artists as Francis Bacon, Frank Auerbach, Michael Andrews and Leon Kossoff, Freud worked tirelessly within a relatively narrow stylistic range. Apart from an early interest in Surrealism, he worked exclusively from life. However, after meeting Bacon in the early 1960s, Freud's painting style became broader and freer. Early in his career, Freud's precise style caught the eye of art historian Kenneth Clark, who championed his work.

This drawing is extremely controlled and still. It is like an aerial view of a landscape in which every field, lake and feature is translated and made specific. Holding these areas together is an invisible force – like a magnet pulling iron filings on a piece of paper. This creates the sense of stillness. Time spent carefully rendering these minute textures is repaid by the way the viewer reads these surfaces. The textures take on the quality of an abstract minimalist drawing; we lose ourselves when reading the complexity of each tiny cell-like structure.

An abstract minimalist drawing can generate luminosity through contrasts, gradations and sharp or soft edges. However, that luminosity is compromised by its ambiguity – the marks are always marks that never become anything else. In Freud's drawing the eye moves from surface to surface, generating luminosity, and that brilliance is intensified when we realize that the area is connected to an object – for example in the side of the cheek.

Lucian Freud (British, 1922–2011) was born in Berlin. the grandson of the founder of psychoanalysis Sigmund Freud. In 1933, the family left Berlin to escape the rise of the Nazis and settled in London. He studied at the Central School of Art, London, and the East Anglian School of Painting and Drawing, Essex. In 1941, he served as a merchant seaman but was invalided out of service and then entered Goldsmiths' College. By 1943, he started to paint seriously and travelled to Paris and then to Greece. While in Paris, he befriended Pablo Picasso (1881–1973) and Alberto Giacometti (1901–66). On his return to London he taught at the Slade School of Fine Art.

See also

Hans Holbein the Younger (p.80)
Carl Philipp Fohr (p.90)
Vincent van Gogh (p.126)

Sources

Freud developed his method of drawing and painting over many years. He had an idea of what the finished image was going to look like from the very outset. He tended to work in a piecemeal way – moving from detail to detail, as shown in this illustration (far left). Students are often tempted to work like this, but unless you have a very strong and clear idea of what your final image should look like, it is very easy to lose sight of the unity of the whole image.

The finished image works best as a single unit. Even if it is collaged together, the overall impact of the whole sheet should work as one. If the drawing is full of details, those details should unfold rather than look like a shopping list of separate items that have no coherent unity and don't really seem to fit together (left). The most important thing is that you understand the overall structure of the image and how the individual details relate to that structure.

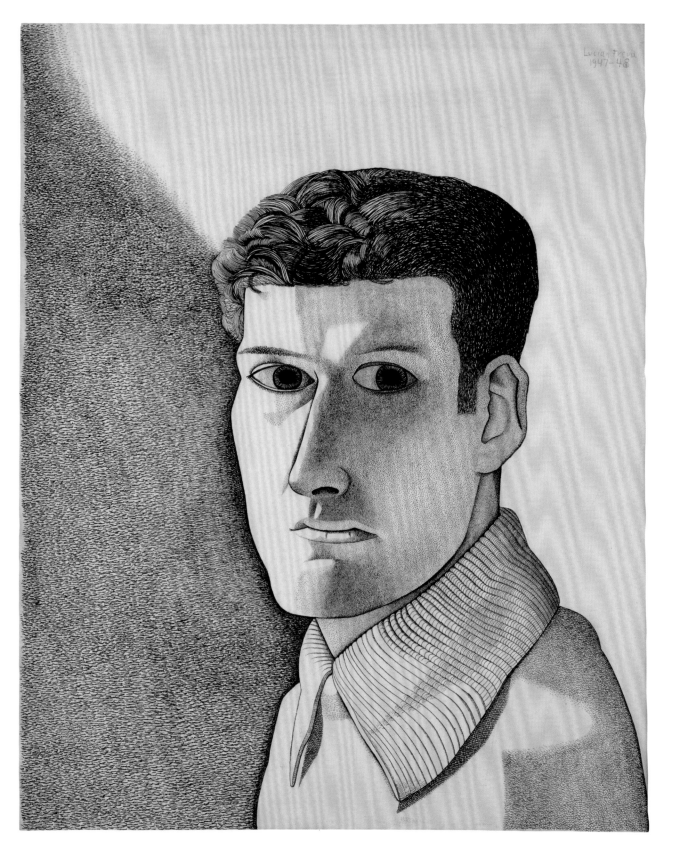

Pieter Bruegel the Elder 112

Claude Lorrain 114

Jean-Honoré Fragonard 116

Thomas Gainsborough 118

Francesco Guardi 120

John Constable 122

Claude Monet 124

Vincent van Gogh 126

Edward Hopper 128

David Bomberg 130

Oskar Kokoschka 132

Dennis Creffield 134

cape

Whether it is a stormy sea smashing into a craggy coastline or the limpid soft tones of a meadow at sunrise, landscape provides a context that helps people understand themselves better. Its enduring and undeniable metaphorical power also suggests intriguing relationships with our past. Just as the nude in art connects us directly with our human form, so the landscape connects us with our place in the world.

As a subject in art landscape has had its enthusiasts in every period, yet since the Renaissance it has not always been regarded as an important one in Western art, although Dutch landscape painting in the 17th century did much to raise its profile. It only moved to centre stage with the the Impressionists in the 19th century. Ironically, landscape drawing was not a key part of the working practice of these artists; of

course there were exceptions, including van Gogh (see p.126), but strictly speaking they were not Impressionists. For artists like Monet, depicting the changing qualities of light was best achieved in paint.

It is no surprise that many 20th-century artists used landscape as a way of moving from figurative or representational art towards pure abstraction. Many would argue that, in moving completely away from any reference to the visual world, something crucial is lost. Nonetheless, the connection between representational and abstract art has given us some of the most compelling work of the last century and beyond. Great artists of every age knew how this worked: the late paintings of Titian and Rembrandt would not be great if they were simply representations in an aribtrary style.

Pieter Bruegel the Elder

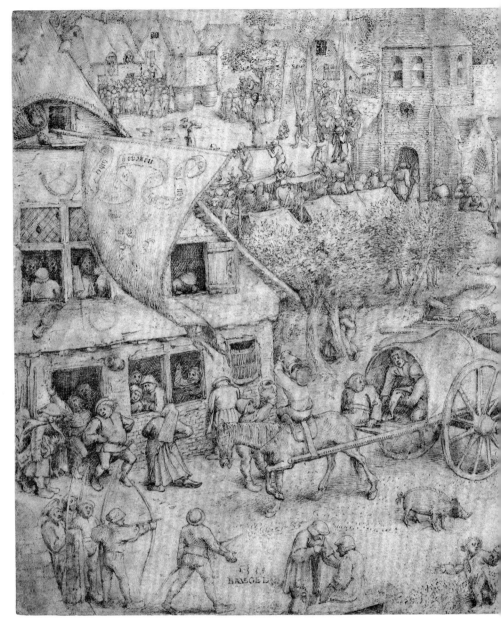

Pieter Bruegel the Elder (Dutch, c. 1525–69) trained under Pieter Coecke van Aelst (1502–50), whose daughter Mayken he married. After leaving Aelst's studio, Bruegel worked for painter, engraver, printmaker and publisher Hieronymus Cock (1518–70). Bruegel joined the Antwerp Painters' Guild in 1551 before making a crucial trip to Italy, staying for three or four years. Much of his early work reflects the influence of Flemish tradition. He then began to synthesize Italianate elements into his landscapes. By 1555 he was back in Antwerp and mixing in intellectual circles. In 1559, he dropped the 'h' from his name in line with humanist ideals, while his son, Pieter Brueghel the Younger, retained the original family name.

Materials

Considering the huge amount of detail in Bruegel's drawing it is a surprisingly small work, although large compared to most drawings of the period. Pen and ink can help achieve a strong sense of unity in a drawing, while also managing to make each detail intricate. Make preparatory drawings or draw light guidelines in pencil before you start with your pen and ink, as shown in this detail (left).

Space

Bruegel's subject looks very believable but when we compare it to a scene of, say, a village fête viewed from a church tower or a small hill nearby, we realize that Bruegel has compressed the space and zoomed in on the details. A photograph comes close to giving us a topographical, accurate view of a scene, yet it would never be compressed in the way that is possible when drawing.

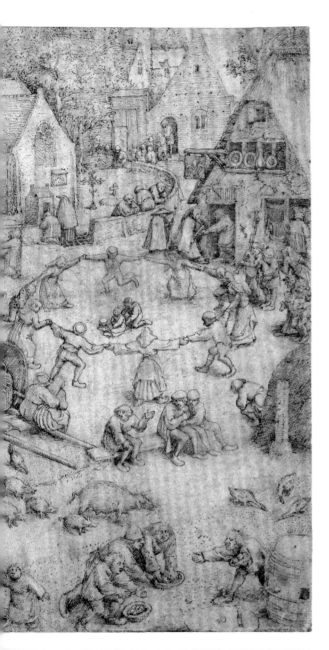

Kermis at Hoboken 1559
Pen and brown ink on laid paper
26.5 × 39.4 cm (10 ⅜ × 15 ½ in.)
Courtauld Gallery, London, UK

It is easy to forget that while Michelangelo, Titian and Tintoretto were creating the great masterpieces of the Italian Renaissance, Pieter Bruegel the Elder was working on some of the most astonishing Northern European paintings of the same period. It is equally unexpected that the organization and focus of Bruegel's work was so different; it is difficult to find a parallel in Italian Renaissance art.

Bruegel travelled to Italy in 1551, spending some time in Rome where he would have witnessed many of the High Renaissance artists at work. It is difficult to assess exactly what degree of influence seeing these Italian paintings had on Bruegel but, compared to the previous generation of Dutch and Flemish artists, Bruegel created a more simplified compositional structure. However, he still packs in small details and in many of his drawings and paintings it seems that everything has been included.

Here Bruegel chronicles the teeming peasant life laid out before him during a summer fair known as a *kermis* (or *kermesse*) in the Flemish village of Hoboken. This kind of subject is known as genre painting – the artist looks down on humanity from up high, observing every secret moment, foible and prank. Bruegel's drawing shows an acute eye for observing the detail of everyday life. The scene seems to unfold, not like a film still or a storyboard scene, but like the entire film in one remarkable shot. The extraordinary thing about this drawing, and about Bruegel's work in general, is that it appears to have a timeless quality that is not confined to one particular period. The drawing is like a collection of memories – affectionately recalled, honestly displayed and beautifully rendered.

See also

Cecily Brown (p.248), **Dexter Dalwood** (p.276), **Paul Harbutt** (p.278)

Sources
We can look at Bruegel's genre drawings in two ways. First at a distance – at this point, the whole surface teems with a shimmering activity that is separate from what is depicted. The second way is close up, tapping in to what is being depicted. Make a sketch of his drawing from a distance, so that you can't see the detail. Try to draw the abstract activity rather than any specific detail (left).

Claude Lorrain

See also

Thomas Gainsborough (p.118)
Claude Monet (p.124)
Edward Hopper (p.128)

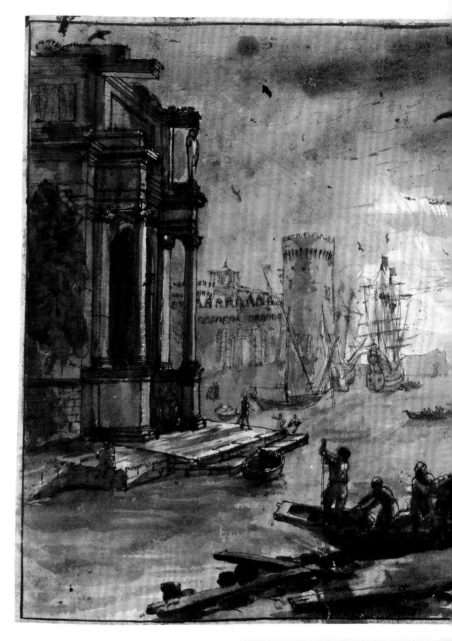

Claude Lorrain (*c.* 1604–82) was born Claude Gellée into a poor family in the Duchy of Lorraine in north-eastern France. He was orphaned when he was twelve years old and moved to Italy, first to Naples and then a year later to Rome. In 1625, he returned to work as an apprentice to Baroque painter Claude Deruet (1588–1660). After a year Claude returned to Rome, where he remained for the rest of his life producing grand landscapes from his detailed sketches in the surrounding countryside. His reputation was sealed after he completed four paintings for Pope Urban VIII between 1635 and 1638.

Tone

Think of a scene as large, generalized shapes and areas of tone. In Claude's foreground, a patch of light on the quay seems wrong. If this happens in your work, close one eye and hold up your finger to block it out. If that unifies the area, then you can rationalize it into one big tone. Try to graduate each area into a separate tone; you can then break those areas down with graduated areas within areas.

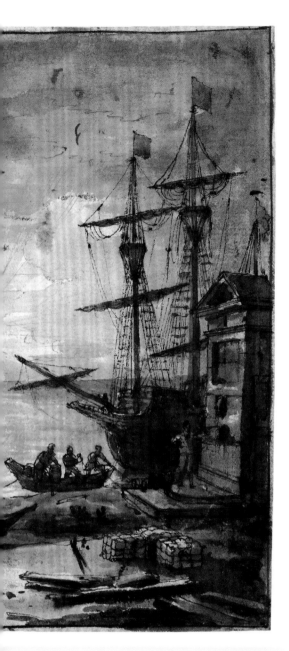

Harbour Scene 1635–82
Pen and brown ink with brown wash and white heightening on white paper
19.6 × 25.6 cm (7 ⅝ × 10 ⅛ in.)
British Museum, London, UK

French-born Claude Lorrain lived most of his life in Italy. His drawings can be divided into three groups: drawings done directly from life, studies for paintings and drawings of finished paintings, known as *Liber Veritatis*. The latter, meaning 'Book of Truth', is a book of drawings recording his completed paintings from 1635 to 1682. This small drawing is from the *Liber Veritatis*. It is a beautiful combination of pen, brown ink wash and white highlighting. Bearing in mind that it is a copy of a painting, it still has a great sense of spontaneity. The compositional tricks that Claude used seem rather clichéd today, but at the time they were highly innovative. The light source, the sun, being close to the centre of the painting, draws the eye in and makes a compelling focal point. The sun's rays echo the perspective's vanishing point and one can see traces of the guidelines Claude used.

There is a general rule when trying to create a sense of space in a picture that Claude has used here brilliantly. The rule states that large, simple, strong contrasts advance towards the eye and softer, smaller, weaker contrasts recede. We can see that the boat in the foreground unloading its cargo is silhouetted against the water, making it a large, simple, strong contrast, whereas the boats in the distance are made up of smaller, more broken marks of lesser contrast. On the left side of the composition, there is a slightly strange building that seems to be almost floating on the water and is rather unconvincingly located in space. This building may have been made darker to maximize the contrast with the light coming from the sun. It is in keeping with the work as an imaginative landscape rather than a topographical drawing.

Composition
The relationship between the large areas of light and shade and the composition of Claude's drawing in its entirety is highly interconnected. Although the light area around the sun forms a focal point, there are strong, long, zigzagging movements into the space, as indicated here (left). The way these large tonal areas and strong linear spatial directions pull the eye around the image as a whole forms the composition of the drawing. Claude has a distinct advantage over those artists who prefer to work directly from the landscape in that he could quite literally invent his subjects to conform to his structural and compositional requirements. If he wanted the quay of the harbour to move diagonally into the space, he could simply change the angle.

Jean-Honoré Fragonard

See also

Claude Lorrain (p.114)

Rembrandt van Rijn (p.146)

Claude Monet (p.124)

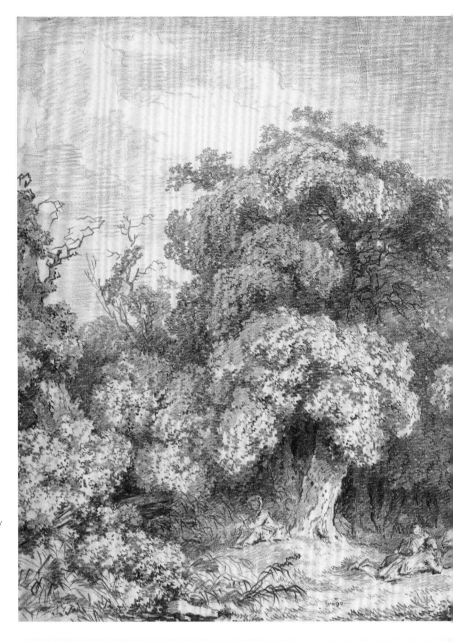

Jean-Honoré Fragonard (French, 1732–1806) was born in Grasse and moved to Paris at eighteen years old, where he was taught by François Boucher (1703–70), Jean-Baptiste-Siméon Chardin (1699–1779) and Charles André van Loo (1705–65). In 1752 he won the Prix de Rome, giving him the chance to go to Italy and study. In Rome, he became a member of the prestigious Académie de France. Back in France, he attracted wealthy patrons and was heralded as a key figure of the Rococo movement – but when Neoclassicism became fashionable, Rococo was passé. Fragonard's patrons met the French Revolution's guillotine and he died impoverished.

Line

Practise making marks to create leaves, trees and grass, as here (left). Look closely at Fragonard's drawing: his marks don't describe each leaf but suggest the look that leaves have. Even if you're only interested in the patterns these marks create, if you want to make a convincing whole you have to consider how they change shape as the forms they are part of move in and out of light and space.

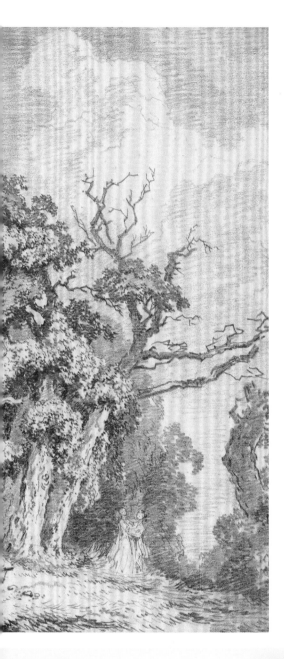

A Gathering at Wood's Edge *c.*1770–73
Red chalk on paper
37.5 × 49.2 cm (14 ¾ × 19 ⅜ in.)
Metropolitan Museum of Art, New York, USA

The first thing that strikes the viewer on looking at this drawing is the perfect surface quality: the tiny horizontal ridges in the laid paper create an almost machine-manufactured finish to the red chalk. There is no ugly rubbing out – everything looks deliberate, subtle and controlled. Just like the scene that is represented, the technique is easy and relaxed: this is an ideal world. If you were fortunate enough to be born into privilege and wealth, the late Rococo period was, in many ways, a great time to live. However, the creator of the drawing, Jean-Honoré Fragonard, was about to see this easy privileged life come to a shattering end with the French Revolution, which deprived him of his patrons, causing him to eventually leave Paris in 1790.

As with all great art, the apparent ease of execution belies the hard-won skills and extraordinary technique. Fragonard had spent about six months in the studio of Jean-Baptiste-Siméon Chardin and then several years with François Boucher as an apprentice. Only five of Fragonard's paintings are dated, so we cannot know for certain when this drawing was executed, but it seems likely to be around 1772. Fragonard's drawings were appreciated by a growing audience as original works by the hand of the artist. His work turned up at public auctions and gained good prices, suggesting that they were intended as independent works of art.

Subject Matter
Although Fragonard made many drawings directly from nature, it is unlikely that the drawing above was; it is too big and too elaborate. However, all those hours he spent working directly from life have been utilized in his imaginary landscape. When working on a large drawing, keep moving back so that you can see the whole image. Don't try to finish one small section first.

Materials
It is possible to replicate the materials and techniques that Fragonard used. Laid paper is simply handmade paper where the wire mesh leaves an imprint on the surface. Buy large sheets of a good thickness. Red Conté chalk (left) is available at good art shops and can also be bought online. You can use the sticky side of a piece of masking tape to gently remove unwanted areas of red chalk.

Rocky Wooded Landscape with Waterfall 1785–88
Black chalk and stump heightened with white on paper
22.5 × 31.9 cm (8 ⅞ × 12 ½ in.)
British Museum, London, UK

Although Thomas Gainsborough painted exceptional portraits, he had a particular passion for landscapes. He produced dramatic reinterpretations of the British landscape that in many ways bear little resemblance to the rolling fields of England, yet they show, as French writer Emile Zola described, 'a corner of nature seen through a temperament'.

Gainsborough would compose a landscape using stones, rocks, earth, pieces of glass and twigs on a table top. He could then position this near a window to get the light coming in from the right angle and draw directly from the set-up. By developing this highly adaptable method, Gainsborough could draw directly from the objects in front of him and add in small figures to give the drawing a sense of scale. This gives his drawings a very direct and visual feel.

In this example, there is a strong sense of the power of nature. The dramatic use of light and shade, heightened by the deep space depicted, gives viewers a strong sense of our own insignificance in the face of the all-powerful forces of nature. Artists of the English Romantic movement went on to develop these themes. For all Gainsborough's poetic sensibilities, he seems to be more modest and pragmatic in his pursuits. There is a feeling of directness and honesty in much of his work that comes from straightforward visual observation.

Sources
Think of the mood that you are trying to evoke before you start building your landscape. If, ultimately, you want to do a dramatic drawing like Gainsborough, some craggy cliffs and rock formations will help. However, if you are interested in a landscape that is more pastoral, then rolling fields with meandering rivers would be more appropriate, as shown in this sketch (left).

Thomas Gainsborough (British, 1727–88) is thought to have trained in London under the French engraver Gravelot (1699–1773) and the English painter and illustrator Francis Hayman (1708–76). Gainsborough's landscape paintings were admired but failed to sell well, and in 1748 he returned to his hometown of Sudbury, Suffolk, to address the market for portraiture, where he painted his renowned *Mr and Mrs Andrews* (c. 1750). In search of clients, he relocated to Ipswich and then to fashionable Bath. He became one of the founding members of the Royal Academy of Arts in 1768 and settled in London six years later, although he continued to paint landscapes.

See also
Claude Lorrain (p.114)
Dennis Creffield (p.134)
Frank Auerbach (p.202)

Subject Matter

Building your own landscape in the studio has several advantages, not least that you can create it from scratch with total control (left). There are useful items all around you (note the use of broccoli heads here as trees) and, along with what is sold in model shops, you can make a realistic set-up. Remember the landscape itself is paramount – focus on creating hills and valleys rather than on minute details.

Lighting is key, so being able to move the table that your landscape is on could make the difference between an exciting set-up and an uninteresting one. Ensure that everything is reasonably secure. Finally, it is important that the position from which you draw your fake landscape is low enough to make it look as though you are on the ground drawing it rather than looking down on it from above.

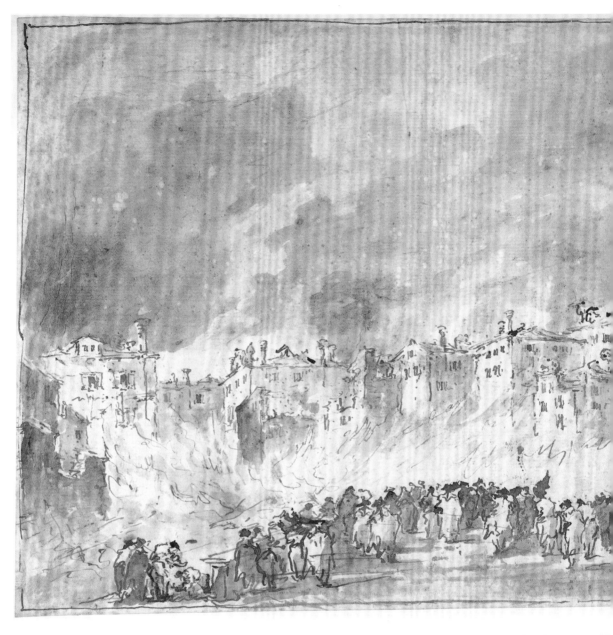

See also

Claude Monet (p.124), **Honoré Daumier** (p.158), **Dexter Dalwood** (p.276)

Francesco Guardi (Italian, 1712–93) was born in Venice into a family of artists and inherited the family workshop after the death of his father Domenico. He often collaborated with his older brother Giovanni Antonio (1699–1760) on the production of figurative paintings, most of which were religious works. In 1719,

their sister married Giovanni Battista Tiepolo (1696–1770), and his lively style and use of bright colour likely influenced Francesco's output. Following Giovanni's death, Francesco concentrated on creating *vedute* of Venice and, after Canaletto (1697–1768), he is the most celebrated view-painter of the 18th century.

Form

Try to understand complex forms that are seen from a distance – for example, a crowd – abstractly. Think about what it looks like and draw that. The more descriptive you make a complex form, the more you'll get stuck in details and lose the characteristic quality. Don't underestimate spontaneous marks made by accident – they can animate an image in a way that considered marks do not.

The Fire at San Marcuola *c.* 1789

Pen and brown ink, brush and brown wash, over black chalk
31.2 × 45.2 cm (12 ¼ × 17 ¾ in.)
Metropolitan Museum of Art, New York, USA

With the exception of Jean-Antoine Watteau operating in France, the early 1700s were almost devoid of interesting artists. The work that would resonate throughout future ages came from the next generation, including Hogarth, Chardin, Boucher, Gainsborough, Fragonard and Francesco Guardi. Guardi, Tiepolo and Canaletto are among a group of artists who made the last serious contribution Venice was to make to painting. Although considered part of this brief revival, they were working in a city that was in decline.

Generally, most of the great work done in the previous 300 years had created forms that were more or less monumental and intact. As the 17th century moved to the 18th, artists began to break up form – animated brushstrokes vibrated across the surface of paintings, creating a wonderful shimmer. However, taking on similar subjects to the great artists of the Renaissance with this lighter, more animated brushwork was always going to look relatively insubstantial and odd. Yet in some subjects this approach worked beautifully, as here.

For this drawing Guardi chose a subject that he had actually witnessed. In 1789 a massive fire destroyed a whole area of Venice and he recorded it in this extraordinary drawing before going on to make it into a magnificent painting. Adopting this more animated brushwork to depict complex form, Guardi has characterized the people in the foreground and then the rooftops in the distance. It is interesting to note that a hundred years later the Impressionists would look to Guardi as one of the artists who showed them the way forwards.

Materials

Wherever you find yourself, there are alternative ways of making marks on paper. For example, in a coffee bar you'll also have your fingers, a napkin and coffee to hand, so try using them, as shown in this sketch (left). Integrate them but don't make it arbitrary – it has to be a part of the drawing. Don't make the mistake of breaking the process into stages – switch from coffee to pencil, back to coffee and then back to pencil.

Subject Matter

If you want to extend your range of subjects, listen to a radio news item and try to visualize an aspect of the story. The temptation is to make a drawn version of a photograph, but resist this. Remember, you are an artist – you are building an image that conforms to certain structural and aesthetic demands, so you're not bound to the realism of a photograph.

John Constable

View of Cathanger Near Petworth 1834
Pencil on two sheets of paper pasted together
20.5 × 34.7 cm (8 ⅛ × 13 ⅝ in.)
Morgan Library and Museum, New York, USA

In 1834, John Constable spent two weeks sketching at
Petworth in West Sussex, the estate of his patron Lord
Egremont. He filled a sketchbook with about twenty
drawings in both pencil and watercolour. In his letters of
this time Constable wrote about the 'chiaroscuro of nature'.
By this he meant, first, the glint of light as reflected off dew-
soaked or wet surfaces, and, second, the drama of light and
shade that underpins all landscape painting and drawing.
In this drawing of Cathanger Farm the forms are not as
broken up and splintered as in his other works of the
same period, but the reflected light is clearly evident. The
meandering River Rother not only pulls the viewer's eye
into the space, it also brings the vast sky down into the

foreground, thereby increasing one's awareness of the
mass of agricultural land on either side of the river.

In the year of this drawing's execution Constable was
fifty-eight years old. Contemporaries included Jean-
Auguste-Dominique Ingres, Eugène Delacroix and Jean-
François Millet; it was a period rich in great yet diverse
artistic talent. Considering this drawing was completed only
a few years before Constable's death, it is surprising that it
is so controlled; most of his work of this period of his life is
freer and more expressive.

Constable was hoping to perfect a natural kind of
painting; he rejected the dramatic sublime in favour of a
more direct and emotional response to the world around
him. Nonetheless, he also believed that the natural world
was a paradigm for artistic perfection. It therefore follows
that, for Constable, a more matter-of-fact and descriptive
approach could be employed as a way of understanding
how the landscape worked visually.

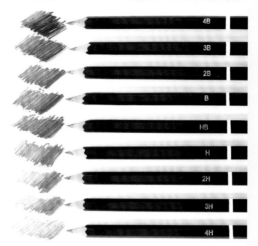

Materials

The join in Constable's drawing (apparent on the far left of the composition) suggests that it was added to or possibly taken from the opposite page of his sketchbook. This explains the slightly curved shading along the edge of the join. The strength and darkness of the blacks suggest his pencil was fairly soft – 2B or softer. Here you can see the varying strengths of tone from very dark (1B) to very light (4H) in different grade pencils (left).

Subject Matter

Constable appears to be looking down on his subject. This is not always possible without being a long way from your subject, but the distance can stop you seeing too many extraneous details. A good way to isolate the specific area for your subject is to have two L-shaped pieces of cardboard with you when sketching outside, as here (left). These can be manipulated to make a small window through which you can view your subject.

Space

When working on a scene like Constable's, the creation of space is important. If an object is near and you can see details, that does not mean that replicating it will make your drawing successful; in fact, the opposite is true. To create space you need to make bigger contrasts and simpler effects in the foreground. As you move back in space, the contrast gets less and forms become more intricate, if more vague, as in this illustration (left).

See also
Claude Lorrain (p.114)
Jean-Honoré Fragonard (p.116)
Jean-François Millet (p.156)

John Constable (English, 1776–1837) was the son of a prosperous corn merchant and began his career working in the family business in East Bergholt, Suffolk. In 1799, he entered the Royal Academy Schools in London where he studied until 1802. He sold only twenty landscapes in England in his lifetime – his landscapes based on oil sketches made from nature were regarded as ordinary in comparison with those fashionable at the time. In 1824, he exhibited three of his works at the Paris Salon and *The Hay Wain* (1821) won a Gold Medal. Eight years later, the Royal Academy finally awarded him full membership.

Claude Monet

The Church at Varengeville, Sunset 1883
Black crayon and scratchwork on Gillot paper
30.5 × 42 cm (12 × 16 ½ in.)
Private collection

In 1856, the young Claude Monet had the good fortune to meet
Eugène Boudin, one of the first French landscape artists to paint
outdoors. Monet had been having drawing lessons since the
age of eleven, but Boudin introduced him to plein air painting.
It proved to be a crucial step in Monet's development as an artist.
After a brief period serving in the military, Monet moved to Paris
where he met Alfred Sisley, Pierre-Auguste Renoir and Camille
Pissarro, with whom he was to develop Impressionism.

Impressionist artists like Monet intensified colour at the
expense of tonal values. They were driven by the sensations of
light communicated or expressed in terms of colour and they
found that they could capture the momentary, flickering effects
of sunlight by painting outdoors. They had to work fast and
the resulting animated brushstrokes gave their work a broken,
fragmented look compared to the work of contemporary Realist
artists. Many Impressionists found it hard to translate their painting
language into a graphic language. This is not surprising, as a
visual language that is based on colour and light is difficult to
translate into black-and-white drawn images. Although Monet made
many drawings, his output was limited compared to other artists.

He painted the subject of this drawing several times and it
demonstrates his extraordinary ability with the medium. However,
it does possess the characteristics of his painting language – the
broken marks, the large areas of light and shade, and the simple
composition. The surface of the drawing seems to shimmer just as
it does in the surfaces of his paintings. This vibration is so optical
and truthful, we almost forget the absence of colour.

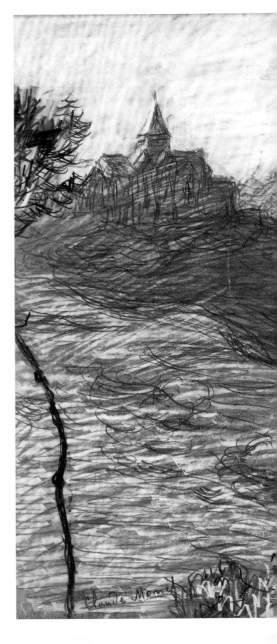

Sources
Drawing outside can be cold,
uncomfortable and very public. It can
also be rewarding; it allows you to make
a direct response to your subject, but
the mass of information presented can
be distracting. This illustration (left)
shows people doing water aerobics on a
beach. It is a complex subject, but when
abbreviated the drawing creates the
right effect without complicated details.

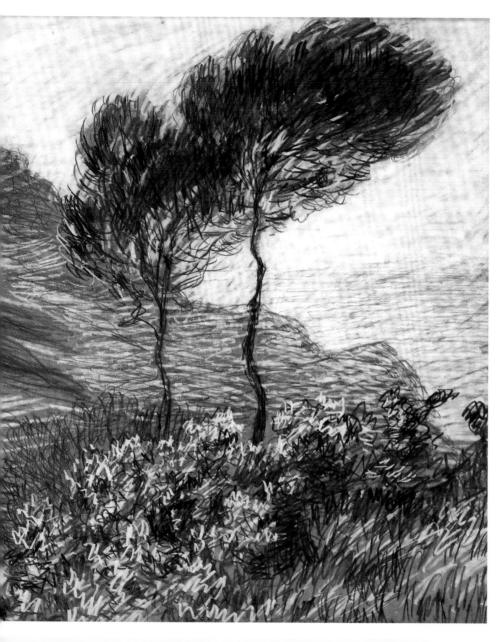

Claude Monet (French, 1840–1926) grew up in Le Havre in Normandy, where he met landscape painter Eugène Boudin (1824–98), who introduced him to plein air painting. In 1859, Monet left for Paris to study at the Académie Suisse. He co-founded the Société Anonyme des Artistes, and the group held its first exhibition in 1874. It included *Impression, Sunrise* (1872), which drew scorn from the critics for its unfinished appearance. Monet's fascination with light reached new heights in his series of paintings depicting haystacks, trees and Rouen Cathedral at different times of day. In later life, he painted the water-lily ponds he created at his home in Giverny.

See also

Claude Lorrain (p.114)
Francesco Guardi (p.120)
Frank Auerbach (p.202)

Composition
Follow the advice of Impressionist artist Pissarro, who said that any subject must be seen primarily as an overall shape. This means that big areas need to be considered – how these are distributed across the paper and then drawn into. Don't forget that every form has a specific character – some are dense whereas others are more transparent, as shown in this illustration (left).

The Sower 1888

Pencil, pen and reed pen and ink, on paper
24.4 × 32 cm (9 ⅝ × 12 ⅝ in.)
Van Gogh Museum, Amsterdam, Netherlands

Vincent van Gogh's life has been forensically examined and, particularly through the letters he wrote to his brother Theo, we can understand much of the thinking behind his extraordinary work. He was only active as a painter for about ten years, during which time he produced a painting every four days and a drawing or watercolour every three days. The year 1888 was a momentous one for van Gogh. He produced many of his greatest masterpieces; he also befriended and dramatically fell out with artist Paul Gauguin, resulting in van Gogh's mental breakdown.

This drawing is based on van Gogh's painting *The Sower*, made in the same year. He produced over thirty drawings of the subject in which he played with different techniques and compositions. Jean-François Millet created a painting of the same subject that van Gogh copied in 1889, but he almost certainly knew Millet's painting well before this date. Many artists of this period believed in the redemptive power of nature and these ideas clearly resonated with van Gogh. While the symbolism of this image is undeniable – the sower represents the eternal cycle of life – the calligraphic inventions are mesmerizing. Transforming the movement and rhythms of the landscape into pen marks that flow across the paper like water, van Gogh presents the earth not as we have seen it, but as we have always felt it. If this transformation were only confined to the earth then the image would look incomplete, but every square centimetre produces its own unique vibrations. The sky seems to tingle with light; the cornfield in the distance looks like the teeth of a comb. The catalyst to all this movement is the sower himself striding forwards, and the urgency and energy in the image is generated by his right leg reaching out.

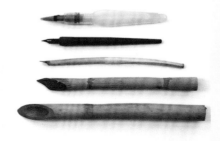

Materials

For the drawing above, van Gogh worked with pens of different thicknesses. He used quills or pens made from dried reeds like the ones illustrated here (left), using the thicker nibs for the ploughed earth in the foreground. As he was working on many variations of the same subject, the composition of each one probably became clearer to him. However, we can see faint traces of

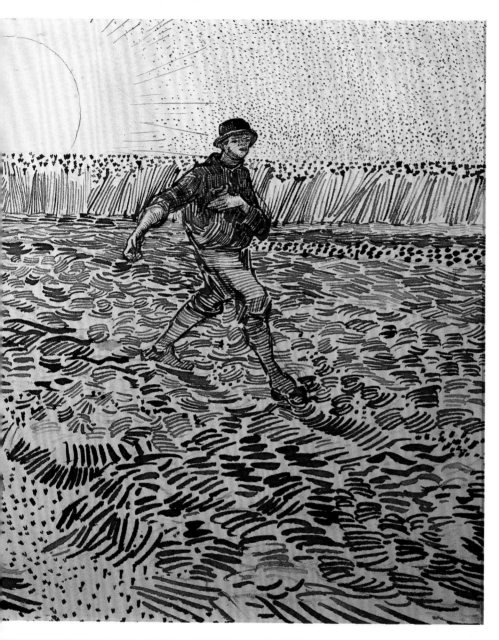

Vincent van Gogh (Dutch, 1853–90) worked in an art dealership and trained as a minister before becoming an artist in 1880. He moved from the Netherlands to Paris in 1886, where he was influenced by the Impressionists and Neo-Impressionists. His style changed from dark, dour depictions of peasant life and he brightened his palette, experimenting with complementary colours and shorter brushstrokes. He was also inspired by Japanese woodblock prints, with their flat use of colour and bold lines. In 1888, he relocated to Arles in Provence, but he severed his left earlobe following a quarrel and in 1889 entered an asylum as a voluntary patient. A year later, he shot himself.

See also
Lucian Freud (p.106)
Rembrandt van Rijn (p.146)
Eva Hesse (p.200)

pencil underneath the ink drawing, so it is therefore very likely that van Gogh sketched out the basic composition before he started using the pen.

As he progressed, particularly with the contours of the earth, it seems as if he was improvising – rather like a jazz musician improvises on a musical theme – holding in his head the idea of the rhythms and movements of the whole image. It is always important to keep your primary idea in mind – for example, the idea of a figure running – while you are working on the whole drawing. Be careful: you don't want everything to reflect 'running' or the drawing will become too stylized, as shown in this illustration (right). What you are attempting to do is play off a series of simple elements, of which running becomes the key sensation.

Edward Hopper

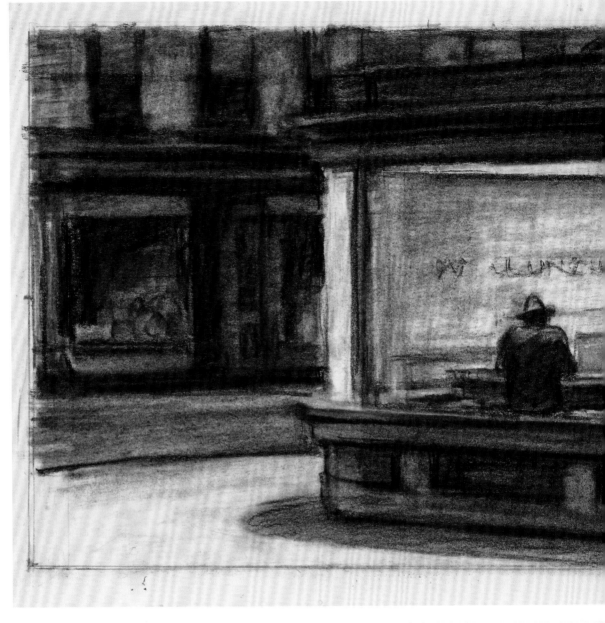

See also

Peter Doig (p.180), **Robert Pugh** (p.182), **Richard Diebenkorn** (p.244)

Edward Hopper (American, 1882–1967) is famed for his depictions of contemporary urban life in the United States. He studied at the New York School of Art (now Parsons School of Design) under William Merritt Chase (1849–1916), who encouraged his students to create realistic paintings of urban scenes.

Hopper worked as a commercial illustrator, while also selling his watercolours and prints. He made three trips to Paris between 1906 and 1910 to study the art there. He gained recognition after his second solo show in New York in 1924 was a sellout, and then decided to pursue a full-time career as an artist.

Subject Matter

A particular place can have more power as a memory than the actual place itself. A useful exercise is to try to remember a place from your childhood – the way we remember things as children is especially potent – and build a series of drawings of each of the details you can recall. Then see if you can construct an image out of these fragments, but remember to always focus on the larger structure.

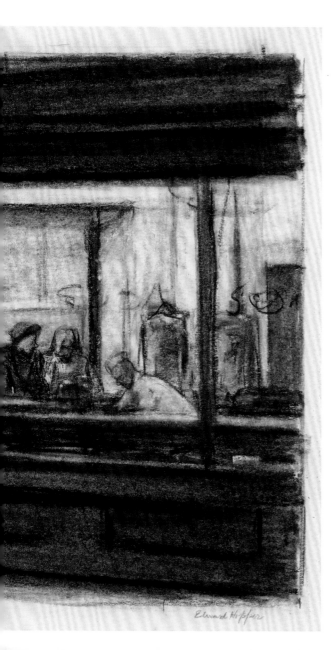

Study for *Nighthawks* 1941 or 1942
Fabricated chalk and charcoal on paper
28.3 × 38.1 cm (11⅛ × 15 in.)
Whitney Museum of American Art, New York, USA

Around 1905 Edward Hopper made several visits to Europe and Paris, ostensibly to study new art movements, but it is telling that he always maintained that at no point during his visits did he ever hear about his contemporary Picasso. What most impressed him was Rembrandt's mighty painting *The Night Watch* (1642). Hopper worked as a commercial artist for over twenty years and it was not until he was in his early forties that he devoted himself entirely to painting. *Nighthawks* (1942) is perhaps the most famous American painting of the 20th century.

By the 1940s Hopper had developed an approach that was rigorous but time-consuming, as he described: 'It takes a long time for an idea to strike. Then I have to think about it for a long time. I don't start painting until I have it all worked out in my mind. I'm all right when I get to the easel.' For *Nighthawks* he did about twenty preparatory drawings; some were of individual details and others simple geometric lines sketching out the basic composition. Hopper did not consider these sketches as important art objects, but simply as part of the creative process. This drawing is more developed, however, and it contains most of the key elements of the final painting. Hopper simplifies forms into large areas of colour; these are attached to the surface by the linear geometry of the sweeping lines that cross the paper. Learning a lesson from Rembrandt, Hopper integrates light into the structure of the image. The long, gently sloping lines are formed by the architecture picking up slivers of light to create an intensely powerful and silent mood. The only element that breaks it is the sharp angle of the barman's back.

Sources
The silence and stillness in Hopper's work gives us space to think. Although Hopper simplifies forms into large areas of colour, those forms don't feel as if they have been flattened or pushed into the paper's surface. His forms are attached to the surface by the linear geometry of the sweeping lines that cross the paper. Finding this structure takes some experimentation, as shown here (left).

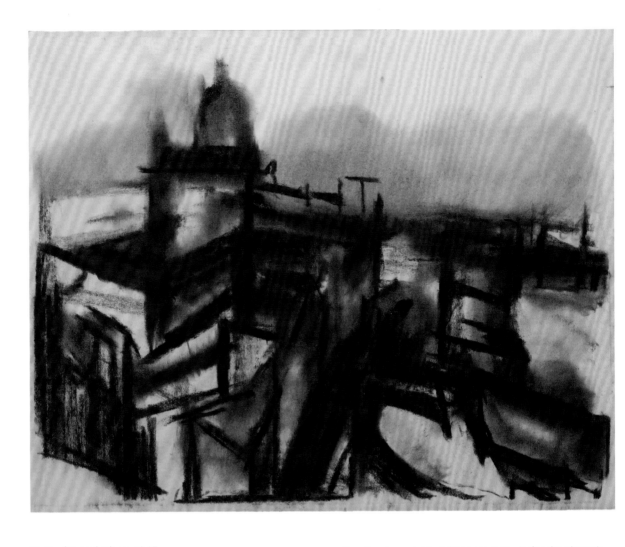

St Paul's and River 1945
Charcoal on paper
50.8 × 63.8 cm (20 × 25 ⅛ in.)
Tate, London, UK

David Bomberg's work changed dramatically over the course of his relatively short life, which was fairly typical of artists of his generation. His early interest in Vorticism and the machine age led him to be expelled from the Slade School of Fine Art by Henry Tonks, who took exception to his unconventional approach and lack of traditional rigour. Although Bomberg later became disillusioned with this approach, these early works display a preoccupation with composition that would stay with him. This drawing shows St Paul's from the west, with the River Thames on the right. The bold lines resemble a type of crude scaffolding that punctuates and enlarges the space. These extraordinary construction lines seem individually separate, yet collectively they transcribe the space and forms.

The sky, river and buildings seem to vie for the viewer's attention: the atmospheric, softer quality of the sky and river make the structures appear even more intense, whereas the buildings and the dome of St Paul's itself contrast with the sky, making it look more transparent and diaphanous. The sides of the buildings next to the black road running through the centre and to the left of the composition are uncompromised by trivial detail and slice into the space dramatically. Bomberg made many drawings of St Paul's Cathedral during World War II, and by 1945 it had become a national symbol of resilience, having survived the heavy bombing of the Blitz from 1940 to 1941.

There is an interesting parallel between Bomberg and his contemporary Hans Hofmann, who became hugely influential on the Abstract Expressionists. Although Bomberg's work is not regarded as internationally significant, his ideas and teaching have had considerable impact on a subsequent generation of British artists, including Frank Auerbach, Leon Kossoff, Dennis Creffield and Howard Hodgkin.

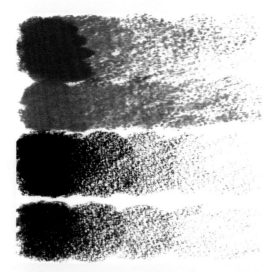

Materials

Bomberg's drawing is made in what appears to be compressed charcoal (left, lower two marks), as opposed to willow charcoal (left, top two marks). Compressed charcoal creates deeply intense black marks that are very difficult to make using willow charcoal; however, the latter erases more completely. You can use a spray fixative and build up layers to make willow charcoal darker, but once fixed it is difficult to rub out.

Sources

The large size of Bomberg's drawing suggests that he did not make it directly from life. The practical difficulties of working on an image this size on an easel in situ are fairly formidable. He may have made his drawing from high up, possibly inside a building or up on a roof like the aerial view shown here (left). Working nearby from a window can give you privacy, but a problem is that you can be too far away from your subject matter.

Form and Space

Bomberg is not interested in extraneous detail: he takes specific qualities from what he sees and reassembles that information into a complete whole. With a complex subject, it is difficult to keep focused on an abstract quality, so you need to concentrate on what the drawing is about. Try squinting at a scene (left) to reduce the amount of detail you see, thereby enabling you to identify large areas of light and shade.

See also

Dennis Creffield (p.134)

Frank Auerbach (p.202)

Leon Kossoff (p.206)

David Bomberg (British, 1890–1957) was born to a Polish-Jewish family in Birmingham, but moved with his family to the East End of London in 1895. He studied at the City and Guilds of London Institute and then the Westminster School of Art under Walter Sickert (1860–1942) and the Slade School of Fine Art, London, under Henry Tonks (1862–1937). He was expelled from the Slade in 1913 and was then associated with various avant-garde art groups, including the Omega Workshops, Camden Town Group and the Vorticists. In World War I, he served on the Western Front. After the war, he turned to landscape painting while travelling in Europe.

Houses of Parliament II 1967
Crayon on paper
56.2 × 76.6 cm (22 ⅛ × 30 ⅛ in.)
Tate, London, UK

The Austrian artist Oskar Kokoschka lived for ninety-four years and was Central European in his attitude and outlook. He never gravitated to the fashionable centres of the art world. From early on, he was encouraged to be an individualist – not to follow any movement or tradition, but to carve his own approach. He had much in common with his contemporary Max Beckmann. Neither wanted to align themselves with the Expressionists, even though their work is now thought to exemplify all the hallmarks of that style.

During World War II, Kokoschka and his wife moved to Scotland, finally making Britain their home in 1946. This drawing is one of a series he made in the 1960s. Kokoschka then went on to create a series of paintings from these sketches that are held in the Tate Collection. These views of London are wonderfuly spontaneous – they exude an extraordinary energy and vitality.

The interesting thing about this drawing is how the space is organized. Kokoschka was particularly interested in space, as he believed that the perception of depth was a key aspect of painting. Here, small pockets of activity seem to float in an envelope of white light. The sweep of Westminster Bridge across the paper seems to magnetically pull or influence the way the other details in the composition are drawn. It is as if Kokoschka has taken a photo and increased the lightness – all the detail in the lighter areas is lost and the darks hover and float. This enables him to treat the sky as an equally transparent form. Kokoschka shows that an image that is essentially an arrangement of small fragments or details can still have the most extraordinary unity.

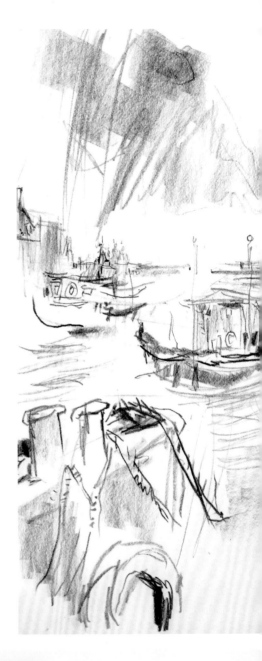

Materials
Kokoschka's large pencil drawing exploits the white paper. There is smudging, which was probably done with a cloth. Be careful when smudging with your fingers, as there is natural oil on your skin that will make the surface look blotchy. If your hand makes marks, try resting it on a sheet of paper (left) or stand up at a drawing board (right) – you can make different kinds of marks in this position.

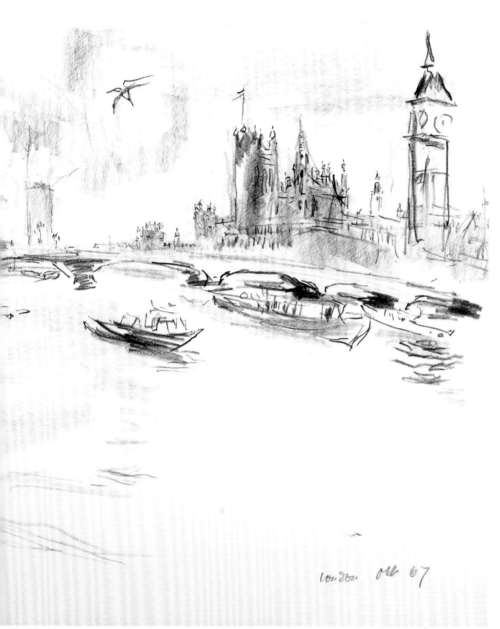

London (inscription) *Lon don* *oll* *67*

Oskar Kokoschka (Austrian, 1886–1980) was born in Pöchlarn in Austria, but his family moved to Vienna in 1889. Kokoschka won a scholarship to study at the School of Arts and Crafts in Vienna. In 1907, he became a member of the Vienna Crafts Studio, producing work influenced by Art Nouveau. In World War I, he was injured while serving in the Austrian army. Afterwards he settled in Dresden and taught at the local Academy. In the 1930s, the Nazis condemned his work as degenerate so he moved to Prague and then London. After World War II, he lived mainly in Switzerland.

See also
John Constable (p.122)
Leon Kossoff (p.206)
Alberto Giacometti (p.242)

Subject Matter

You can approach outside drawing in various ways. For example, you can have a clear idea and stay focused on that. Alternatively, don't have any preconceptions and use the drawing to find out what interests you. Ask yourself what is the first thing that strikes you when you look at a subject and make that your subject. Each approach is valid; experiment and look for others.

Durham: The Central Tower 1987
Charcoal on paper
101.6 × 92.5 cm (40 × 36 ⅜ in.)
Tate, London, UK

In 1985, Dennis Creffield was commissioned by the Arts Council of England to draw every cathedral in the country. With forty-two cathedrals in total, it was a massive undertaking and he even bought a camper van so that he could visit each location. Although he only managed to finish eleven cathedrals, they are among the most impressive drawings of the late 20th century. Creffield studied under artist David Bomberg from 1948 to 1951 before going to London's Slade School of Fine Art. We can see from this drawing that Bomberg made a lasting and significant impression on Creffield's work.

Creffield invents extraordinary forms – miraculous constructions of fragile marks that seem to coagulate into a form that is at once trembling and yet incredibly strong. Almost the whole sheet is filled with the form of the cathedral pushing out to the edges of the paper. Creffield revealed that he wanted the paper to be like a single musical instrument, with every part responsible for the sound it produces. The natural qualities of the charcoal marks are in perfect harmony with the scale and construction of the stone pieces that make up the cathedral. Charcoal is the perfect medium for creating both the monumental and the transparent. The forms Creffield invents are inspiring in much the same way that the majestic buildings themselves are.

Dennis Creffield (British, born 1931) was born in London and studied with David Bomberg (1890–1957) at the Borough Polytechnic, London, from 1948 to 1951. He became a member of the Borough Group from 1949 to 1951. He attended the Slade School of Fine Art from 1957 to 1961, where he won the Tonks Prize for Life Drawing and the Steer Medal for Landscape Painting. From 1964 to 1968 he was Gregory Fellow in Painting at the University of Leeds. In 1987, he was commissioned by the South Bank to draw all the medieval cathedrals of England; the resulting exhibition toured the UK to great acclaim from 1988 to 1990.

See also

David Bomberg (p.130)
Frank Auerbach (p.202)
Leon Kossoff (p.206)

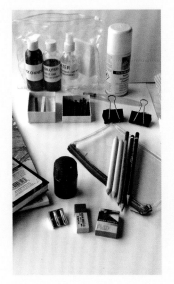

Materials
Throughout the history of art, artists have always worked outside directly from life. The Impressionists were the first to benefit from the invention of collapsible metal paint tubes in the mid-19th century. With drawing it's easier – at the very least, you only need a pencil and a sketchbook. However, if you choose to work with charcoal you may want to take some fixative too. Have all your necessary materials ready and prepared to take with you (left).

Sources
Drawing in a city can be difficult, as one is always being interrupted. Creffield points out that if someone sits writing in public they seldom get interrupted, but people are fascinated by someone drawing and will even enter into conversation. Listening to music on headphones can help, as can working very early in the morning, when few people are around, or at night. In a busy place you can be more anonymous than in one with few people around (left).

Michelangelo 140

Sofonisba Anguissola 142

Federico Zuccaro 144

Rembrandt van Rijn 146

Elisabetta Sirani 148

Francisco Goya 150

Jean-Auguste-Dominique Ingres 152

Alfred Edward Chalon 154

Jean-François Millet 156

Honoré Daumier 158

Edgar Degas 160

John Singer Sargent 162

Vincent van Gogh 164

Walter Richard Sickert 166

George Grosz 168

Pablo Picasso 170

Max Beckmann 172

Henri Matisse 174

Georg Baselitz 176

Paula Rego 178

Peter Doig 180

Robert Pugh 182

Being able to draw a clothed figure well means that almost every subject is at your fingertips. One only has to take a short walk around a museum to notice that most paintings and drawings depict figures dressed in a variety of clothing. The way clothes hang, reveal or obscure the bodies beneath them can express a multitude of subtle and not so subtle feelings. For example, Jean-François Millet's man pushing a wheelbarrow (see p.156) is dressed, as one would expect, as an agricultural worker, yet the lived-in, worn attire also represents a crucial expressive element of the work. If we compare it to Alfred Edward Chalon's drawing of a dispute during a game of cards (see p.154), the clothes provide a completely different vehicle for expression: sharp and crisp, the folds of fabric create a syncopated rhythm across the surface.

Often there will be more than one figure shown and the interrelationship between figures is another important element in how a drawing is viewed. Edouard Manet maintained that doing a single figure was very tricky but making several figures work together was a truly monumental task. Rembrandt – probably the greatest figure painter of any period – created a rapport between the suggested rhythms of clothing and the bodies beneath to extraordinary emotional and visual effect (see p.146). However, it is never solely Rembrandt's ability to render the weight and texture of clothes so convincingly that causes viewers to be moved by his work. Many artists can produce textural effects, but what Rembrandt does is reveal the humanness of the figure, and through this and the work's narrative he generates empathy as well as mystery.

Lamentation (recto) *c.*1530
Reddish chalk, partly over pre-drawing in black chalk, on paper
32 × 24.9 cm (12 ⅝ × 9 ¾ in.)
Albertina, Vienna, Austria

Although Michelangelo is considered one of the greatest draughtsmen in the history of art, we should beware of losing all sense of criticism. Nonetheless, this drawing of the Lamentation is magnificent. Although incomplete, there is so much going on and so much to find extraordinary that its lack of finish is never an issue.

First, consider the overall composition and structure. The central, arabesque-shaped Christ figure snakes up the drawing. As the eye moves from the bottom to the top, the extraordinary distortion of Christ's left leg and the peculiar knee sticking into the back of Christ's knee gradually become apparent. Moving up and there is a sudden disruption – Christ's head is not where you expect it to be; instead it is to the left. Moving down the left-hand side under Christ's head, there is the peculiar, flattened-out, twisted arm. In fact, the more you look at it the more distorted and contorted the image becomes.

These distortions are not simply a matter of compositional artistry: they make the viewer connect with the suffering of Christ on a physical level. However, from a student's perspective we are interested in how Michelangelo arrives at such extraordinary distortions. This is where the sketchier, abbreviated sides of the drawing become significant. The figure on the left is generally much less specific; see how the head almost hovers in between the shoulders, as if Michelangelo is playing with its exact location. As the eye scans backwards, forwards, up and down, it is as if he is placing it in a pocket of space.

Michelangelo (Italian, 1475–1564) was born Michelangelo di Lodovico Buonarroti Simoni in Caprese, Tuscany. He began an apprenticeship in the Florence workshop of painter Domenico Ghirlandaio (*c.* 1449–94) in 1488, but after a year he transferred to the academy of sculptor Bertoldo di Giovanni (*c.* 1420–91), sponsored by Lorenzo de' Medici. After Lorenzo's death in 1492, Michelangelo decamped to Venice, then Bologna, before arriving in Rome in 1496, where he secured a reputation as a sculptor and painter. In 1508, he started work on his fresco cycle in the Sistine Chapel. The ensuing decades saw him achieve success in many fields, and in 1546 he was appointed architect to St Peter's.

See also

Pontormo (p.76)
Titian (p.258)

Composition
When you draw, especially with Conté chalk, work swiftly and lightly, sketching out approximate rhythms rather than specific shapes (far left). Don't worry about the exact position of any single form, let them evolve. As you go, try to identify the larger rhythms and build your composition around them (left). Ignore your idea of where detail should be because it is anatomically correct; be steered by the logic of the drawing, not illustrative description.

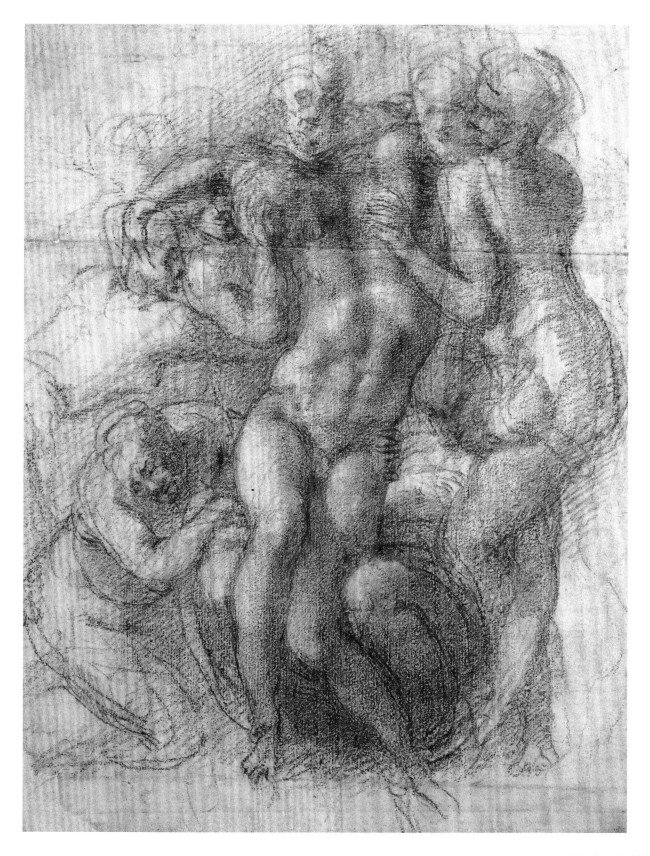

Old Woman Studying the Alphabet with a Laughing Girl 1550s

Black chalk heightened with white on paper
30.1 × 34.5 cm (11 ⅞ × 13 ⅝ in.)
Uffizi, Florence, Italy

Sofonisba Anguissola might not be a familiar name to many but she was one of the more interesting artists of the High Renaissance. She was well regarded during her own lifetime and was appointed as an official court painter to King Philip II of Spain. After working in Spain and Sicily for many years, she spent over thirty years in Genoa and lived well into her nineties. Art historian Giorgio Vasari wrote that Anguissola 'has shown greater application and better grace than any other woman of our age in her endeavours at drawing'.

This drawing is not in the best condition, but we immediately notice the figure-of-eight shape linking the two figures. Created by the intertwined arms and hands, it intensifies the drawing's sense of playfulness. This clever figure of eight is slightly undermined by the girl's gaze looking out at us, the viewers. There is an interesting rapport between the expression on the old woman's face and that of the young girl. The individual character of both figures is expressed in the way each form is modelled: the young girl is more upright and perky, whereas the old teacher is dumpy and rotund. A surprising detail is the depiction of the girl's teeth – a rare thing in almost every period, perhaps because the baring of teeth tends to be associated with aggression. Whether this is true or not, it certainly gives the drawing an edge.

Sofonisba Anguissola (c. 1532–1625) was born in Cremona and she trained with local painters Bernardino Campi (1522–91) and Bernardino Gatti (c. 1495–1576). In 1559, she became court painter to Elizabeth of Valois, Queen of Spain. So highly was she regarded that King Philip II arranged her first marriage to Fabrizio de Moncada, Viceroy of Sicily, in 1571 and provided her dowry. They lived in Sicily, but de Moncada died in 1579. At the age of forty-seven, Anguissola married a nobleman and moved to Genoa, where she painted and taught. Her last years were spent in Sicily, where she continued to paint into old age.

See also

Henry Tonks (p.96)

Walter Richard Sickert (p.166)

Robert Pugh (p.182)

Subject Matter

Extreme facial expressions tend to be less convincing in drawing and this seems particularly true of laughing. Laughing tends to happen for a moment and is usually over quickly. Seeing that expression depicted and fixed means that the viewer can look at it for an abnormally long time. A more subtle expression like that of the Mona Lisa is sustainable and therefore more believable.

A laughing face or a strongly obvious facial expression tend to be a dominant focal point that photography often uses to great effect. In the hands of a draughtsman, it can also be a key compositional device. In this image (left), not only are there formal connections between shapes, rhythms, light and shade, but there is also a psychological connection between the two figures. They are looking at each other, which places the viewer in a very specific position. The viewer becomes a witness or eavesdropper to an intimate moment.

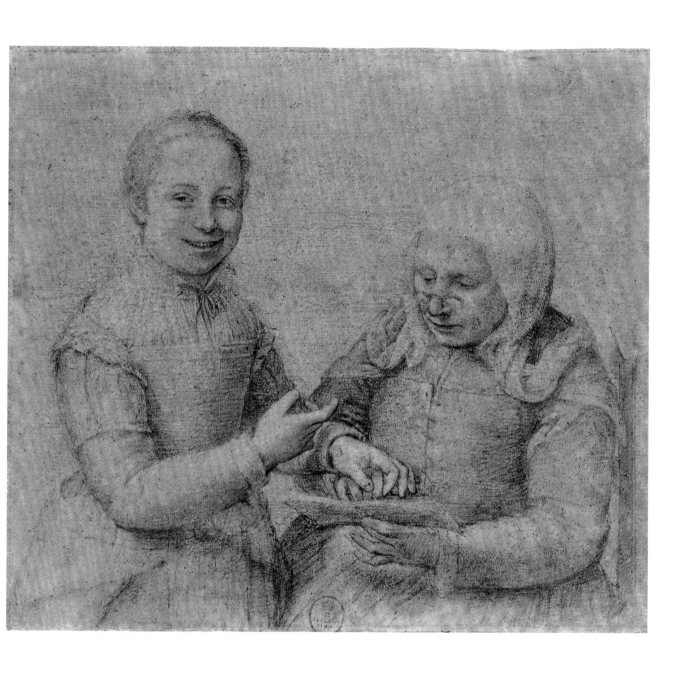

Federico Zuccaro

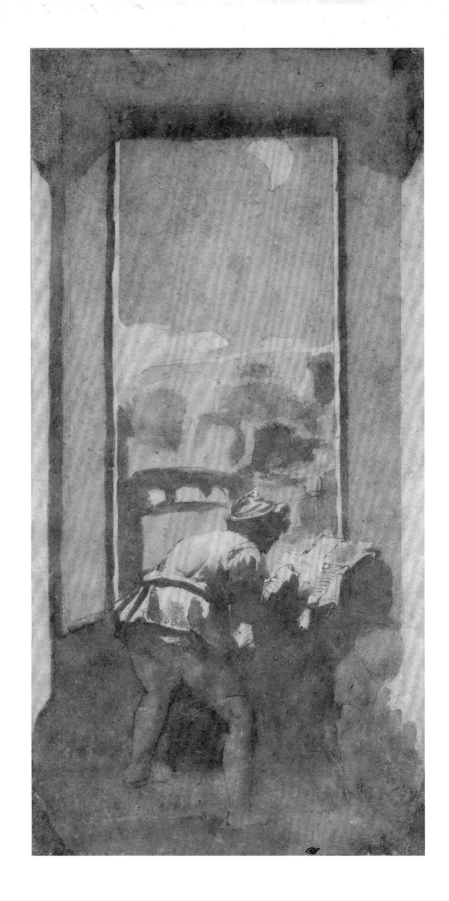

Man Drawing by Moonlight from the Window of a House *c.*1590

Pen and brown ink with brown wash on off-white paper
35.6 × 17.8 cm (14 × 7 ⅛ in.)
Ashmolean Museum, Oxford, UK

Federico Zucarro made several, more descriptive drawings of this subject, but this one is the most evocative. The subject is Zucarro's brother, Taddeo, who is depicted working on a moonlit landscape while staying in the house of their friend Calabrese. The drawing has many superb qualities, but what is most immediately apparent is the appropriateness of the medium. Zucarro has used pen and brush with brown ink – a technique that bridges the divide between drawing and painting. The highlights are sharp and clearly defined and yet the shadows bleed into each other in an immensely suggestive way. Look closely and you see that Zucarro first made a simple line drawing with a pen of the key parts of the subject. Yet he has resisted the temptation to fill in the underdrawing in a precise way with the ink wash; it seems casual while feeling completely right. The treatment of the landscape beyond as a series of abstract shapes contained within the long narrow shape of the window suggests an oriental style.

Compositionally, it is an interesting format and arrangement. There is a general guide to the division of any rectangle, known as 'the rule of thirds', which was recorded in the late 18th century. This rule states that any rectangle can be divided into nine equal areas and that a composition that uses these lines and areas as a structural framework will be better than one that does not. Here, the horizontal divisions are approximately at the figure's belt and then further up at the first cloud. Such rules are given little credence today, but use whichever methods you feel necessary.

Federico Zuccaro (Italian, *c.* 1540–1609) and his brother, Taddeo (1529–66), were Mannerist painters from Urbino. Taddeo worked as a fresco decorator in Rome. After his death, Federico took over his studio and completed work for the influential Farnese family at their palace in Caprarola and for the Sala Regia in the Vatican. He had huge success and for a time was considered the most famous living painter. He travelled throughout Europe, painting court portraits in England and frescoes at the Spanish royal residence of El Escorial near Madrid. He was elected the first president of Rome's artists' association, the Accademia di San Luca, in 1593.

See also

Polidoro da Caravaggio (p.78)

Claude Lorrain (p.114)

Francisco Goya (p.150)

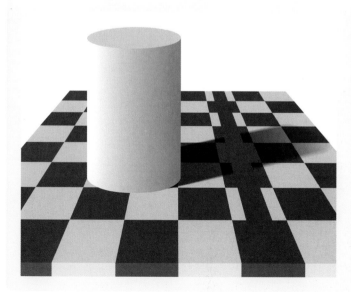

Tone
As the human eye can pick out details within shadows, artists often fall into the trap of making shadowed areas too detailed, thus disrupting the overall unity of an image. This illustration shows a chequerboard with a shadow cast from a cylinder. The white square in shadow looks lighter than the black square in the area without shadow – yet, they are exactly the same tone, as indicated by the line through both squares. Keep details in shadowed areas to the absolute minimum.

Materials
With a wet medium such as an ink wash the paper will often buckle, leading to pools of watery ink on the surface. To avoid this, stretch your paper first: dampen it all over, then secure the edges to a clean, smooth drawing board with strips of water-based gum tape and leave to dry. Expensive paper is often not always the best to work with. Use paper that feels slightly dry to the touch – watercolour papers or preferably ordinary thick cartridge paper.

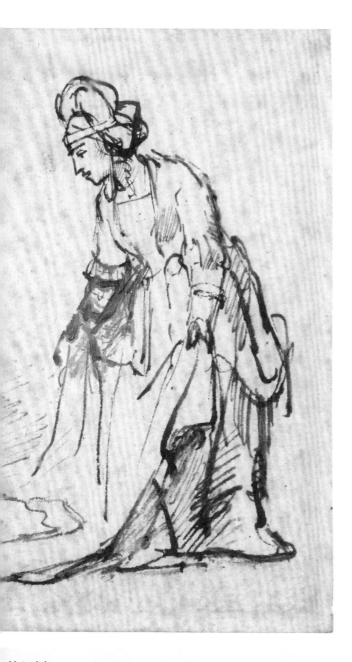

Rembrandt van Rijn (Dutch, 1606–69) studied under painters Jacob van Swanenburgh (*c.* 1571–1638) and Pieter Lastman (*c.* 1583–1633). He opened a studio in his hometown, Leiden, producing many of his numerous self-portraits. His work caught the eye of Constantijn Huygens, secretary to the Prince of Orange, resulting in commissions from The Hague. In 1631, Rembrandt moved to Amsterdam and cornered the market for portraits of wealthy patricians. He became a member of the Guild of St Luke in 1634; his workshop prospered and his fame grew with a series of biblical and historical masterpieces. In later years his commissions dried up, and he was declared bankrupt in 1656.

See also

Pablo Picasso (p.102)

Walter Richard Sickert (p.166)

Robert Pugh (p.182)

Materials

Drawings made with iron gall ink were common in Europe from the late Middle Ages. When first applied, iron gall ink is a dark blue-black, but over time it turns brown. Pen allows for clear strokes but it is also impossible to erase. Dissatisfied with two arms in the centre of his drawing, Rembrandt altered them with white paint, which has faded, and we can see the original marks showing through.

There are many modern sketching pens available – experiment with these to find which kind suits you. Be as free as possible with the lines you draw. Think about how naturally fluid a signature is and try to apply this confident, directed freedom in your drawing (far left). With an ink pen, practise drawing drapery – an ideal subject for this kind of drawing. As pen can't be erased, think in terms of layers of

information – broad sweeps of lines, then shaded areas and specific details, as shown in the illustration (left). When drawing drapery, always keep a reasonable distance away so that you can see the relative values and big rhythmic shapes easily. If you are too close, you will get sucked into the details and lose any sense of the larger, sweeping forms.

Elisabetta Sirani

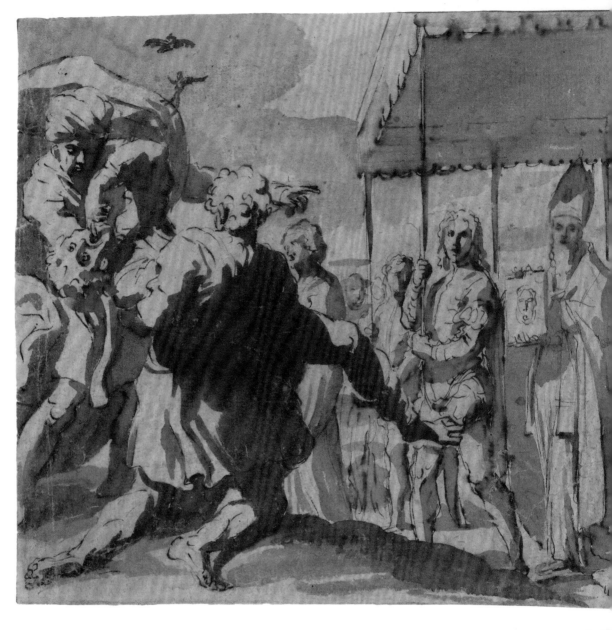

See also

Polidoro da Caravaggio (p.78), **Honoré Daumier** (p.158)

Elisabetta Sirani (Italian, 1638–65) was a Baroque painter and printmaker from Bologna. She trained under her father, a painter of the School of Bologna, Giovanni Andrea Sirani (1610–70). After he became incapacitated because of gout in 1654, she took over the family workshop and became the family's primary breadwinner. She was a prolific artist, producing more than 200 paintings, fifteen etchings, hundreds of drawings and at least thirteen altarpieces. She painted portraits and landscapes as well as allegorical works, and historical and biblical narratives, often featuring women. She was commissioned by royals, diplomats, clerics and nobles, and she was so popular that her clients often visited her studio to watch her work.

Materials

Sirani used brown ink with a brush pen. The sepia brown pigment and off-white creamy paper result in a highly appealing combination. With this choice of materials, the introduction of white highlights can produce startling effects. Sirani used white to make adjustments such as in the central figure's cloak. You can also try scraping the surface of the paper to remove unwanted ink.

The Deliverance of the Demoniac of Constantinople by St John Chrysostom *c.*1659
Pen, brown ink and wash heightened with white over graphite
14.9 × 23.9 cm (5 ⅞ × 9 ⅜ in.)
National Gallery of Art, Washington DC, USA

It is possibly a little unfair to compare Elisabetta Sirani with Raphael but had she died ten years later it may not have seemed so. Sirani was hugely talented, but she did not live to realize her full potential. Compounded with this is the availability of her art; although she has works in many prestigious galleries, they are not always accessible. She produced over 200 paintings, a number of etchings and hundreds of drawings – all of which should be available at least online. Her father, Giovanni Andrea Sirani, was principally responsible for teaching Elisabetta and setting up a successful studio. By the time he became incapacitated with gout, Sirani was capable of taking over the studio and building on its reputation. At this time Bologna was sufficiently enlightened for women to thrive in their own right, and Sirani developed a fluid, speedy style of painting.

This drawing is interesting because of the strange scene that is depicted, especially on the left-hand side of the composition. The figure being carried seems to be caught up within the strong, dark shadow. At first it is hard to identify exactly what is happening, but as you visually unravel the image it becomes clear that the figure on the left has been possessed by demons. The power of this drawing comes in the rupture between light and shade and form. It is an enormously confident work: lines seem to cross the surface of the paper, in one moment describing a sleeve or the side of a face and in the next simply animating the surface or doing both. Shadows seem precisely placed but never feel as if they are filling in areas. It is truly a virtuoso piece.

Form
Sirani disconnects shadows from their forms so that the shadow becomes a new form or an expressive element that is independent of it. Consider the shadow formed by the kneeling figure on the left as highlighted (left). The shadow seems to be caught up with the form of the man he is carrying. While the viewer can see into the shadow to make sense of these forms, the initial perception is that the shadow is an independent element in the composition. These effects become clearer the more you look at Sirani's drawing. On the far right, a man in a turban is kneeling down. The shadow that breaks up the form of his robe is shaped like a crack of forked lightning. Try to use this rupture between light and shade and form as an expressive element in your drawings.

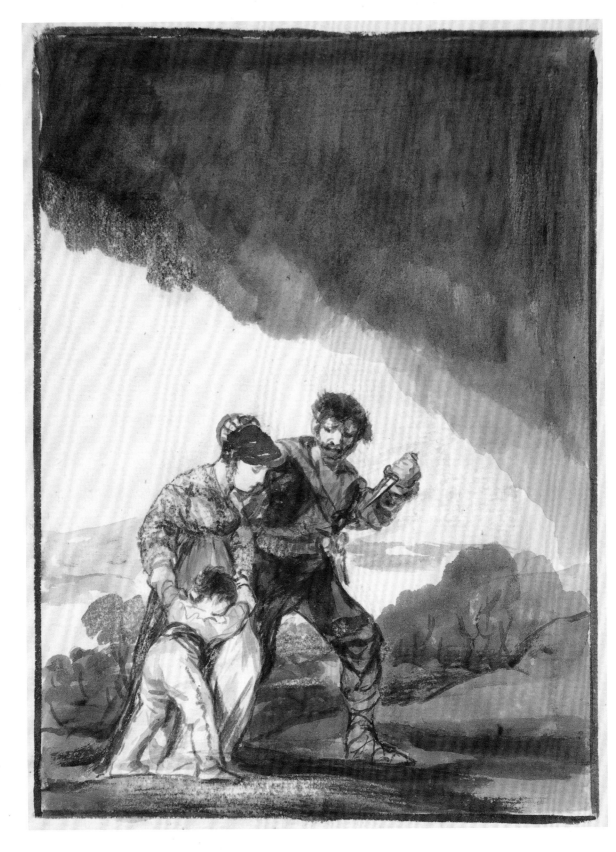

Francisco Goya

God Save Us from Such a Bitter Fate *c.* 1815–20

Brush with Indian ink and grey wash and scraping on laid paper
26.8 × 18.7 cm (10 ½ × 7 ⅜ in.)
Metropolitan Museum of Art, New York, USA

It is not known if Francisco Goya was familiar with William Hogarth's work in London – Goya would have been eighteen when Hogarth died – but the two artists do share some interesting similarities. Like Hogarth, Goya produced several volumes of prints that commented on the social ills of the tumultuous period in which he lived. It is fair to say that Goya was the greater artist and in this drawing and the series from which it is taken – the Black Border Album – Goya is at his best. He made more than 800 paintings and over a thousand drawings, about half of them in eight sketchbooks and half as preparations for paintings and prints.

In this drawing, the nightmarish atmosphere is enhanced by the strange sense that the figures are stuck and cannot move – it is as if they have been frozen. They are aware of the imminent danger but unable to do anything about it. The image resembles a film still or a scene from a storyboard; the diagonal, flat shapes suggest scenery wings from either side of a stage. Even the figures look a little flat – like the very scenery that surrounds them. Yet the whole arrangement has been carefully composed within a rectangular black border. The variations in texture not only create highlights but also engage the eye with the surface of the paper, resulting in a range of textures from translucent smoothness to uneven coarseness. The peculiar black cloud that seems to hang over the three figures is clearly a portent of doom – loaded with symbolism. It is a brilliant way of achieving a surprising composition.

Francisco Goya (Spanish, 1746–1828) found success early in his career, receiving commissions from Spanish aristocracy. He was appointed painter to King Charles III and in 1789, he became court painter to King Charles IV, producing grand portraits. His work became more experimental after he suffered an illness that left him deaf in *c.* 1792, and altered again after France invaded Spain in 1808, featuring gruesome content in a darker style. From 1815, he withdrew from public life but continued to produce works, including his Black Paintings (1819–23), a series of sombre murals in his house near Madrid, before retiring to Bordeaux, France.

See also

Claude Lorrain (p.114)
Elisabetta Sirani (p.148)
Paul Harbutt (p.278)

Materials

Goya's skill enabled him to make such spontaneous drawings with only a brush and different tones of wash. This is challenging. Begin by using rough pencil guidelines to establish the position of the main forms. Then use light washes, gradually making them darker as the drawing develops (left). As your confidence grows, play with the drying time of each layer – work a darker tone into a lighter wet area, then let the wash dry before you apply another layer.

Subject Matter

Goya was one of the greatest artists to explore the darker recesses of the human imagination. We cannot know how he did this, but there is a link between how he used formal graphic language and the subject he depicted. Choose a subject you feel very strongly about. Keep a note of your dreams as a starting point. When you translate ideas into drawings, they have to work as compositions. Here (left) everything is heightened – light and shade contrasts and forms are exaggerated.

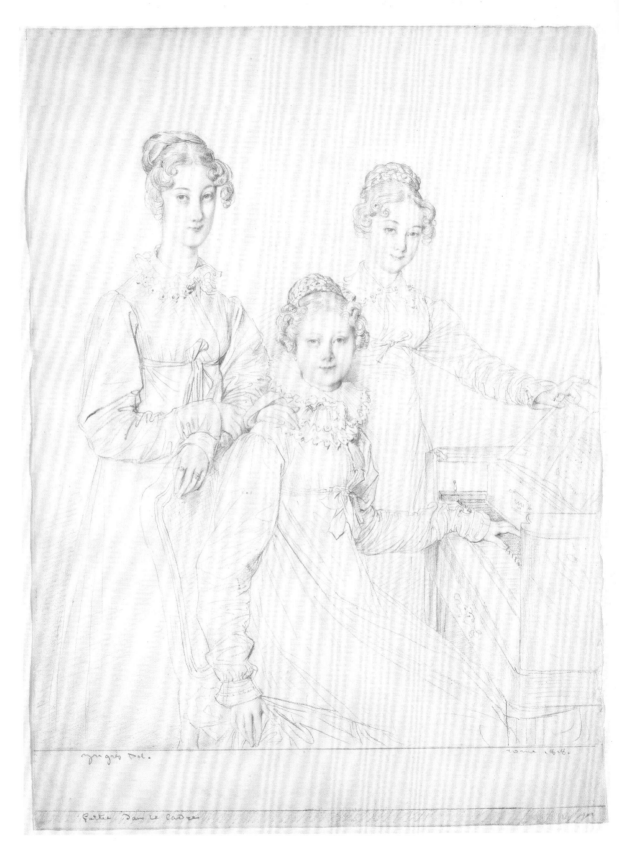

The Kaunitz Sisters 1818

Graphite on laid paper
30.2 × 22.2 cm (11⅞ × 8¾ in.)
Metropolitan Museum of Art, New York, USA

This drawing by Jean-Auguste-Dominique Ingres was a commissioned portrait of the three daughters of Austria's ambassador to Rome. They gather gracefully around a piano, probably in the family music room where the composer Paganini gave a private recital in 1819. The precision and elegance of Ingres's line drawing is astonishing. However, it should not be forgotten that primarily this is a commission. The likeness of each sister is important, but this is a drawing by a great master. Look at each face in turn while simultaneously being aware of their position in space. The seated figure is in the forefront, but flick your eye back to the figure with her hand on the sheet music and notice how there is a distinct jump in space. Move left to the other standing figure and the eye moves forward in space again. The position of these forms within the loose adumbrated marks that describe the sisters' dresses articulates the space in which they exist.

Although Ingres does not distort the heads, he makes a radical treatment of the arms and hands, even the bodies. Structural arabesques sweep down into the rest of the drawing. The treatment of the heads compared to that of the clothes could lead to the image breaking up, but instead Ingres creates two ranges of marks. The heads (and, to an extent, the hands) are treated in a softer, more shaded style, whereas the clothing and piano are more linear. Within both these stylistic inventions, Ingres makes marks from hard to soft. As a result, the viewer never feels that the two styles are conflicting. On the contrary, they set each other off beautifully.

Jean-Auguste-Dominique Ingres
(French, 1780–1867) studied under Neoclassical painter Jacques-Louis David (1748–1825).in Paris. In 1801, he won the Prix de Rome and was soon receiving portrait commissions from Napoleon Bonaparte. Ingres lived in Italy from 1806, first in Rome and then in Florence, where he produced his first female nudes, including *La Grande Odalisque* (1814). Success in France came in 1824 at the Paris Salon. Ingres returned to Paris and worked as official painter to the newly restored monarchy. He received the cross of the Légion d'Honneur in 1825 and a year later became a professor at the École des Beaux-Arts.

See also
Georges Braque (p.62)
Alberto Giacometti (p.242)

Space
The immaculate and refined drawing style of a great master like Ingres can seem impossible for students to emulate. Developing technical skills, as shown in this detail (left) takes time, but is possible with enough practice. The style or superficial look of the drawing should not be your first or primary concern. First, identify how points in your subject can be translated into a drawing. Position yourself in the corner of a room looking out

onto it. It is always helpful if you have a model available. Next, decide on what objects in the room you want to include in your composition. Next take ten ping-pong balls and, using some Blu-Tack, stick them onto various points within the area of the room you are including in your drawing. When you start drawing, concentrate on the position of each of these ping-pong balls relative to one another. Build up your drawing by referencing these points, as shown here (left).

A Quarrel Over Cards Undated
Brown and grey ink with brown chalk over graphite
31.9 × 43.2 cm (12 ½ × 17 in.)
British Museum, London, UK

Imagine Chalon in 1805 – twenty-five years of age, young, ambitious and just out of London's Royal Academy of Arts School. Inspiring artists of the period included masters such as Francisco Goya, Jacques-Louis David, Jean-Auguste-Dominique Ingres and Jean-Honoré Fragonard. It is not known whether Chalon, who lived in London, had contact with the work of all these artists – the Napoleonic Wars were then affecting the cultural exchange between England and France – but Chalon would have been familiar with J.M.W. Turner, John Constable and, more importantly, Thomas Gainsborough, Jean-Baptiste Greuze and Jean-Honoré Fragonard. Generally, Chalon produced rather average society portraits, although these brought him fame and a good income.

This drawing is not typical of Chalon's oeuvre, most of which is not made to this high standard. Although Chalon was born in the same year as Ingres, 1780, his work is inferior, yet this drawing contains much that is to be admired. It depicts a dispute that has erupted over a game of cards; across the upturned table, a man is threatening another who is already down on the floor while a woman tries to restrain him. One of the first things the viewer notices is the rhythmic movement across the paper. It does not matter where the eye starts, it quickly moves from one diagonal to the next, generating a feeling of ordered chaos. There is little or no space established by the representation of the floor in the foreground; the viewer is launched straight into the action, adding to the immediacy of the image. These rhythms are echoed in the way the clothes of the figures are freely drawn. An atmospheric background made from simple horizontals and verticals creates the perfect foil for the unfolding drama.

Alfred Edward Chalon (Swiss, 1780–1860) was born in Geneva, but settled with his family in England as a child and spent his working life in London. He entered the Royal Academy in 1797 and exhibited from 1810. A draughtsman, painter and watercolourist, he became a successful portraitist and was appointed Painter in Watercolour to Queen Victoria. An illustration he did of the monarch, called the 'Chalon Head', was used as the basis for a series of postage stamps. He is known for his flattering portrayals of female sitters and was closely associated with the London stage, completing portraits of opera singers and dancers that were often reproduced to decorate musical programmes.

See also

Thomas Gainsborough (p.118)
George Grosz (p.168)
Max Beckmann (p.240)

Materials

Chalon's drawing is only a little larger than A3 size, which is fairly large for drawings of the period. He started with free, light, pencil marks laying out the basic composition (far left). As with most wash drawings of this period, a light-toned wash was first applied, making sure not to go over the highlights (left, middle). The principal subject was then redrawn over the top. This drawing makes good use of a grey wash that is predominant in the background. Cold colours tend to recede – the coolness of the grey helps push these areas back. Gradually, the denser sepia brown, shadowed areas are added in (left). The temptation is to add more detail as the drawing progresses. Instead, try to concentrate on these simple figures and how they work together.

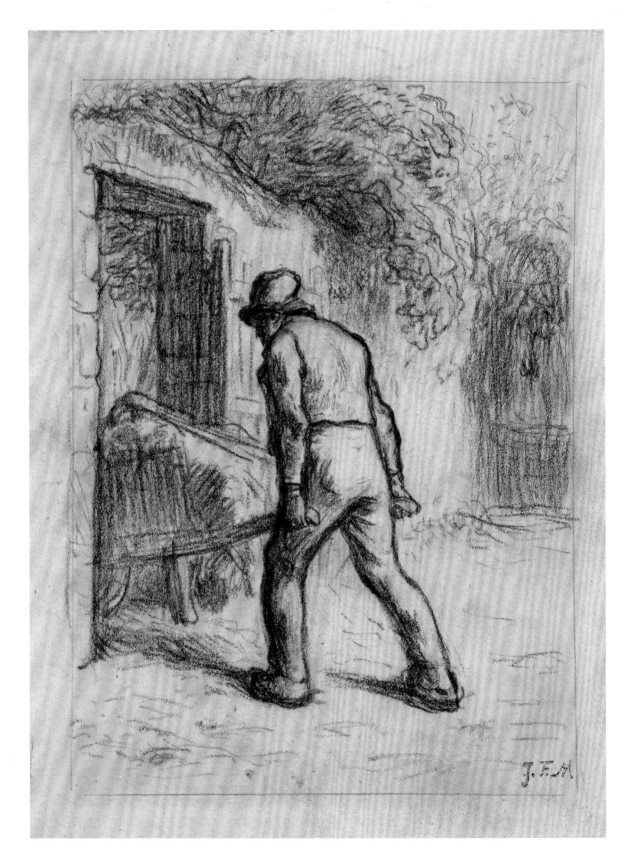

Study for Man with a Wheelbarrow 1855–56

Black Conté crayon on beige wove paper
20 × 15 cm (7 ⅞ × 5 ⅞ in.)
Museum of Fine Arts, Boston, Massachusetts, USA

Jean-François Millet was a key member of the Barbizon School in rural France. Although he trained as a portrait painter, he is best known for his landscapes. From the dating of various drawings and paintings of this subject, it appears that this work was done four or five years after the painting, probably in preparation for an etching print; note the ruled box around the drawing. The drawing was likely done from memory or directly from the painting, and probably not from life. This is important because it looks like the figure has been accentuated and is therefore slightly separate from the surroundings. However, in terms of scale and spatial positioning, the figure is logically located in a context. The space from the ruled line at the bottom of the drawing – across the uneven ground, into the figure's feet then back along the wall and into the dark door on the right-hand side – is clearly defined with the minimum of fuss.

Millet's drawing of the figure as a heavy, solid, simplified form shows the influence of Honoré Daumier. Millet, in turn, had a profound effect on Vincent van Gogh, and this drawing shares many similarities with van Gogh's *Digger in a Potato Field* (see p.164). Here the journey the eye makes from the head, down the arm and then the leg, and into the ground brilliantly suggests the load the figure is supporting. This is less convincing when the eye moves into the wheelbarrow, which feels weightless. Although optical authenticity may be lacking, the drawing still beautifully conveys the self-contained independence of the rural worker.

Jean-François Millet (French, 1814–75) was born into a farming family at Gruchy in Normandy. He first studied with local painters and then moved to Paris in 1837 where he trained at the École des Beaux-Arts under Paul Delaroche (1797–1856). His first painting, a portrait, was accepted at the Salon of 1840. He turned to creating pictures of rustic life, famously exhibiting *The Winnower* (c. 1847–48) at the Salon in 1848, which horrified the bourgeoisie but won favour with the new Republic that followed the Revolution of that year. In 1849, he settled at Barbizon, near the forest of Fontainebleau, where he helped found the Barbizon school of naturalistic painters.

See also

Honoré Daumier (p.158)
Vincent van Gogh (p.164)

Line

Millet's drawing is all about the quality of contour and the weight it expresses. The contour is an expression of the figure's internal solidity – it strains with tension. In the first illustration (far left), the books push down heavily on the cushion. Try to emphasize lines to express this heaviness. In the second illustration (left), a weight is tied to a suspended cushion. Use contour lines to express the weight pulling down on the cushion.

Space

The background in Millet's drawing is important, but it is understated. The small amount of space in the bottom of the picture draws the eye into the picture space, placing the solid form within the three-dimensional world represented. When drawing a single isolated figure and trying to create this impression of weight, it can be effective to position your figure in this way. It can make the figure seem removed, but the advantage is that you take in the whole figure.

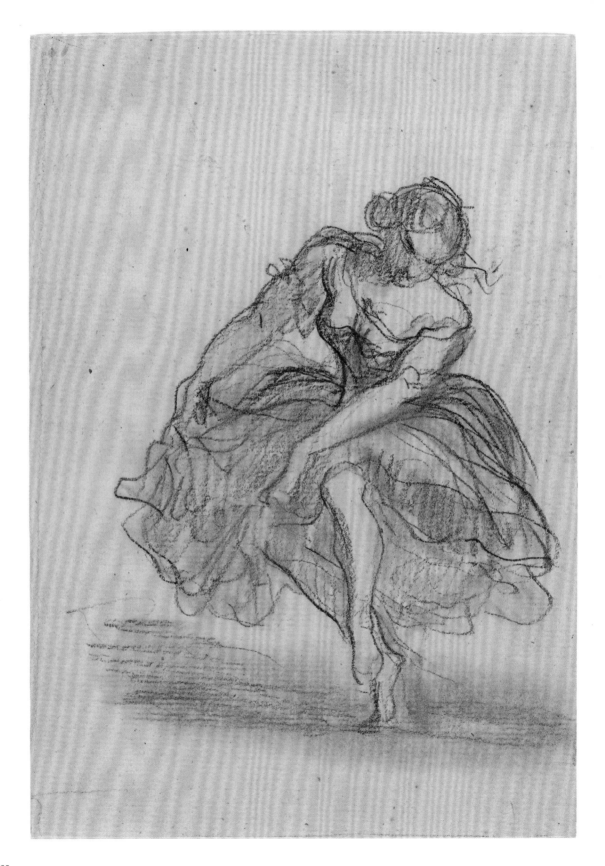

Honoré Daumier

Dancer Undated
Crayon over charcoal on laid paper
21.1 × 14.8 cm (8 ¼ × 5 ⅞ in.)
National Gallery of Art, Washington DC, USA

In most of Honoré Daumier's work, forms have a monumental quality; they feel as if they are substantial and made to last. Occasionally, however, he produces something that expresses a different quality. Empathy plays an essential role in almost any aesthetic experience for both artist and viewer. Here, the repeated contours suggest movement; they evoke the impulses that come from deep within and culminate in movement. In this small drawing (half a sheet of A4 paper), Daumier manages to combine not only what a dancer looks like when she is dancing, but also what it feels like to dance. He captures an internal urge that is also utterly physical.

As with all great artists, it is how the accumulation of marks is managed, shaped and structured that produces a compelling image. In this drawing, the repeated contours seem to coagulate in certain areas. As you look from the dancer's raised foot up the leg to the knee and across the arm, the side of the torso and breast get darker and more emphatic. This journey straight up the figure seems to push the head and shoulder forwards in a violent manner. The surroundings play no significant role in the way the dancer looks, but the fact that there is almost nothing there allows us to focus our attention exclusively on the figure – we are hypnotized. The use of light and shade is apparent, but not overly emphasized as it is in many of Daumier's works. He cleverly puts the shadow on the ground, but then connects the figure by way of one small foot – this makes the figure look like a spinning top.

Honoré Daumier (French, 1808–79) was dubbed 'Molière with a crayon', as he brilliantly chronicled his times, producing more than 4,000 lithographs satirizing the hypocrisies of 19th-century France. He studied art at the Académie Suisse in Paris and gained notoriety at the age of twenty-three with his censored *Gargantua* (1831), a grotesque rendering of King Louis-Philippe I drawn in protest at an outrageous tax increase, which landed Daumier a six-month prison sentence. After all freedom of political expression was banned in France, Daumier directed his sardonic crayon towards society in its entirety, attacking its greed, corruption and foibles with his caricature of the fictitious archetypal villain Robert Macaire.

See also

Edgar Degas (p.160)
Vincent van Gogh (p.164)

Line

In Daumier's drawing, the contour seems to fight to break free. These rhythmic strands of contour bring to life the forms that they are tenuously connected to. This sketch (left) shows the first few marks. The contours are more like echoes of a form in movement than a description of a three-dimensional form – it has more in common with a flapping sail trying to break free of its fastening. Shading can give a sensation a more substantial form.

Sources

One would think that this would be an ideal opportunity to work from a photograph. But Daumier's drawing is not about one moment – it is about a series of moments. Working directly from a moving model can be daunting, but try drawing your own hand holding a tissue (left). Keep the tissue moving while you draw. Start with something evocative; you can then gradually make the drawing more specific in particular areas if you need to.

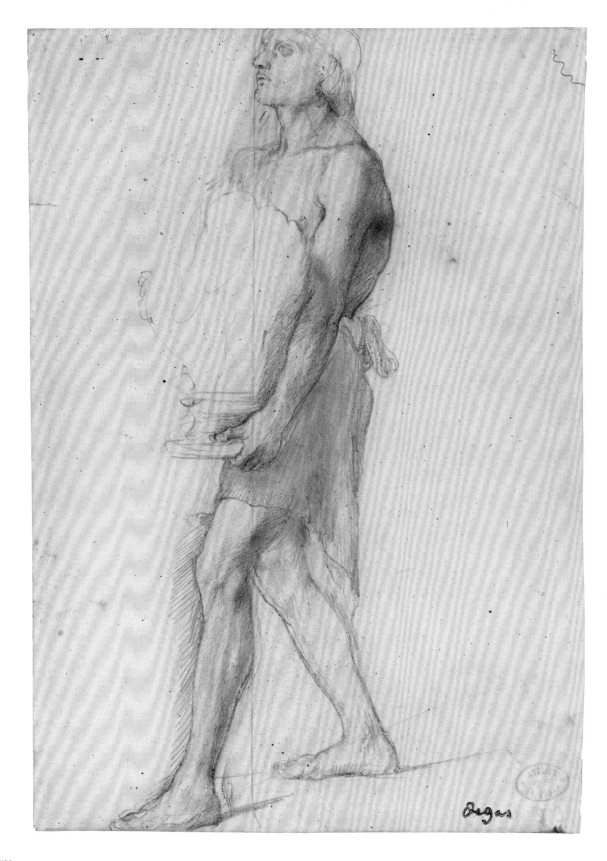

A Man Carrying an Urn, study for the painting
The Daughter of Jephthah 1859–61
Graphite on cream-coloured wove paper
30.1 × 21.2 cm (11 ⅞ × 8 ⅜ in.)
Smith College Museum of Art, Northampton, Massachusetts, USA

Early on, Edgar Degas wanted to become a classical history painter. The artists he most admired were Jean-Auguste-Dominique Ingres, Eugène Delacroix, Honoré Daumier and El Greco. Ingres, whom he met in 1855, offered him advice: 'Draw lines, young man, and still more lines, both from life and from memory and you will become a good artist'. Degas never achieved any notable success with his history paintings and soon moved towards realism using a classical visual language. Although associated with Impressionism, Degas always disregarded *plein air* painting. He explained, 'no art was ever less spontaneous than mine. What I do is the result of reflection and study of the great masters, of inspiration, spontaneity, temperament...I know nothing.'

 In this early drawing by Degas, we see what is essentially a very classical subject. What is extraordinary is not its allusion to an arcane subject, but the very real and physical expression of weight. Looking at the drawing, it is as if we can judge exactly how heavy the urn is. Strangely, the urn itself is the one thing in the drawing that has not actually been defined. It is the artist's exceptional ability to capture the effects of the forces at work on the man's body that make this drawing so powerful – the way the downward pressure of the weight of the urn suggests which lines and tones to emphasize in the anatomy. The way viewers pick up on these visual clues makes us feel the weight the man is carrying.

Edgar Degas (French, 1834–1917) first studied law, but was determined to become an artist. He enrolled in the École des Beaux-Arts in Paris, after which he spent three years in Italy studying the Old Masters. When he returned to Paris, he struggled to reconcile the influence of Andrea Mantegna (1431–1506), Paolo Veronese (1528–88) and France's Eugène Delacroix (1798–1863) as he sought to find his own style in several history paintings. Degas exhibited at the Paris Salon for the first time in 1865 and was one of the Société Anonyme des Artistes who exhibited together from 1874. Their first show was called the 'Exhibition of the Impressionists' because the artists' style of painting lacked detail.

See also

Jean-François Millet (p.156)
Paula Rego (p.178)
Peter Paul Rubens (p.262)

Materials

It is difficult to get a life model to hold a heavy weight for any prolonged period of time, so you have to draw quickly and prioritize the information you put down. Getting both the size of the drawing and the medium right is crucial. A big drawing in pencil, as illustrated here (left), will make it difficult because it will take a long time for you to make your marks, whereas using charcoal on a small scale makes it difficult to be precise.

The weight of an object is impossible to see – a cube of iron can look the same as a cube of wood. However, the effect that a difference in weight has can easily betray its weight. Degas highlights three aspects in his figure: the straight arm, raised chin and push down on the back leg. The straight arm is contrasted with the vertical in the cloth behind and the emphasized contours in the arm itself. The slightly raised chin is a natural reaction to holding weight up. The most important is the push down

on the back heel where everything is supported.

 As you draw, use a plumb line to compare angles on these forms (arm, chin, heel) in relation to verticals. The more aware you are of the vertical, the more you'll notice anything that is different. A plumb line is only one way of keeping lines at the right angles. For example, by emphasizing the lean backwards (which may depart slightly from the plumb line), you create an intense feeling of balance.

John Singer Sargent

See also

Honoré Daumier (p.158)

Frank Auerbach (p.202)

Auguste Rodin (p.232)

John Singer Sargent (American, 1856–1925) was born in Florence, Italy, to US parents and spent most of his life in Europe. The first time he visited his parents' native country was just before his twenty-first birthday. He studied in Paris under the eminent portrait painter Carolus-Duran (1837–1917). Initially, Sargent's work was fêted by the establishment, but after the scandal caused by his portrait *Madame X (Madame Pierre Gautreau)* (1883–84), Sargent left Paris. He was twenty-eight years old and from this time onwards he lived in London. He continued to travel often and visit the United States to work on commissions.

Line

Sargent used a pencil and sketchbook to record this simple composition. Slightly bigger than an A4 sheet of paper, it has been executed rapidly. When working with pencil it is important to remember that, even though it is a relatively sharp instrument, it can be used on its side, blunt or very sharp. In this illustration (left), you can see the different kinds of marks possible when using a pencil.

Madame X (Madame Pierre Gautreau) 1883–84
Graphite on off-white wove paper
24.8 × 33.5 cm (9 ¾ × 13 ⅛ in.)
Metropolitan Museum of Art, New York, USA

John Singer Sargent made more preparatory studies for *Madame X* than for any other portrait he produced. It seems that he was almost obsessed with this subject. The scandal that resulted from the first finished painting completely destroyed the reputation of young American socialite Virginie Gautreau (Madame X), who was married to French banker Pierre Gautreau, and wrecked Sargent's reputation as a portrait painter in France, where he was attempting to build a career.

In this preparatory drawing there is nothing scandalous or even unconventional – the confidence and ease with which Sargent positions the figure on the sofa and sketches in the principal features is typical of his mastery. He draws the sofa almost like a cartoonist making a spontaneous gestural mark (Al Hirschfeld's cartoons for *The New Yorker* or Aubrey Beardsley's work come to mind). It captures the rhythmic shape so well that it feels as if you could run your hand along its curves. The beautifully evocative way Sargent has drawn the face, neck and shoulders of his sitter is at once expressive and concise. The sensitive use of pencil in the head and neck is nicely contrasted with the harder shading of the back of the dress. However, with the dress Sargent has made no effort to transform the scribbled marks into the rhythms of the folds of material; they remain as scribbles. Of course, this is a preparatory sketch – probably completed in minutes using a pencil – but truly great artists never seem to make this kind of disconnection. In fact, they cannot help but make connections.

Materials
Practise spontaneous gestural lines that capture some visual characteristic of the subject. Start by choosing rhythmic and curvy subjects. Try to emulate the rhythms that you identify in your subject with simple lines. Vary the pressure, speed, breadth of line; most of all, work fast. The lines you make will often look wrong, but with practice and study of great artists your judgement will gradually improve.

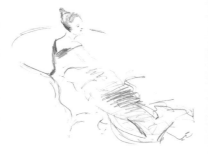

Sources
You'll often find when drawing that some periods prove more effective than others. This illustration (left) shows an exaggerated version of what is wrong with Sargent's drawing. The left side works well, but in comparison the right side does not. Making connections will help to unify your drawing – that unity creates a sense of completeness, resulting in a successful drawing.

Digger in a Potato Field: February 1885
Chalk on paper
54.5 × 42.4 cm (21½ × 16¾ in.)
Van Gogh Museum, Amsterdam, Netherlands

The first thing that strikes the viewer seeing this drawing in reality is its large size. Compared to most drawings of the same period, it is about four times bigger. Its sheer energy and force are immediately evident. If you look at very early, crude drawings by van Gogh and compare them to those made later in his career, you can see the phenomenal progress he made. By 1885 – the year this work was made – he had totally mastered his medium. Furthermore, he was using that medium to express the connection he had with what he saw around him. It would not be possible to make this drawing without huge empathy and an innate physical connection with the activity of hard work. Van Gogh knew what that felt like. This is not some dry, observational drawing: it is a lived experience translated by a master into a work of genius.

The force created by the movement of the eye from the head into the shoulder, down the arm to the elbow, to the hand and finally down to the ground is truly remarkable. The journey from the head across, in between the shoulders to the small of the back and the saggy ill-fitting trousers, down the right leg into the clog and to the ground, is equally extraordinary. If you look at the gap between the right-hand side of the drawing and the figure, it is as if the wheatfield is moving back in space but also supporting the figure; it is simultaneously deep and flat. The same can be said for the left-hand side above the spade. This drawing sees van Gogh at the absolute zenith of his creativity.

Vincent van Gogh (Dutch, 1853–90) was born in North Brabant, Netherlands. He struggled to make a career, working in an art dealership and training as a minister before deciding to become an artist in 1880. He moved to Paris in 1886 and was influenced by the Impressionists and Neo-Impressionists. In 1888, he moved to Arles in the south of France, planning to create an artists' colony. There he produced more than 200 paintings in fifteen months. He severed his left earlobe following a quarrel, and in 1889 he entered an asylum as a voluntary patient for a year, although he continued to paint. The next year he moved to Auvers-sur-Oise near Paris, but after only a few months he shot himself in the chest.

See also

Rembrandt van Rijn (p.146)

Jean-François Millet (p.156)

Honoré Daumier (p.158)

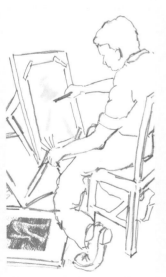

Sources
Van Gogh often worked directly from life, with his easel pitched in the fields. However, when drawing a moving figure, memory also plays a key part in bringing it to life. It is likely that van Gogh finished his drawing in the studio. Be very careful when doing this, as the temptation can be to make it more refined and descriptive, thus losing the vitality created by working directly. Often it is better to do a copy and work on that copy in the studio (left).

Form
Van Gogh was interested in the character of form. The contrast between the characteristics of certain forms clarifies their individuality. Here (left) the figure's right leg pushes down into the clog and the ground. The mark could be described as the compression of a coiled spring. The other leg is extended and straighter. Move your eye from one side of the sketch to the other and the two characteristics are more obvious. This is a useful way of seeing how forms work.

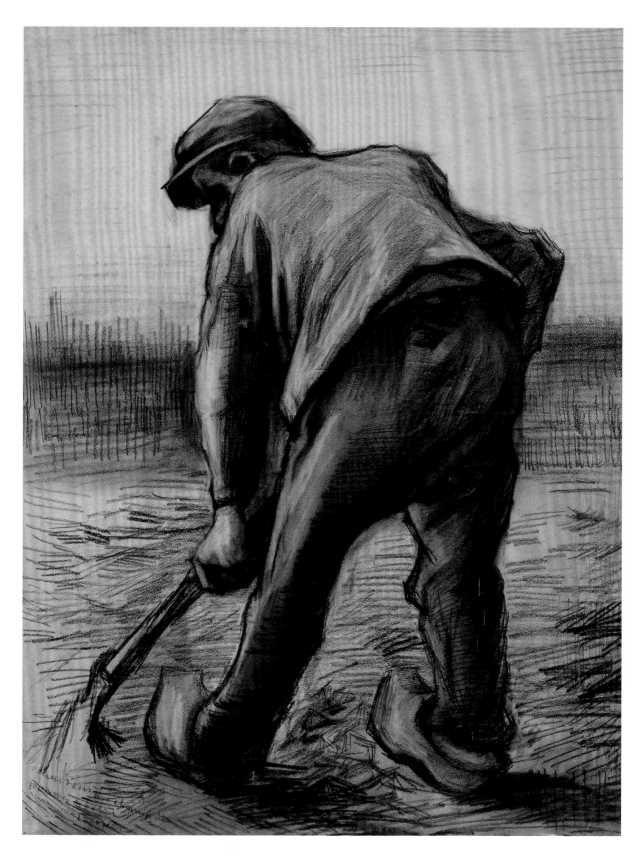

Persuasion (previously known as The Camden Town Murder, or La Belle Gâtée) *c.*1908

Chalk on paper
26.7 × 22.2 cm (10 ½ × 8 ¾ in.)
Bristol City Museum and Art Gallery, UK

Walter Richard Sickert bridges the gap between French Post-impressionism and the mid 20th-century School of London artists, which included Francis Bacon, Frank Auerbach, Lucian Freud and Leon Kossoff. There were three major influences on Sickert's work during the period from 1907 to the outbreak of war in 1914. In the 1890s Sickert met and formed a friendship with Edgar Degas. Degas was no Impressionist; he despised *plein air* painting and urged Sickert to work in the studio and from drawings. Sickert was also passionate about the theatre; he had as a young man briefly considered a career on the stage and he carried this interest through to his work. After a period working in Europe, in 1905 Sickert returned to London where he rented a series of cheap lodging rooms as studios. In 1907 a famous murder of a prostitute in Camden Town captured his imagination. The work he produced over the following years explored the subtle connection between this subject – usually showing two figures, a clothed male figure and a naked female – and the material substance of paint.

This drawing demonstrates Sickert's mastery of both his craft and the physiological drama he is depicting. It shows no obvious act of violence; in fact, it might not even be violent at all. It is, however, a moment of high emotional ambiguity. It is the possibility of a violent act taking place that makes this drawing so troubling. The viewer searches in vain for clues that it is a loving act rather than a murderous one.

Walter Sickert (British, 1860–1942) was a cosmopolitan figure: born in Germany to an Anglo-Irish mother and a Danish-German father, he spent most of his life in England but also lived for periods in Dieppe and Venice. Sickert studied art under James McNeill Whistler (1834–1903), but also formed a close relationship with Edgar Degas (1834–1917). Sickert believed that art should confront the gritty facts of ordinary life. In 1911 his ideas led to the creation of the Camden Town Group, which painted realistic scenes of city life. In later life, he caused a sensation by openly basing some of his compositions on press photographs.

See also

Raphael (p.188)
Cecily Brown (p.248)
Titian (p.258)

Form
It is not always easy to create difficult-to-read forms. In his drawing Sickert uses a point of view that is problematic to interpret – looking down on the woman (far left). Loose chalk marks break up the continuity and logic of the form, and this allows for various readings. This is entirely fitting, because the mood of the scene hinges on the sense that things are not what they seem. The ambiguous forms generate an ambiguous psychological effect.

Sources
There are various anomalies: the size of the front of the bedstead is very small, the man's foot and leg seem flat and the legs are implausibly small compared to his body. While you are drawing it is not necessarily important to be conscious of these anomalies, but it is helpful to be able to read the effects and decide whether to leave them in the drawing or make adjustments accordingly. A more realistic drawing (left) will not have the same visual and psychological effect.

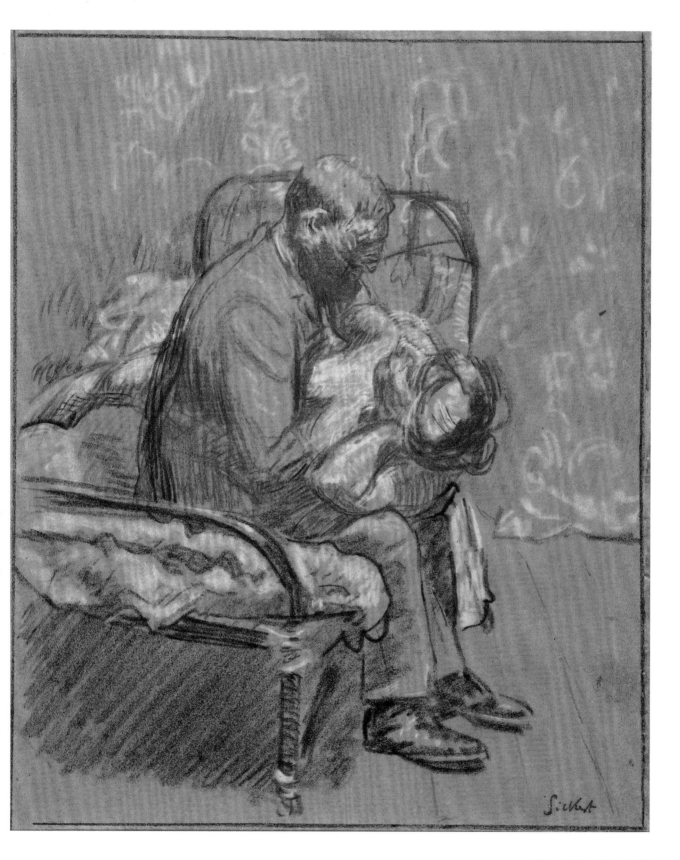

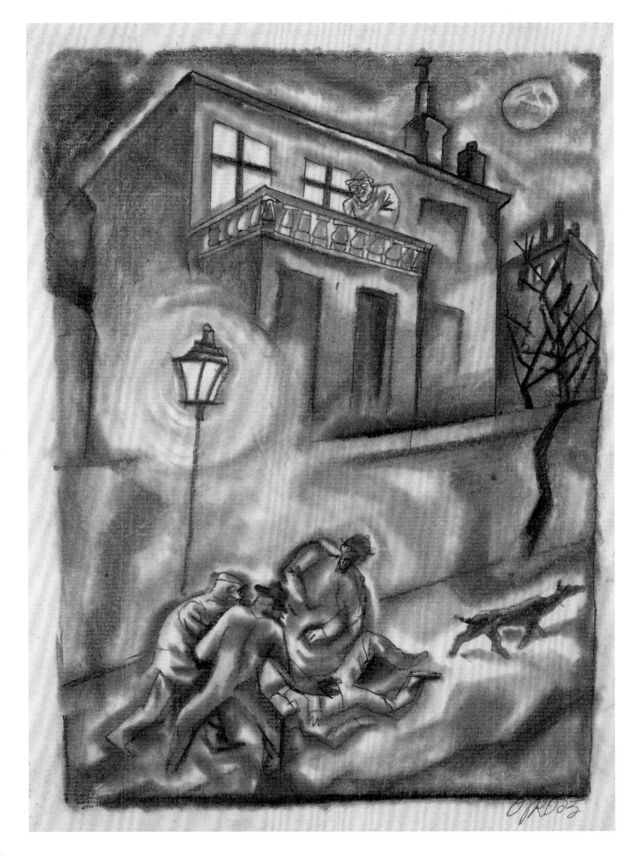

The Attack 1915
Graphite on paper
28.6 × 22.2 cm (11 ¼ × 8 ¾ in.)
Hirshhorn Museum and Sculpture Garden, Washington DC, USA

In 1933, after a twenty-year period of frenzied work, George Grosz left Germany for the United States. Although most of what he did over the next twenty-six years was technically superb, it lacked the bite and raw energy of his early works. These were made in Berlin during the Weimar Republic – a time of political extremism and extraordinary artistic activity following World War I. Grosz found almost everything he saw during this period disgusting and horrific, as he described: 'My drawings expressed my despair, hate and disillusionment; I drew drunkards; puking men; men with clenched fists cursing at the moon. . .I drew soldiers without noses; war cripples with crustacean-like steel arms.' Yet, like Hogarth or Goya, Grosz transformed disturbing events into exceptional art.

This intensely moody drawing depicts an attack on a man in a city street. The lighting, perspective and disjointed space all work together to create a feeling of panic and tension. Superficially the drawing looks as if it pays little attention to perspective, but this is not the case. Many characteristics have been exaggerated and heightened perspective is also manipulated to intensify the mood. For example, the house behind the wall is made to look as if it towers over the men in the foreground. Like many artists who went on to become part of Dadaism and Surrealism, Grosz regarded Cubism very differently to its proponents. For him, the fracture and disjointed surface of the canvas was a metaphor for the degradation and violence he observed in German society.

George Grosz (German, 1893–1959) studied art in Dresden, Berlin and Paris. His experiences in military service in World War I resulted in a mental breakdown and changed him completely. After his discharge, Grosz returned to art with a purpose, creating savagely satirical pen-and-ink drawings. With writer Wieland Herzfelde (1896–1988) and artist John Heartfield (1891–1968), Grosz became active in the Berlin Dada movement and joined the Communist Party. His position became precarious with the rise of the Nazis and he moved to the United States in 1932. He returned to live in Berlin in 1959, where he died soon after.

See also

Alfred Edward Chalon (p.154)
Max Beckmann (p.240)
Paul Harbutt (p.278)

Sources

Although Grosz was never a Cubist, the ideas undeniably influenced him. The zigzag forms of the group of figures in the foreground are echoed through the whole of his drawing – the shadow on the road, up into the dog and again up through the tree into the sky. This jarring criss-crossing movement also expresses the flickering streetlight. None of these effects would have been possible without Cubism.

It can be helpful to use a photograph to work from (far left). There are many things that you can do to take your drawing away from the photograph so that it becomes less literal – playing with the perspective, breaking forms up and exaggerating lighting effects among others. What you will find is that as the drawing progresses you will start to generate an atmosphere or mood. It is important to identify this early on and accentuate it in the direction you identify, as shown in this illustration (left).

Pablo Picasso

Portrait of Erik Satie 1920
Graphite pencil with charcoal on paper
62 × 48 cm (24 ⅜ × 18 ⅞ in.)
Musée Picasso, Paris, France

Pablo Picasso was a giant of 20th-century art. He had a long and successful life and was hugely prolific, producing over 55,000 works. Picasso took Cubism through its development in the early 20th century, but by 1917, when he visited Italy for the first time, he was moving away from the constraints of his revolutionary ideas. Although many of the drawings and paintings Picasso did during the early 1920s had nothing to do with Cubism, in this drawing there is a rhythmic quality that echoes the fractured surfaces of the early Analytical Cubist works.

This portrait of French composer Erik Satie is interesting from two points of view – looking back to Cubism and looking forward to the artist's later work. Judging by the revisions, it has been adjusted and refined many times. If we compare it to his Cubist drawings, one of the biggest differences is that here Picasso is happy to accept the blank space around the figure of his sitter. He has balanced the simplicity of the area around the figure with the rhythmic complexity of the figure itself – apparent in the folds of Satie's suit and his interlocking hands. The artist's awareness of the shape of the space around the figure seems to change or influence the way he has made those internal rhythms; the two areas interact. It is as if the folds in the clothing have changed how the fingers look or vice versa. Here, we witness Picasso not only identifying surprising qualities or characteristics, but creating connections between them. It is in this that he presents an enthralling new way of seeing.

Pablo Picasso (Spanish, 1881–1973) shifted from one style to another and between media. A child prodigy, he studied at La Coruña Arts School when he was eleven years old and enrolled at the Real Academia de Bellas Artes de San Fernando in Madrid at the age of twenty. In 1904, he settled in Paris, where he was to forge the tenets of Cubism. From 1918 to 1936, he turned to more traditional style, known as his Classicist period, when he collaborated with composers and the impresario Sergei Diaghilev's Ballet Russes, working on décor for *The Three-Cornered Hat* (1919) and *Pulcinella* (1920), and drawing portraits of the dancers.

See also

Jean-Auguste-Dominique Ingres (p.152)
Tintoretto (p.260)
Paul Klee (p.268)

Composition
With an isolated subject surrounded by empty space, it is easy to forget the placement of the main form in relation to the whole paper. Like Picasso it is a good practice to draw a box into which the objects can be placed, as shown (left). Don't press too hard with the pencil, so that you can adjust the size and proportions of the box. On an average-sized piece of paper, say A3, leave a gap of about 3 cm (1⅛ in.) around the edge. This can then be adjusted if necessary.

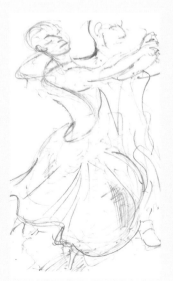

Form
Picasso used Cubist ideas in his drawing. even though superficially he does not appear to. The rhythms created by the folds in Satie's suit are echoed throughout, just as in this sketch (left) the rhythms in the dancer's dress evoke a sense of movement. But they also produce anatomical inaccuracies. From the look of the erased lines, Picasso simplified his work and took out unnecessary complications. This approach will help you create a more concise image.

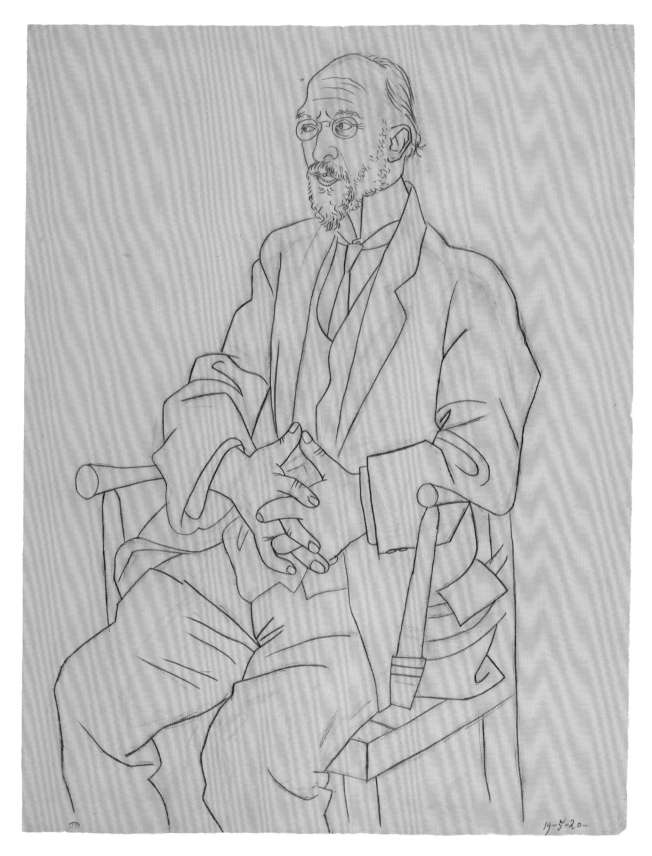

19-5-20-

Max Beckmann

See also

Pontormo (p.76)

Michelangelo (p.140)

Rembrandt van Rijn (p.146)

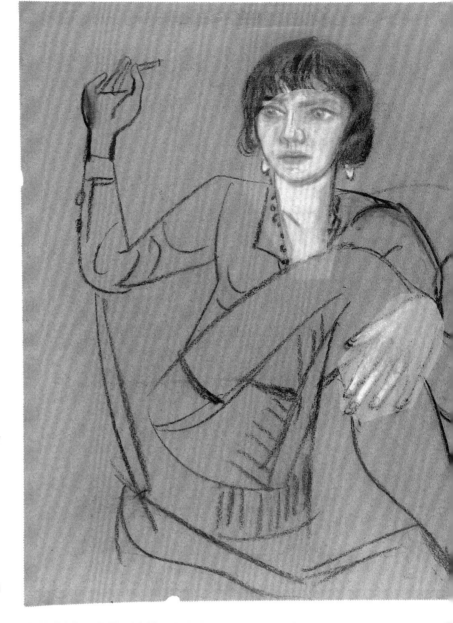

Max Beckmann (German, 1884–1950) was born in Leipzig. He moved to Berlin in 1904, where he was elected to the board of the Berlin Secession. The influence of Impressionism is prevalent in his early work, but his style changed after serving as a medical volunteer in World War I. In the 1920s, Beckmann was hailed as the leader of the Neue Sachlichkeit (New Objectivity) movement, which rejected Expressionism in favour of realism. His fortunes altered with the rise of the Nazis, who viewed modern art as morally corrupt and confiscated more than 500 of his works. Beckmann emigrated, first to the Netherlands and, after World War II, to the United States.

Materials

Working with white on toned paper gives a drawing great impact. While it can create striking effects, it can also break up the overall unity. Introducing any new element in the final stages of a drawing is perilous. You can upset the balance and relationships created. This sketch (left) shows that adding a bed has made it very difficult to integrate the new element into the whole drawing.

Mathilde 'Quappi' Beckmann in a Club Armchair 1927
Charcoal and white chalk on brownish-grey wove paper
42.3 × 53.3 cm (16 ⅝ × 21 in.)
Kupferstichkabinett, Staatliche Museen zu Berlin, Germany

Although Max Beckmann completely rejected being labelled as a particular type of artist, his work bears all the hallmarks of what is now known as Expressionism. His work has a strident daring about it – it seems to slash across the canvas or paper in bold. decisive movements like the swish of a sword blade. With only a few lines, he establishes the position and scale of his subject. Such ability does not just happen; it is the result of many years of studying great art and working from life. Beckmann made thousands of drawings, not all of them successful, but they helped develop his signature instinctive style.

In this drawing of Beckmann's wife Quappi, he establishes a crude, almost flat design with only a few deft lines. The woman's shoulder and arm, and to some extent the thigh, look flat and stuck on but, by contrast, this makes the legs seem all the more shapely and alluring. Beckmann does not appear interested in accurate proportions; in fact, he deliberately disrupts our expectations of them. If you compare this drawing to others of his that are more finished, you can see where he might have proceeded to take this one. It is hard to imagine that he was happy leaving the blank space on the right – he would want to bring this up on to the surface by filling it with activity. Nevertheless, this drawing seems to be more about a pair of sexy legs and some elegantly shaped shoes.

Form

We have only seriously questioned whether a visual representation is distorted since photography became a dominant medium. The work of artists such as Michelangelo and El Greco have shown that distorted forms can be the most moving. Generally, we accept extraordinarily high-key colour, yet as soon as a form becomes exaggerated then we begin to feel uncomfortable.

This is a mistake, because disconnections and distortions are part of the way we communicate deep internal feelings and sensations. Think of the written language: we use idioms to express very strong feelings – for example, to laugh one's head off. Experiment with trying to convert idioms into a drawn image, as demonstrated by this illustration (left).

Henri Matisse

See also

François Boucher (p.216)

Paul Cézanne (p.224)

Balthus (p.246)

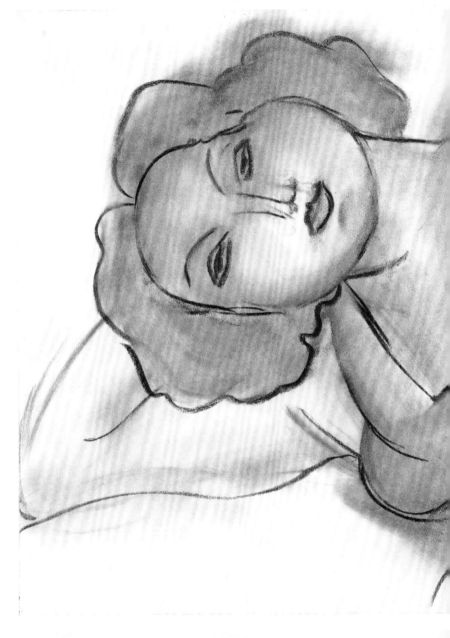

Henri Matisse (French, 1869–1954) called the last years of his life, from 1941 to 1954, his 'second life'. After radical colon surgery for cancer in 1941, he was an invalid, and much of his work was done confined to bed or a wheelchair. Matisse was unable to paint and he made paper cut-outs, including his famous blue nudes of simple, female forms cut from blue-painted sheets of paper. Matisse was born in Le Cateau-Cambrésis in northern France and he moved to Paris in 1891 to study painting. He founded Fauvism with André Derain (1880–1954) in 1905. Matisse remained in Paris during most of World War I, but in 1917 he relocated to Nice, where he began to use his signature intense colour.

Materials

Matisse used willow charcoal, which is easy to rub out. Look under the finished lines of his work: there are fainter ones that have been partly rubbed out. Try working rapidly to first achieve a simple visual idea. You can then respond to these instinctive marks by revising the form or line. The smudging and ghost lines made by revisions will increase the volume of the form, as shown (left).

Woman Resting 1941
Charcoal on paper
40.4 × 54.4 cm (15 ⅞ × 21 ⅜ in.)
Los Angeles County Museum of Art, California, USA

The two giants of 20th-century art, Pablo Picasso and Henri Matisse, changed the course of painting with Cubism and Fauvism respectively. Both artists have much to teach anyone learning to draw, but Matisse arguably offers more by way of instruction and clarification of his ideas in words. He produced hundreds of drawings and photographically recorded the stages of many of his works, so we can see the development of his ideas. In 1908 his patron and friend Sarah Stein, Gertrude Stein's sister-in-law, helped found the Académie Matisse as a private, non-commercial school, where Matisse taught until 1911. Stein carefully recorded Matisse's advice to the class in which she studied in the illuminating Sarah Stein's *Notes of a Painter* (1908).

In this drawing of a reclining woman, Matisse creates a deep sense of intimacy. He achieves this by moving the picture plane (see Introduction, p.31) right up close to the model, so that she fills the entire frame. This creates a sense that the viewer is standing there, almost able to reach out and touch her. The photographs and video footage of Matisse working show that he was often much closer to the model than we might normally expect. However, you do not actually need to be as physically close; the French landscape and portrait painter Jean-Baptiste-Camille Corot, for example, moved the picture plane close to his landscape subjects without physically moving nearer. Moving the picture plane can have a huge impact on the way the viewer engages with an image. The closer the picture plane is to the subject, the more intimate the drawing feels; the further away the picture plane is from the subject, the more detached the response of the viewer.

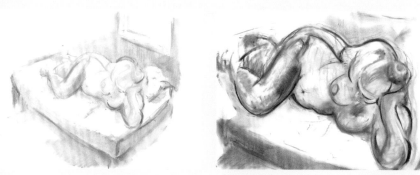

Space
Matisse builds his whole composition in relation to the edges of the paper: the space is compressed on the surface of the paper and out to its edges. Play with the picture plane by moving in and out from a subject, as shown in these two sketches (left). Note how this affects the feel or mood of the drawing. Spend time on these drawings, as quick sketches can only reflect changes in a limited way.

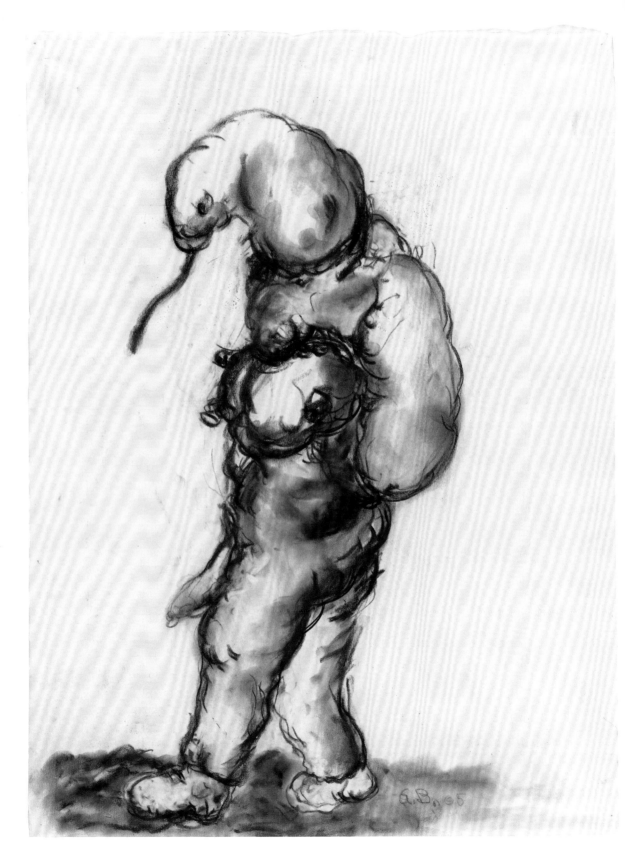

Untitled 1965
Charcoal on wove paper
49.5 × 37.6 cm (19 ½ × 14 ¾ in.)
British Museum, London, UK

Georg Baselitz was one of a group of artists, including Markus Lüpertz, Blinky Palermo, Sigmar Polke and Gerhard Richter, who left Communist East Germany for West Germany during the 1950s and 1960s. These artists were trying to redefine their individual identity within the context of post-war Germany. Threats to masculinity and national identity, not to mention the contemporary power and prevalence of New York and the Abstract Expressionist movement, presented the kind of resistance they responded to. These were the forces that shaped Baselitz's early work.

There is a repulsive beauty to Baselitz's output of the late 1950s and early 1960s – a slithery, voluptuous beauty, as if the entrails of living bodies were made visible and celebrated, as seen in this drawing. These are drawings done from the inside out – not in an optical or observational way, but in a visceral, gut-wrenchingly nightmarish way. The ideal medium to express this is through the luxurious slipperiness of oil paint and the graphic quality of charcoal. Internal organs appear to spill out from clothes in these gross and crude images. Baselitz manages to harness the tactile qualities of the medium in pursuit of his artistic vision. This kind of work has to be done almost in a trancelike state – not worrying about the technical aspects of making, but instinctively responding to where the imagination takes the artist. Although this drawing is not large – and many of Baselitz's drawings and paintings are huge – it still packs an enormous punch.

Georg Baselitz (German, born 1938) was born Hans-Georg Kern and adopted the pseudonym 'Georg Baselitz' as a tribute to his hometown of Deutschbaselitz. He moved to what was West Germany in 1956. He had his first solo exhibition at West Berlin's Gallerie Werner & Katz in 1963. The show caused a scandal when the authorities seized two of his paintings 'for reasons of public decency', one being *The Big Night Down the Drain* (1962–63) depicting a boy masturbating. In 1965, Baselitz spent six months in Florence, Italy, where he started painting people and objects upside down.

See also
Paul Cézanne (p.224)
Willem de Kooning (p.270)

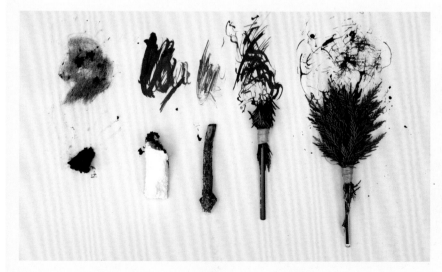

Materials
Experiment with different materials. These illustrations were made (from far left) with mud, pieces of decaying wood and pine needles taped to the end of a pencil. Although impermanent, they can open up new possibilities for the subject.

It may be that you start a drawing with a specific idea and then, because the materials create an unexpected look on paper, you fight it. But if your medium is doing something unusual or at odds with your original intentions, go with it and let the drawing develop as the medium suggests. You can always come back to your original idea with a different medium.

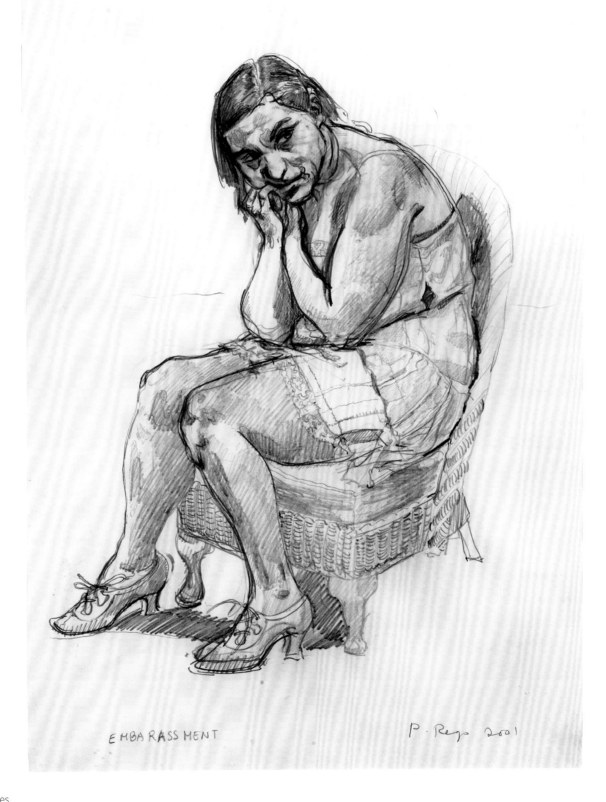

EMBARASSMENT

P. Rego 2001

Embarrassment 2001

Pencil on paper
42 × 29.7 cm (16 ½ × 11 ¾ in.)
Fundação Paula Rego, Cascais, Portugal

Paula Rego has lived most of her life in London, but for inspiration she turns to her native Portuguese culture and childhood. Like many artists of her generation, she rebelled against the way she was taught at the Slade School of Fine Art in the 1950s. However, she moved away from the more experimental ideas of the 20th century and in 1990 became artist in residence at London's National Gallery. This gave her proximity to the great masters and appears to have made her consider more explicit figuration in her work.

Exploring the imaginative world of the child is central to Rego's work. This is a world of simple stories that often have magical but brutal outcomes. This drawing initially appears to be a straightforward representation of a seated figure. The pose and body language are very important in a figurative drawing, as they are one of the first things we notice. Closely following this reading of body is the facial expression, something that the old masters understood brilliantly. They often looked to express religious fervour, agony and ecstasy, whereas Rego speaks to us more directly of our own fears and worries. First she gets the pose – one that suggests embarrassment – exactly right. Then she captures the right expression on the model's face. She uses her formal visual language to make explicit and intensify this feeling of embarrassment, but she does it in a really interesting way. She picks out details that one would think might not be important – for example, the wicker chair or the laces on the shoes. These details are beautifully integrated into the overall arrangement.

Paula Rego (Portuguese, born 1935) has lived in London since 1975, but her childhood in Portugal living under a dictatorship looms large in everything she does. She is known for her output as a printmaker and her beautifully drawn illustrations of usually dark stories with a magical realist feel. In 1952, she was admitted to the Slade School of Fine Art, where her fellow students included her future husband Victor Willing (1928–88). When they had completed their studies, Willing and Rego moved to Portugal, where they lived for twenty-three years. Back in London, Rego rapidly built a reputation as an artist and was shortlisted for the Turner Prize in 1989.

See also
Alfred Edward Chalon (p.154)
Robert Pugh (p.182)
Paul Harbutt (p.278)

Sources

Most artists keep a sketchbook, and although many don't use it outside the studio it is nevertheless a very useful tool. Observing people's postures and gestures will help your drawing develop and become more expressive. Your first instinct will be that you have to make a drawing comprehensive, but when working in a sketchbook this is not the case (far left).

It is very tempting to think purely in terms of recording what things might look like, but you can expand on this idea. When you're drawing, try to connect what you're noticing with how you're feeling. So, for example, if you are on a crowded train and feeling slightly claustrophobic, try to observe what things look like while you are in that state of mind compared to when you are not; your drawing style may change when you are anxious (left). Make a written note of your feelings, too, as this can often trigger memories at a later date.

See also

Honoré Daumier (p.158)
Georg Baselitz (p.176)
Dexter Dalwood (p.276)

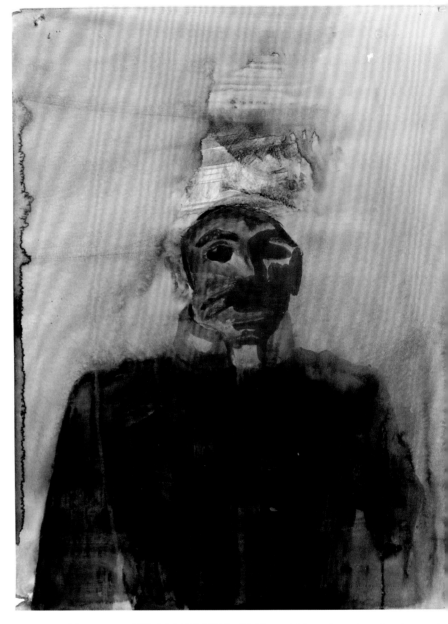

Peter Doig (British, born 1959) was born in Edinburgh. In 1962, he moved with his family to Trinidad, and then in 1966 to Canada. He relocated to London in 1979 to study first at the Wimbledon School of Art and then at St Martin's and Chelsea Schools of Art. In 1989, he worked part-time as a dresser at the English National Opera. He emerged as a leading figure of the British art scene in the 1990s, creating a sense of excitement around landscape painting when the slick, conceptual art of the Young British Artists was in vogue. He returned to live in Trinidad in 2002.

Sources

Artists have used photography since its invention in the 19th century, although in its early years there was a problematic relationship between the two art forms. Probably the least effective way to use a photograph is to make a replica on a larger scale by painting or drawing it. It might be satisfying to do this once. However, as with most working processes, it is important to first establish what you

Guest House 3 2002
Mixed media on white wove paper
55.5 × 75.6 cm (21⅞ × 29¾ in.)
Art Institute of Chicago, Illinois, USA

Peter Doig is regarded as one of the most important living painters. The images he creates generate an extraordinary mood that references both tradition and contemporary experience. Nor does he suffer from the dilemma of many figurative artists about the role of photography in art. Doig once worked as a part-time dresser at the English National Opera, where he helped performers with their awkward period costume. One evening he and a fellow dresser donned costumes and walked out on stage. A photograph of that moment was taken and the picture remained in Doig's studio for years. When he was later working on a painting that needed figures in a particular position, he found that nothing he tried seemed right. Remembering the photograph, he placed the two figures in a little gate entrance of the stone wall he was painting and everything fell into place. Doig used the same technique in this piece, a drawing overlaid with watercolour.

Doig uses photographs in a very interesting way – more as provocations than as pieces of specific information. He may have a photograph that reminds him of a particular mood or is significant in some way; this could act as the starting point for a painting or be introduced as it develops. As that photograph is recreated in paint, it starts to have its own life and triggers yet more ideas and feelings for him. These are then acted on; he might destroy that particular contribution or it may take the image in a new direction. Doig uses these photographic contributions like memories – they are elements of the collage that go on to create the finished work. In this transformative process, the medium that Doig uses is critical. Taking a photographic image and recreating it completely changes its nature. No longer fully descriptive detail, it becomes an evocation of mood.

are trying to achieve. Doig shows that the way we record past events by means of a photograph can play a role in how we end up making our paintings and drawings.

If you use a photograph more directly, then it is important to transform it in some way. Even if you use it as an element within a collage, the context in which you place it has to transform both itself and the rest of the collage. You can use a new medium to make that transformation. For example, Doig painted directly from a photograph in a very unphotographic-like medium – watercolour. Try experimenting with different media that have an awkward relationship with the way a photograph looks. Consider not only a change of medium, but also using an instrument that might make it difficult to create intricate detail – for example, a large brush (far left) or pen and ink (right).

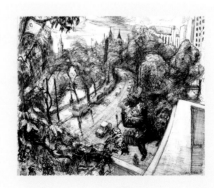

See also
Rembrandt van Rijn (p.146)
Georg Baselitz (p.176)
Miquel Barceló (p.208)

Robert Pugh (British, born 1950) was born in London. He trained at Byam Shaw School of Art. His interest is in painting people and he has exhibited in group exhibitions, including at the Royal Academy, the National Portrait Gallery and the Whitechapel Gallery. Pugh has a long-standing interest in printmaking and works with soft ground etching and multiplate colour aquatints. In 2016, he was awarded the Etching Guild Master's first prize at the 'Intaglio International Exhibition' in Latvia. His etchings are in various permanent collections, including those of the East London Printmakers Archive, the Victoria and Albert Museum and Scarborough Museum. He is a member of the Printmakers Council, East London, and also of the Brighton Independent Printmakers.

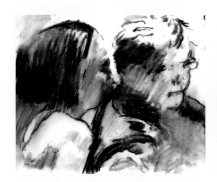

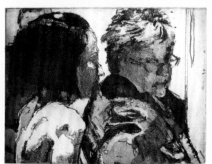

Squeeze 2016
Graphite pencil on paper
15 × 20 cm (5 ⅞ × 7 ⅞ in.)
Collection of the artist

This drawing is from a series Robert Pugh made exploring the idea of empathy. It is based on a video performance by Marina Abramović and her then partner Ulay, titled *Imponderabilia*, which was shown at the Galleria Communale d'Arte Moderna, Bologna, Italy, in 1977. Abramović and Ulay stood in the entrance to the exhibition, forcing visitors to squeeze through the gap between them. The discomfort for visitors was made more acute by the fact that both artists were naked. She described the piece at the time: 'the public entering the museum has to pass sideways through the small space between us. Each person passing has to choose which one of us to face.' For Pugh the performance piece triggered personal memories of awkward situations, and he wanted to replicate this sense of unease.

He rapidly produced over thirty small drawings, each taking no longer than five minutes, in which he explored the relationship between the uncomfortable feelings expressed in the video, his memories of similar feelings and the formal consequences within the drawing. (This is the only drawing that remains of the thirty or so that preceded it.) The speed of execution prevented superfluous details becoming a distraction. As he made each drawing he found that, while the figures remained a similar size, the edge of the paper was being pulled in as if the figures were being compressed. Pugh made several significant changes in the first few drawings: in the video Abramović showed her naked breast, but as Pugh progressed it became clear that simply showing a naked shoulder would make the image more intense. Here, the jacket the woman is wearing became more tightly wrapped as if to protect her from embarrassment and Abramović's partner has disappeared from the frame altogether.

Materials
Pugh used graphite sticks and pencil on ordinary thick cartridge paper to explore the feelings expressed in the video installation. A good exercise is to try drawing the same subject as here, but in a different medium (far left). As you can see from Pugh's final colour print (left), switching to a new medium can suddenly open up new visual and emotional possibilities in your drawing.

Sources
Inspiration can come from unexpected sources and from the work of other artists, albeit in different media. Working in a different medium stops you from 'copying' and helps you focus on reinventing the idea that has stimulated you. See the drawings elsewhere in this book by Tintoretto (p.260) and Naldini (p.214) of a sculpture by Michelangelo depicting Samson slaying the Philistines.

Raphael	188
Lee Krasner	190
Nicolas de Staël	192
Hans Hofmann	194
Philip Guston	196
William Turnbull	198
Eva Hesse	200
Frank Auerbach	202
Joan Miró	204
Leon Kossoff	206
Miquel Barceló	208

Abstract art does not attempt to represent an accurate depiction of visual reality; instead it uses shapes, colours, textures and marks to achieve its effect. Abstract art looks to remove simple visual elements such as tone, line and colour from the objects being represented. For some viewers, the experience of looking at an abstract work enables them to appreciate the qualities of line and tone in a way that is impossible or difficult when they represent objects. However, all our visual understanding comes from experience of the real world and the power of those lines and tones is inevitably rooted in visual experience. Even if we draw random marks on a piece of paper, a viewer will try to make sense of those marks in some way and, in making sense of them, will eventually return to their individual experience of reality.

Nonetheless, it is important to understand that the relationship between abstraction and representation is complex. When working on an abstract image, understanding the role that visual experiences play in giving those abstractions meaning helps an artist make images that are more intense and meaningful. Any artist hoping to make representations with more clarity and power will not succeed without fully understanding the ways in which abstractions can be made to reveal the representation behind them. For example, Philip Guston's extraordinary drawing (see p.196) seems both fragile and monumental: his organic forms appear to disintegrate into something completely unrecognizable. By contrast, Eva Hesse's simple repetitive shapes look as if they have been steamrollered into the surface of the paper (see p.200).

Study for the Drapery of a Man *c.* 1503

Black, brownish-black and white chalks on pale buff paper
38 × 23 cm (15 × 9 in.)
Ashmolean Museum, Oxford, UK

Like Raphael's portrait of a young woman (see p.74), this drawing was made when the artist was about twenty years old, although it could not be more different. Aside from the change in subject matter, this image has a greater sense of freedom and an almost feverish quality. It is as if the robe is materializing before our eyes and Raphael has captured it at the moment it comes into being.

Leonardo da Vinci made many studies of drapery in which he focused on the accurate description of light falling on each fold of fabric. Here, Raphael has isolated the form, although there are a few marks suggesting a shoulder and arm, and concentrates on the energy that the folds convey rather than any descriptive accuracy. The marks seem to break away from the surface of what is being depicted and because of these free multiple alternatives, we sense that the form under the cloth is moving as well.

It is important to remember that practitioners look at drawings differently to art historians. As an artist you look at this drawing and ask, does it suggest a new way of seeing something familiar? This extraordinary, unexpected reinvented form looks like a disintegrating ice-cream cone or some whirlwind twister rather than a sketchy study for drapery. To create this kind of visual poetry – drawing an object as if it were something else in order to make it more 'real', more itself – is challenging but fascinating.

Raphael (Italian, 1483–1520) was born in Rome as Raffaello Sanzio. He was the son of Giovanni Santi (*c.* 1435–94), who was a court painter to the Duke of Urbino, Federico da Montefeltro. Raphael received an apprenticeship at Perugia, Umbria, where he spent time in the studio of Pietro Perugino (*c.* 1450–1523). Raphael moved to Florence in 1504, where he produced some of his famous paintings of the Madonna. In 1508, Pope Julius II summoned him to Rome, where he painted frescoes for the Vatican. Other projects that he completed in the city include portraits, a series of tapestries for the Vatican and architectural designs for St Peter's Basilica.

See also

Honoré Daumier (p.158)
Philip Guston (p.196)
Egon Schiele (p.236)

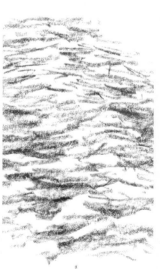

Sources

When drawing directly from life or drawing in a representational way, it is easy to think that the more descriptive the drawing is the more like the object the drawing becomes. As we have seen elsewhere in this book, this is not the case unless you are interested in an illustrative rendering of form. A large part of the power a drawing has comes from it making us see in a new way. This may not be explicit, but it is often felt. For example, if you are drawing leaves on the forest floor (far left) and you find that the drawing only gets worse the more you work, look for some way of transforming the way you are 'seeing' the leaves. Ask yourself, in this context what are the leaves like? Do they look like something else? You might think that they look like the wind making patterns on waves on the sea (left). When you come up with an idea of seeing an object differently like this, try and draw it like that.

Lee Krasner

Nude Study from Life 1939
Charcoal on paper
63.5 × 48 cm (25 × 18 ⅞ in.)
Private collection

Since her death in 1984, Lee Krasner has become increasingly recognized not as the wife of Jackson Pollock, but as a worthy artist in her own right. It is fair to say that many of her paintings owe much to Pollock's influence but, judging by the quality of the early drawings, that influence may not have been entirely positive. She destroyed many of the paintings she did around this time after she became involved with Pollock in 1942.

The single biggest influence on her early work (aside from the opening of New York's Museum of Modern Art in 1939, Postimpressionism and Cubism) was Hans Hofmann. Hofmann's teachings bridge the gap between Abstract Expressionism and the European figurative tradition. He was mainly concerned with pictorial structure, spatial illusion and colour relationships, and in the way that these could be abstracted to create an independent parallel reality.

Here, Krasner works towards preserving unity while creating a dynamic whole. This drawing shows the influence of Cubism, but the lines are more expressive. We see traces of the head twisting to the left, yet she uses lines to cut straight across forms, flattening them to produce planes that dissect and penetrate the space. The drawing is remarkably consistent in its pictorial logic, although others from the same period are less so – there is a mixture of abstracted planes and illusionistic realism that is not as successful. In this drawing, however, it is interesting to see her reducing and taking out some of the more illusionistic elements.

Lee Krasner (American, 1908–84) was born in New York and studied at Hans Hofmann's (1880–1966) School of Fine Art. Krasner's work of this period is comprised of blocklike forms, delineated with bold, black outlines that have been worked and then subsequently reworked. Krasner married Jackson Pollock (1912–56) in 1945. The couple's decision to decamp to The Springs, near East Hampton in Long Island, afforded both artists the opportunity for further experimentation, and Krasner developed her *Little Images* (1946–49) series, comprising an indeterminate mass of discrete gestures that cohere on the picture plane as a single field. She subsequently experimented with techniques, including collage.

See also

Hans Hofmann (p.194)
Alberto Giacometti (p.242)
Willem de Kooning (p.270)

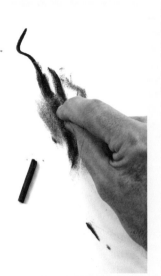

Materials
Even experienced students can find charcoal difficult to use. Remember that charcoal will rub off quickly and easily if it is only sitting on the paper's surface. Try to push it into the surface of the paper (left). This can be quite a vigorous process, so use your fingers to push it in hard. You can also use a fixative spray to fix the drawing on the paper. It's then possible to draw over the fixed drawing, although it will then be very hard to rub out.

Line and Form
Krasner's drawing is highly abstract. It is difficult to see a specific line referring to an object, although there is a sense of the seated model. With this style of drawing. try to identify the principal planes early in the process and extend them to make an interesting overall structure. as shown here (left). However, it is important that this doesn't then become a way of stylizing the image but a real discovery that lends dynamism to your composition.

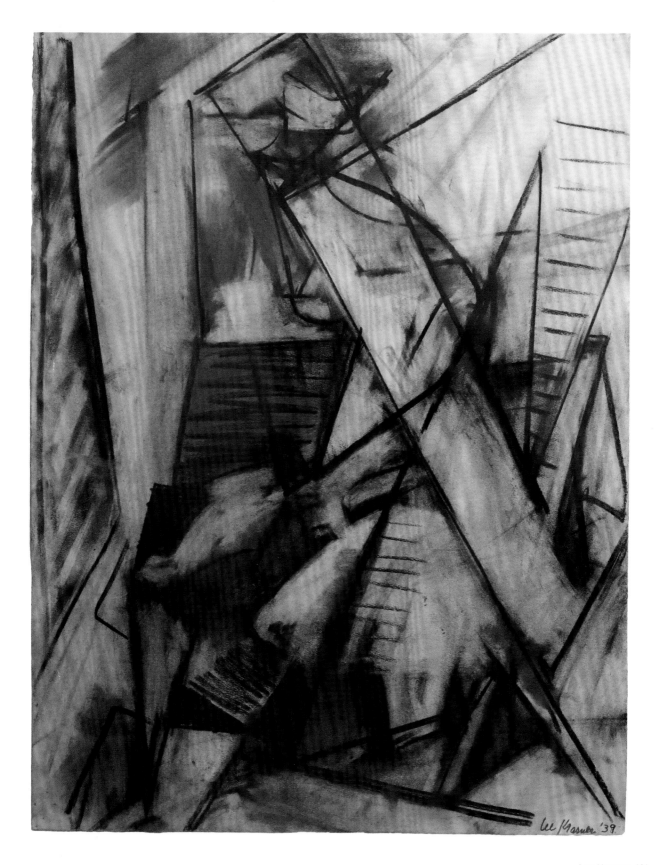

Lee Krasner '39

Nicolas de Staël

Composition 1945
Charcoal on paper
50 × 40 cm (19¾ × 15¾ in.)
Private collection

Although Nicolas de Staël did not regard himself as part of any art movement, his highly abstract work shares similarities with American Abstract Expressionism and with its French precursor, Tachisme. Although there was a dramatic shift in the art world from Paris to New York during the 1930s and 1940s, many of the finest artists of the 20th century – Picasso, Matisse, Beckmann, Miró, Giacometti and Balthus – were still working in Europe and producing great work. De Staël lived in France, but he had several successful shows in the United States and England in the early 1950s. His work possesses many of the hallmarks of the great American Abstract Expressionists – large paintings with blocks of colour moving across the surface of the painting.

This drawing is from a series of highly abstracted work he did in the 1940s. He sets up a kind of uniform void for these black streaks to exist in. For the viewer it seems impossible to connect these marks with anything that might exist in reality. You are forced to simply enjoy the streaky, wiggly pleasure induced by these confident marks. Many of the other drawings in this series have a tenser surface that spreads from left to right and top to bottom, all the way to the edges. Here, however, the lines are emphatically on top of the background tone, making the whole image seem much more transparent. This feels strongly like a man-made, abstract reality.

Nicolas de Staël (Russian-French, 1914–55) was born into an aristocratic family in St Petersburg, who were forced to move to Poland after the Russian Revolution. By 1922, both of his parents had died and he was adopted by some Russian expatriates in Brussels, where he went on to study art at the Académie Royale des Beaux-Arts. From 1936 to 1938 he travelled widely in Europe and North Africa before settling in Paris, where he trained under Fernand Léger (1881–1955). When World War II broke out he joined the Foreign Legion. After the war, he became one of the leading abstract painters of the School of Paris.

See also

Dennis Creffield (p.134)
Joan Miró (p.204)
Anselm Kiefer (p.272)

Materials
Abstract art focuses on the artist's engagement with his or her materials. Developing an instinct for the right mix of materials and the effects they produce is central. When you remove any reference to the real world (objects, space, form, light and shade), you are left with the materials that make your marks. The visual pleasure of looking at an abstract work comes from the materials. It allows a purging of unnecessary information that can bring you closer to a purely aesthetic experience.

Sources
When artists talk among themselves, it is often about the technical and material possibilities rather than the spiritual. Artists may be in a state of trance when creating, but we can't articulate its nature as this aspect of art is unknowable. We know about composition and light and shade, and we can see that at times they work and at others they don't. Paradoxically, abstract drawing (left), while entirely concerned with materials, is almost impossible to talk about.

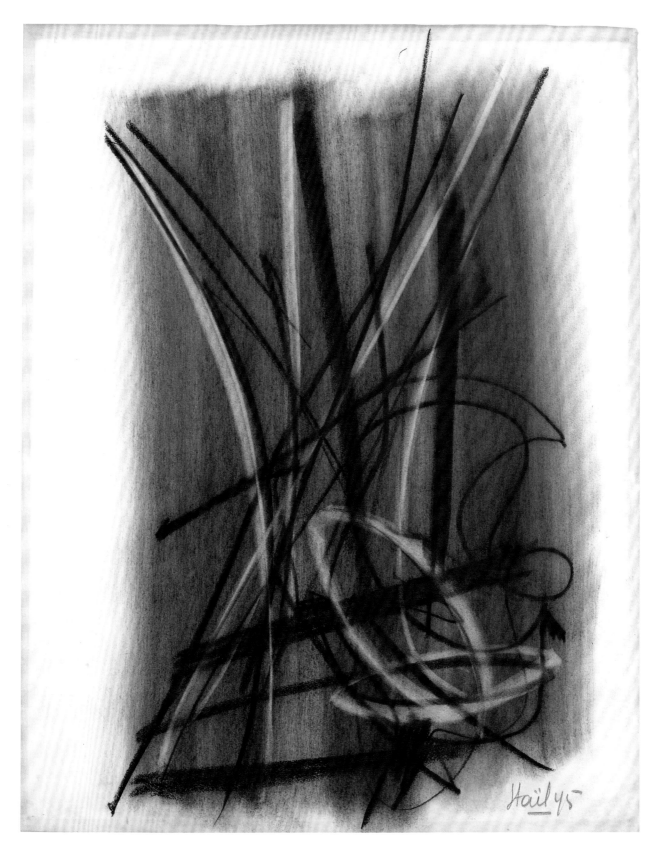

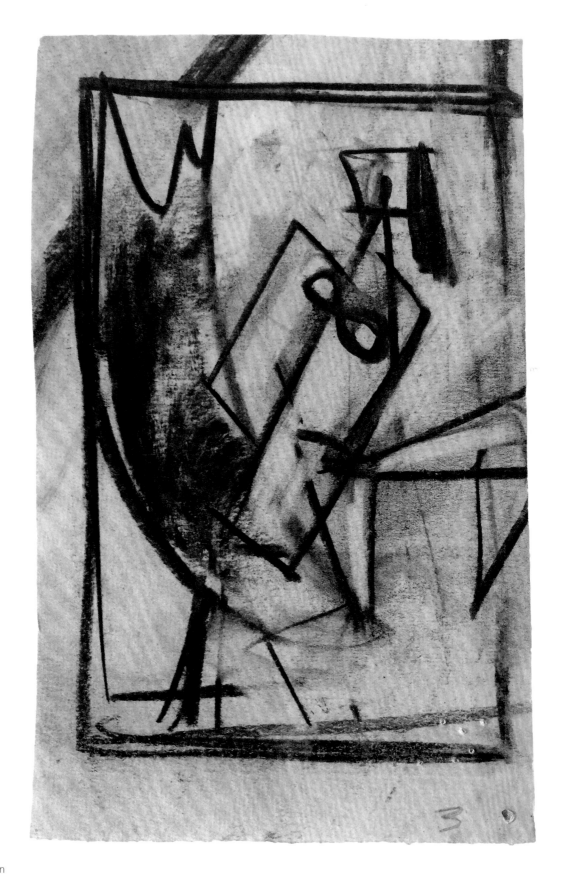

Hans Hofmann

Untitled (One of Six Original Charcoal Sketches) *c.*1947
Charcoal on paper
25.4 × 17 cm (10 × 6 ¾ in.)
Private collection

From the late 1930s to the 1950s, a concentration of the world's most innovative artists was working in New York rather than Paris. These were the Abstract Expressionists. The name was coined by art critic Robert Coates in 1946, but many of the movement's ideas originated in German Expressionism and the work of artists such as Wassily Kandinsky, Paul Klee and Joan Miró.

By 1932, when Hans Hofmann emigrated to the United States, he had already founded and closed his own art school in Munich. In the mid 1930s he opened his first US school in New York and later another in Provincetown, Massachusetts, where he spread knowledge of European modernist art styles. Hofmann's writing profoundly influenced the Abstract Expressionists and they moved towards the idea that, by removing any familiar or descriptive subject matter, the paint and canvas itself become the subject.

Although not one of Hofmann's best drawings, this sketch is interesting because it shows the way he thought about pictorial structure. It is one of six sketches made at the base of a drawing from life by one of his students. Hofmann has defined a rectangle in which he has drawn big, simplified, sweeping lines. This reveals his ideas about linear architecture and how it forms the structure – for example, how the diagonal movement of the figure from left to right is balanced by the big curve that comes in from the top left-hand side, which pushes down from the model's head into her shoulder and continues into the tabletop. Even though it is almost diagrammatic, it is a powerful little drawing.

Hans Hofmann (German-American, 1880–1966) moved with his family to Munich from Bavaria when he was six years old. Although interested in mathematics, science and music as well as art, he began studying art formally in 1898. In 1904 he moved to Paris, where he befriended many leaders of the modernist movement, including Henri Matisse (1869–1954), Pablo Picasso (1881–1973) and Georges Braque (1882–1963), but his most important friendship was with Robert Delaunay (1885–1941), whose emphasis on colour over form was highly influential on his work. In 1932 Hofmann moved to New York, where he opened the Hans Hofmann School of Fine Arts in Manhattan.

See also
Nicholas Volley (p.66)
Lee Krasner (p.190)
Willem de Kooning (p.270)

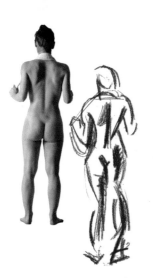

Tone and Line
In abstract drawing, light and shade are not used traditionally. Tone simply differentiates one area from another – while it may hint at a change in light and shade, it may not conform to that. The same applies to line: lines are not connected to contours or edges of forms, but indicate lines of force or synthesized planes. Simplifying visual language will help you capture a dynamic aspect of a subject without compromising on details (left).

Sources
When working from a model in life, it is very easy to lose sight of some of the basic, simple visual ideas that you discovered early on in the process of learning to draw. It is really useful to keep a sketchbook close by so that you can refresh and clarify those early ideas by means of a small abbreviated sketch (left). As you become more confident, you will be able to integrate these abbreviated sketches into your drawing without fear of losing unnecessary details.

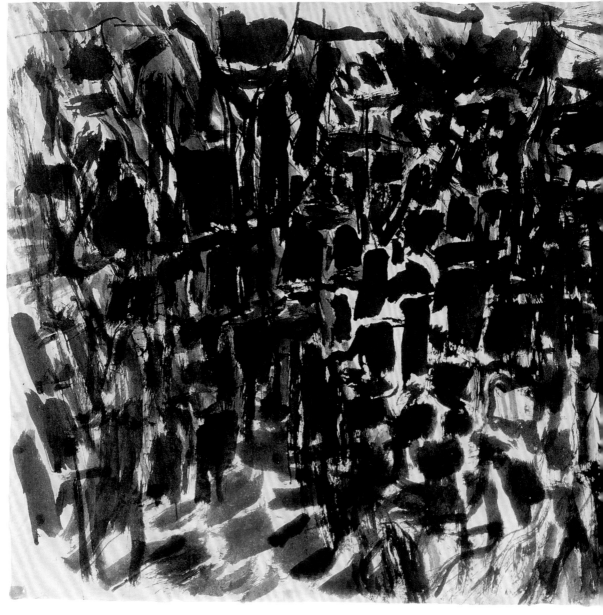

Philip Guston

See also

Nicolas de Staël (p.192), **Joan Miró** (p.204)

Philip Guston (American, 1913–80) came from a Russian-Jewish family. He went to school with Jackson Pollock (1912–56) in Los Angeles, where they were both expelled for writing a paper criticizing the school for valuing sports over arts. In the 1930s he worked for the Federal Art Project, producing murals influenced by Mexican artist Diego Rivera (1886–1957).

In the 1950s, Guston became one of the chief exponents of Abstract Expressionism. He returned to figuration in 1970 with a show at New York's Marlborough Gallery, which horrified some of his supporters who thought his new work cartoonlike. However, he is best known for the Abstract Expressionist paintings that he continued making up to his death.

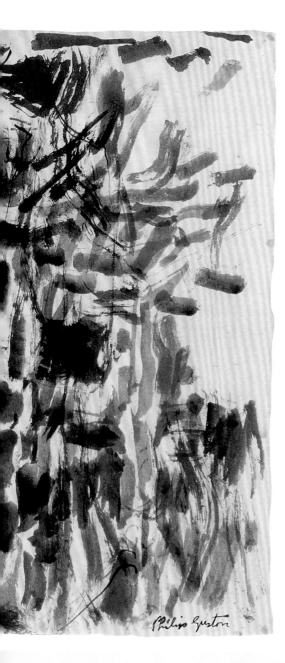

Untitled *c.*1953
Ink on paper
62.2 × 99.1 cm (24 ½ × 39 in.)
Acquavella Galleries, New York, USA

Philip Guston was familiar with the work of European abstract artists such as Jean Arp, Nicolas de Staël and Joan Miró, many of whom had exhibited in New York during the 1930s and 1940s. Abstraction was the most significant art movement of the mid-20th century and many North American artists wanted to be part of it. Although Guston started out as a figurative painter, by 1947 he had moved towards abstraction. He spent more than twenty years making purely abstract work that was highly regarded and he became close friends with many of the Abstract Expressionists. In 1967, however, when Guston started painting highly figurative work, partly inspired by the cartoons of Robert Crumb, many of these artists felt totally betrayed.

Guston's abstract work superficially resembles the late water lily paintings of Claude Monet. However, the crucial difference is that Guston's abstract work always feels like he is at a distance from the forms he is inventing. They feel like organic, natural forms, unlike those of Nicolas de Staël (see p.192), for example, which feel more man made. Guston's abstract improvisations create a world that looks half formed. Things appear to be in a state of flux – they have not yet materialized into anything believable. Most of Guston's paintings and drawings from this period have an organic and natural cell-like structure. The images are conceived from the middle of the composition outwards and they often feel incomplete – it is as if the artist cannot get to the edge of the paper. When we compare his later work with these early abstract drawings, it seems quite likely that this incompleteness was a factor that preoccupied Guston and prompted the change to a more figurative style.

Line
When we say that the parts of a drawing 'relate' to each other, we mean the way one line or mark connects or contrasts with another. These relationships can be created mindfully or instinctively. For example, the marks in the box (far left) – a few dots, an 'L' shape, a couple of longer lines – can be made to look like a face. You read them together and make a connection. In the second illustration (left), the marks have a connection but it is less obvious what they depict. They have a logic – solid, more broken up, very broken and reformed – but no explicit meaning. We can see the start of a possible division – between marks being representational or abstract. Or could they be both? In Guston's image, we see the marks have a connection and that collectively they make a unified whole.

William Turnbull

Head 1955
Black ink and coloured pencil on paper
53 × 42 cm (20 ¾ × 16 ½ in.)
Turnbull Studio, London, UK

William Turnbull is one of the most important British sculptors and painters of the second half of the 20th century, yet only art world enthusiasts know his name. In 1948 he moved to Paris where he met artists such as Brancusi and Picasso, but it was his friendship with Alberto Giacometti that made the deepest impression on him. Giacometti moved easily from sculpture to painting to drawing, exploiting and using each medium's quality to express his visual ideas of space and form. As Turnbull's work developed, he too used different media in a very similar way. The first of Turnbull's head series were clearly influenced by Giacometti, but he quickly developed these ideas into his own visual language.

During World War II, Turnbull was an RAF pilot; he discovered that, when flying, space felt more like an object, which is completely different to the way you experience it when on the ground. In this drawing the object (the head) feels more like a space; each spatter and squiggle floats freely, the circular line only just holding them together. This abstracted head shape and what looks like a hint of the neck and shoulder could in fact be the sun, a tree or any number of other objects. Yet it feels to the viewer most like a head. This image is reminiscent of the work of Jean Dubuffet or Paul Klee. The sensation when viewing it is like suddenly arriving on the middle of a ladder. Some viewers will want to go down to see where it comes from, whereas others will be happy to continue going up the ladder to see where it might take them.

William Turnbull (British, 1922–2012) was born in Dundee. After he left school he worked as a labourer and attended evening classes in art at Dundee University. From 1939, he worked as an illustrator at publisher DC Thomson. In World War II, he served in the Royal Air Force as a pilot. After the war, he enrolled at the Slade School of Fine Art, where he studied painting and then sculpture. He then travelled to Italy and Paris, where he mixed with the avant-garde. In 1950, he had a joint show with Eduardo Paolozzi (1924–2005) at the Hanover Gallery, London. He settled in London, where he joined the Independent Group and taught at the Central School of Arts and Crafts.

See also
Oskar Kokoschka (p.132)
Alberto Giacometti (p.242)

Materials
Turnbull tries to keep the surface alive and in a state of flux, not letting the marks take the image into a random chaotic mess or solidify and become static. He is performing a balancing act.

Don't try to describe where the nose is or where the mouth might be or anything that specific. This approach has more in common with improvisation – not description. In the early stages let the chance quality of the marks lead you, as in this illustration (left).

Composition
With loosely expressionistic drawings, it's difficult to know which marks to make first. In the Turnbull the large circle was probably done first, followed by the pen squiggles; then paint spatters were added after which more lines, then some whitish grey gouache towards the end.

Don't make your drawing too small. The dimensions need to be big enough to allow marks to be made with freedom. If the paper is too small, the image will be dense and overworked (left).

No title *c.*1965–66
Ink wash on paper
29.8 × 23.2 cm (11¾ × 9⅛ in.)
Hauser & Wirth, Zurich, Switzerland

The American sculptor and artist Eva Hesse died of a brain tumour when she was only thirty-four years old. Influenced initially by Abstract Expressionism and then Minimalism, she was one of the post-war artists whose innovative work in the 1960s heralded the Post-minimalist movement.

We mostly think of art as representing a characteristic of the real world or reflecting an experience such as an emotion or feeling. With Minimalism, no attempt is made to represent an outside reality; the artist wants the viewer to respond only to what is in front of them. The medium from which it is made and the form of the work are the reality. Minimalist artist Frank Stella famously said of his paintings: 'What you see is what you see.'

This drawing is beautifully simple. A series of circles are sandwiched between a series of rectangular strips. Nothing could be simpler, but the effect, with its series of repetitive shapes echoed across the surface, is almost hypnotic. However, there is something troubling among the repetition. One line of circles has no strip separating it from the next. As the eye moves across the circles, it starts to see minute differences – the viewer gets sucked into the surface of the drawing and into the material. Taking in the whole image it is almost like looking down on a tray of cakes or buns in a baker's that have been squashed flat. As you examine the picture, your mind wanders from association to association – but always with this compelling pulse running through the image.

Eva Hesse (German, 1936–70) fled Germany with her Jewish family in 1939. Her mother was traumatized by life in exile and committed suicide when Hesse was aged ten. Eva went to the United States, where she studied painting at the Cooper Union School of Art, New York. She also took classes at the Art Students League and the Pratt Institute. From 1957, she trained at the Yale School of Art and Architecture. Initially, she worked as an abstract painter and commercial designer, then in the 1960s in Dusseldorf she switched to producing sculptures and installations using unconventional and industrial materials. She was diagnosed with a brain tumour in 1969 and died within a year.

See also

Piet Mondrian (p.56)
Giorgio Morandi (p.64)
Paul Klee (p.268)

Materials
In Hesse's drawing, there is an acceptance of the qualities of the media that gives it a fragile feel. But the way it is organized generates certainty and strength. Preserving the unique qualities of your media and playing to their strengths can produce strong results. It is tempting to be too precise and neat, thereby eliminating the quirks that characterize the handmade. Repetitive patterns pull the viewer into the surface of an image, making them look closely.

Subject Matter
Humans are programmed to find order in chaos. The instinct to make connections between things that at first sight don't look connected is a fundamental driving force behind creativity. Photography can be very helpful in finding subjects that can be used in this kind of drawing (far left). Remember: when you do your drawing from a photograph, you are not making a replica photograph – you are making a transformation (left).

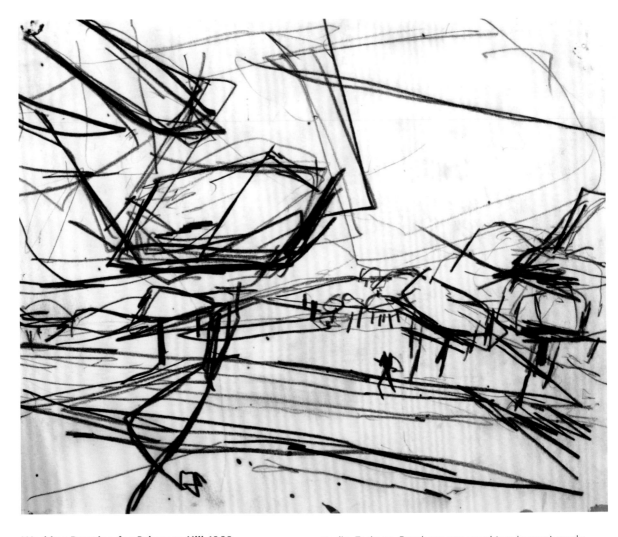

Working Drawing for *Primrose Hill* 1968
Graphite on paper
25 × 30.5 cm (9⅞ × 12 in.)
Tate, London, UK

Although this is a small drawing, it has extraordinary energy. However, it feels crazy with so many lines pinging about and it is important to understand the ideas behind it. David Bomberg was an influence on the young Frank Auerbach and he was taught by Walter Richard Sickert, who in turn was influenced by Edgar Degas. Sickert changed the face of British painting at the turn of the 20th century by bringing a gritty urban realism to shake up a genteel Edwardian complacency. Yet it was Sickert's way of making the material substance of paint transform the tawdry ordinariness of a simple domestic scene that was so startling. Sickert understood that drawing from life was crucial to this. He rented studios that were real bedsits or lodging rooms, and was convinced that any mood could be recreated in the studio. Early on, Bomberg was caught up in avant-garde Vorticism and it was only later he came back to the ideas that Sickert had planted. He expressed this in what he described as 'spirit in the mass'. It was this direct encounter with the mass of a form that he wanted to capture.

Auerbach's way of working was not conducive to making an urban landscape painting *in situ*, so he used drawings to record his sensations. He then worked from them back in the studio. This drawing is one of a series of quick sketches made while standing in front of the motif. Primrose Hill is in Camden, an area of north London where Auerbach has lived for most of his life. The lines are adumbrated marks that suggest an aspect of the scene that is usually subsumed in distracting details. In New York, artists like Hans Hofmann looked at similar issues of representation, whereas in 1960s London Oskar Kokoschka created highly dynamic drawings of the River Thames. The thread that connects artists from different centuries is one that defies art's historical categorization but opens up a way of looking at familiar work.

Subject Matter

Auerbach's approach has developed over many years and to merely ape his style would be a mistake; instead, try to understand his process. The gestures, in the form of pencil marks, become moments in time, like the marks a skater leaves on the ice – the visible evidence of a performer's possession of the space. Auerbach reinvents the form through these lines. Start your drawing by working from a photograph (left).

Scale

The size of your drawing is important. Small, sketchbook-size drawings can be made in quick succession. This fluid approach will help you move away from making a drawing that describes objects. Draw a box within which you remake the landscape. leaving a white frame around the edge as here (left). This will remind you of the whole field you are considering. If you need to change the proportions, extend one side.

See also

David Bomberg (p.130)
John Singer Sargent (p.162)
Lee Krasner (p.190)

Frank Auerbach (German-British, born 1931) was born in Berlin to Jewish parents. They sent him to England to escape Nazism in 1939 and he never saw them again. In London, Auerbach studied at St Martins School of Art and the Royal College of Art, but he was most inspired by his lessons with Vorticist painter David Bomberg (1890–1957) at Borough Polytechnic, and by his friendship with future Expressionist painter Leon Kossoff (born 1926). In his first solo show in 1956, Auerbach was criticized and championed for his thick impasto technique. He has taught in Britain's leading art schools and was the subject of a major retrospective exhibition at London's Tate Britain in 2015–16.

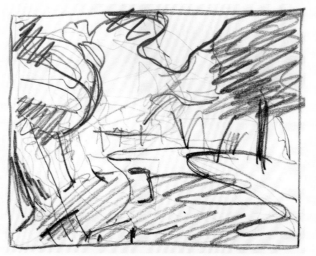

Line

As you look at your subject, you will be reducing different sensations into gestural lines – an edge of a shadow here, a groove in the ground there or the force of a form somewhere else. The way these condensed sensations interact will become apparent as the drawing starts to take shape (left). Try to keep the drawing simple to start with. Do not worry about making a mess, but remain fluid.

Figure Pulling Out a Nail of a Sick Person 1977

Graphite pencil on paper
23.4 × 27.5 cm (9¼ × 10⅞ in.)
Fundació Joan Miró, Barcelona, Spain

The history of art is littered with artists who have expressed contempt for bourgeois society and those who pander to its tastes. Though amongst the former, Joan Miró has been elevated as one of the most important 20th-century artists by those same people and their institutions. Like Paul Klee, André Masson and other Surrealists who were born in the late 19th century, Miró felt compelled to destroy the conventional language of painting.

This drawing contains echoes of Picasso's painting *Night Fishing at Antibes* (1939) in its structure and in the signs and symbols that Miró uses. Viewers will always approach such images with their own set of experiences and associations, and so long as these are rich enough to trigger strong feelings it is arguable whether understanding the connections to artists and movements of the 20th century is necessary. A key aspect of Miró's drawing is that we as viewers 'connect' with it because it refers to our own bodies.

As you move your eyes around the drawing, the white paper seems to increase in brightness and shapes echo across the surface. If you look at the small moon-shaped object right in the middle, just under the arrow, and then move down the curve, you reach what could be the head of a figure. This head shape is incomplete, but it is finished enough to trigger a possible reading. If you move up another slightly wobbly line to the right, you suddenly find that you have become immersed in yet another fragmented form. Halfway up this fragmented form there seems to be an echo of the crescent moon. These journeys constantly entertain the viewer.

Joan Miró (Spanish, 1893–1983) was born in Barcelona to a family of craftsmen. From the age of fourteen to seventeen, he studied at the Barcelona School of Commerce. Then in 1912, he entered the Llotja School of Industrial and Fine Arts, where he studied landscape and decorative art. During the 1920s Miró lived in Paris, where he met Pablo Picasso (1881–1973), joined the Surrealist movement and experimented with automatism. He returned to Spain for a few years, but left to live in Paris again because of the Spanish Civil War. In 1956, he moved to Palma, Majorca.

See also

William Turnbull (p.198)
Paul Klee (p.268)
Ken Kiff (p.274)

Sources
Miró – together with André Masson and several other Surrealist artists – was a pioneer of automatic drawing. To practise this method you begin by drawing anything that comes into your head (left). Don't try to draw any particular objects – simply allow the drawing to go wherever your mind wanders. It is quite likely that the marks you draw will suggest a subject, but that subject won't necessarily be figurative.

Subject Matter
Another approach is to find a series of symbols or signs. You can't choose just any kind of symbols – you need ones that convey intrigue or mystery. Road signs, for example, would be too limited and prosaic. Celtic symbols (left) are more useful. Take elements of these and try to construct a subject, using the symbols as a vehicle to trigger associations. Miró connects with us because he uses the human body as the vehicle for his symbols.

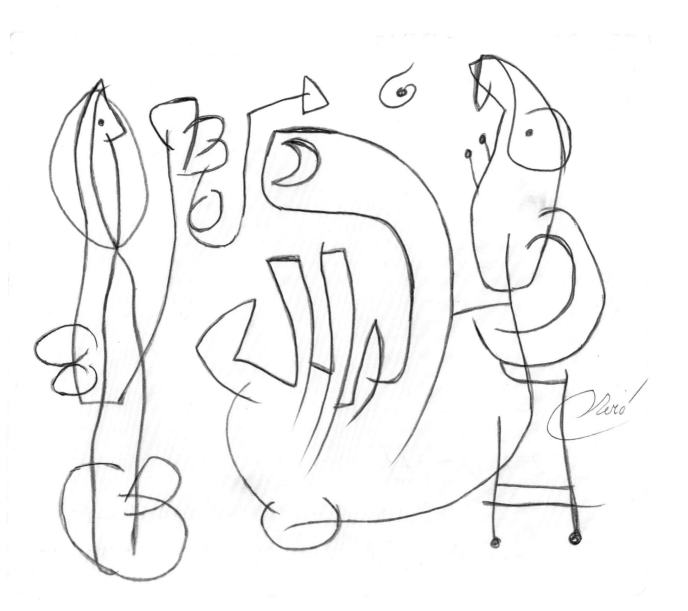

Leon Kossoff

Christ Church, Spitalfields 1990
Charcoal and gouache on paper
75.7 × 66 cm (29 ¾ × 26 in.)
Tate, London, UK

Leon Kossoff is one of a group of artists active in London from the 1940s who are loosely known as the School of London. It includes Frank Auerbach, Francis Bacon and Lucian Freud. Such group labels are not always helpful, as the work of artists is so different. However, Auerbach and Kossoff in particular share similarities in terms of the sheer dynamism of their work. Both convey a visceral energy that elevates mundane, everyday subjects to another level.

This drawing depicts an 18th-century church designed by Nicholas Hawksmoor. It is a subject Kossoff returned to repeatedly and he explained his motivation in a letter to a student in 1986: 'The urgency that drives me [is to do with]. . .the awareness that time is short, that soon the mass of this building will be dwarfed by more looming office blocks and overshadowed, the character of the building will be lost forever, for it is by its monumental flight into unimpeded space that we remember this building.' It is interesting that for Kossoff the memory of this building is very much to do with its presence within a particular space. Changing the space around an object can completely change the way the object looks and therefore the way you remember it. Kossoff identifies the way the space surrounding the object affects its appearance, but when he comes to translating those sensations onto paper, the size of the paper presents another kind of space that imposes its own restriction. It is not only an impression of the object in reality, it is also a drawing of the consequence of putting those sensations into another context – that of the paper.

Leon Kossoff (British, born 1926) was born into a Russian-Jewish family in London. During World War II, he was evacuated to Norfolk where he lived with a family who encouraged his interest in art. When he returned to London in 1943, he enrolled at St Martin's School of Art. He also took drawing classes at Toynbee Hall, studied under David Bomberg (1890–1957) at Borough Polytechnic and attended the Royal College of Art. From 1959, he started to teach in various London art schools. He is commonly associated with a circle of School of London painters that includes Frank Auerbach (born 1931), Francis Bacon (1909–92) and Lucian Freud (1922–2011).

See also
David Bomberg (p.130)
Frank Auerbach (p.202)
Alberto Giacometti (p.242)

Sources

It would be impractical, though not impossible, to make a large drawing directly from life in a busy city. Often when we see drawings in reproduction they are diminished, because we don't see their true size. Yet, even on this reduced scale, Kossoff's drawing is convincing. Walking past the church you would be more likely to see it as tilted and incomplete rather than dead vertical and realistic (see left). He captures that moment of recognition so well.

Space

There are two types of space: the actual space an object is in and the two-dimensional space made by the edges of the paper. Kossoff draws the church in response to both real space and two-dimensional picture space, so we accept the odd bend in the tower. Be aware of these two ways of understanding space. When you walk outside, try to become aware of how buildings look. Then sit and make a drawing of what the buildings looked like as you were walking (left).

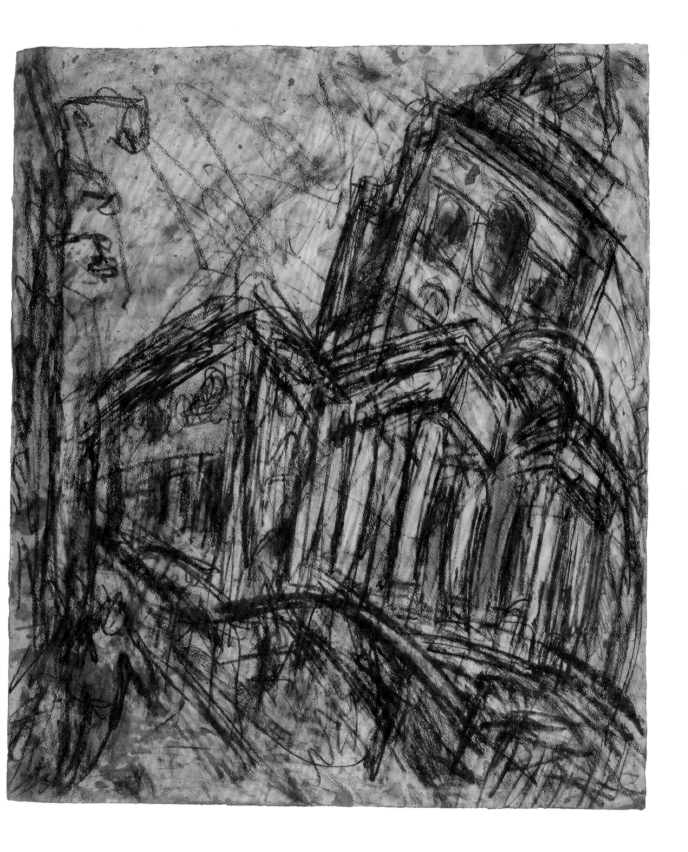

Miquel Barceló

Miquel Barceló (Spanish, born 1957) was born in Felanitx, Majorca. His first contact with art was through his mother, who painted in the Majorcan landscape tradition. He then studied art in Palma de Majorca and Barcelona. Barceló works across several disciplines, including sculpture, ceramics, collage and book illustration, but he is most famous for his paintings, which incorporate earth, sand and organic materials. After seeing the work of Jackson Pollock (1912–56) in 1979, he adopted the US artist's drip-paint technique. Since 1988 Barceló has divided his time between Paris, Majorca and Mali, and his works often focus on African culture and landscapes.

Untitled VII 1994
Mixed media on paper
75 × 104 cm (29 ½ × 41 in.)
Private collection

During the 1960s and 1970s, the world focused on contemporary art movements such as Pop art, Minimalism and Conceptual art. In the 1980s Miquel Barceló – along with artists such as Francesco Clemente, Lucian Freud and Francis Bacon among others – came to prominence as part of a wider resurgence of interest in painting. Many of these artists shared a high regard for tradition and the achievements of great artists of the past, coupled with a highly experimental attitude.

The physical relationship Barceló has with his materials seems to make painting into a sculptural activity; however, his drawing is much lighter in touch. During the 1980s he travelled extensively in Europe, the United States and West Africa, and became fascinated by Mali, where he set up a studio. In this drawing of an African landscape, the brown paper represents the arid ground scorched dry by the sun. The globs of molten lead dripped onto the paper burns into the surface. Traversing the paper from one side to the other are beautifully manipulated runs of watercolour, similar to the hardened pathways made by human traffic walking across the plains. Barceló's drawing recalls Leonardo da Vinci's advice to artists to study geological features such as rock formations for ideas of composition. Coincidental marks have a quality to them that is almost impossible to replicate consciously. However, these often don't work and the attrition rate for drawings produced in this way is high.

See also
Georg Baselitz (p.176), **Philip Guston** (p.196)

Materials
Experimenting with different materials can be a major distraction, but it can also be liberating for the artist and open up a new relationship with the subject. If you have work that you did many years ago, it could be interesting to revisit the same subject in a different medium. Here a simple, tonally modelled pencil drawing (far left) has been transformed years later into looser, more rhythmic pen and wash (left).

Form
To say these marks are visually ambiguous would imply a vagueness that the drawing doesn't have. In the illustration (far left) the artist has chosen a fairly descriptive image. The reworked image (left) is freer and more suggestive. Concentrate on making spontaneous marks that can be interpreted in different ways. Don't worry if you make 'mistakes': they may suggest surprising possibilities.

Giovanni Battista Naldini 214

François Boucher 216

Pierre-Paul Prud'hon 218

Louis Joseph César Ducornet 220

Jean-Baptiste-Camille Corot 222

Paul Cézanne 224

Edgar Degas 226

Georges Seurat 228

Edvard Munch 230

Auguste Rodin 232

Henri Matisse 234

Egon Schiele 236

Suzanne Valadon 238

Max Beckmann 240

Alberto Giacometti 242

Richard Diebenkorn 244

Balthus 246

Cecily Brown 248

Marlene Dumas 250

The nude is at the centre of the Western art tradition. Even at times when their preoccupations have focused elsewhere, most artists work with this subject at some stage in their career. Every age has its own particular concerns and has approached the subject in different ways. From the spare simplicity of Pierre-Paul Prud'hon (see p.218) to the sculptural qualities of Louis Joseph César Ducornet (see p.220) and the economic elegance of Suzanne Valadon (see p.238), the nude provides an insight into the way artists work.

Through close examination of the artists featured in this chapter, you can learn an enormous amount and develop conceptual, technical and methodological skills. The nude presents us with a subject that can be studied in a perfectly controlled environment. The traditional, even north light of

the art-school studio has provided an excellent milieu for generations of artists to learn how to draw the life model. Many of the basic terms of the nude's visual language have been passed down from generation to generation and have not changed. Using the whiteness of paper to represent natural light and the black of charcoal to create shadows, for example – as well as the myriad graduated tones inbetween – is taught the same today as it was 500 years ago.

Our awareness of abstract qualities enables us to produce images that move beyond mere resemblance. Although many non-professionals initially aim at a simple likeness, this can soon become boring. Drawing from a life model provides the perfect subject, the studio offers the perfect environment and the medium of drawing is the most simple and accessible means.

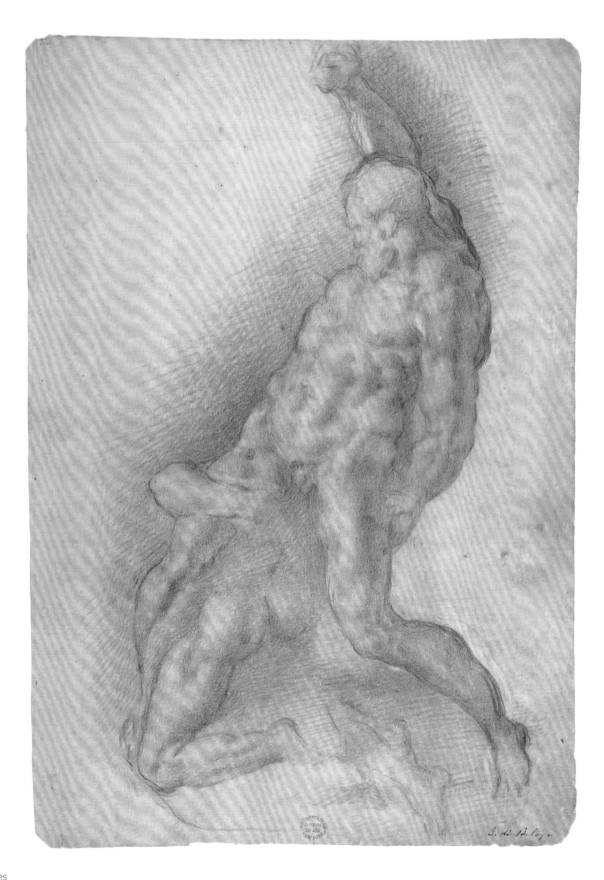

Giovanni Battista Naldini

Samson Slaying the Philistine, after Michelangelo 1537–91
Red chalk on paper
33.4 × 23.2 cm (13 ⅛ × 9 ⅛ in.)
Metropolitan Museum of Art, New York, USA

In the final years of his life, Giovanni Battista Naldini was regarded as one of the most important artists working in Florence; history, however, tells us a slightly different story. There are only a few surviving drawings by Naldini, although they do possess a vitality and unity that many of his paintings do not. Naldini joined the studio of one of the greatest draughtsmen of the Renaissance, Pontormo, at the tender age of twelve and he remained there for about eight years. From about 1560 to 1561, after Pontormo's death, he studied in Rome where he would have seen Michelangelo's work. Michelangelo's preparatory sculptures of Samson and the two Philistines were widely known and copied (although the marble was never completed) and Naldini made one of his most brilliant drawings from this subject.

Although Tintoretto's study is considerably larger, Naldini's drawing feels very monumental – like a drawing twice the size. Tintoretto guides the viewer's eye rapidly over the bumpy, lumpy, muscular surface but Naldini creates a massive powerhouse of a form. The way the torso is drawn seems to compress a titanic strength; in contrast, the leg on the right-hand side seems almost puny at first glance. Much of this power comes from the relationship Naldini forged between the internal modelling and the external contours: certain forms have been emphasized and others reduced – attention is drawn to the shoulders, for example, but not the lower arm. The shading also has a density that suggests solidity but seems surprising when not developed in certain areas, such as between the legs.

Giovanni Battista Naldini (Italian, 1535–91) trained at the Florentine studio of the Mannerist painter Pontormo (1494–c. 1556) from the age of twelve. After Pontormo died, Naldini spent some time in Rome, after which he returned to Florence. He had various patrons in Tuscany, but his output was mainly for the powerful Medici family. He collaborated with the artist, architect and writer Giorgio Vasari (1511–74) on various projects, including works for the Palazzo Vecchio and the decorations for the funeral of Michelangelo (1475–1564). In 1563, Naldini helped found the first drawing academy in Europe, the Accademia del Disegno.

See also
Pontormo (p.76)
Michelangelo (p.140)
Tintoretto (p.260)

Materials and Form
Conté crayon contains wax, which makes it harder to rub out. If you find it difficult to get the right scale or size in relation to the paper, put a small, light mark where you want the extremities, as here (left). Put a mark at the top of the paper where the hand might be and one at the bottom for the foot. This will remind you to look all the way from foot to hand with your actual subject and your sketch. It will help you assess where divisions are along that movement. If you flick

your eyes from foot to hand, you will unconsciously take in the shoulder's position. This is more effective than measuring with the end of a brush or pencil.

Try to build the form from the centre out, as shown (left), to create a better sense of volume. Do not put the features in first, but attend to any part that swells outwards. With a face, for example, you could start with the middle of the cheek. That way you go back into space towards the contour.

François Boucher

Female Nude Sitting on a Couch Undated

Red chalk and pastel
24.1 × 27.5 cm (9 ½ × 10 ⅞ in.)
Musée Bonnat-Helleu, Bayonne, France

Aside from Jean-Antoine Watteau, the beginning of the 18th century was notable for a dearth of outstanding artists. Most of the Baroque masters – Rubens, Velázquez, Rembrandt and Claude – were dead. Although the subsequent Rococo period exemplified frivolity and superficiality, its achievements should not be underestimated. Rococo art expresses a sensuality and eroticism that was relatively unencumbered by religion or pretentious mythology. Although the style is elaborate, the subjects are often simple. For example, a naked woman lying in a sexually provocative manner is approached frankly and directly. In the Renaissance, layers of mythology would have obscured this subject.

In François Boucher's drawing, the model's transparent drapery is initially striking and represents a virtuoso demonstration of the artist's technical mastery. Next, the distortions attract the eye. Anyone who has drawn from life can see that foreshortening has been almost forgotten. Boucher would not have known how to make comparative measurements, but he is trying to create an impression of sensuality, not one of proportional accuracy. For example, look from the model's knee to the hand behind, up the arm into the shoulder, through the neck and into the tipped-back head – the movement takes the eye through an arabesque line that is echoed in the push of the hip and the curve of the belly. An arabesque generates sensuality – contours are compressed as forms touch one another, expressing their softness. It is almost as if the viewer could touch them and feel the give of the flesh under the skin.

François Boucher (French, 1703–70) first trained under his father, Nicolas (1672–1743), a minor painter, and then with historical painter François Lemoyne (1688–1737). Boucher won the Grand Prix in 1723 but his prize of a trip to Italy was delayed, so he spent time painting and printmaking. He finally travelled to Italy in 1728 and returned to Paris in 1731. The same year, he was admitted as a history painter into the French Royal Academy. He won commissions from King Louis XV, including decorations for the Palace of Versailles. In 1765, he was made First Painter to the King and elected as director of the Academy.

See also
Jean-Antoine Watteau (p.86)
Henri Matisse (p.174)

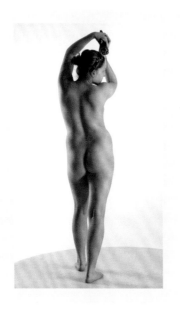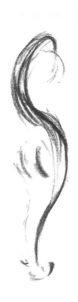

Subject Matter

Over a period of years, Boucher reshaped traditional drawing language in order to express his ideas of sensuality. His subject – a woman lying naked on a bed – is a simple one, but it also has a long history of symbolic meaning in art. However, Boucher makes sensuality his subject. This could easily have resulted in sentimentality as plenty of Rococo art did. Making a successful drawing of this nature is one of the most difficult challenges an artist can face. You must always try to avoid cliché (unless you are trying to be ironic in a postmodern way, although this seldom works).

Try to connect your understanding of what sensuality is with the language you are using. For example, in Boucher's drawing the arabesque line or shape is strongly linked with these feelings. Try to find the arabesque in your subject as illustrated (see left) by the model's pose and sketch of the arabesque shape.

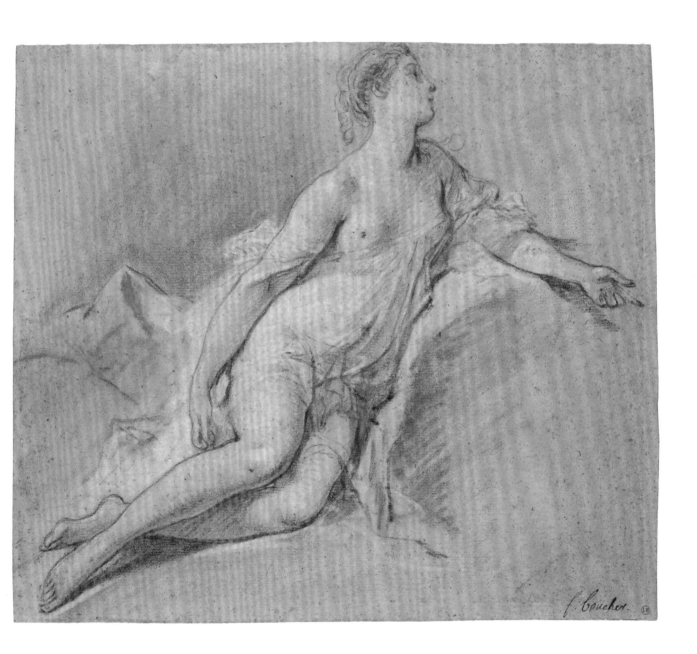

Standing Female Nude, Seen From Behind 1785–90

Charcoal heightened with white chalk on blue paper
61 × 34.9 cm (24 × 13 ¾ in.)
Museum of Fine Arts, Boston, Massachusetts, USA

The ideas behind Pierre-Paul Prud'hon's way of drawing were not revolutionary. Although he had mixed feelings about Neoclassicism, this drawing of a nude was in the by then well-established Neoclassical style of idealized proportions, using a conventional visual language. However, the drawing has such elegance and is so complete, it is still very convincing.

The figure is a series of parts that have been pieced together and each part is given a size in relation to the rest of the figure. Those relationships, however, have been determined by the conventions of Neoclassicism, not from observing the world around him. In 1683, Gérard Audran produced *Les Proportions du Corps Humain* (*The Proportions of the Human Body*). This book lays out very precisely the rules that were deduced from measuring the human proportions found in Greek and Roman art. In Prud'hon's drawing, you can see how small the feet are in relation to the body and how masculine the body is compared to the head. This odd feeling of disconnection between parts and the whole can sometimes be used to considerable effect, but often destroys any sense of unity the drawing might have. Yet here, Prud'hon has managed to create unity with some clever tonal shading (see bottom right) and highly refined contours. Most artists do not fit that neatly into one category and Prud'hon is no exception: many of his drawings and paintings mix Neoclassical simplicity and spareness with the richness, vitality and drama of Romanticism. This drawing, however, is a Neoclassical masterpiece.

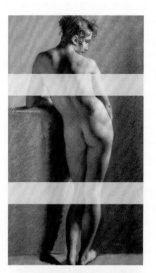

Sources

The predominant practice was for artists to assemble the parts of a drawing as if it were a collage (see left). Gathering visual information of the human form has often been done directly from life. It is important to decide on what you are aiming for as you bring the parts together. Playing with different arrangements will suggest different effects. For example, making the head very small will make the body seem monumental.

Composition

Although the assembled parts can be seen as separate, a drawing is not effective if it lacks unity. For example, a blurred charcoal rectangle is unified; put some shapes in it and it breaks up the unity. The style of line or shading has an effect, too. Here, large shadows (accentuated, left) take the viewer's eye on a journey from toe to head and connect the assembled parts. Identify big areas of light and shade early on.

Tone

Prud'hon uses a tonal structure familiar to artists from the Renaissance. When you use this technique, keep control of the big tonal relationships. Most of the image has four or five tones. The mid-tones make up a small percentage. Here you can see:

A. Highlight
B. Shadow
C. Mid-tones
D. Reflected light
E. Reflected light
F. No reflected light

See also

Paul Cézanne (p.224), Henri Matisse (p.234)

Pierre-Paul Prud'hon (French, 1758–1823) was born in Burgundian town of Cluny, the tenth son of a stonemason. He began studying painting in Dijon at the age of sixteen. He changed his name from 'Pierre Prudon' to 'Pierre-Paul Prud'hon' out of regard for the Flemish artist, Peter Paul Rubens (1577–1640), and possibly to evoke nobility. He then spent four years studying in Paris, but it was his subsequent stay in Italy that left the deepest impression on his painting. On his return to France, Prud'hon became a supporter of the Revolution and was one of Napoleon Bonaparte's favourite artists. One of his most talented pupils was the artist Constance Mayer (1744–1821), with whom he collaborated and was very intimate; but she committed suicide in 1821 and he died two years later.

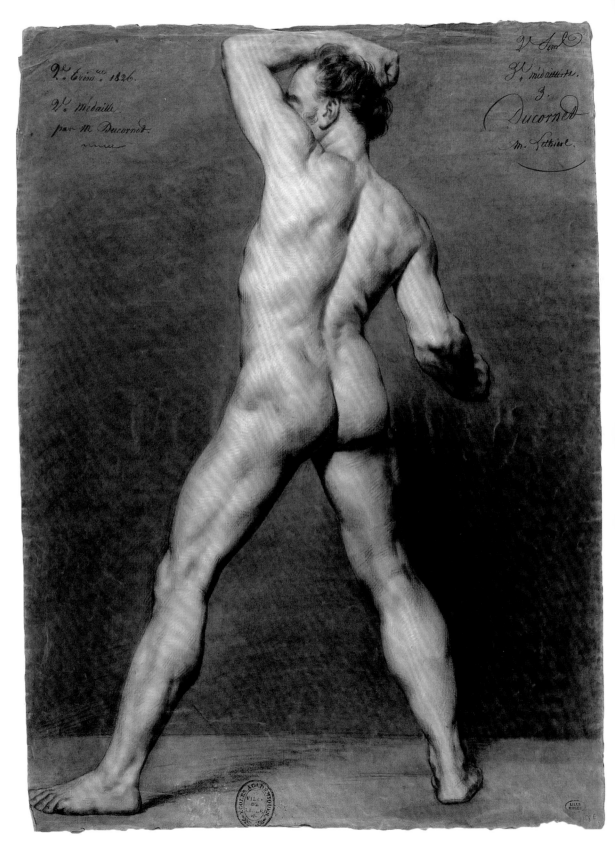

Etude d'homme nu de profil (Male Nude in Profile) 1826

Black chalk with white highlights on light brown paper
61.6 × 45.1 cm (24 ¼ × 17 ¾ in.)
Palais des Beaux-Arts de Lille, France

Superficially academic in convention, this drawing by Louis Joseph César Ducornet uses a language that later became almost completely discredited. The first drawing academy – the Accademia delle Arti del Disegno – was established in 1563 by Cosimo I de' Medici in Florence. It was not until 1661 when Louis XIV reorganized the Académie française in an attempt to control artistic activity that a wider set of conventions became predominant. This system dominated Europe for about 150 years. Gradually, however, its conventions became more rigid and formulaic, causing its ultimate demise. The academic system laid down strict learning procedures for students who began drawing individual features of Greek sculptures and gradually progressed to the full figure. Only when these were deemed good enough would the student move to drawing a live model.

Ducornet's drawing focuses on the three-dimensional qualities of the male form and uses highly conventional visual language to communicate simple sculptural ideas. Unlike most academic drawings, it has a sense of unity that comes from the way the eye moves from surface to surface. The outstanding characteristic here is the way the eye is taken over each plane, around the form and into the contour, making clear not only the smaller undulations but also the way the large forms are locked together. However, spatially it has problems. For example, the model's left arm seems to occupy a different space compared to his torso. This is not uncommon in academic drawings as the artist is preoccupied with rendering detail in a very specific style.

Louis Joseph César Ducornet
(French, 1806–56) was born of poor parentage in Lille. He was deformed from birth, having neither arms nor thighs, and only four toes to his right foot. While still a child, he used to pick up pieces of charcoal from the floor with his toes, and the rough sketches he made showed so much promise that he received local instruction in art. With the help of the municipality of Lille, he was sent to Paris, where he studied under Guillaume Guillon-Lethière and François Gérard. Using his foot, he painted biblical and historical scenes, as well as portraits.

See also
Michelangelo (p.140)
Giovanni Battista Naldini (p.214)
Pierre-Paul Prud'hon (p.218)

Materials

Using toned paper with black and white chalk helps to create a fuller, three-dimensional sense of the form. You can use different coloured papers (see left). Blue-grey paper creates a sense of atmospheric space underneath, whereas warm browns are more earthy and rough. Cream and pale brown papers tend to be used with red Conté crayon. This simply moves the chalk up to the surface (because red/warm colours advance towards the eye).

Form

Understanding how planes work is crucial. A plane is an approximately flat surface that has an overall direction in relation to the paper's surface. Here (left) the plane from the cleft of the model's buttocks to the small of his back moves back in space away from you, but also into your picture space. Over-emphasizing the planes will make the drawing look schematic and boring. Here, the transitions between planes is such that you feel the surface of the model is clearly expressed.

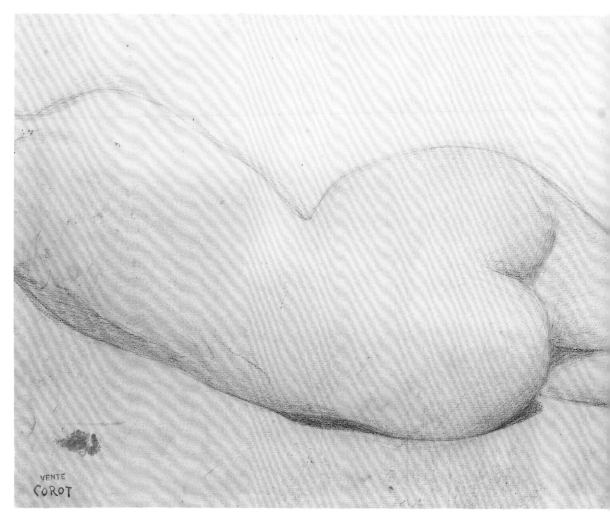

Naked Woman, Lying on the Left Side
From Behind *c.* 1830–40
Black crayon
23.4 × 50.1 cm (9 ¼ × 19 ¾ in.)
Louvre, Paris, France

By 19th-century standards this is a large drawing, around half a metre (1½ ft) long. Although primarily remembered for his landscape work, Jean-Baptiste-Camille Corot was also a highly regarded painter and draughtsman of portraits and figures. In fact, Edgar Degas – like many of the Impressionists, who greatly admired Corot – preferred these works to his landscapes. Of the more than 3,000 works that Corot painted, over fifty are portraits and thirteen depict reclining nudes, whereas there are numerous figure drawings. Corot did not start painting until he was in his mid twenties; this drawing of a nude dates from sometime in the 1830s, so he would have been relatively inexperienced at the time.

Corot found himself caught between two powerful art movements – the tail end of Neoclassicism and Romanticism on the one hand, and on the other the emerging interest in Realism. Perhaps by instinct Corot was a Realist, but throughout his life he could not entirely put aside the Neoclassical influence.

This extraordinary drawing combines an abstract elegance and rich sexuality. Although it was almost certainly created directly from life, it seems more like an abstract sculpture by Constantin Brancusi than a realistic drawing of a model. The lighting on the figure is particularly strong and the model casts a small but distinct shadow on the bed. The fact that the bed sheet has no folds or modulations makes the whole figure seem to hover in space. Yet, strangely, the bed has a physical presence that generates a rapport between itself and the form of the figure. Corot has achieved this very pure-looking form by keeping the overall shape simple. The line is subtle and unfussy, whereas the space is shallow.

Jean-Baptiste-Camille Corot
(French, 1796–1875) trained with
Achille Etna Michallon (1796–1822)
and then Jean-Victor Bertin
(1767–1842). Corot travelled widely,
including extended trips to Italy and
France, and while travelling he drew
and painted directly from the motif.
He would then reference his small
studies and sketches to produce
fully worked-up oil paintings in
the studio. His poetic landscapes
became popular through the 1840s,
and by the 1850s his reputation as
a leading landscape artist was
established. From about this time,
his style changed. He began to use
a more diffuse light and adopted a
limited palette. This technique lent
his paintings the atmospheric and
serene ambience for which he is
now famous.

See also

Leonardo da Vinci (p.72)

Raphael (p.74)

**Hans Holbein
the Younger** (p.80)

Materials

Corot has concentrated on
keeping everything subtle
and uncomplicated. If you
simply use black crayon or
chalk and take the tonal
values up high – in other
words, keep everything
light – it reduces the amount
of shading you have to
do (left). Remember that
as you create a simpler
shaded form, it becomes
more crucial to position the
transition tones correctly.
A side effect of such a
simplified form is that it
emphasises the contours.

Subject Matter

Drawing from a life model in
the studio as Corot did (see
left) has been practised for
centuries and has produced
works of great originality.
Developing technical skills
while engaging with a
subject is also likely to elicit
very human feelings, which
is crucial in learning to make
art. However, if you focus
solely on technique then
your drawings will become
boringly academic. The
objective is that any skill or
technical ability is the servant
of your intentions.

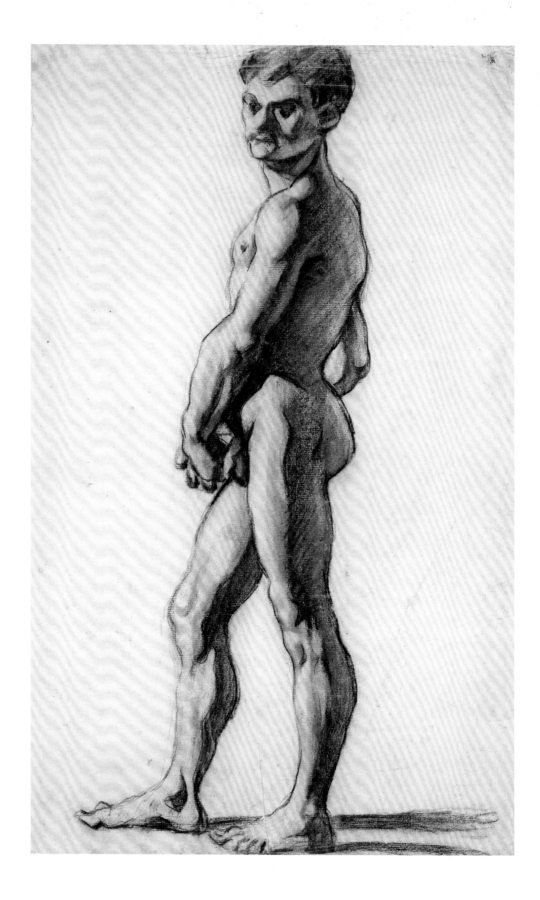

A Male Nude *c.*1863

Black chalk with stump on laid paper
49.3 × 31 cm (19 ⅜ × 12 ¼ in.)
Fitzwilliam Museum, Cambridge, UK

Paul Cézanne is thought of as one of art's great revolutionary figures but here, in this early work, he uses very conventional drawing language. Compared to a drawing by Pierre-Paul Prud'hon, the tonal structure is almost identical. Of course, there are differences; here, Cézanne's flagrant disregard for an idealized form with proportions that conform to the academic rules and regulations of art is obvious.

Around the time that this drawing was made, many male life models were soldiers who, having no war to fight, were looking for unskilled work in the cities. These men were physically fit but hardly the Greek ideal. Cézanne's problem was that he had no desire to idealize the figure; however, the studios he worked in demanded a different approach to straightforward realism and some of his fellow students even ridiculed him. It was this blatant realism – rather than a revolutionary development of graphic language – that put Cezanne at odds with the establishment.

Compared to many more refined, early 19th-century drawings, Cézanne reduces the transition tones. This makes the light look more dramatic. Here, the tones are generalized; large areas are synthesized rather than broken up into smaller, more detailed areas. The tonal value of each area has been gauged in relation to the other areas – for example, the model's chest looks as if its tonal value has been compared to the light area of the stomach and the dark of the face.

Paul Cézanne (French, 1839–1906) began his career studying law, but in 1861 he switched to art and attended the Académie Suisse in Paris, where he met Camille Pissarro (1830–1903). However, consumed with self-doubt, Cézanne returned to his hometown of Aix-en-Provence. In 1862, he went back to Paris, where he exhibited at the Salon des Refusés and mixed with Impressionist artists. In 1872, Cézanne began working at Pontoise with Pissarro, who helped him to develop his mature style. Cézanne participated at two of the Impressionist exhibitions but preferred to work alone. After a solo show in 1895 he began to achieve recognition.

See also
Pierre-Paul Prud'hon (p.218)
Henri Matisse (p.234)

Scale

It is vital to establish and hold the scale for a figure. Draw a mark where you want the top of the head and mark where you want the foot, as shown (left). Keeping to these guide marks will help prevent the figure from becoming too big or small. It also encourages you to look at both your subject and drawing from head to toe quickly, allowing your brain to register more accurate proportions. Moving from one area to the next without considering the whole will cause problems later on.

Tone and Line

Keep in mind the two distinct aspects of visual language: contour lines and light and shade. As you work, don't worry about integrating them; instead, let them exist in the drawing separately, as here (left). This is particularly important at the beginning of the drawing, as it will allow you to develop it quickly. It is easy to reduce the size of a drawing, but often you will need to extend it. Leave a border around the edge of the drawing so that you can extend it if need be.

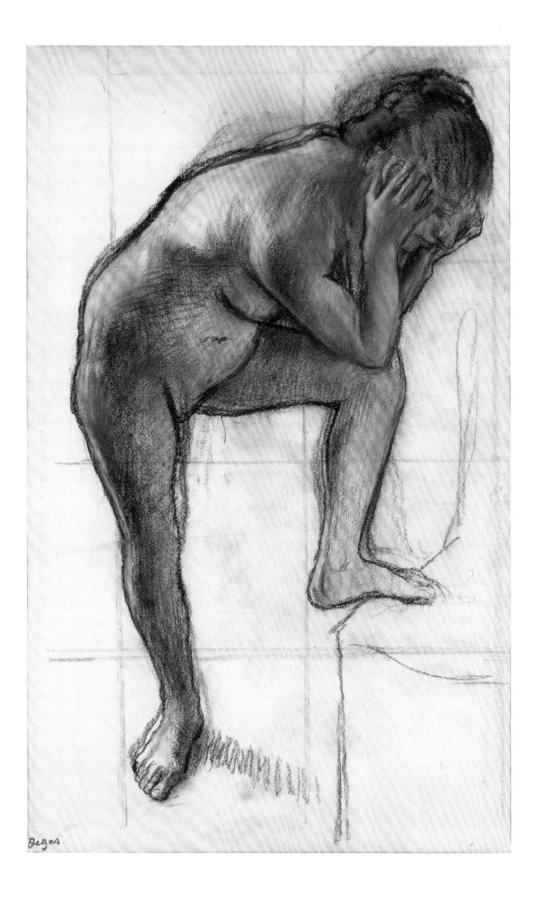

Femme nue debout (Naked Woman Standing) *c.*1880–83
Pastel and charcoal on blue-green paper
49.5 × 30.7 cm (19 ½ × 12 ⅛ in.)
Musée d'Orsay, Paris, France

Edgar Degas was one of the greatest innovators, both technically and creatively, and he produced hundreds of drawings. From the early age of eighteen he registered as a copyist at the Louvre. This was an established convention among young artists and it served two purposes: it provided an income – copies that were approved were bought by the state for exhibition in provincial galleries around France – and it was an important part of their education. It was through this experience that Degas met, in 1855, the greatest draughtsman of the age, Jean-Auguste-Dominique Ingres – an encounter that profoundly influenced him.

This drawing of a naked woman standing was made when Degas was in his late forties, by which time he had absolute mastery of his medium. The cool blue-green of the paper comes through the black charcoal to create light-filled shadows that allow the contour lines to retain their integrity. The economic use of colour in the highlights is perfectly judged and gives the figure the quality of a substantial form – as if it is solidifying into the highlights. Degas is not interested in spatial context. He is preoccupied with the relatedness of forms – for example, in the dramatic way the weight of the torso is pushing down the leg. Degas continually reinvents forms in terms of visual perception. It is as if the human figure is surprising and different every time he draws it, no matter how similar the poses. Yet, more than this, Degas seems to tap into something that is directly physical, visual and intellectual.

Edgar Degas (French, 1834–1917) first studied law, but was determined to become an artist. He enrolled in the École des Beaux-Arts in Paris, after which he spent three years travelling Italy studying the Old Masters. Degas exhibited at the Paris Salon for the first time in 1865 and was one of the Société Anonyme des Artistes who exhibited together from 1874. Their first show was called the 'Exhibition of the Impressionists' because the artists' style of painting lacked detail. The group mounted eight shows, but Degas always resented being labelled an Impressionist. He is known for his work in pastel.

See also
Jean-Auguste-Dominique Ingres (p.152)
Henri Matisse (p.174)
Auguste Rodin (p.232)

Materials
Degas used rag paper. Made using old French military uniforms, the blue dye gave this paper its particular colour. Good quality, pale blue-green paper is difficult to get hold of and is not particularly easy to make. You can dye paper with ink as here (left), but if you then rub the surface with an eraser you will lose some of the blue. One of the best similar papers is the cheap grey sugar paper used in schools. However, this will fade if hung in natural light.

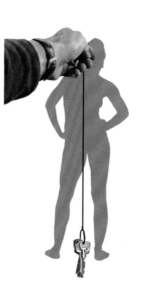

Composition
Faintly drawn underneath Degas's nude is a large grid that may have been an aid to see the verticals and horizontals. Artists still use a plumb line; this is simply a weight on a string that you hold up in front of your subject as a guide to the vertical (left). You can place a pencil at 90° to the vertical, which gives a perfect horizontal. The plumb line is useful, especially to make a figure feel balanced, but you can get dependent on it, so avoid regular use if possible.

Study for *Les Poseuses* 1886–87
Conté crayon on laid paper
29.7 × 22.5 cm (11 ¾ × 8 ⅞ in.)
Metropolitan Museum of Art, New York, USA

One of the biggest scientific influences on artists in the 19th century was the work of Michel Eugène Chevreul. His research into optics and perception was taken up by Georges Seurat and developed into a painting method known as divisionism or pointillism. Although in the hands of his followers this method became rather stilted, Seurat's paintings are in a different league. Pointillism refers to the small dots of colour placed on the canvas. The method was based around the idea that colour was best mixed by the eye on the canvas rather than on the palette. In this way colours could be kept pure and therefore more intense. As for many of the Impressionists, translating an essentially colour-based painting language into a graphic medium that was black-and-white presented certain challenges.

Many of Seurat's drawings were studies for larger paintings – this example was for *Les Poseuses* (The Models, 1888) – where he was primarily interested in understanding how to present a certain kind of form. Seurat used roughly textured paper and hard, compressed Conté crayon to produce the numerous small dots. There are no strong linear contours, only a range of finely graduated tones – a hard thin line would disrupt the unity achieved. Yet, in some areas, such as the girl's thigh on the left-hand side, the tightness of the toning has produced a more exact edge. It is as if the model has been seen through a kind of textured fog. The way the feet hit the bottom of the paper pushes the picture plane closer to the figure, thus creating a flatter, more intimate image.

Georges-Pierre Seurat (French, 1859–91) entered the École des Beaux-Arts in 1878. Uninspired, he began to study the colour theories of scientist Michel Eugène Chevreul (1786–1889), which explored the understanding of optical effects and perception, and the emotional significance of colour. His first large-scale painting, Bathers at Asnières (1883–84), reflects his application of colour theories and painstaking pointillist technique. The work was rejected by the Paris Salon in 1884 but was hung at the Salon des Indépendants. Towards the end of his life he concentrated on works depicting coastal settings and entertainment, such as circus scenes and nightlife.

See also
Gustave Courbet (p.92)
Raphael (p.188)
Alberto Giacometti (p.242)

Materials
The paper will be critical to your success with this method. Most textured watercolour papers are impregnated with glue. You need a textured paper that feels dry and warm rather than cool. When rubbing Conté crayon out, keep the putty rubber clean and lighten your touch near the area you don't want to rub out. Or use the sticky side of masking tape to lift the crayon – don't drag the tape across the surface; just gently touch the back as shown here.

Form
With this style it is important to work from the inside of forms out towards the edges. Remember, the effect you want to achieve is as if the forms are emerging out of a fog. So that you can accurately judge the effect of tonal gradations, periodically look at the drawing from at least 2 metres (6½ ft) away. You will often see artists half closing their eyes when looking at their subject. This helps you lose details and better judge the simple areas of light and shade.

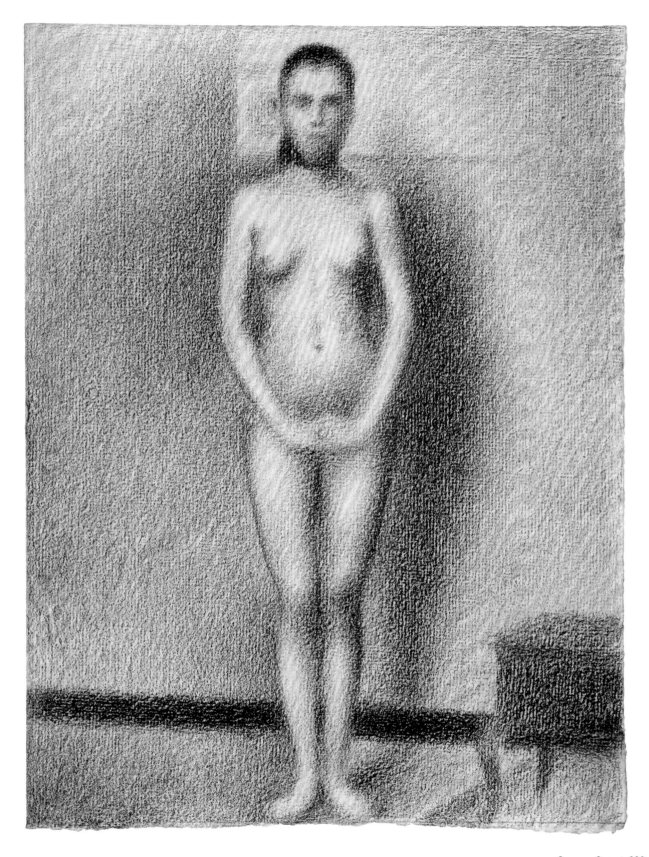

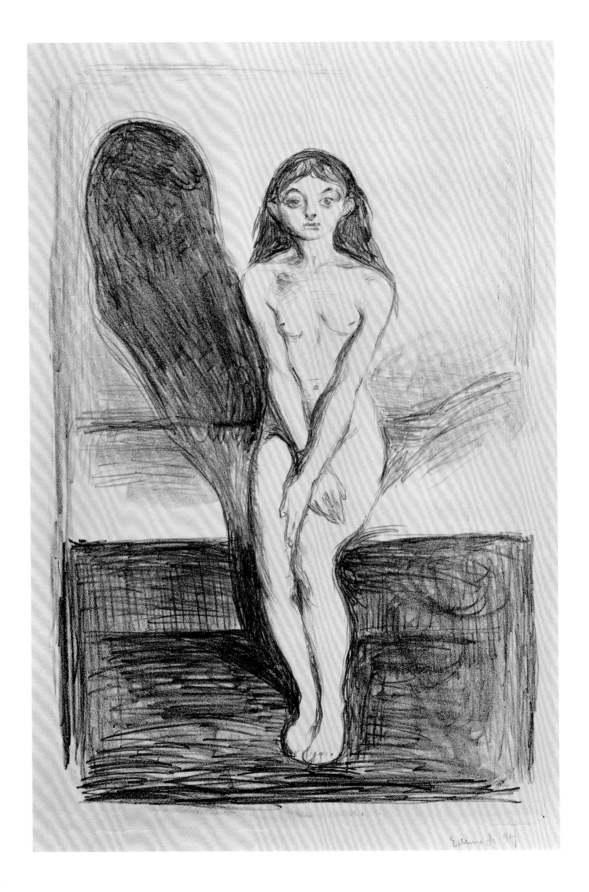

Sketch for Puberty 1894
Lithograph
41.2 × 27.5 cm (16 ¼ × 10 ⅞ in.)
Kupferstichkabinett, Staatliche Museen zu Berlin, Germany

This study was made for an extraordinary series of paintings that Edvard Munch completed from the late 1880s to the mid 1890s. His notes explain how he noticed that the original atmosphere of an underlying sketch can be lost, and how he scraped into the overlaying paint, almost searching in the oils for his initial expression. This drawing preserves that underlying sketch. It is simple and sensitive, yet enormously powerful. Although it is actually a lithograph, it has all the immediacy and subtlety of a pencil drawing. Munch was fascinated by photography and used it in his work, often enlarging the photographed image directly onto the canvas. This resulted in one of the qualities that makes Munch's paintings so accessible to the modern eye.

Here, what strikes the viewer first is the pose – knees pinned together and arms crossed as if to protect the young model's modesty. It brilliantly captures the awkwardness of puberty. Next, the eye registers the peculiar phantomlike shadow that seems to grow out of her side. This shadow is loaded with symbolic meaning. Like many artists of his era, Munch was interested in the supernatural and he believed that it was possible to see ghosts and spirits, particularly via the medium of photography.

This image uses forceful and scratchy black scribble and although it is Expressionistic (and Munch greatly influenced German Expressionism in the early 20th century), it also shows incredible sensitivity in the lighter areas, adding to its power as a work of great subtlety.

Edvard Munch (Norwegian, 1863–1944) studied art at Oslo's Royal School of Art and Design under naturalistic painter Christian Krohg (1852–1925). Through trips to France, Germany and Italy, he became influenced by Impressionism and Symbolism. His parents, a brother and a sister died when he was young, and mental illness affected him and another sister. Although his life was troubled, he planned his angst-ridden paintings carefully, and *The Scream* (1893) is regarded as an icon of existential anguish. After a nervous breakdown in 1908, Munch's work became more optimistic, and he increasingly turned to painting scenes of nature.

See also
Pablo Picasso (p.102)
Max Beckmann (p.172)
Balthus (p.246)

Composition
Always try to keep your composition simple. An underlying structural simplicity helps create unity in even the most complex image. When working directly from nature this can be difficult, as there always seem to be so many possibilities. Try to focus on the biggest areas you can identify and decide how those shapes fit your paper. If you are working from memory or imagination it is a little easier, as you can move things around more freely.

Sources
Although Munch took ideas from photographs, he rarely copied them in detail. He was brilliant at inventing images that characterized feelings. When choosing a subject, call on your own experience. Weeping, for instance, is familiar to us all. This illustration has shapes that curve down like a sad mouth. Don't be too obvious: start with the feeling and use abstract shapes to build the image up. The finished piece need not be figurative, but it has to express the feeling.

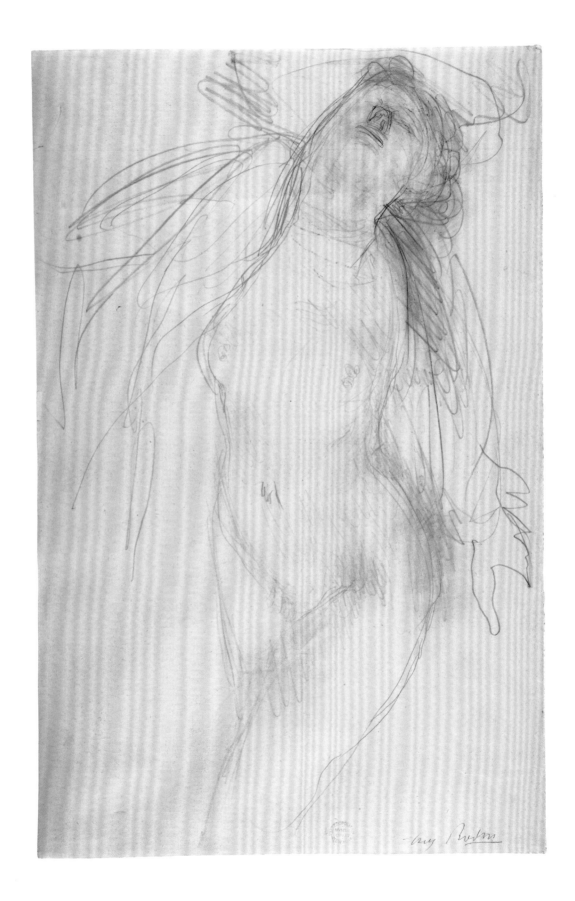

Auguste Rodin

Nude Female Figure Reclining on Side Undated
Pencil on paper
36.1 × 23.5 cm (14 ¼ × 9 ¼ in.)
Metropolitan Museum of Art, New York, USA

Auguste Rodin, who is often mistakenly described as an Impressionist sculptor, did not receive recognition for his work until he was in his mid thirties. He knew from early on that he wanted to be a sculptor and he spent years working for commercial studios on big institutional commissions in Paris and Brussels. In 1880 Rodin won a commission to sculpt a bronze door for the not-yet-built Musée des Arts Décoratifs and he made hundreds of preparatory sketches. Although the door was never cast in Rodin's lifetime, *The Gates of Hell* became his most important work. The complex composition of figures contained within it supplied him with subjects for the rest of his life.

Most sculptors' drawings have a sense of the three-dimensional – the form of the object is being worked out in the drawing. This is certainly the case with Rodin's early drawings; he uses light and shade to create volume. As the 19th century drew to a close, however, his drawings took on a different aspect and contours began to separate away from form. Here, Rodin's contour lines express movement rather than describing a form. It is as if Rodin has a direct gestural response to the movement of the form. He's not processing the information and making it into a two-dimensional version of the sculpture. Rodin is more interested in synthesizing the rhythms he identifies in the model and relating them to an overall shape. His drawing captures a silhouetted version of the model that encapsulates the rhythmic sensuality.

Auguste Rodin (French, 1840–1917) began drawing in earnest at ten years of age and soon began sculpting in clay, yet his talent was not recognized for many years, and he was rejected by the École des Beaux-Arts in Paris three times. His first public artworks were decorative street sculptures created in workshops from other people's designs. During the 1860s, Rodin became frustrated with his artistic output and had a breakdown. After he recovered, Rodin visited Italy, where he was inspired by classical art and determined to update it in his own work. His first major public work was *The Gates of Hell* (1880), which finally assured his fame.

See also

Honoré Daumier (p.158)
Pablo Picasso (p.170)
Frank Auerbach (p.202)

Line and Form
One of the hardest things to teach students is the difference between outline and contour. Students often quote Rodin as an example of an artist who uses outlines, but these aren't outlines in the way they often mean. They aren't silhouettes of a form. Rodin is looking at a separate form that contains the rhythmic movement he has identified. Within this movement a huge amount of three-dimensional form is implied, if not explicit. Most of Rodin's sculptures don't relate to the space around them. Like his drawings, they are about internal dynamics rather than the relationship between external space and form. We see more evidence of this in drawings where he colours in separate areas.

He also practised drawing without looking (known as blind contour drawing). With this method remember that you are trying to synthesize a series of sensations of rhythmic movement into a single line that makes a new form, as shown here (left).

Académie de jeune femme (Nude of a Young Woman) *c.* 1900

Charcoal and stump on cream wove paper
62.5 × 47.3 cm (24 ⅝ × 18 ⅝ in.)
Private collection

By 1900 Henri Matisse was moving away from a more traditional tonal and impressionistic painting language, and this drawing marks one of the last of these early works. From this point, he began to develop an interest in extreme colour combinations that resulted in what became known as Fauvism.

Here, Matisse has completely mastered a simplified tonal way of drawing. Captured directly from life, the model stretches the whole length of the paper and is enveloped in a smoky charcoal background. This technique, known as sfumato, allows tones and colours to shade gradually into one another, resulting in soft, hazy forms. There are no lines here, only areas of light that emerge from the background. The extraordinary fluidity Matisse has achieved never contradicts a perfect sense of the model's balance and twisted form.

The drawing was probably made at one of the studios Matisse attended by 1905. After the death of his teacher Gustave Moreau and following Matisse's return from the South of France, he attended Eugène Carrière's workshop at the Académie Camillo. The approach this drawing takes is very reminiscent of Carrière's work. In *Notes of a Painter* (1908), Matisse stated that he was fundamentally interested in the human figure above all else. Although this drawing it is not particularly revolutionary in the context of when it was made, it does show Matisse's willingness to take a way of working to an extreme. This was a characteristic that was to underpin his periods of experimentation.

Henri Matisse (French, 1869–1954) was born in Le Cateau-Cambrésis in northern France. He took drawing classes while working as a legal clerk and moved to Paris in 1891 to study painting. He went on to become one of the founders of Fauvism with André Derain (1880–1954) in 1905. Matisse remained in Paris during most of World War I, but in 1917 he relocated to Nice, where he began to use intense colour, which is most apparent in his paintings of odalisques and the interiors of rooms. In 1925, he was awarded the highest French honour, the Légion d'Honneur, for his services to art. After surgery in 1941, Matisse was unable to paint and he made paper cut-outs.

See also

Pierre-Paul Prud'hon (p.218)
Paul Cézanne (p.224)
Georges Seurat (p.228)

Materials and Tone

Matisse first covered the paper with a mid-tone charcoal layer. This has been gently rubbed into the paper's surface using a tissue (see far left). He then placed darker areas while working rapidly over the whole figure. Using a putty rubber, he pulled out the lighter areas. This method is key to learning how to use light and shade when working from life. First, arrange your objects with the light coming from a three-quarter position. Look at the extremities of your grouping and gently mark them in on your pre-toned paper. Now half close your eyes and look over the objects, noting the lightest and darkest areas. Rapidly flick your eyes to the paper and place in some darks in the approximate position. Do the same with the lights – they radiate outwards, so draw them pushing out as shown (left) and not filling a shape. You can make edges sharper or softer. It's hard to make very black shadows – try using a fixative and going over them after it dries.

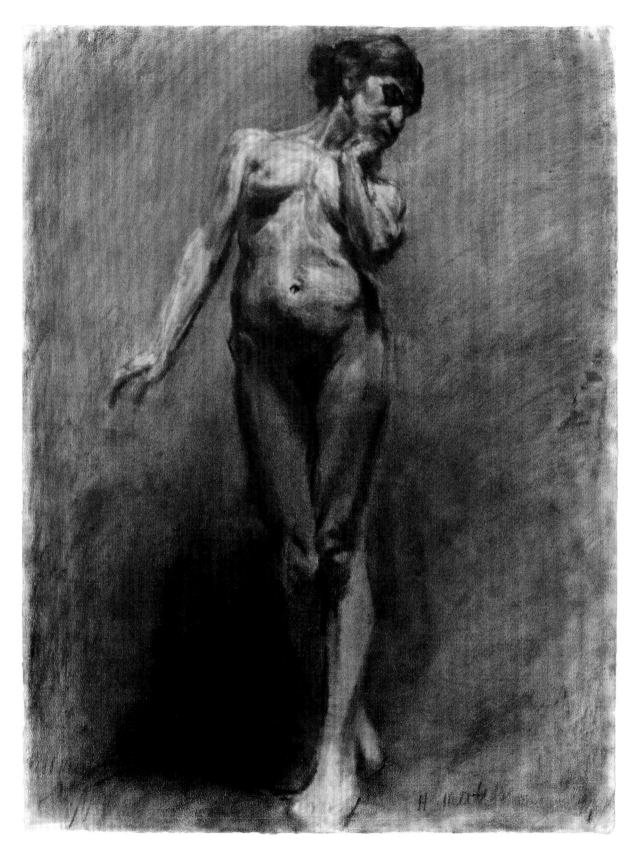

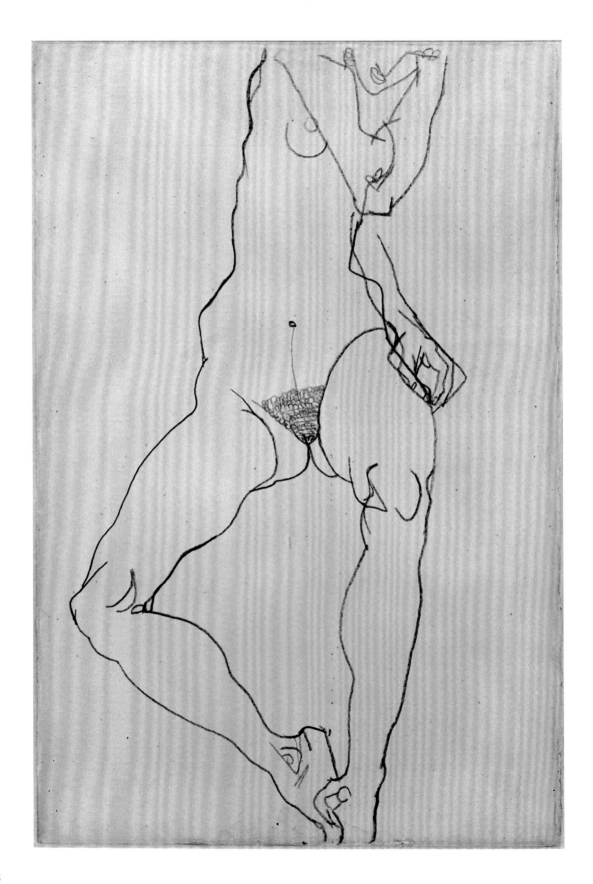

Sitzender weiblicher Akt (Seated Female Nude) 1914
Pencil on Japanese paper
47.5 × 32 cm (18 ¾ × 12 ⅝ in.)
Albertina, Vienna, Austria

Egon Schiele was only twenty-eight when he died in the Spanish flu pandemic of 1918. Despite this, his influence on the Expressionist art movement and beyond has been considerable, and he produced some of the finest examples of drawing in the 20th century. His radical approach to the naked human form and questionable lifestyle still challenge viewers, and his work is variously regarded as erotic, grotesque or pornographic. Schiele produced about three thousand drawings during his very brief life. Of these, it is the simple pencil drawings that remain the most effective.

In this drawing, the most obvious characteristic is that there is almost no space created – everything is flattened out. Looking from the foot up to the knee, on both legs, to the crotch, there is no sense of the journey in space back to the torso. There is a mere hint of a spatial jump provided by the reduction in size of the shoulders. A simple pencil line captures the tense, wrought twisting of the body. The figure is trapped by the edge of the paper, as if crammed into the boxlike shape, in an extremely awkward relationship. The tension created from the bottom of the paper, where the feet touch, to the top where the shoulder pushes out is extraordinary. The diagonal zigzagging limbs are echoed in the jarring contours – everything shudders and jolts. The contour line expresses a muscular tension that conveys a sense of anxiety totally unlike, say, the rippling musculature of a Michelangelo nude. Yet, there is a kind of strength in this anxiety; there is no sense of physical sickness.

Egon Schiele (Austrian, 1890–1918) was admitted to Vienna's Akademie der bildenden Künste (Academy of Fine Arts) at just sixteen years old but left to form the Neukunstgruppe (New Art Group). He was a friend of Symbolist artist Gustav Klimt (1862–1918) and took Klimt's expressive line further to describe angst-ridden bodies. Schiele's sexually honest subject matter was thought shocking at the time, and in 1912 he was imprisoned briefly for indecency. When World War I broke out, he joined the army, but by 1917 he was back painting in Vienna. In 1918, Schiele found success at the Vienna Secession, but he died that year, a victim of the flu pandemic.

See also
Auguste Rodin (p.232)
Balthus (p.246)
Cecily Brown (p.248)

Materials

It is not necessary to use an elaborate range of materials to create images that are deeply moving – simple means often communicate more directly. Schiele's drawing was likely done from life and perhaps took no more than 15 to 20 minutes to complete. Many great artists recommend drawing fast, so practise this. Vary the degree of pressure you put on the pencil to make simple lines come to life. Remember, these lines should be felt as well as seen.

Form

To help you become more sensitive and responsive to the human skin and body, draw your hand holding a piece of velvet (see far left). Ask yourself what velvet is, and let the hand take on the characteristic look of the velvet. Try this with different materials – hold in your hand some cellophane and again draw your hand with the characteristic look of the material of cellophane as shown (left). In this way you will open up new possibilities of representation.

Nude Undated

Black chalk (fixed) with touches of graphite
24.6 × 19.1 cm (9 ⅝ × 7 ½ in.)
Metropolitan Museum of Art, New York, USA

The Belle Époque refers to a period from 1871 to the outbreak of World War I during which Western European art, music and literature flourished. Suzanne Valadon's life and art seem to define and encapsulate this era. Although she was born in the same decade as Gustav Klimt, Edvard Munch, Pierre Bonnard and Henri Matisse, the artists that influenced her most were Pierre Puvis de Chavannes and Edgar Degas. She modelled for both artists, and Degas became a lifelong friend who encouraged her and purchased her work.

Valadon was immensely talented and this drawing is one of her finest. There is a very beautiful sense of the line condensing – with enormous economy and elegance – the forms. As in the work of other artists – Paul Gauguin comes to mind – the interplay between forms generates a kind of visual poetic beauty. The cushion of the sofa on the left-hand side of the drawing has a parallel with the body – it is almost as if the sofa is a different kind of body. This poetic interconnection and dialogue are not easy to make, but she achieves them superbly. The position of the woman's figure in relation to the entire sheet of paper is again absolutely right. The right-hand side, however, is less convincing and unresolved, suggesting that this was a sketch for a painting or an unfinished drawing.

Suzanne Valadon (French, 1865–1938) worked as an acrobat in the circus when she was a girl, but had to abandon her career after a fall. She then became an artist's model and was popular among the artists of Montmartre, including Pierre-Auguste Renoir (1841–1919) and Henri de Toulouse-Lautrec (1864–1901). The latter brought her drawings to the attention of Edgar Degas (1834–1917), who encouraged her to develop her talent, and she became a full-time painter in 1896. After World War I, she gained critical and financial success until her ill health took its toll. She was the mother of the artist Maurice Utrillo (1883–1955).

See also

Paul Gauguin (p.94)
Honoré Daumier (p.158)
Balthus (p.246)

Line

It is easy to confuse contour with outline. A contour is a line or series of lines that overlap, suggesting that one form is in front of another. The best way to remember this is to think of the outline as the silhouette of a form (far left, top and middle). A contour is a line that is overlapping (far left, bottom). It is very important to remember that even expert commentators on art will have slightly varying definitions for these terms – the term 'contour' can change meaning depending on who is using it. To practise finding contours, an excellent exercise is to put four or five oranges on a table and place a damp, soft cloth over the top (left, top). This way you can see where the contours are (left, bottom). If you find it difficult to identify a contour, look from the middle of the form out towards the edge and keep flicking your attention from inside to outside the form. Gradually, you will become more aware.

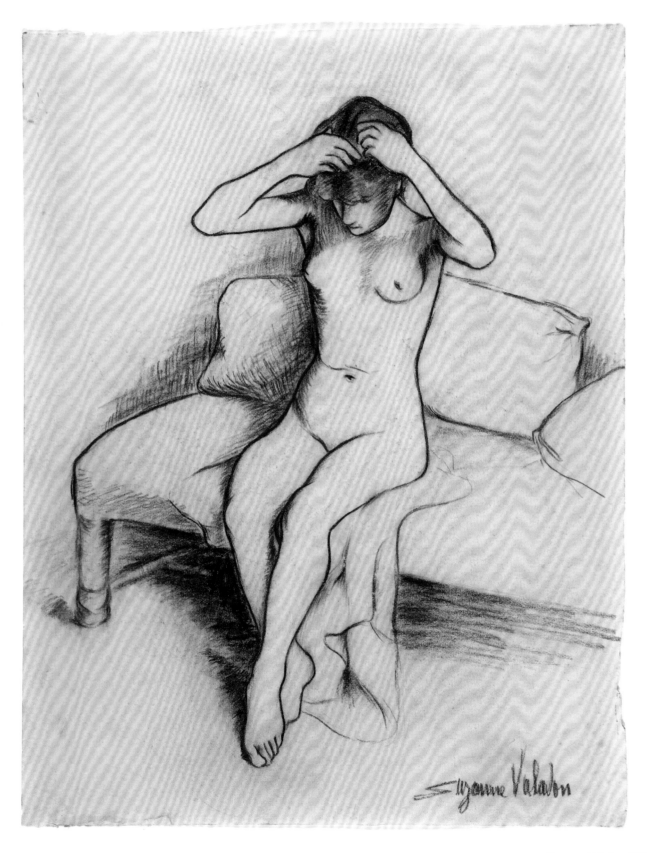

<div style="float:left">Max Beckmann</div>

Women Fishing 1949
Pastel and charcoal with stumping on cream wove paper
60.5 × 44.7 cm (23 ⅞ × 17 ⅝ in.)
Art Institute of Chicago, Illinois, USA

Like his contemporaries Pablo Picasso and Henri Matisse, Max
Beckmann shared a certain scepticism of the value of purely
abstract art. Yet, he also rejected Expressionism, despite much of
his work often being described as such. Beckmann, was deeply
affected by World War I, when he served as a medical officer. Like
many artists of his generation, he developed a highly original visual
language. He explored traditional subjects – still lifes, landscapes
and self-portraits – but he also drew on Germanic mythology
and folk stories as a vehicle to express his ideas and emotions.
This drawing shows women fishing; for Beckmann fish symbolized
men's souls. For modern viewers, allegorical subjects have become
largely irrelevant or difficult to access. Yet, it is not familiarity with
these subjects that makes this image come alive; it is the artist's
conviction and the quality of his engagement that convinces us
of their authenticity.

This drawing is crowded with activity, but the underlying
structure and composition is simple and cleverly organized. It
allows Beckmann to cram divisions into each area and pocket of
space without the overall composition becoming confused. This
creates an almost hysterical atmosphere: there is no place for
the eye to rest, no chance to take stock. No sooner has the eye
deciphered one element, than the next is jostling and demanding
attention. In the hands of a lesser artist this approach would
inevitably lead to a confused and incoherent image, yet Beckmann
always masterfully maintains control.

Max Beckmann (German, 1884–
1950) served as a medical volunteer
in World War I and the horrors he
witnessed affected him greatly,
producing work that reflected his
anxiety and disillusion. In the 1920s,
Beckmann led the Neue Sachlichkeit
(New Objectivity) movement that
rejected Expressionism in favour
of realism. When the Nazis rose
to power in the 1930s Beckmann
emigrated, first to the Netherlands
and, after World War II, to the
United States, where he taught in
art schools in Brooklyn and St Louis.
At that time, his work was often
autobiographical, and sometimes
featured fish, possibly a reference to
Christ as a symbol of hope.

See also

Elisabetta Sirani (p.148)
Paula Rego (p.178)
Ken Kiff (p.274)

Materials
Stumping (left, top) is a
more effective way to create
softness in transition tones
than using your fingers,
which can be greasy and
will leave a blotchy effect
on the surface of the paper
(left, middle). Alternatively,
you can use a cloth (left,
bottom). Stump – essentially
compressed and rolled
paper – will allow you
greater control in your
drawing while still blurring
the charcoal evenly. Spend
time experimenting without
drawing anything specific.

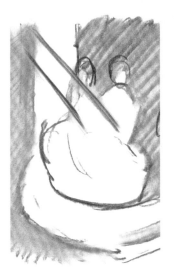

Shape and Space
This illustration (left)
shows the big areas of
the composition that
are established early on.
Deciding how these big
areas fit together will
help you organize the
whole image. It becomes
easier to play with space
if you understand how the
composition fits together.
For example, in the top left
corner the space could be
either something in the
foreground that is leaning
over, such as a tree, or it
could be an object in space.

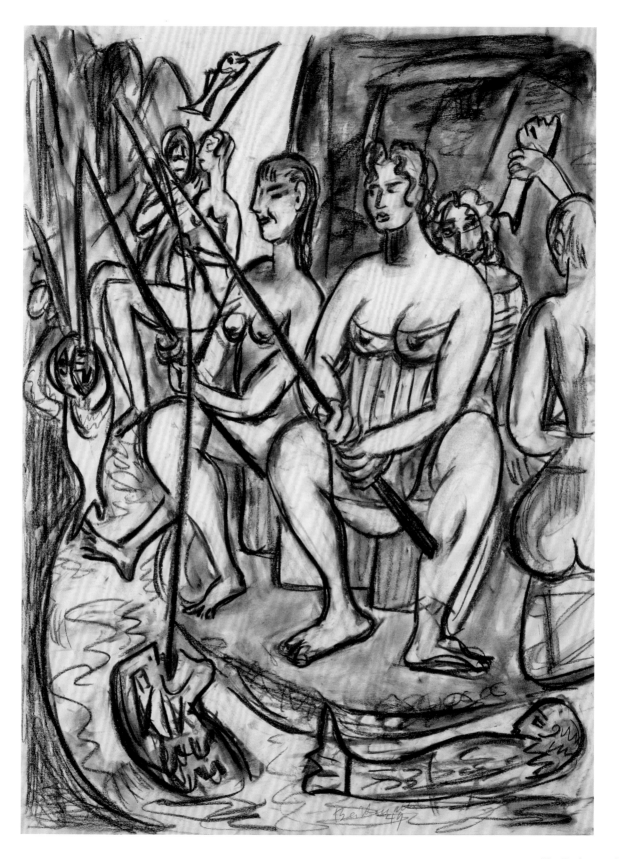

Standing Figure 1955
Pencil on paper
63.5 × 48 cm (25 × 18 ⅞ in.)
Sainsbury Centre for Visual Arts, Norwich, UK

Alberto Giacometti stands out as a maverick who forged his own unique path in 20th-century art. Although he was part of the Surrealist movement, he soon moved away from the group, declaring that one day he woke up and realized that reality was more extraordinary than anything he had in his imagination. Giacometti was also one of the most articulate commentators on his own art. There are excellent and illuminating dialogues between him and critics that explain his thinking in detail.

It is very difficult to regard his works as anything other than an exploration of the perception of reality. Giacometti was fascinated by how things appeared in space and how that appearance could be reformed into painting, sculpture and drawing. He once told an interesting story about how he was looking at a Greek sculpture in the British Museum and thinking that underneath the surface there was solid stone. However, when he then looked at the people looking at the sculpture they appeared transparent in comparison.

What this drawing does brilliantly is give that transparency a form that is on the one hand three-dimensional – you understand that this is a person with the qualities of a living being – but on the other hand also seems so affected by the space between Giacometti and his subject that it is almost unrecognizable. It exists and does not exist at the same time. If we look directly at the figure's body, it seems insubstantial and strange – but if we focus on the head and become aware of the body (not directly looking at it), it looks incredibly real.

Alberto Giacometti (Swiss, 1901–66) created his first sculpture at the age of fourteen. His father, Giovanni (1868–1933), was a Post-Impressionist painter and his first teacher. Alberto studied art in Geneva and then toured Italy, sketching classical architecture. In 1922, he moved to Paris, where he trained under French sculptor Émile-Antoine Bourdelle (1861–1929) for three years and experimented with Cubism and Constructivism. After meeting French writer André Breton in 1930, Giacometti joined the Surrealists. During World War II he moved back to Geneva, returning to Paris after the war to develop his original style of elongated, figurative bronzes with an irregular finish.

See also

Giorgio Morandi (p.64)
Nicholas Volley (p.66)
Paul Cézanne (p.224)

Materials
Giacometti mostly used a quite hard pencil – possibly H or HB – on plain white cartridge paper. This medium suited Giacometti, but you don't have to use exactly the same materials. What is important is that you understand what it is you are trying to do. Gradually building up the lines, not making emphatic statements about the blocks of shading, may feel easier to do in a different medium (see left). Experiment with materials, focusing on the objective.

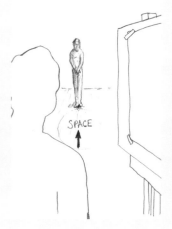

SPACE

Subject Matter
Choosing the angle and distance from the subject is crucial. If you are very close, you may see the way forms lock together but find it difficult to see the whole figure in context. Once you have positioned the model, work from a single focal point. At a distance, look directly at the sitter's nose or head, then draw everything in relation to that point (see left). Try to notice what the feet look like without looking directly at them. Don't commit to a fixed scale: let it develop gradually.

Alberto Giacometti **243**

Untitled 1961
Charcoal on paper
42.9 × 35.6 cm (16 ⅞ × 14 in.)
Private collection

The dominance of Abstract Expressionism in the United States during the mid-20th century is well documented. However, alongside it there emerged a group of painters, based in and around San Francisco, known as the Bay Area Figurative Movement. This group, which included Richard Diebenkorn, Elmer Bischoff and Henry Villierme among others, explored figuration while acknowledging the concerns of Abstract Expressionism.

This drawing is from one of Diebenkorn's sketchbooks, in which he did hundreds of drawings directly from life during this period. Diebenkorn divides the paper into simple sections, carefully balancing synthesized areas of different tones. Looking at the progressive development of his sketchbook drawings, we know that he tended to start with clear linear divisions across the whole paper. This meant that from the outset he was thinking about the unity of the whole image rather than a single form within a rectangle. The three-dimensional parts of the model he was drawing were less important than the two-dimensional divisions within the paper's boundary. The model is simply an interesting form to include, giving the abstract divisions a scale and spatial context. This is not exclusively a linear set of relationships. The linear structure is inextricably connected to the tonal structure; the edges of the shapes of tones become the linear framework. What makes the drawing so dynamic and engaging is the speed we are able to read the divisions of these tones as light and shade: this is quicker with a figure compared to an abstract landscape.

Richard Diebenkorn (American, 1922–93) was born in Portland, Oregon, and raised in California. He studied at Stanford University during the early 1940s, where he received his formal art training from Daniel Mendelowitz (1905–80). During this time, he was introduced to the paintings of Edward Hopper (1882–1967), which inspired his representational style. Diebenkorn's studies were then disrupted by a stint in the Washington Marine Corps during World War II. Afterwards, he continued his education at the California School of Fine Arts, where he met his most influential teacher, David Park (1911–60). During the 1950s, Diebenkorn co-founded the Bay Area Figurative Movement along with artists such as Park and Elmer Bischoff (1916–91).

See also

Edward Hopper (p.128)
Lee Krasner (p.190)
Hans Hofmann (p.194)

Scale and Composition
The most important element in this type of drawing is the edge of the paper. You don't have to draw all the way to the edge, but it is advisable to draw a box within which you can think about how you're going to divide that area up, as shown here (left). Draw the box in relation to the extremities of your main subject. Note the highest point and the lowest point of the subject that you want to include. Diebenkorn included the foot at the very bottom and the part of the subject

that is furthest to the right. Looking up, he'd see the head and note where that was. Seeing the diagonal moving from the foot up the shin through to the head gave him the angle relative to the vertical. This allowed him to assess where the head was in relation to the foot. Comparing positions and angles relative to a vertical is the best way to proceed. Using a plumb line or any verticals in the background (see left) will help you assess these more accurately.

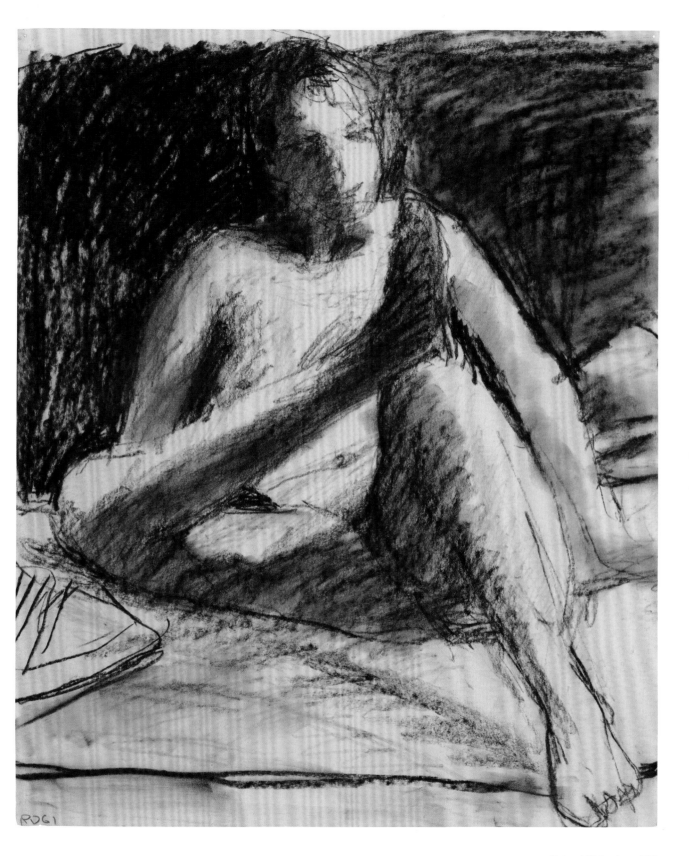

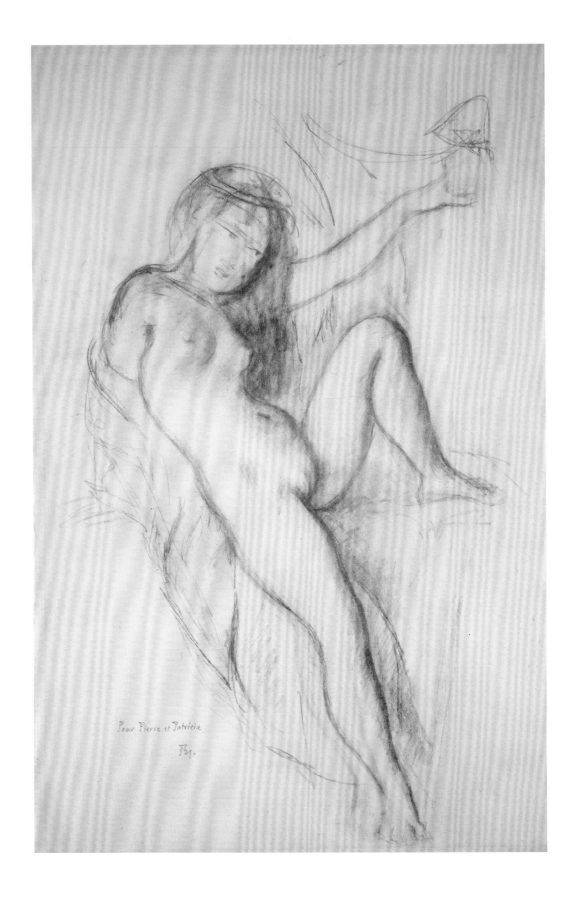

Pour Pierre et Patricia

Study of a Nude 1964
Pencil on paper
76.2 × 49.8 cm (30 × 19 ⅝ in.)
Museum of Modern Art, New York, USA

Baltusz Klossowski de Rola – better known as Balthus – was well connected to many of the important writers and artists of his day, yet he was never swayed by the Cubists or the reductive experiments of the modernists. Early on he was interested in Surrealism, but he soon carved out his own distinctive figurative style. His paintings often depicted young pubescent girls.

This drawing represents an aesthetic celebration of an adolescent body. He transforms a beautiful young girl's body into a series of forms, arranging them on the paper to suggest a visual unfolding in the way that we might look at an actual girl. Balthus often took years to complete his paintings; he worked on creating a structure that was in perfect harmony with the mood and intention of the painting, and the studies he made reflect that obsession. The strong diagonal movement from the girl's foot up the body seems to support the appealing curves that move from robe to body – almost like a dance hopping up the line.

Balthus bears witness to the extraordinary power and beauty of adolescent sexuality. Using great skill and superb judgement, he translates these perceived phenomena into an aesthetic that allows us to relive his appreciation for ourselves. There are artists whose work seems pornographic because it never makes this transformation of taking a subject that is sexually alluring but pure, and communicating it aesthetically. That aesthetic transformation is crucial, because it takes what is natural and makes it into something we can appreciate – art grounded in truth.

Balthus (Polish-French, 1908–2001) is the sobriquet of Balthasar Klossowski, Count de Rola. Aged thirteen, forty of his drawings were published in a book, *Mitsou* (1921). In 1926, Balthus went to Florence, where he studied and copied the work of Early Renaissance master Piero della Francesca (*c.* 1415–92). The other key influence on him was family friend and Impressionist painter Pierre Bonnard (1867–1947). During World War II, Balthus escaped France for Switzerland. Balthus's paintings often depicted pubescent girls in erotic poses and he is noted for being the only living artist to have his artwork included in the Louvre's collection.

See also

Gustave Courbet (p.92)
Egon Schiele (p.236)
Suzanne Valadon (p.238)

Sources
The structure of the drawing should be simple so that the eye can register the image quickly and from a distance. To remind yourself of that structure, especially if working on a drawing over some time, make an outline sketch no bigger than a playing card in a sketchbook or on the paper's margins. Teachers often do this to illustrate a point – there is no reason why you shouldn't do this for yourself (see left), as small sketches can really clarify matters.

Tone
Balthus very cleverly connects a simple diagonal to a series of curves that echo the forms, as shown in this illustration (left). Along with the effect of the soft, low lighting, he evokes a feeling of youthfulness. The light of the paper is used to keep these forms and the structure is reduced to merely a few simple lines. When you are drawing, try to be as economic as possible by continually erasing any unnecessary lines and shading.

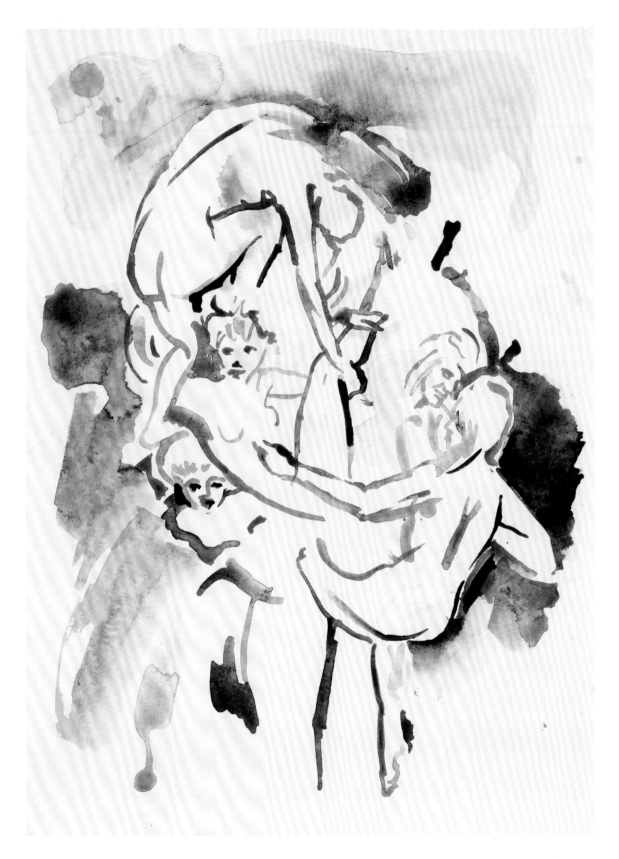

Untitled 2011
Watercolour and gouache on paper
36.2 × 26 cm (14 ¼ × 10 ¼ in.)
Thomas Dane Gallery, London, UK

Unlike much of Cecily Brown's art, this is an instantly recognizable subject that illustrates one of the central dialogues within her work. Many 20th-century artists have been preoccupied with the conflict between figuration and abstraction – never allowing figuration to dominate for fear of descriptive tediousness, while shunning pure abstraction for fear of decorative blandness. Like Philip Guston, who suffered from a similar anxiety, Brown seems to play with this tipping point. She is completely engaged by the game and in doing so she shapes her visual language. Her work holds that critical moment of transformation where all is chaos and flux, when an object or sensation moves from abstraction to figuration and becomes her own coherent painted reality. This transformation becomes a kind of organism through which she plays with associations and connections.

Here, lines are ambiguous; one moment they describe an arm or a fold, the next they fluidly morph into an animated gesture. The swirl of the figures – weightless and suspended in space, or possibly falling – contrasts with the drips of paints running down in vertical lines. The elliptical movement uses both coincidence and intention to give the image a mistakenly easy feel, but something more sinister is at play. These figures are insubstantial phantoms that are coming into being, but they will never take on the characteristics of solid, three-dimensional forms because Brown will immediately destroy such an obvious resolution – tone, shape, line and form are all under threat.

Cecily Brown (British, born 1969) was born in London, where she studied at West Surrey College of Art and Design and the Slade School of Fine Art. While enrolled at the Slade she was an exchange student at the New York Studio School and after she graduated in 1993 she relocated to New York, where she now lives. She worked as a waitress and in an animation studio, and experimented in filmmaking, before becoming a painter full time. In the late 1990s, Brown shifted focus to the human figure. Her work is influenced by the Old Masters, Analytical Cubism and Abstract Expressionism, and addresses themes of sexuality and pornography.

See also

Philip Guston (p.196)
Miquel Barceló (p.208)
Willem de Kooning (p.270)

Materials
Brown uses a brush rather than pencil or chalk. Using a more difficult-to-control medium can result in creating chance marks, such as in this illustration (left), that allow for unintentional interpretations. Brown's work feels very spontaneous and as viewers we can recognize a collision between the desire to create a specific image and an immediate response to the media. The transparent watery marks give her image a fragile quality.

Sources
Photographs are sometimes used not for the literal information they hold but for what they can evoke. This may come from an unlikely source – for example, from a fault line in the reproduction or a crease or some dirt. The photograph is not so much a photograph, but more of an object that provokes an emotional response. It is a good idea to keep a sketchbook full of photos, scribbles and sketches as shown here: they may be useful for ideas in the future.

Couple Kissing 2014
Watercolour on paper
37 × 28 cm (14 ⅝ × 11 in.)
Frith Street Gallery, London, UK

Although Marlene Dumas moved to the Netherlands in 1976, most of her formative years were spent in Cape Town, South Africa, during times of great turmoil. It is not surprising therefore that her work expresses a political awareness. She mostly uses very thin, stained colour in her paintings and water-based drawings. To an extent this choice of medium was a reaction to artists of the 1960s and 1970s, such as Anselm Kiefer and Georg Baselitz, who used thick, gestural oil paint. At the conference 'An Appetite for Painting' in 2014, she revealed that she does not actually like paint; she said that from an early age all she ever wanted to do was to make marks and that is what makes her feel alive.

It is interesting that Dumas rarely works directly from life but usually from flat images. There is a palpable tension in her work as she wrestles with the destruction of the surface and the creation of an image. In this drawing we can see elements of this struggle. The materials she uses are unruly and create their own character; they often do things that are at odds with her intentions. It is the disruption caused by these 'mistakes' that builds the tension within the composition. This tension in turn generates a feeling of ambiguity or oddness. Even in a moment of tenderness – such as a couple kissing – there is the potential for fear. This is what makes the image true and not sentimental.

Marlene Dumas (South African, born 1953) trained in Fine Art at the University of Cape Town from 1972 to 1975. She moved to the Netherlands in 1976, where she attended Ateliers '63, Haarlem, and from 1979 to 1980 she studied at the Psychological Institute, University of Amsterdam. She came to prominence in the mid-1980s for her figurative paintings on themes of racial and ethical intolerance. In 1995, she represented the Netherlands in the 46th Venice Biennale. Her oils and ink-and-watercolour works feature the female form, children and imagery from contemporary events, and often explore themes on art and pornography, and art and the concept of beauty.

See also

Georg Baselitz (p.176)
Peter Doig (p.180)
Dexter Dalwood (p.276)

Materials
When doing water-based drawing, have several sheets of paper ready on drawing boards, as shown here. You may be trying to make a specific image, but it is also about responding to what is happening on the paper at the moment of creation. You will probably make many mistakes – having paper ready will help you be less precious about any one image. Using thick watercolour paper helps prevent buckling – you can also stretch the paper before you start working (see p.42).

Sources
Matisse said that it was only by looking at his earlier work that he could identify what his next step might be. It is up to each artist to use their work as a way of discovering the right direction ahead. Although each image will seem as if it is, to an extent, a definitive statement, it is also part of an ongoing continuum. It is a good idea to take photographs of every painting and drawing that you do. Then if you lose or destroy work, you have a record of your past thoughts.

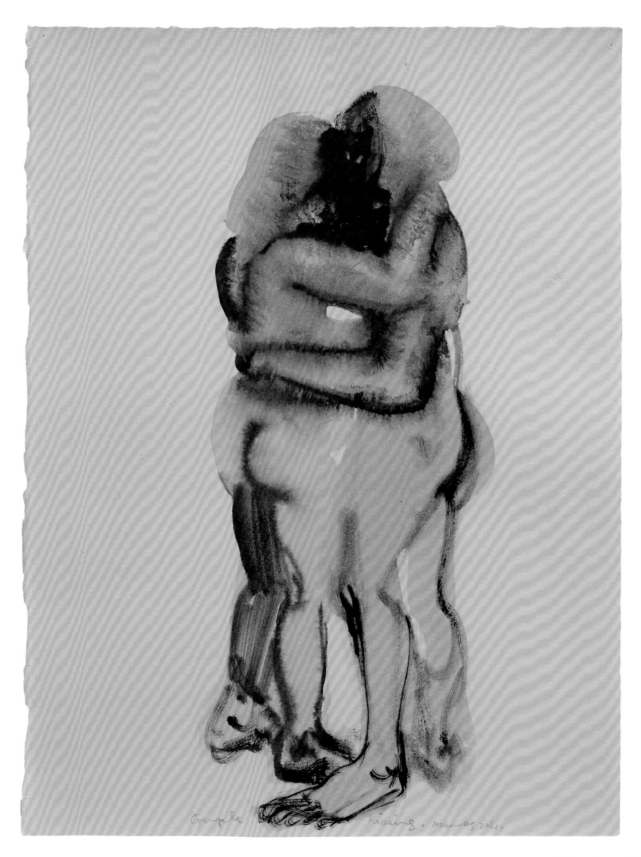

Hieronymus Bosch	256
Titian	258
Tintoretto	260
Peter Paul Rubens	262
John Martin	264
René Magritte	266
Paul Klee	268
Willem de Kooning	270
Anselm Kiefer	272
Ken Kiff	274
Dexter Dalwood	276
Paul Harbutt	278

Recreating on paper the imaginary world that we construct inside our heads is a strand of artistic creativity that dates back thousands of years. It is a genre that continues to fascinate both artists and public audiences alike. When we look at the work of artists we tend to feel that we have a window into their innermost thoughts and visions. When you come to work on your own drawings, no matter how realistic they may be, your imagination plays a crucial role in shaping the eventual image. However, all the artists included in this chapter have followed their imaginations in a way that is – to varying degrees – disconnected from the real world.

How do we define that imaginary world inside our heads that can be inhabited by anything we choose? All artists use their imaginations in different ways and to some extent fantasize

about their subject matter. Yet what is extraordinary about the artists included here is their ability to create specific forms for the world within their heads. For example, this could be as precise and realistic as the hedonistic scene depicted in Paul Harbutt's *The Charnel House* (see p.278) or as crazy and strange as the dreamlike world created by Ken Kiff (see p.274).

But what is it that convinces viewers that these imaginary worlds are so plausible? It is, of course, the way in which these images are constructed. It is the extraordinary ability of this diverse group of artists to organize their work in such a way that enables us to believe. As in the theatre, we need to suspend our disbelief when looking at drawings that fall within the realm of fantasy. We need to allow the artist to take us into their fantastical world.

The Tree-Man *c.*1500

Pen, iron gall ink and bistre on paper
27.7 × 21.1 cm (10 ⅞ × 8 ¼ in.)
Albertina, Vienna, Austria

Although little is known about Hieronymus Bosch, we do know that during his lifetime his work was popular and collected throughout Europe. He created an imaginary world that referenced the world around him, yet was full of weirdly complex transformations, potent warnings and dark superstitions. The imagery is soaked in fear of transgression of the prevailing social and religious morality. The 'Tree-Man' seen in this drawing also appears in the Hell panel of his renowned triptych *The Garden of Earthly Delights* (1490–1510).

Initially, this drawing seems to portray an entirely believable landscape; however, it is actually made up of a series of assembled parts that only loosely fit together. As the eye moves from one detail to the next, these disconnections become more apparent. The foreground has a strange weathered tree right in the middle; move your eye clockwise along the bank past the fawn and up the tree curving over into the sky and a delicate, C-shaped arc holds all the implausible floating objects. Each individual detail, although part of an overall composition, has little relationship with another. These disconnections undermine the topographical space in an interesting and odd way, and the bizarre imagery is completely in step with this disconnected space. Viewing a Bosch image is like taking a journey inside the artist's head. He depicts an internal world that has been given the veneer of an external reality. It takes time to look at his well-organized images: they unfold slowly as the eye moves around them and represent an enduring interest in imagery that haunts humankind.

Hieronymus Bosch (Dutch, *c.* 1450–1516) was born Jeroen van Aken. He adopted his name from his birthplace, 's-Hertogenbosch, a city in the southern Netherlands where he spent most of his life. He came from a family of artists and achieved significant success in his lifetime, with his fantastical work being collected in the Netherlands, Spain and Austria. In 1488, he joined the influential and wealthy Brotherhood of Our Lady religious group that contributed significantly to the cultural life of the city. Civic records and the accounts of the Brotherhood show that he was one of the town's wealthiest men.

See also
Ken Kiff (p.274)
Paul Harbutt (p.278)

Pen

Pencil

Charcoal

Materials

Bosch's drawing was made using pen and ink. The range of marks a pen nib can create is more restricted than that of a pencil or charcoal, as illustrated here (left). The principal difference is that shaded areas have to be done using multiple lines known as hatching – on top of which can be placed more lines known as cross-hatching. This technique can also be achieved with pencil and chalk, but the results can be varied.

Subject Matter

Bosch probably sketched out the idea for his subject first or made small drawings in preparation, but it's also possible that his ideas grew and mutated as he drew. The imagination is like a muscle – it needs to be used and stretched. A good exercise is to take ordinary objects and draw them quickly, as here (left, top). Take the drawings, turn them upside down or on their sides and make them into something else – maybe a creature (left, bottom) or part of the scene.

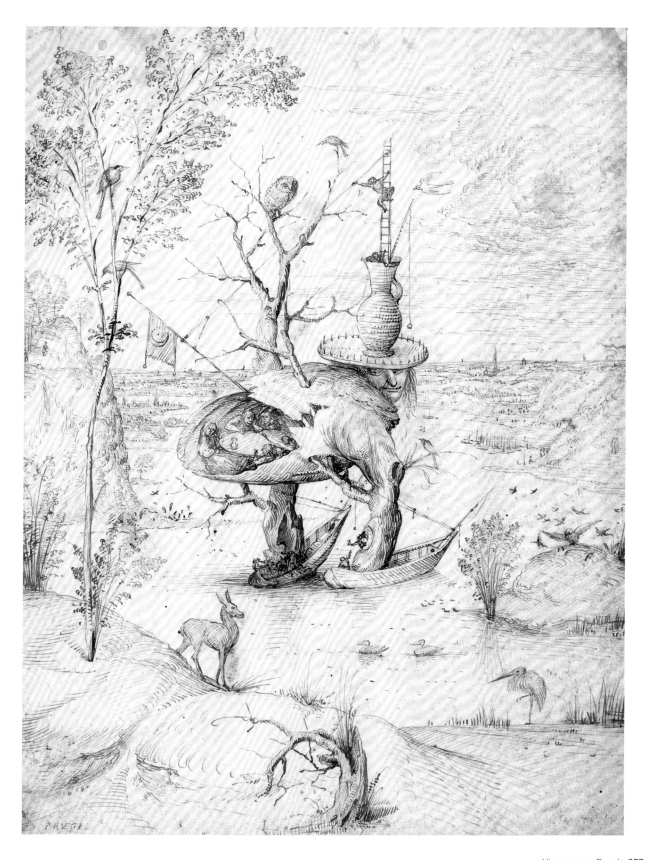

Horse and Rider Falling *c*.1537

Black chalk on grey paper
27.4 × 26.2 cm (10 ¾ × 10 ⅜ in.)
Ashmolean Museum, Oxford, UK

Titian flourished after the three key High Renaissance artists Leonardo da Vinci, Michelangelo and Raphael. These artists were based in Rome and Florence, whereas Titian was in Venice, which was to provide the next wave of great Italian artists. This drawing was made as Titian was developing his later style. Around the same time he began work on a commission depicting the Battle of Cadore, but it was destroyed in a fire at the Doge's Palace in 1577. It was Titian's most important work and attempted to rival Giulio Romano's *Battle of the Milvian Bridge* (1520–24), Michelangelo's ill-fated *Battle of Cascina* (1504–06) and Leonardo da Vinci's *Battle of Anghiari* (1505).

A rather poor copy of the destroyed painting in the Uffizi shows a figure on horseback that is strikingly similar to the one seen here. It is difficult to tell if this drawing has been cropped; assuming it has not, we can see how the composition creates a strong sense of chaos. The roughly square format has extraordinary diagonal movement going across from bottom left to top right. Just off centre are the main torso and shoulders of the horse – a massive powerhouse of a form. All of the elements are just about balanced. The horse's front leg pushes down into the bottom of the drawing; the horse's rider has his left leg on the ground. You know that in the next moment everything will come crashing down, but the soldier's lance may well strike the decisive blow. The forms and incredible energy the rough chalk marks make seem totally in harmony. The brown chalk grid suggests that Titian decided it was good enough to scale up and perhaps use in the painting.

Titian (Italian, *c.* 1485–1576) is the soubriquet of Italian artist Tiziano Vecellio. He studied in Venice under painter Giovanni Bellini (*c.* 1430–1516) and received his first important commission in 1510, producing a series of frescoes for the Scuola del Santo in Padua. His reputation burgeoned with a series of commissions, culminating in the enormous success of his first public work in Venice, an altarpiece for the Church of Santa Maria Gloriosa dei Frari. The ensuing years saw Titian become the leading Venetian artist, and he was equally inventive in allegorical, devotional and mythological painting, as well as portraiture.

See also

Michelangelo (p.140)

Walter Richard Sickert (p.166)

Peter Paul Rubens (p.262)

Space and Scale

In a life-drawing class you may be faced with a difficult angle to draw from, as here (left). This usually means extreme foreshortening. Treat it as a challenge and look for the angle and relative distances between points. You don't need to make dozens of measurements; make a few, then work freely within them. Try to keep a sense of the overall movement by not fixating on one area; instead, move your eye rapidly all over your subject and then over the drawing itself.

Subject Matter

If you don't have a model to draw from, a good exercise is to put a mirror on the floor or on a table, as shown (left). Ensure that it is well supported on a flat surface. Stand where you can see your reflection. Focus on the abstract relationships of shapes and angles of lines – not on the object making sense. Keep the marks you make free to begin with and be prepared to change them as you discover that things are either in the wrong place or the wrong size.

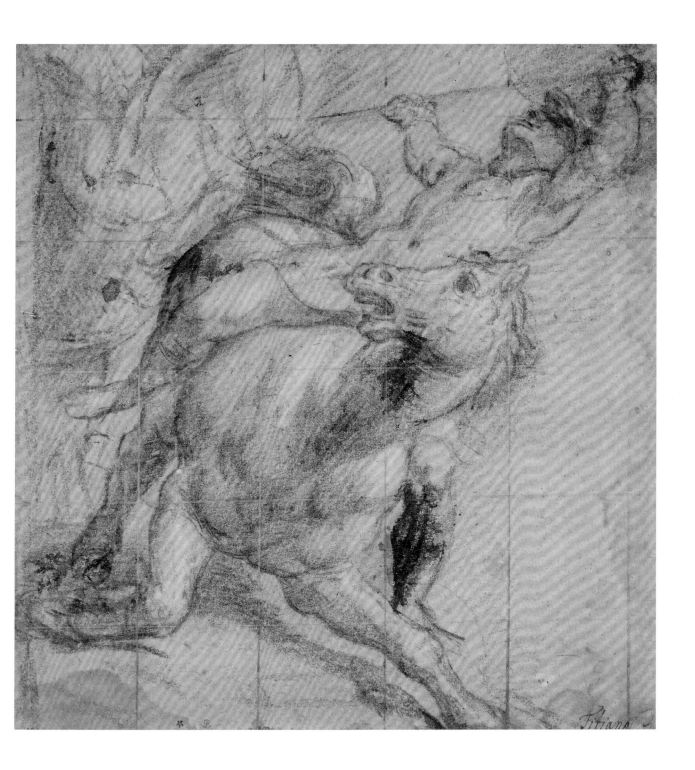

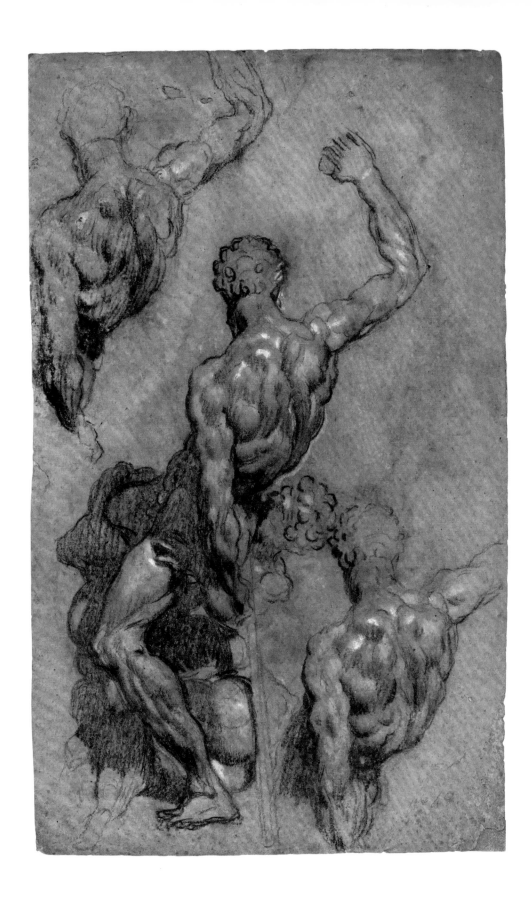

Studies after Michelangelo's *Samson and the Philistines* *c.*1545–50
Black chalk, heightened with white, on blue paper
45.2 × 27.3 cm (17 ¾ × 10 ¾ in.)
Courtauld Gallery, London, UK

Michelangelo was in his early seventies and working in Rome when Tintoretto – who was based in Venice and travelled little – is thought to have completed this drawing. Another artist, working in Florence, Giovanni Battista Naldini, made a drawing of the same sculpture. Although it was never made into a finished marble, Michelangelo made several models that were greatly admired and much reproduced. The original sculpture was designed for a public space where it would be seen from all sides, and the fierce energy expressed in the spiralling, twisted, interlocked forms make it a fascinating subject to draw.

Tintoretto's drawing was originally executed on very thin paper, which was stuck onto a thicker sheet at a later date. Both sides are very rough. Clumps of unbeaten fibre create an undulating quality, with sections that seem to have been sanded down. Some holes that go through the paper have been patched up, whereas others remain untouched. The faint colour suggests a washed paper, however: blue-grey fibres can be seen in the paper's structure. The central complete figure stretches diagonally from the bottom left corner to the top right. The placement of the figure in relation to the sheet feels appropriate and was probably made before the two secondary studies. This is important, as an awareness of the positioning of the figure in relationship to the shape of the paper helps the rhythmic dynamics of the drawing. This rhythmic energy was central to Tintoretto's vision.

Jacopo Tintoretto (Italian, *c.* 1518–94) was the son of a dyer, Jacopo Comin, and became known by his nickname 'Tintoretto' (little dyer). He was a native of Venice and rarely left the city, painting almost exclusively for local patrons. In 1562, he was commissioned to produce three large paintings for the Scuola Grande di San Marco. A couple of years later, he won the most ambitious commission of his career, a series of paintings for the Scuola Grande di San Rocco, which he worked on until 1588 and that chart the development of his style towards a looser, rougher finish and more summary treatment of landscape.

See also

Michelangelo (p.140)

Giovanni Battista Naldini (p.214)

Pierre-Paul Prud'hon (p.218)

Form and Materials
Many Renaissance artists found a twisting form moving up the paper striking. Before you focus on details, identify the bigger, underlying movements you want to make. Using diluted Chinese ink and a piece of polystyrene, make a broad mark that sums up that identified movement. (Water-based Chinese ink is better than Indian ink.) Practise this, identifying one or two principal rhythmic movements (left). When you have a mark you are

satisfied with, try to develop it using charcoal, focusing on contours and light and shade. Let both the contours and the underlying rhythmic marks exist separately. If possible, have a life model pose in varying positions, ideally three. Mark the position of their feet on the floor and draw each pose for no more than five minutes, then return to the first pose/drawing and start the process over. This will allow it to dry so that when you use the charcoal it will sit well on the ink (left).

See also

Lee Krasner (p.190)

Max Beckmann (p.240)

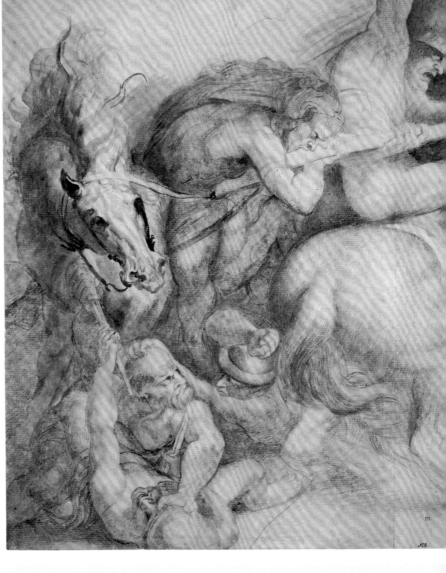

Peter Paul Rubens (Flemish, 1577–1640) received a good education as a child and became an artist at the age of twenty-two. Two years later, in 1600, he went to Italy and entered the service of the Duke of Mantua, Vincenzo I of Gonzaga, who sent him on his first diplomatic mission to Spain. Rubens spent eight years in Italy, where he improved his technique. He returned to Antwerp with a style and a reputation that preceded him. Some of the most influential personalities of Europe were his patrons, including King Charles I, Philip IV of Spain and Marie de Medici.

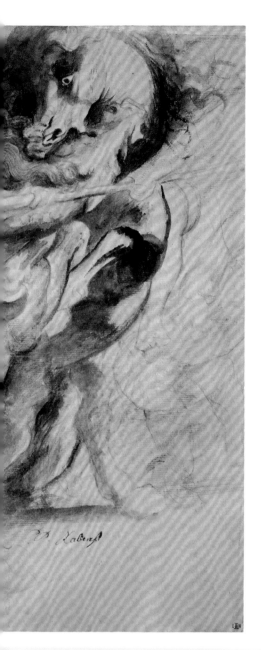

Battle of the Standard *c.*1600
Black chalk with touches of red, and grey and brown wash
41.5 × 52.1 cm (16 ⅜ × 20 ½ in.)
British Museum, London, UK

When standing in front of a large canvas by Peter Paul Rubens, one is awed by the sheer power expressed. The collective strength of all the elements pulling with and against one another is breathtaking. This is a surprisingly large drawing, but considering the subject matter and complexity, it needs to be sizable. It depicts a skirmish of men, some on horseback, attempting to capture the standard. As with many of Rubens's subjects, he creates an intense, intertwined structure that fills the paper and suggests enormous energy. This structure, although elaborated to a high degree, is usually relatively simple. A great sweeping diagonal underpins the whole composition and every detail is drawn in relation to it. If the various elements were not drawn in relation to that diagonal, the composition would end up bitty and disjointed.

Rubens used drawings to plan major compositions. Studio assistants would then scale up the drawings and transfer them onto the vast expanses of canvas. It is always fascinating to see how a drawing was used to make the resulting painting and if it stands on its own as a singular work of art. The sources of these drawings were often other paintings, perhaps by different artists as well as completely original compositions. In this instance, elements are believed to have been taken from a now lost fresco by Leonardo da Vinci at the Palazzo Vecchio in Florence that Rubens copied; that work, dated 1603 and titled *The Battle of Anghiari,* is now in the Louvre museum in Paris.

Composition
Another approach is to work from the abstract to the figurative, as shown in this sequence (left). Start with simple lines that strike you as interesting. Then see if you can build a series of forms – some figures, gaps and objects – that create a human drama. As we see in the Rubens, if this powerful rhythmic and structural framework is set at the beginning, detail often becomes almost unnecessary.

Joshua Commanding the Sun to Stand Still upon Gibeon *c.*1822

Pen and brown ink, brown wash over chalk
40.3 × 61 cm (15 ⅞ × 24 in.)
Metropolitan Museum of Art, New York, USA

In 1821, the leading English portrait painter Sir Thomas Lawrence described John Martin as the most popular artist of his day. He was collected by royalty throughout Europe and influenced many of the writers and thinkers of the Romantic movement. After his death, however, there was a gradual decline in his popularity, and by the mid-20th century he was almost entirely forgotten.

It seems somehow fitting that an artist who produced such portentous scenes was born in the opening year of the French Revolution. There were three key influences on Martin's work: money, religion and landscape. It is very easy to look back at these artists and forget that they had to make money to live. Martin believed in natural religion, which essentially means that God, the soul, spirits and all objects of the supernatural are considered as part of nature and not separate from it. Martin was born in Northumberland, where the dramatic landscape played a central part in the way his artistic imagination developed.

What is striking about this highly complex and detailed drawing of a biblical event is Martin's absolute control. It depicts a truly fantastic scene of heroic and epic dimensions. The imagery has more in common with the films of D. W. Griffith or Cecil B. DeMille than with paintings that were contemporary to his own. These images work like film, in that they present the viewer with a complete picture that has an immediately recognizable context for all the completely realistic details contained within it. Some years later, the Pre-Raphaelites similarly found biblical stories inspiring.

See also
Claude Lorrain (p.114), **Thomas Gainsborough** (p.118)

Materials

Although the drawing above looks as if it used sophisticated materials, if you break the process down it is actually quite simple. Martin would have first had an approximate idea in mind. For his subject of Joshua commanding the sun, he would almost certainly have drawn the whole out in pencil in detail before building up the tones as seen in this detail from his drawing (left).

Sources

With a landscape drawing, you could start with a photograph of an Alpine scene. This may stir your imagination, but it's not the best way to proceed. It's better to build your image up from simple component parts. Martin is telling a story, but the mood creates the context for the narrative. Edward Hopper's images work in a similar way; his use of space is not as vast or illusionistic, but the mood is as important.

Composition

Most landscape artists would agree that the basic structure needs fixing early on. This illustration (left) gives a rough idea of the basic structure Martin may have had in mind. Although he would not have painted this onto paper, it would have been a key part of the way his drawing was to progress. Try to do a drawing like this early on, so that you are clear as to the structure you want to achieve.

John Martin (British, 1789–1854) was born in Northumberland. He was apprenticed to a coach painter in Newcastle until 1806, when he moved to London to work as a glass and china painter. Martin had ambitions to paint grand historical and literary subjects and found success in 1812 when his painting of *Sadak in Search of the Waters of Oblivion* was shown at the Royal Academy. He went on to create small-scale landscape paintings and sepia drawings of a classical inspiration. He found fame in 1821 when he exhibited *Belshazzar's Feast* to popular acclaim and his celebrity also gave him the opportunity to make a living as a commercial printmaker.

The Storm 1927
Graphite pencil on paper
18.7 × 23.7 cm (7 ⅜ × 9 ⅜ in.)
Private collection

René Magritte used a traditional pictorial language – simple use of light and shade, relatively straightforward use of colour and space, and clear three-dimensional forms. He did not want objects to be confusing unless it was intentional. Unlike the Cubists, Magritte did not question his formal language; however, he dealt with fact, not reason. Although Impressionism and Cubism influenced Magritte's early work, the ideas of these movements did not truly inspire him. It was not until he was twenty-eight that he produced his first Surrealist painting, which was derided when exhibited in 1927. At about this time Magritte met André Breton in Paris and became formally involved with the Surrealists.

Completed around the same time, this drawing encapsulates a very simple idea. Walking in a storm can feel as if you are being hit by sharp objects; this work is a poetic visualization of that experience, but done in a matter-of-fact style. The manifestation of such a bizarre notion executed in an almost diagrammatic way produces a magical, dreamlike mood.

Magritte noted in 1937 that there is a 'secret affinity between certain objects'. He pointed out that we are all familiar with the bird in a cage, but it is more interesting if we replace the bird with a fish or a shoe. The artist initially tried to provoke shock in his images by juxtaposing objects that were unrelated and arbitrary, but then realized that by putting together objects that shared an affinity – an egg in a birdcage – he achieved the same effect but more poetically. This small, unassuming drawing marks the beginning of a series of paintings and drawing that changed the way we understand the world around us.

René Magritte (Belgian, 1898–1967) had a childhood shaped by his mother's tragic suicide in 1912. She drowned herself in the River Sambre and Magritte was present during the recovery of her body. The image of his mother floating in the river with her dress obscuring her face may have influenced his art. He studied at the Académie des Beaux-Arts in Brussels from 1916 to 1918 and then worked as a commercial artist until, in 1926, he received a contract with Galerie Le Centaure in Brussels that enabled him to paint full time. He then moved to Paris, where he became friends with André Breton and other Surrealists. After three years, he returned to Brussels.

See also

Hieronymus Bosch (p.256)
Paul Harbutt (p.278)

Subject Matter

The role written language plays in the process of finding new subjects can be extremely rewarding. A good exercise that relates directly to Magritte's Surrealist style is to take idioms that you find particularly interesting and then play with them in a way that produces new, unusual subjects. For example: drink like a fish. The temptation is to do a straightforward illustration (far left). When developing ways of finding new subjects, remember the basic compositional considerations that will make an image both interesting and compelling. When drawing out your first idea, place your objects within a box or rectangle (left, middle). This will help you to consider the whole paper and not only individual objects, and should lead to an improved final image (left).

Paul Klee

Burdened Children 1930
Graphite, crayon and ink on paper on board
65 × 45.8 cm (25 ⅜ × 18 in.)
Tate, London, UK

The work of Paul Klee fits in well with the modernist interpretation of art history. He was influenced by the early 20th-century movements of Expressionism, Cubism and Surrealism. From early on, Klee developed a close friendship with his colleague Wassily Kandinsky at the Bauhaus art school, and he painted his first purely abstract painting in about 1914. Klee famously said that drawing was 'taking a line for a walk'; he taught and wrote extensively about his ideas, declaring: 'I begin where all pictorial form begins: with a point that sets itself in motion.'

 Here, Klee sees form through the movement of that point. The line creates movement across the surface of the paper and the form comes from both the overlapping planes implied by the cell-like structure and the emphasized lines. The image is extremely linear, but if you look carefully the lines are not simply the result of a uniform, continuous dragging of the charcoal. They are carefully stressed and nuanced lines that have come about through perceptive assessments and revisions. The charcoal has been used on its edge in some places and on its end in others. The introduction of the small figurative trigger points – dots that could be eyes – is similar to what Cubists did when they painted a realistic nail into a still-life painting. Klee's title may refer to the stick-figure forms, which look rather like children who are carrying something on their heads. It could also be that the weight of the line and the way the line traps the forms of the children is a burden in itself.

Paul Klee (Swiss, 1879–1940) was born near Bern and moved to Munich when he was nineteen years old to enter the Academy of Fine Arts. After completing his degree, he visited Italy and familiarized himself with the work of the Italian masters. Back in Munich in 1911, he met Wassily Kandinsky (1866–1944), Franz Marc (1880–1916) and August Macke (1887–1914) and joined their art group Der Blaue Reiter (The Blue Rider). After a visit to Tunisia in 1914, his work moved towards abstraction. In World War I, he served in the German army painting camouflage on aircraft. After the war, he taught at the Bauhaus in Germany, first in Weimar and later in Dessau.

See also
Joan Miró (p.204)
Cecily Brown (p.248)
Hieronymus Bosch (p.256)

Sources

Working directly from life will suit some people but not others, whereas the idea of working from memory or imagination causes some people great anxiety. As you discover different ways to make drawings, you will gradually become more able to respond quickly to new ideas or sensations.

 Many great masters have said how important it is to draw what you see – but, if we only drew what we saw around us, we would not be making the most of this powerful and versatile medium. Klee invented shapes and signs that give us a visible expression of a feeling. Starting from this internal point is challenging, but can be very rewarding.

 Start with something simple like laughing and build shapes and lines that suggest this (far left). Try everything from the literal to the highly abstract. As you play around, note any ideas that come into your head, and then see if you can develop a drawing from them (left).

Seated Woman 1952
Pencil, pastel and oil on two sheets of paper
30.8 × 24.2 cm (12 ⅛ × 9 ½ in.)
Museum of Modern Art, New York, USA

What strikes the viewer when looking at this drawing is the manic craziness of the lines: some parts appear not to have moved or been changed, whereas others seem to have been sliced up, erased and moved many times. It feels like it was made in a moment of frenzy, yet it is a drawing that has been carefully altered and refined. Why has Willem de Kooning made so many revisions? The answer lies in the way he prioritizes unity of surface. Look at the woman's arm on the right-hand side and you see that the inside is formed by what looks like a letter sticking out of the pocket. These shapes suggest something literal, but as the eye moves towards the left-hand side there is an almost horizontal line formed by the bottom of the arm shooting off down across to some red on the extreme left-hand side.

De Kooning used found photography in his art, and images of alluring lips in cigarette advertisements provided the starting point for the series 'Women', from which this work is taken. He did about 200 drawings based on this theme. The artist claimed: 'I get the paint right on the surface. Nobody else can do that.' This is a large part of what these drawings are about – getting things to stick to the paper's surface. The subject references three-dimensional form, which is a complete contradiction of the flatness of paper. Abstract Expressionists like de Kooning were obsessed by this. It is in that act of creating something that looks both three- and two-dimensional that the power of painting and drawing lies. The way these two co-exist and become the picture's reality allows the artist to explore the possibilities of representation and expression.

Willem de Kooning (Dutch-American, 1904–97) studied fine and applied art at night at the Academy of Fine Arts and Applied Sciences in Rotterdam from 1918 to 1924, while apprenticed to a commercial art and decorating company during the day. He then spent two years studying in Brussels and Antwerp before emigrating to the United States. There he befriended Stuart Davis (1892–1964), John D. Graham (1886–1961) and Arshile Gorky (1904–48), and became an artist full time, painting several murals for the Federal Arts Project. In 1953, his 'Women' series caused a sensation as the public were affronted by the grotesque depictions of women and critics were disappointed by the inclusion of figurative elements in abstract art.

See also
William Turnbull (p.198)
Frank Auerbach (p.202)
Cecily Brown (p.248)

Scale
When working, you need to think all the time about the surface of the paper being an active component of the drawing. Every time you start to be descriptive, you must destroy or re-invent. There are three ways to do this: using line, shade and, if you choose, colour (as here). The size of the drawing will have a huge impact on how you go about this process. It's easy to make the image so big that it's difficult to create any intensity. You can reduce the drawing size as you proceed.

Materials
When using mixed media, try to use all of the materials from the very beginning. Don't start with one medium, put it down and move to the next. Switching backwards and forwards will help you disrupt the image in a creative way. As you work, try to move your mind from the instinctive to the highly conscious. Many artists work in an almost trancelike state. While this is valid, it is equally important to flick back to using your critical faculties.

Elisabeth 1978
Graphite on paper
43.8 × 43.8 cm (17 ¼ × 17 ¼ in.)
Private collection

Anselm Kiefer is one of a number of influential artists to emerge from post-war Germany who addressed issues inherited from the catastrophes of World War II in their work. Kiefer's dialogue with this troubling past, which encompasses both the war and issues of gender, is expressed in powerful symbols and motifs. But how do we read these images if we are not troubled in the same way? The answer to this question points to the enigmatic power of images. Kiefer produces complex, expressive and surprising visual triggers that provoke a response in us – if we are susceptible.

The subject of this drawing is Elisabeth von Osterreich, who married Emperor Franz Joseph I of Austria when she was sixteen. After she had given birth to a son in 1858, she suffered from ill-health and became obsessed with maintaining her youthful figure and beauty. She demanded to be sewn into leather corsets daily and had ludicrously strict and lengthy beauty routines. She was stabbed to death in 1898 by an Italian anarchist.

In this small drawing we are aware of the artist's use of graphite. Kiefer was not interested in how he could use graphite to control light and shade, line, contour or form, but only in the immediately recognizable motif and its impact. There is a rapport between the motif (a woman in 19th-century dress) and the purity of the materials. Kiefer's rough, graphite background shading is never compromised by his trying to nuance the edge of the figure. The dress is scribbled; because its shape conforms to our idea that it is a particular type of dress, we interpret that scribble accordingly.

Anselm Kiefer (German, born 1945) is a former pupil of Joseph Beuys (1921–86) and, like his mentor, he explores themes of German history, myth, identity, literature and art history, particularly the period under Nazi rule and the Holocaust. Such explorations have also seen him produce large-scale canvases, photos and structures reflecting the monumental scale of fascist rallies and the architecture of the Nazi's favourite architect, Albert Speer (1905–81). He studied law and languages at Freiburg University. From 1966, he trained in painting with Peter Dreher (born 1932). He attended the School of Fine Arts at Freiburg, and then at the Art Academy in Karlsruhe.

See also

Joan Miró (p.204)
René Magritte (p.266)
Dexter Dalwood (p.276)

Materials

Even when focusing on the symbolic aspect of a subject, it is still important that the materials you choose enable you to create the desired effect. Drawing the same subject matter with different materials will help you better see how material and subject matter influence one another. Although clichéd, a crudely drawn heart with an arrow through it, for example, as here (right), has a very different effect to a perfectly rendered stylized version.

Sources

Using a subject primarily as a symbol rather than trying to capture its appearance can give an artist more freedom. Symbols are reliant on a degree of familiarity, so it follows that a symbol can soon become a cliché if overused. Certain clichés have so many sentimental or trivial connotations that they are unusable – for example, palomino horses galloping through the surf on a beach. It is important to find subjects or symbols that are familiar but not overused.

Ken Kiff

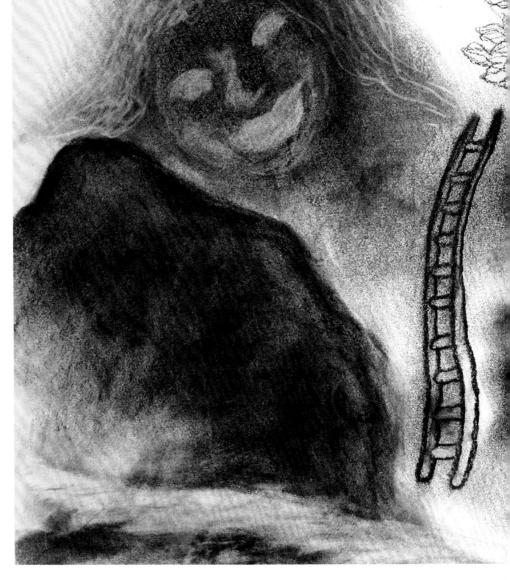

Ken Kiff (British, 1935–2001) was born in Dagenham, East London, and went to the Hornsey School of Art from 1955 to 1961. A painter, illustrator and engraver, Kiff was instrumental in the revival of figurative painting in the early 1980s. He was also influential as an art teacher at Chelsea School of Art and the Royal College of Art. From 1992 to 1993, he was the associate artist at London's National Gallery. Influenced by the work of Paul Klee (1879–1940), Marc Chagall (1887–1985) and Joan Miró (1893–1983), his own paintings featured vibrant, expressive colour, dreamlike landscapes and grotesque figures.

Sources

Getting into the habit of working regularly is helpful in many ways. Drawing is a skill and the more you practise the better you get. Getting into a routine can give you the freedom to experiment. If you wait until you have an idea before you sit down and start to draw, the idea may disappear or not seem as good as it did. Spend a couple of hours drawing each week, no matter what you feel like.

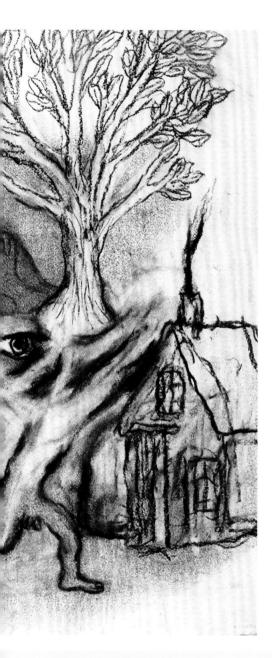

Ladder 1991
Charcoal on paper
56.5 × 75.9 cm (22 ¼ × 30 in.)
Marlborough Fine Art Gallery, London, UK

The figurative artist Ken Kiff defined fantasy as 'a way of thinking about reality'. His images include elements of the recognizable that move strangely around his compositions in defiance of a predictable ordered world. Kiff's imagination uses and transforms reality. He then draws this transformation – through an extraordinary process – presenting the viewer with a new reality. This reality is convincing because it gives shape and form to feelings and perceptions that we have not been able to achieve ourselves. The American modernist poet Wallace Stevens, whose work was strongly influenced by the art of Paul Klee and Paul Cézanne, believed that: 'Reality is the product of the imagination as it shapes the world.'

Kiff's work was insistently figurative at a time in the 20th century when critical attention primarily valued abstract art, and his work was often criticized. In 1971 he started work on what he called 'The Sequence' – a series that was to last until his death in 2001. Each week he set out to produce at least one or two images in acrylic on paper. As he worked he would go back over the efforts of previous weeks and make revisions, sometimes picking up on work he had done years before.

In Kiff's dreamlike drawing, objects become enchanted and distorted in their relationships to other objects but also by the picture surface. The ladder is unquestionably a ladder but it bends because of both the demands of the artist's imagination and the demands of the picture. The tree is behind the man, but the man becomes the roots of the tree. As viewers we can read this image because we understand the objects depicted, but the spell is created by the interactions between them.

See also

Joan Miró (p.204), **Paul Klee** (p.268), **Paul Harbutt** (p.278)

Space

Using ambiguities of space and scale to try and recreate our internal world is an important part of visual language. The relative size of objects can magically transform an image. Michelangelo's figures become monumental as the heads start to get smaller. In Kiff's drawing the house seems weirdly small whereas the eye is ludicrously big, but it is these anomalies that generate the dreamlike atmosphere. In this illustration (left), not only does the artist reduce the size of the buildings, but he also isolates them, surrounding them with colour. This manipulation of scale creates an ambiguous effect. The buildings seem weightless, which relates to the falling figure, also without weight. They also have an angular external shape that creates another connection with the shape of the falling figure, thus a whole.

Study for *Room 100, Chelsea Hotel* 1999

Graphite and collage on card
25.8 × 29 cm (10 ⅛ × 11 ⅜ in.)
Simon Lee Gallery, London, UK and Hong Kong, China

Dexter Dalwood's subject here is the room at New York's Chelsea Hotel where Nancy Spungen met her violent and untimely death in 1978, allegedly at the hands of her punk singer boyfriend Sid Vicious. In similar works by Dalwood, subjects such as Bill Gates's bedroom, Liberace's dressing room and Kurt Cobain's greenhouse are given new life in this way. These scenes are figments of the artist's imagination, informed by gossipy magazine articles or news stories, but not experienced directly. This is celebrity culture as seen through a very sensitive and well-organized sensibility. Dalwood takes popular cultural touchstones and reported events and recreates them so that they feel like our own experiences.

This drawing is a preparation for a much larger painting, but it has the key features that make it a highly compelling image. We are seeing the destroyed hotel room after the terrible event. The view is almost forensic, as if we were a detective who has come to make sense of the scene. Dalwood uses some clever devices: the lack of exact horizontals or verticals generates a sense of chaos; the drawing has intensity even though there is very little colour. He creates an empty yet oppressive mood by placing only one or two objects in the room. We have all been in hotel rooms just like this, with little or no personality. The mix of collage and pencil instils yet more discord and the drawing separates away from documentary reportage, becoming a work that builds tension. This is not entirely intentional, as it is not replicated in the painting, but it seems like a shorthand way of making a particular type of drawing.

Dexter Dalwood (British, born 1960) was born in Bristol and moved to London to study, first at St Martin's School of Art and later at the Royal College of Art. He is known for his large canvases featuring fantasy cityscapes and interiors that suggest famous people, literary figures and significant events by their environment, such as *Sharon Tate's House* (1998) and *Kurt Cobain's Greenhouse* (2000). His paintings meld art history and popular culture as they pay homage to the works of artists including Henri Matisse (1869–1954), Ed Ruscha (born 1937) and David Hockney (born 1937). In 2010, he was shortlisted for the UK's prestigious Turner Prize.

See also

Francis Picabia (p.98)
René Magritte (p.266)
Paul Harbutt (p.278)

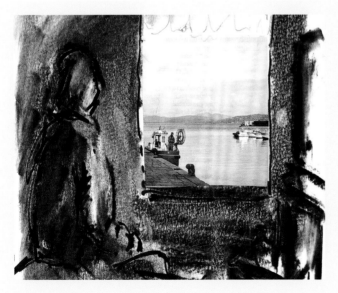

Materials

When using collage, stretch the paper to avoid buckling. A thick, heavier paper such as 300gsm also helps. Using collage can be an exciting departure from traditional materials, but there are pitfalls. By adding a piece of a photograph, for example, you are introducing a new reality into the drawing, as shown here (left). It can easily just look stuck on top, almost protruding from the paper's surface. This can take away or reduce the integrity of the paper that you're using.

Pieces of cut-out photographs can also look like a hole in the surface of the paper, which will appear equally odd. What you should seek to do is play with the image while keeping the surface unified. You should aim for a dialogue between the various parts of the drawing. It is therefore best to put the collage pieces in as early as you can. You will then, unconsciously, take into account this new element as you continue to work on the rest of the drawing.

The Charnel House 2015
Pencil on paper
49.5 × 61 cm (19 ½ × 24 in.)
Gibson Family Collection, London, UK

Strands of Paul Harbutt's work have been profoundly influenced by his peripatetic lifestyle – from his early years in a rough north London suburb to New York in the 1970s. This drawing refers to Harbutt's hedonistic time in New York during the heyday of Andy Warhol and Studio 54. Although this period is the starting point for the drawing, it feels more like a dance around the memories of a lifestyle that has been witnessed rather than lived. With many drawings, there is a correlation between the time spent creating it and the time required to look at it. This is not a work of visual trickery but an imaginative reflection on Harbutt's inner world – sympathetic but emotionally detached and non-judgmental. The title refers to a place where human corpses and bones are stored.

Looking at this carefully composed drawing takes time. It does not unfold in a linear way like a story (although it is possible to read it in that way). Curves in the various body shapes echo across the image and details – the sleeping child, the plate of half-eaten pizza, the drug paraphernalia – hold the viewer's gaze. Compartments framed by a doorway or a window separate us, as if part of the scene but also a separate reality. Each character depicted is lost in his or her own world.

A photograph is an image of reality made in a fraction of a second, whereas an observational drawing is a collection of moments synthesized into a unified whole. This work looks as if it should be a combination of the two, but it is not. Harbutt's imaginary world is illuminated by contemporary neon light that leaves everything open to scrutiny yet, like the world we create in our heads, his world doesn't quite make sense. Arms are twisted, the space distorted and scale odd – where is the truth in memory?

Paul Harbutt (British, born 1947) was born in London. He attended Harrow School of Art from 1960 to 1963 and the Royal College of Art, London, from 1967 to 1970. He then travelled to New York, Seville and Rome, where he fashioned his own style influenced by Italian Surrealism. His first solo show was held at the Galleria Mara Chiaretti, Rome, Italy, in 1976. Since then he has exhibited throughout the world. In 1999 and 2002, he was visiting artist to the Phillip Guston Studio at the American Academy in Rome. From 2003 to 2008 he was art professor at Cornell University in Rome. He lives in New York.

See also

Francisco Goya (p.150)
Paula Rego (p.178)
Hieronymus Bosch (p.256)

Sources

Harbutt had a clear idea of the general subject of his drawing, but as he progressed it underwent many revisions in composition and the objects included. Try to retrieve fragmented memories of a subject and reassemble them in a loose, instinctive way. As you progress, aim to develop a rapport between your imaginary world and your drawing. Harbutt has described this process well: 'I knew I wanted to include a particular type of table so I started drawing it. As I was drawing I thought it would be good to have an ashtray on the table. As I drew the ashtray, I thought it should have some cigarettes in it. It was as if placing the table provoked a series of possibilities, some of which I included.' This is an interesting way of making a drawing – it is like the old parlour game of consequences, but based on those memories and imaginative leaps.

Abstract art
Style of art that does not attempt to represent an accurate depiction of real life but instead consists of forms, shapes and colour, independent of subject matter. Abstract art, non-figurative art and non-representational art are loosely related terms that are similar but not always identical in meaning.

Abstract Expressionism
Post-World War II art movement in American painting characterized by a desire for freedom of expression and the communication of strong emotions through the sensual quality of paint. Developed in New York City in the 1940s, it also became known as the New York School and put the city at the centre of the Western art world, a role formerly filled by Paris.

Analytical and Synthetic Cubism
Picasso's dealer Daniel-Henry Kahnweiler made this distinction in *Der Weg zum Kubismus* (1920): Analytical Cubism is characterized by a fragmentary appearance of form with multiple viewpoints and overlapping planes whereas Synthetic Cubism is characterized by simpler shapes, brighter colours and the use of collage.

Automatism
A method whereby the act of drawing, writing or painting is based on chance, free association, suppressed consciousness, dreams and states of trance. As a means of supposedly tapping into the subconscious mind, it was adopted with particular enthusiasm by the Surrealists.

Barbizon School
A school of French landscape painters that was active from the early 1830s through to the late 1870s and takes its name from a village on the edge of the Forest of Fontainebleau near Paris. Some of the most prominent features of the school are its tonal qualities, colour, loose brushwork and softness of form. Leaders of the school were Théodore Rousseau, Jean-François Millet and Charles-François Daubigny. The group later influenced the Impressionists.

Baroque
Characterized by a self-confident, dynamic and relatively realistic approach to depiction, this style originated in Rome, where it peaked around 1630 to 1680, but was influential across Europe. Unlike many earlier styles it was also used for non-religious themes such as portraits, still lifes and mythological subjects. Its chief exponents were Peter Paul Rubens and Caravaggio.

Bauhaus
Revolutionary modernist school of art, architecture and design established by Walter Gropius at Weimar in Germany in 1919. Artists including Paul Klee and Wassily Kandinsky worked there and its philosophy of 'form follows function' transformed art, typography, graphic design, architecture and industrial design.

Chiaroscuro
Italian for 'light-dark'. The dramatic effect created by balancing or strongly contrasting light and shade in a painting or drawing.

Collage
Style of picture-making in which materials (typically newspapers, magazines, photographs, etc.) are pasted together on a flat surface. The technique first gained prominence with the rise of Cubism in the early 20th century, particularly in the work of Pablo Picasso and Georges Braque.

Conceptual art
Art in which the most important factor is the idea or concept as opposed to the form, medium or final appearance of the work. Its heyday was in the 1960s and 1970s, although the same principles were used by Marcel Duchamp decades earlier.

Contour
A line or a series of lines that represent forms that overlap. This kind of line is very different to an outline (the outer edge of a silhouette). The differentiation is crucial: understanding how a contour line increases the ability of the artist to create three-dimensional forms is a basic skill.

Cool and warm colours
Warm colours approximate towards reds and yellows whereas cool colours approximate towards blues and greens. Warm colours tend to advance towards the eye whereas cool colours tend to recede. The way colours act in an image is dependent on the relationship they have with other colours.

Cubism
Early 20th-century avant-garde movement led by Pablo Picasso and Georges Braque that revolutionized Western European painting and sculpture. In Cubist art, forms resemble geometric shapes such as triangles or cubes and structure is often created by a series of seemingly unconnected forms vaguely fitted together to make a whole. Cubists abandoned the idea of a fixed viewpoint, resulting in objects appearing fragmented and abstracted.

Dada
Art movement started in 1916 in Zurich, Switzerland by writer Hugo Ball as a reaction to the horrors of World War I. It aimed to overturn past traditional values in art, and was notable for its introduction of 'ready-made' objects as art, and its rejection of the notion of craftsmanship. Core artists included Marcel Duchamp, Francis Picabia, Jean Arp and Kurt Schwitters.

Expressionism
Modernist movement originating in Germany at the beginning of the 20th century that extended to a wide range of the arts including architecture, painting, literature, theatre, dance, film and music. Expressionist art is intense, characterized by loose, flowing brushstrokes and often showing a distortion of the subject's form. It is literally 'expressive' of the artist's state of mind when creating it. Many artists labelled as 'Expressionist', Max Beckmann for example, disliked the label.

Fibonacci sequence
Named after the medieval Italian mathematician, a pattern whereby each number is the sum of the two preceding numbers (1, 1, 2, 3, 5, 8, 13, 21, 34 and so on). By visualizing each number as a square (increasing in size like the

number sequence) and connecting the opposite corners of each square, the Fibonacci spiral is created (see p.40).

This sequence is closely connected to the **golden ratio**: a special number found by dividing a line into two parts so that the longer part divided by the smaller part is also equal to the whole length divided by the longer part. The golden ratio is abundant in nature from the spiral pattern of a conch shell to the proportions of the human face.

Artists realized that the Fibonacci spiral is an expression of an aesthetically pleasing principle: the **rule of thirds**. This is used in the composition of a picture; by balancing the features of the image by thirds, rather than strictly centring them, a more pleasing flow is achieved. The rule of thirds is applied by aligning a subject with the guide lines and their intersection points, placing the horizon on the top or bottom line, or allowing linear features in the image to flow from section to section. Since the Renaissance, artists have created pleasing images that demonstrate the Fibonacci spiral in their composition.

Figurative art
Representative art in which figures and forms are faithfully recreated; the antithesis to abstract or Expressionist art. Figurative art is not synonymous with figure painting (art that depicts the human figure) although human and animal figures are common subjects.

Foreshortening
The effect achieved by exaggerating the size of the elements in a picture that are nearest to the viewer and by correspondingly reducing the size of the elements that are further away.

Formal language
The fundamental terms an artist uses in order to communicate ideas or sensations. The formal terms of this language refer to space, form, tone, shape, line and colour.

Gestural line
A more free and instinctive response to the artist's subject. It assumes that a mark made instinctively has a different, more valuable quality than a mark that tries to describe the object more literally.

High-key colour
Describes drawing and painting that uses intense and saturated colour.

High Renaissance
Period from *c.* 1490 to 1527 when Rome was sacked by the troops of Charles V. The most important artists were Leonardo da Vinci, Raphael and Michelangelo.

Imaginary space
Refers to the space artists recreate in their imaginations.

Impressionism
Revolutionary approach to painting landscape and scenes of everyday life pioneered in France by Claude Monet and others from the early 1860s, and which was later adopted internationally. Often created outdoors (*en plein air*) and notable for the use of light and colour as well as loose brushwork. The first group exhibition held in 1874 was dismissed by critics, particularly Monet's painting *Impression, Sunrise*, which gave the movement its name.

Likeness
The notion of an accurate representation of individual facial features in a realistic mode is an idea that is rooted in the Western European art tradition and one that did not gain widespread currency until the Renaissance. Facial likeness is relatively easily achieved – the most important aspect is the position of the features in relation to the overall shape of the head and face.

Lithography
Technique in which a design is drawn on to a surface using a medium such as a greasy ink or a crayon and then treated so that it is fixed. Water is applied to the design; this will not adhere to the greasy areas. An oil-based ink is then rolled over the surface, which adheres to the greasy areas of the design, but not to the wet areas. Paper is applied to the surface and the work is passed through a press, creating a reverse image of the design on the paper.

Low-key colour
A range of dark value colours from mid-tone to black.

Minimalism
Style of abstract art – characterized by a spare, uncluttered approach and deliberate lack of emotive expression or conventional composition – that arose in the second half of the 20th century and flourished mainly until the 1970s. Practitioners range from Yves Klein and Lucio Fontana to Ellsworth Kelly and Kenneth Noland.

Neoclassical
Art that draws inspiration from the classical art and culture of ancient Greece and Rome. Neoclassicism has its origins in Rome in the mid 18th century but quickly became popular all over Europe as artists travelled to Italy to complete their art education on the Grand Tour. In modern art the term has also been applied to a similar revival of interest in classical styles during the 1920s and 1930s.

Outline
The outermost edge of a silhouette of any form. In drawing, concentrating on the outline will create flatness and reduce any impression of three-dimensional form.

Photorealism
Genre of painting, drawing and graphic media that aims to reproduce the look of a photograph as accurately as possible. It is used to refer specifically to an American art movement that began in the late 1960s and the early 1970s.

Picture plane
An imaginary plane positioned between the artist and the objects they are depicting; it represents the physical surface of the drawing or painting and the size of the plane equates with the size of the paper. If the artist and his subjects stay in exactly the same position and you move the imaginary plane towards the object, the objects become smaller in relation to the size of the plane (see p.31).

Picture space
Refers to the apparent space behind the picture plane of a painting or drawing, created by perspective and other techniques.

Plein air

Phrase borrowed from the French *en plein air* meaning 'in the open air' to describe painting created outdoors. It is particularly used to describe work where a painter reproduces the actual visual conditions seen at the time of painting. This method contrasts with studio painting or academic rules, and was adopted by the Impressionists.

Pointillism

Theory and technique involving the application of small areas or dots of paint to the canvas in order to obtain intense colour effects optically rather than by mixing colours on a palette. Georges Seurat and Paul Signac developed the technique in 1886. Also known as divisionism.

Pop art

Term coined by British critic Lawrence Alloway for an Anglo-American art movement that lasted from the 1950s to the 1970s. It is notable for its use of imagery taken from popular cultural forms such as advertising, comics and mass-produced packaging. Key figures included Richard Hamilton and Eduardo Paolozzi in the United Kingdom and Robert Rauschenberg, Andy Warhol and Jasper Johns in the United States.

Pre-Raphaelites

The Pre-Raphaelite Brotherhood was a secret society of young artists founded in 1848 by William Holman Hunt, John Everett Millais and Dante Gabriel Rossetti. Inspired by the theories of critic John Ruskin, who believed in the benefits of working from nature, and opposed to the conventional painting shown at the Royal Academy (and the promotion of Raphael) the Pre-Raphaelites believed in an art of serious subjects treated with maximum realism.

Realism

Literally art that depicts its subject in a realistic manner. Realism was a movement that began in France after the 1848 Revolution. It reacted against the exotic subject matter and exaggerated emotionalism and drama of the Romantic movement, which dominated French literature and art from the late 18th century.

Real space

The three-dimensional world we perceive.

Rhythm

In drawing rhythms are created when patterns or connections between similar elements are established across the surface of the image. These patterns pull the eye in specific directions at various speeds.

Rigger brush

The longest, thinnest round watercolour brush is made from kolinsky sable hair. Designed for painting the rigging on ships, it is ideal for continuous fine lines.

Rococo

French 18th-century movement and style that was a reaction against the symmetry, grandeur and strict principles of the Baroque era. Rococo artists used a more light-hearted, flowing and ornate style that has since become seen as frivolous and superficial.

Romantic movement

The antithesis of classicism, this artistic, literary, musical and intellectual movement originated in Europe towards the end of the 18th century. It broadly focused on the experience of the individual, instinct over rationality and emotional responses to nature.

Schematic drawing

Method of drawing that builds up forms from simple geometric shapes that conform to normal expectations. These geometric shapes are gradually altered to become more realistic. An electrical diagram would be an extreme version of schematic drawing.

School of London

Term invented by artist R. B. Kitaj to describe a group of London-based artists who in the 1970s painted in figurative styles in the face of avant-garde approaches such as Minimalism and Conceptualism.

Series

Work in which images are produced based around a certain theme or idea. Each image may or may not be related to a previous or subsequent image but all are connected to the original idea.

Silverpoint

One of the most commonly used drawing techniques used in ancient times and up to the end of the 15th century in which a silver rod or thin piece of wire is dragged across a slightly abrasive surface. Also known as metalpoint.

Structure and composition

These two terms are understandably often confused because to some extent they overlap. However, each term has a slightly different meaning. Composition refers more broadly to the overall distribution of large areas of specific or unspecific shapes, whereas structure refers to the way these shapes and forms create relationships between each other.

Surrealism

Influential art movement that began in the early 1920s and is best known for its strange and illogical imagery. Although the visual language used is often traditional and descriptive, the images created can be deeply disturbing.

Topographical drawing

The detailed description or drawing of the physical features of a place or region, especially in the form of contour maps. Human-made features such as roads, railways and landfills are considered part of a region's topography.

Transition tones

Tones of light and shade that connect the lightest part of an image to the darkest part. Often described as halftones (mid-tone) and quarter tones (halfway between the mid-tone and one of the extremes).

Vanishing point

The point on the horizon line at which receding parallel lines viewed in perspective begin to converge. As things get further away, from us, they seems smaller and closer together. When they get far enough away, distances become ever tinier and so form a single point.

Vorticism

Short-lived avant-garde movement in British art and poetry of the early 20th century, partly inspired by Cubism.

Index

A

Abstract Expressionism 20, 130, 190, 192, 195, 197, 244, 270, 280
abstraction
 composition 199
 definition 280
 figuration 36–7, 249, 263
 form 190, 209
 line 190, 195, 196–7, 203
 materials 190, 192, 199, 200, 209
 overview 186–7
 scale 203
 sources 189, 192, 195, 204, 206
 space 206
 subject matter 200, 203, 204
 tone 195
Académie de jeune femme
 (Matisse) 234, 235
Adjectives, lines and marks
 (Carlier) 8
aesthetics 41, 159, 192, 247
Alberti, Leon Battista 16
Analytical Cubism 59, 281
Anguissola, Sofonisba 142–3
arabesque line 216
art, compared to illustration 16–19
Artaud, Antonin 104–5
The Attack (Grosz) 168, 169
Audran, Gérard 219
Auerbach, Frank 202–3, 206
automatic drawing 204
avant-garde 61, 104, 131

B

Bacon, Francis 39, 106
Balthus 246–7
Barbizon School 157, 281
Barceló, Miquel 208–9
Barcelona Drawing No. 12 (Noble) 30
Barocci, Federico 82–3
Baroque 86, 281
Baselitz, Georg 176–7
Basket and Candlestick (Volley)
 66, 67
Battle of the Standard (Rubens)
 262–3
Bauhaus 281
Bay Area Figurative Movement 244
Beckmann, Max 132, 172–3, 240–1
The Bitch of the Baskervilles
 (Picabia) 98, 99
blending
 chalk 77

charcoal 174, 234, 240
pastels 44, 96, 240
tools 46, 47
blind contour drawing 233
Boaz and Ruth (Rembrandt) 146–7
Bomberg, David 130–1, 134, 202
Bonnard, Pierre 60–1, 83
Bosch, Hieronymus 12, 256–7
Bottle and Bowl (Gris) 58, 59
Boucher, François 15, 216–17
Boudin, Eugène 124, 125
Braque, Georges 54, 62–3
Brown, Cecily 248–9
Bruegel, Pieter the Elder 112–13
brush pens 48, 49
brushes 45, 48, 49, 151, 249
Burdened Children (Klee) 268, 269
Burning Up No. 1 (Noble) 18

C

Camden Town Group 166
Carlier, Alison 8
Carracci, Annibale 84–5
Carrière, Eugène 234
cave painting 11
Cézanne, Paul 15, 66, 224–5
chalk 43–4, 46, 47, 77, 86, 88, 140
Chalon, Alfred Edward 138, 154–5
charcoal
 abstraction 190
 fantasy 261
 figures 174
 heads 101
 landscape 131, 134
 nudes 234
 techniques 42–3
 types 46, 47
Chardin, Jean-Baptiste-Siméon
 15, 66, 92
The Charnel House (Harbutt) 278–9
Chevreul, Michel Eugène 228
chiaroscuro 28, 122
children 16
Chinese ink 44, 48, 49, 261
Christ Church, Spitalfields (Kossoff)
 206, 207
Chrysanthemum (Mondrian) 56, 57
The Church at Varengeville, Sunset
 (Monet) 124–5
clothing 138, 139, 153
Coffee (Bonnard) 60
collage 45, 51, 276
color
 cool and warm 155, 281

high-key 281
local color 282
low-key 282
paper 86, 221, 227
trois crayons 86, 87
composition
 abstraction 199
 fantasy 262–3, 265
 figures 140, 142, 145, 151, 154–5, 170
 heads 75, 85
 landscape 113, 115, 125
 nudes 219, 227, 231, 240, 244
 overview 34
 still life 60
 techniques 40–1
Composition (de Staël) 192, 193
Compositional Madonna sketch
 (Noble) 34
conceptual art, definition 281
Constable, John 122–3
Conté crayon 43–4, 46, 47, 85, 117, 215, 228
contour
 definition 281
 fantasy 261
 figures 159
 heads 75, 77, 83
 line 33
 nudes 219, 223, 225, 227, 233, 238
 tone 83
copying 19, 23, 36, 37
Corot, Jean-Baptiste-Camille 175, 222–3
Couple Kissing (Dumas) 250, 251
Courbet, Gustave 92–3
Creffield, Dennis 134–5
Cubism 16, 23, 59, 62, 63, 169, 170, 190, 281

D

Dada 98, 169, 281
Dalwood, Dexter 276–7
Dancer (Daumier) 158, 159
Daumier, Honoré 157, 158–9
de Kooning, Willem 270–1
De Stijl 57
Degas, Edgar 15, 24, 27, 44, 160–1, 166, 222, 226–7
Delacroix, Eugène 37–9
*The Deliverance of the Demoniac
 of Constantinople by St. John
 Chrysostom* (Sirani) 148–9
Les Demoiselles d'Avignon
 (Picasso) 23

depth 31
Diebenkorn, Richard 244–5
Digger in a Potato Field (van Gogh) 157, 164, 165
Discombobulated Policeman No. 6 (Noble) 20
distortion 173
Doig, Peter 180–1
Dorothy Schubart (O'Keeffe) 100, 101
drapery 146–7, 188, 189, 216
drawing
 definition 8
 fine art compared to illustration 19
 history 11–16
Ducornet, Louis Joseph César 212, 220–1
Dumas, Marlene 250–1
Durham: The Central Tower (Creffield) 134, 135

E

El Greco 173
Elisabeth (Kiefer) 272, 273
Embarrassment (Rego) 178, 179
enlargements 37
erasers 46, 47
etching 49
expression, facial 142, 269
Expressionism 132, 173, 231, 237, 281

F

faces 70–1, 142 *see also* heads
fantasy
 composition 262–3, 265
 contour 261
 form 261
 line 269
 materials 256, 261, 264, 270, 272, 276
 overview 254–5
 scale 258, 270, 275
 sources 263, 264, 269, 272, 274, 278–9
 space 258, 275
 subject matter 256, 258, 266–7
Fauvism 174, 175, 234
Female Nude Sitting on a Couch (Boucher) 216, 217
Femme nue debout (Degas) 226, 227

Fibonacci sequence 34, 40, 281
figurative art, definition 281
Figure Pulling Out a Nail of a Sick Person (Miró) 204, 205
figures *see also* nudes
 clothing 138, 139, 153
 composition 140, 145, 151, 154–5, 170
 form 149, 159, 164, 166, 170, 173
 geometric shapes 16, 32
 line 157, 159, 162–3
 materials 145, 146–7, 148, 151, 155, 161, 163, 172, 174, 177, 183
 overview 138–9
 sources 159, 163, 164, 166, 169, 179, 180–1, 183
 space 153, 157, 175
 subject matter 142, 151
 tone 145
The Fire at San Marcuola (Guardi) 120–1
fixative 46, 47
flatness 31
Fohr, Carl Philipp 90–1
foreshortening 258, 281
Forest (Noble) 22–3
form
 abstraction 190, 209
 distortion 173
 fantasy 261
 figures 149, 159, 164, 166, 170, 173
 heads 77, 85, 90, 104
 landscape 120, 131, 134
 nudes 215, 221, 227, 228, 233, 237
 overview 33
 still life 57, 59, 66
Fragonard, Jean-Honoré 15
framing 41, 123
Freud, Lucian 20, 39, 90, 106–7

G

Gainsborough, Thomas 15, 118–19
A Gathering at Wood's Edge (Fragonard) 116–17
Gauguin, Paul 94–5, 126, 238
genre painting 113
geometric shapes
 composition 34
 figures 16, 32
gestural line, definition 281
 see also line
Ghosts No. 5 (Noble) 26
Ghosts No. 7 (Noble) 27
Giacometti, Alberto 199, 242–3

Girl in the Street (Noble) 35
Girl with Head in Hands (Noble) 14
God Save Us from Such a Bitter Fate (Goya) 150, 151
golden ratio 34, 40, 281
gouache 48, 49
Goya, Francisco 15, 150–1
Gris, Juan 58–9
Grosz, George 168–9
Guardi, Francesco 15, 120–1
Guest House 3 (Doig) 180–1
Guston, Philip 187, 196–7, 249

H

hairspray 46, 47
Harbor Scene (Lorrain) 114–15
Harbutt, Paul 255, 278–9
hatching 256
hats in self-portrait 92
Head (Turnbull) 198, 199
Head of a Bearded Man (Pontormo) 76, 77
Head of a Girl (Leonardo da Vinci) 11, 72, 73
Head of a Man, Seen from Behind (Barocci) 82, 83
Head of a Man (Watteau) 86, 87
The Head of St. Thomas (Polidoro da Caravaggio) 78–9
heads
 children 16
 composition 75, 85
 form 77, 85, 90, 104
 likeness 80
 line 77, 80, 83, 86, 90, 104
 materials 72, 83, 85, 86, 88, 96, 98, 101, 103
 overview 70–1
 shape 104
 sources 80, 88, 96, 102, 106
 space 101
 subject matter 78–9, 92, 95, 98
 tone 75, 83, 92
Hesse, Eva 187, 200–1
High Renaissance 12, 142, 281
Hofmann, Hans 130, 190, 194–5
Hogarth, William 151
Holbein, Hans the Younger 80–1, 90
Hopper, Edward 101, 128–9, 264
Horse and Rider Falling (Titian) 258, 259
Houses of Parliament II (Kokoschka) 132–3

I

idioms 173
illustration, compared to art 16–19
imagination 254–5, 269
Impressionism 110, 124, 161, 225
Indian ink 44, 48, 49
Ingres, Jean-Auguste-Dominique
 152–3, 154, 161
inks
 fantasy 256, 261
 figures 145, 148, 155
 landscape 112
 techniques 44
 types 48, 49
iron gall ink 48, 49, 147

J

Jean-Honoré Fragonard 116–17
*Joshua Commanding the Sun
 to Stand Still upon Gibeon*
 (Martin) 264–5

K

The Kaunitz Sisters (Ingres) 152, 153
Kermis at Hoboken (Breugel) 112–13
Kiefer, Anselm 272–3
Kiff, Ken 27, 255, 274–5
Klee, Paul 8, 33, 268–9
Kokoschka, Oskar 132–3
Kossoff, Leon 206–7
Krasner, Lee 190–1

L

Labille-Guiard, Adélaïde 88–9
Ladder (Kiff) 274–5
Lamentation (recto) (Michelangelo)
 140, 141
landscape
 composition 113, 115, 125
 fantasy 264–5
 form 120, 131, 134
 line 116, 129
 materials 112, 117, 121, 123, 126–7,
 131, 132, 134
 overview 110–11
 sources 113, 118, 124, 129, 131, 134
 space 112, 123, 131, 132
 subject matter 117, 119, 121, 123,
 128, 133
 tone 114
laughter 142, 269

Leonardo da Vinci 11, 12, 20, 70,
 72–3, 75, 209
Liber Veritatis (Lorrain) 115
likeness 80
line
 abstraction 190, 195, 196–7, 203
 fantasy 269
 figures 157, 159, 161, 162–3
 heads 77, 80, 83, 86, 90, 104
 landscape 116, 129
 nudes 216, 225, 227, 233, 238,
 244, 249
 overview 33
lithography 49, 230, 231
local color 282
Lorrain, Claude 12, 114–15

M

*Madame X (Madame Pierre
 Gautreau)* (Sargent) 162–3
Magritte, René 12, 266–7
A Male Nude (Cézanne) 224, 225
Male Nude in Profile (Ducornet)
 220, 221
*Male Portrait (The Lute Player
 Mascheroni)* (Carracci) 84, 85
Man at Night (Self-portrait) (Freud)
 106, 107
Man Carrying an Urn (Degas) 24,
 160, 161
*Man Drawing by Moonlight from the
 Window of a House* (Zuccaro)
 144, 145
Man Lying in the Street (Noble)
 12–13
Man Walking with Woman in Shadow
 (Noble) 38
Manet, Edouard 139
Martin, John 264–5
materials
 abstraction 190, 192,
 199, 200, 209
 fantasy 256, 261, 264,
 270, 272, 276
 figures 145, 146–7, 148, 151, 155,
 161, 163, 172, 174, 177, 183
 heads 72, 83, 85, 86, 88, 96,
 98, 101, 103
 landscape 112, 117, 121, 123, 126–7,
 131, 132, 134
 nudes 215, 221, 223, 227, 228, 234,
 237, 240, 242, 249, 250
 still life 65
 types and techniques 42–51

*Mathilde "Quappi" Beckmann
 in a Club Armchair*
 (Beckmann) 172, 173
Matisse, Henri 15–16, 37, 66, 92,
 174–5, 234–5, 250
Michelangelo 12, 140–1, 173,
 215, 275
Millet, Jean-François 126,
 138, 156–7
Minerva Protects Pax from War
 (Rubens) 33
Minimalism 200, 282
Miró, Joan 204–5
mixed media 45, 96, 98, 180–1,
 209, 270
Model Looking Down (Noble) 28
Mondrian, Piet 55, 56–7
Monet, Claude 111, 124–5
Morandi, Giorgio 20–3, 55,
 64–5, 66
movement *see* rhythm
Munch, Edvard 230–1

N

Les Nabis 61
*Naked Woman, Lying on the
 Left Side From Behind*
 (Corot) 222, 223
Naldini, Giovanni Battista 214–15,
 261
negative space 31
Neoclassicism 219, 222, 282
Neo-Plasticism 57
Neue Sachlichkeit (New Objectivity)
 movement 172
No Title (Hesse) 200, 201
Noble, Guy 8–9, 10, 11
Nude (Valadon) 238, 239
*Nude Female Figure Reclining on
 Side* (Rodin) 232, 233
Nude Seen from Behind (Noble) 29
Nude Study from Life (Krasner)
 190, 191
nudes
 composition 219, 227,
 231, 240, 244
 form 215, 221, 227, 228, 233, 237
 line 216, 225, 227, 233,
 238, 244, 249
 materials 215, 221, 223, 227, 228,
 234, 237, 240, 242, 249, 250
 overview 212–13
 scale 215, 225, 242, 244
 shape 240

sources 219, 231, 247, 249, 250
space 240
subject matter 223, 242
tone 219, 223, 225, 234, 244, 247

O

O'Keeffe, Georgia 42, 100–1
Old Woman Studying the Alphabet with a Laughing Girl (Anguissola) 142, 143
outline
 compared to contour 233, 238
 definition 282
ox gall ink 48, 49

P

paper
 colour 86, 221, 227
 invention 11
 stretching 42, 145, 250
 texture 228
 types 50, 51
pastels 44, 45, 46, 47, 83, 96
pattern 57
pen 44–5, 112, 145, 147, 256
pencil
 figures 161, 162
 heads 103
 landscape 123, 132–3
 nudes 237, 242
 scale 161
 smudging 132
 still life 65
 techniques 42, 162
 tone 123
 types 46, 47
pens 48, 49, 126–7
perspective 16, 115, 169
Persuasion (Sickert) 166, 167
photography
 collage 276
 compared to still-life 65
 composition 41
 mixed media 180–1, 270
 as source 34–6, 200, 249
 transparency 98
photorealism 34, 282
Picabia, Francis 98–9
Picasso, Pablo 15–16, 23, 63, 70, 102–3, 170–1, 204
picture plane 31, 175, 282
Pissarro, Camille 125
plein air 124, 125, 282

plumb lines 161, 227, 244
Pointillism 228, 282
Polidoro da Caravaggio 78–9
Pollock, Jackson 190
Pontormo 76–7
Pop art 282
Portrait of a Serviceman (Tonks) 96, 97
Portrait of Dora Maar, Sleeping (Picasso) 102–3
Portrait of Erik Satie (Picasso) 170, 171
portraits 70–1 *see also* heads
Preparatory Sketch for Coffee (Bonnard) 60–1
Pre-Raphaelites 282
printmaking 49
Prud'hon, Pierre-Paul 20, 212, |218–19
Pugh, Robert 182–3
putty rubbers 46, 47, 228, 234

Q

A Quarrel Over Cards (Chalon) 154–5
quills 48, 49

R

Raphael 12, 72, 74–5, 188–9
Realism 92, 222, 282
Red Hoodie (Noble) 27
reed pens 48, 49, 126–7
Rego, Paula 27, 178–9
Rembrandt van Rijn 12, 49, 70, 71, 111, 139, 146–7
Renaissance 12, 142, 261, 281
rhythm
 abstraction 36
 definition 282
 fantasy 261
 figures 140, 147, 154, 163, 170
 form 33
 nudes 233
Rocky Wooded Landscape with Waterfall (Gainsborough) 118–19
Rococo 12–15, 86, 88, 116, 117, 216, 282
Rodin, Auguste 232–3
Romantic movement 118, 264, 282
rubber 47
Rubens, Peter Paul 12, 33, 262–3
rule of thirds 34, 40, 145, 281

S

Samson Slaying the Philistine, after Michelangelo (Naldini) 214, 215
Sargent, John Singer 162–3
scale
 abstraction 203
 fantasy 258, 270, 275
 nudes 215, 225, 242, 244
schematic drawing, definition 282
Schiele, Egon 236–7
School of London 166, 206, 282
Seated Woman (de Kooning) 270, 271
Self-portrait (Artaud) 104, 105
Self-portrait (Courbet) 92, 93
Self-portrait (Fohr) 90, 91
Self-portrait in Profile (Noble) 19
sensuality 88, 216, 233
series 39
Seurat, Georges 228–9
sfumato 234
shape
 heads 95, 104
 landscape 125
 nudes 240
 overview 31
shellac 49
Sickert, Walter Richard 166–7, 202
signatures 65
silverpoint 11, 72–3, 282
Sir Thomas Lestrange (Holbein) 80, 81
Sirani, Elisabetta 148–9
Sitzender weiblicher Akt (Schiele) 236, 237
Sketch for Puberty (Munch) 230, 231
sketchbook drawings (Noble) 8–9, 11, 24–5, 33, 37
sketchbooks 37–9, 61, 179, 195, 203, 249
smudging 132–3
sources
 abstraction 189, 192, 195, 204, 206
 fantasy 263, 264, 269, 272, 274, 278–9
 figures 159, 163, 164, 166, 169, 179, 180–1, 183
 heads 80, 88, 96, 102, 106
 landscape 113, 118, 124, 129, 131, 134
 nudes 219, 231, 247, 249, 250
 overview 34–9
 still life 61

The Sower (van Gogh) 126–7
space
 abstraction 206
 fantasy 258, 275
 figures 153, 157, 175
 heads 101
 landscape 112, 123, 131, 132
 negative 31
 nudes 240
 overview 31
 still life 59, 62, 63, 66
Spooky Moon (Noble) 11
Squeeze (Pugh) 182–3
St Paul's and River (Bomberg) 130
Staël, Nicolas de 192–3
Standing Female Nude, Seen From Behind (Prud'hon) 218, 219
Standing Figure (Giacometti) 242, 243
Standing Figure (Noble) 32, 33
Stella, Frank 200
Stevens, Wallace 275
still life
 composition 60
 form 57, 59, 66
 materials 65
 overview 54–5
 sources 61
 space 59, 62, 63, 66
 structure 57, 59
 subject matter 57, 60–1, 65, 66
 tone 63
Still Life (Morandi) 64–5
Still Life with Glass, Fruit Dish and Knife (Braque) 62–3
The Storm (Magritte) 266–7
structure 33, 57, 59
Studies after Michelangelo's Samson and the Philistines (Tintoretto) 260, 261
Study for Les Poseuses (Seurat) 228, 229
Study for Man with a Wheelbarrow (Millet) 156, 157
Study for Nighthawks (Hopper) 128–9
Study for Room 100, Chelsea Hotel (Dalwood) 276, 277
Study for the Drapery of a Man (Raphael) 188, 189
Study of a Nude (Balthus) 246, 247
Study of a Seated Woman Seen from Behind (Labille-Guiard) 88, 89
stumping 47, 240

subject matter
 abstraction 200, 203, 204
 fantasy 256, 258, 266–7
 figures 142, 151
 heads 78–9, 92, 95, 98
 landscape 117, 119, 121, 123, 128, 133
 nudes 223, 242
 overview 39
 still life 57, 60–1, 65
Surrealism 104, 169, 204, 266–7, 282
symbols 204, 272
Synthetic Cubism 59

T

Tachisme 192
Tahitian Faces (Frontal View and Profiles) (Gauguin) 94, 95
techniques
 composition 40–1
 materials 42–51
 set-up 40
texture 80, 96, 102, 103, 106, 151
Theatre of Cruelty 104
The Third Policeman No. 4 (Noble) 20
The Third Policeman (Noble) 21
three-colour chalk technique 86, 88
Tintoretto 215, 260–1
Titian 12, 111, 258–9
tone
 abstraction 195
 figures 145
 heads 75, 83, 86, 92
 landscape 114
 nudes 219, 223, 225, 234, 244, 247
 overview 28
 paper 86
 still life 63
Tonks, Henry 96–7, 130
topographical drawing, definition 282
transition tones, definition 282
 see also tone
transparency 98
The Tree-Man (Bosch) 256, 257
trois crayons 86, 88
trompe l'oeil 31
Turnbull, William 198–9
Two Figures in the Street (Noble) 34
Two Men at a Forest Crossroads (Noble) 16–17

U

The Undertaker (Noble) 11
unity
 definition 27
 detail 106
 fantasy 270
 figures 163
 heads 80, 103, 106
 nudes 219, 221, 244
 still life 66
 surfaces 221
Untitled (Baselitz) 176, 177
Untitled (Brown) 248, 249
Untitled (Diebenkorn) 244, 245
Untitled (Guston) 196–7
Untitled (One of Six Original Charcoal Sketches) (Hofmann) 194, 195
Untitled VII (Barceló) 208–9

V

Valadon, Suzanne 212, 238–9
van Gogh, Vincent 15, 70, 111, 126–7, 157, 164–5
View of Cathanger Near Petworth (Constable) 122–3
vision 19–23
Volley, Nicholas 66–7
Vorticism 130, 282

W

watercolour 48, 49
Watteau, Jean-Antoine 24, 86–7
Woman in the Shadow No. 3 (Noble) 39
Woman Looking Back (Noble) 15
Woman Looking Down (Noble) 28
Woman Resting (Matisse) 174–5
Women Fishing (Beckmann) 240, 241
Working Drawing for Primrose Hill (Auerbach) 202

Y

Young Woman, Half-Length, Seated (Raphael) 72, 74, 75

Z

Zuccaro, Federico 144–5